FLASH

Scott J. Wilson, Ph.D. Shannon Wilder Chris Volion

Africa • Australia • Canada • Denmark • Japan • Mexico New Zealand • Philippines • Puerto Rico • Singapore United Kingdom • United States

ONWORD PRESS

Flash 5 (Inside Macromedia) by Scott J. Wilson, Ph.D.

Executive Marketing Manager: Maura Theriault

Channel Manager: Mona Caron

Executive Production Manager: Mary Ellen Black

Production Manager: Larry Main

East normirrion to use material from this text or product, contact us by Tel (800) 730-2214 Fax (800) 730-2215 www.thomsonights.com

Library of Congress Cataloging-in-Publication Data ISBN No. 0-7668-2010-6 Production Editor: Tom Stover

Art and Design Coordinator: Mary Beth Vought

Cover Design: Brucie Rosch

Full Production Services: Liz Kingslien Lizart Digital Design, Tucson, AZ

We would like to thank the following parties for allowing us to use their images within our book and exercises. The images may appear individually or as part of a collage.

Corel Digital Imagery © Copyright 2001 Corel Corp. Figures 6-1, 11-1, 13-1, 17-1, 19-1, 21-1, 23-1, 26-1, 27-1

PhotoDisc Digital Imagery © Copyright 2001 PhotoDisc, Inc. Figures 14-7, 14-8, 14-10, 15-14, 15-15

Chris Volion Figures 1-1, 1-2, 1-3, 8-11, 18-11

NOTICE TO THE READER

Publisher does not warrant or guarantee any of the products described herein or perform any independent analysis in connection with any of the product information contained herein. Publisher does not assume, and expressly disclaims, any obligation to obtain and include information other than that provided to it by the manufacturer.

The reader is expressly warned to consider and adopt all safety precautions that might be indicated by the activities herein and to avoid all potential hazards. By following the instructions contained herein, the reader willingly assumes all risks in connection with such instructions.

The Publisher makes no representation or warranties of any kind, including but not limited to, the warranties of fitness for particular purpose or merchantability, nor are any such representations implied with respect to the material set forth herein, and the publisher takes no responsibility with respect to such material. The publisher shall not be liable for any special, consequential, or exemplary damages resulting, in whole or part, from the readers' use of, or reliance upon, this material.

All Web sites referred to in the exercises and examples in this book are intended to be purely fictional.

Business Unit Director: Alar Elken

Acquisitions Editor: James Gish

Developmental Editor: Jeanne Mesick

Editorial Assistant: Jaimie Wetzel

a division of Thomson Learning, Inc. Thomson Learning™ is a trademark used herein under license

Printed in Canada 2 3 4 5 XXX 05 04 03 02 01

For more information contact Delmar, 3 Columbia Circle, PO Box 15015, Albany, NY 12212-5015. Or find us on the World Wide Web at http://www.delmar.com

ALL RIGHTS RESERVED. No part of this work covered by the copyright hereon may be reproduced or used in any form or by any means—graphic, electronic, or mechanical, including photocopying, recording, taping, Web distribution or information storage and retrieval systems—without written permission of the publisher.

iv

Table of Contents

FLASH 5 TABLE OF CONTENTS

CHAPTER I

Getting Started
Introduction
An Overview of Flash
Flash – Art and Technical Skills
Instructional Approach 4
Learning Strategies
Icons for Quick Access
Using the Book – On Your Own7
Using the Book – Within a Classroom8
Windows vs. Macintosh
Getting Your Computer Ready9
Take a Look at the CD-ROM II
File Extensions and Descriptions
Opening a New File in Flash 12
What's New in Flash 5? 15
Summary

CHAPTER 2

Flas	h's Interface
	Introduction
	Flash's Metaphor
	Flash's Interface
	Guided Tour – Flash's Default Interface
	The Stage
	The Work Area
	The Timeline
	The Toolbox
	The Menus
	The Toolbar (Windows Only)
	The Panels
	The Library
	The Controller
	The Movie Explorer
	Flash's Help
	Summary

Opening, Playback, and Control of Movies)
Introduction	
Guided Tour – The Controller and Playhead	
The Timeline	
Playback Speed	
Guided Tour – Movie Properties	
Summary	

Drawing with Flash	49
Introduction	
Graphic Formats	
The Benefits of Using Vector Graphics	
Practice Exercise – Drawing Simple Shapes	
Practice Exercise – Using the Tool Modifiers	
Guided Tour – Introduction to Layers	
Summary	

CHAPTER 5

Creating Frame-by-Frame Animations.	87
Introduction	88
Guided Tour – Frames, Keyframes and the Timeline	88
Practice Exercise – Creating a Frame-by-Frame Animation	96
Onion Skinning	101
Guided Tour – The Onion Skin Tools	101
Summary	105

CHAPTER 6

Application Chapters Designing the Interface	107
What are the Application Project Exercises?	
Application Project Description	
Application Exercises – An Overview	
Application Exercise – Designing the Interface	
Summary	

CHAPTER 7

Importing Artwork into Flash	
Introduction	
Importing Files from Other Programs	
	from Freehand
Bitmap vs. Vector	
Practice Exercise – Importing and Con	verting Bitmap Images
Summary	

Organizing Movies with Layers and Groups	29
Introduction	
Grouping Objects	
Guided Tour – Group Editing Mode	
Creating Nested Groups	
Practice Exercise – Grouping and Ungrouping Objects	
Working with Layers	
Practice Exercise – Adding Objects to Layers	
Summary	

Text	and Layout Tools	151
	Introduction	
	Control of Text in Flash	
	Guided Tour – Text Options in Flash 153	
	Practice Exercise – Formatting and Inserting Text	
	Guided Tour – Text as Graphic Elements	
	The View Menu	
	Guided Tour – Controlling the Display View	
	The Info Palette	
	Guided Tour – Working with Rulers, Guides, and Grids	
	Summary	

CHAPTER 10

Symbols, Instances, and Libraries
Introduction
Guided Tour – Exploring the Library
Symbols
Symbols and Behaviors
Symbol Editing Mode
Practice Exercise – Creating and Editing Symbols
Practice Exercise – Modifying Instances of a Symbol
Guided Tour – Font Symbols
Summary

CHAPTER II

Application Chapter: Creating Re-usable Symbols	203
Introduction	
Application Exercise – Creating Re-usable Symbols	
Summary	

CHAPTER 12

Shape and Motion Tweens
Introduction
What is Tweening?
Motion Tweens
Motion Guides
Shape Tweens
Guided Tour – The Frame Panel
Practice Exercise – Motion Tweens and Motion Guides
Practice Exercise – Shape Tweens
Summary

Application Chapter: Adding Animation	3
Introduction	
Application Exercise – Adding Animation	
Summary	

Working with Movie Clips and Smart Clips	37
Introduction	
Characteristics of Movie Clips	
Movie Clips and Graphic Symbols	
Practice Exercise – Creating a Movie Clip 240	
Guided Tour – Testing Movie Clips and the Bandwidth Profiler	
Smart Clips	
Practice Exercise – Customizing Smart Clips	
Summary	

CHAPTER 15

Using Button Symbols
Introduction
The Characteristics of Button Symbols
Enabling Buttons
Guided Tour – The Button States
Practice Exercise – Creating Button Symbols
Practice Exercise – Creating Animated Buttons
Adding Actions to Button Instances
Guided Tour – The Actions Panel
Practice Exercise – Adding Actions to Button Instances
Summary

CHAPTER 16

Adding Interactivity with Actions	77
Introduction	
ActionScripts and Actions	
Guided Tour – Basic Actions	
Frame Actions and Object Actions	
Practice Exercise – Using Play, Stop and Go To	
Summary	

CHAPTER 17

Application Chapter: Movie Clip and Button Content	289
Introduction	
Application Exercise – Movie Clip and Button Content	
Summary	

Adding Sound
Introduction
Obtaining Sound Files
Properties of Sound Files
Sound File Types Supported by Flash
Practical Considerations When Using Sound

Guided Tour – Adding Sound to the Timeline	808
Sound Sync Options – Event, Stream, Start and Stop	312
Guided Tour – Sound Effects	313
Practice Exercise – Adding Sound to a Button	314
Work-arounds With Using Sound 3	817
Summary	818

Application Chapter: Creating Sound Effects	321
Introduction	
Application Exercise – Creating Sound Effects	
Summary	

CHAPTER 20

Organizing Movies.	327
Introduction	28
Using Scenes	28
Playback of Scenes	30
Plan Ahead – on Paper (Outline & Storyboard)	31
Practice Exercise – Creating a Movie with Multiple Scenes	33
Practice Exercise – Using Actions With Scenes	37
Using a Pre-loader	40
Practice Exercise – Building a Pre-loader	41
Practice Exercise – Loading and Unloading Movies	44
Summary	19

CHAPTER 21

Application Chapter: Setting Up Scenes	
Introduction	
Application Exercise – Setting Up Scenes	
Summary	

Publishing Flash Movies	57
Introduction	
Publishing Your Movie	
Export Options	
Export Image	
Export Movie	
Publish Settings	
Guided Tour – Publish Settings	
Optimizing Movie Files	
Guided Tour – Bandwidth Profiler	
Guided Tour – Publishing Movies	
Inserting Flash Movies into HTML Documents	
The Flash Player Plug-in	
Inserting Flash Movies into Dreamweaver Documents	
Guided Tour – Sharing a Library 385	
Summary	

Introduction	0
Application Exercise – Building a Pre-Loader	0
Summary	2

CHAPTER 24

Advanced Actions: Creating Drag-and-Drop Movie Clip Actions	393
Introduction	394
What is Drag and Drop?	394
Guided Tour – startDrag and stopDrag Actions	395
Practice Exercise – Creating a Basic Drag Action	397
Practice Exercise – Nesting A Button in a Movie Clip for a Drag Action	400
Practice Exercise – Drop Actions	403
Summary	414

CHAPTER 25

reating Forms in Flash
Introduction
Editable Text Fields
Guided Tean — The Text Optione Nanel 111111111111111111111111111111111111
Form Processing
Practice Exercise – Creating a Form
Summary

CHAPTER 26

Application Chapter: Information Form	27
Introduction	
Application Exercise – Information Form	
Summary	

CHAPTER 27

Application Chapter: Publishing the Site	3
Introduction	
Application Exercise – Publishing the Site	
Summary	

CHAPTER 28 (See the CD-ROM)

Quick Reference Guide	 	•	• •	•	•	•	•	•	 •	•	•	•	•	•	•	•	•	•	•	•	•	•	•	•		439
Introduction																									440	
The Menus	 									•	• •				•										440	
Keyboard Shortcuts Window	 •										•					•			•					•	445	
Keyboard Shortcuts	 																								446	
The Toolbars	 										•														453	
The Toolbox	 																								454	
The Timeline	 										•				•	•			•				•		455	
The Stage	 																								455	
The Panels	 															•									456	

X

Preface

If you want to learn Macromedia's Flash, the animation and Web authoring tool that is absolutely "shocking" the daylights out of the World Wide Web, you've picked up the right book.

We know Flash inside and out. We've been an Authorized Macromedia Training Provider for nine years, and have taught Flash since its debut.

Our book allows you to tap into the real-world experience of our instructors who are also successful developers in the multimedia and web-development industry. Through the use of our many Tips, Shortcuts and occasional Cautions, we'll give you the benefit of this "true and tested" experience.

We designed our book from the ground up to be the essential hands-on resource for Flash users. We focus on what you need most, concentrate on the most frequently used features and functions, and present the information within the context of "hands-on" learning.

Those who have taken our Flash courses are among the best trained in the industry. Why? Because our teaching method is based on a classroom-tested model of instruction. It works, whether you're learning in a classroom or on your own.

Our learning strategies are centered on the concept of "learning-by-doing." With numerous exercises and screen capture illustrations, you will build your experience base as you work through our book.

We focus on the "need-to-know" functions of Flash, and help you get down to the business of building leading-edge Web applications - fast.

We provide a "real-world" focus that reflects the development needs, project objectives, and Flash functionality typical of professional Web sites.

We deliver the professional experience of successful Flash developers – you'll learn valuable tips and shortcuts that only the experts know.

We hope you find our book valuable and have some fun along the way!

Scott J. Wilson, Ph.D.

Instructional Architect for the OnWord – Inside Macromedia Series

ACKNOWLEDGMENTS

Acknowledgements

First and foremost we want to thank the thousands of students who have attended our classes over the last nine years. Through your enthusiasm and probing questions, you have given us not only enjoyment in teaching the classes but have helped us become better at what we do.

We would like to thank the many people at Macromedia with whom we have worked over the years: in the Authorized Training Program; Authorized Developer Program; Value Added Reseller Program; Technical Support; Marketing / Trade Events; and Development / Engineering teams.

We would like to thank the past and present faculty members at Media Magic, who have not only done a great job in providing instruction, but who have also helped us revise and improve our instructional methodology in teaching the many classes over the years.

We want to sincerely thank the many people at OnWord Press/ Thomson Learning for the help and encouragement they have provided: James Gish, for helping us to better target and focus the Inside Macromedia Series; Jeanne Mesick, "carrier of the big stick" – your help, guidance, encouragement, feedback, suggestions, good humor and warm smile have been greatly appreciated (more than you know); Thomas Stover, for technical expertise and work behind the scenes; Liz Kingslien (Lizart Digital Design) for your wonderful production work and enjoyable working relationship; and Vincent Nicotina, for work on our CD-ROM.

From Shannon

Thanks to all my colleagues and friends at the University of Georgia, especially everyone in OISD and ECT. To my good friend Meg who lives up to her name spelled backwards. And to my wonderful husband, Lance, the only man I know that would buy his wife a purple house for her birthday.

From Chris

I'd like to thank my wife for her support and patience while I was busy juggling this book, two teaching jobs and an administrative role at church (yes Janet... now I'll have time to scoop the kitty-litter and take out the trash on a regular basis). I also thank God for the utterly unexpected career opportunities I've seen in the last couple of years and the U.S. Army for teaching me how to Be All That I Can Be. I'd also like to point out to the teachers and school counselors of my past that I am not, as it were, incorrigible.

From Scott

Shannon and Chris – many thanks for all your hard work helping to bring this work into being. Amy – bless you for hanging in there, doing what you do to help our students and faculty in every way you can. Marie-Claire, my wise and beautiful wife, thank you from the bottom of my heart for your continued support, faith and love. Many thanks to my family, teachers, students, friends, colleagues and fellow human beings – from whom I have learned so much along the way.

The author and Delmar Thomson Learning gratefully acknowledge the assistance of our review panel, who all made significant contributions to this project. Our heartfelt thanks are extended to:

Tara Holod Graphic Design Program Coordinator Allentown Business School Allentown, PA

Debbie Rose Myers Senior Instructor Art Institute of Fort Lauderdale Fort Lauderdale, FL

Piyush Patel Director of Multimedia and Digital Communications Program Northern Oklahoma College Tonkawa, OK

Tom Bates LaRoche College Pittsburgh, PA

PTER

Getting Started

Chapter Topics:

- Introduction
- An Overview of Flash
- Flash Art and Technical Skills
- Instructional Approach
- Learning Strategies
- Icons for Quick Access
- Using the Book –
 On Your Own
- Using the Book Within a Classroom
- Windows vs. Macintosh
- Getting Your Computer Ready
- Take a Look at the CD-ROM
- File Extensions and Descriptions
- Opening a New File in Flash
- What's New in Flash 5?
- Summary

Introduction

In this first chapter, you will get a quick introduction to Flash and then more detailed information that will help you in working with the rest of this book and the CD-ROM that accompanies it. The chapter concludes with a brief review of the new features in Flash 5. We hope you will find our book help-ful in your quest for knowledge, and that you will find Flash a powerful and fun tool to use.

By the end of the chapter you will be able to:

- list skills that are frequently needed to create multimedia projects.
- list the Learning Strategies used in this book.
- · describe the Icons for Quick Access used in this book.
- create a directory on your computer for saving the exercises you'll work with in this book.
- locate necessary exercise files on the included CD-ROM.
- open the Flash 5 program.
- · list the new features of Flash 5.

An Overview of Flash

Macromedia's Flash is one of the industry's leading authoring software programs being used to create high-impact Web sites that include graphics, animation, sound and interactivity. Flash uses a highly visual interface in which elements can be introduced, positioned and easily animated without the heavy-duty programming that was commonly required only a few years back. Flash integrates drawing and paint tools similar to those found in Macromedia's Freehand and Adobe's Illustrator, so you can easily create new elements from scratch, or import and modify them if developed in another graphics program.

Flash 5 can output (or Publish) files using a variety of file formats, greatly increasing the distribution options for your projects. The programs you build with Flash can ...

- ... run in a Web browser as a stand-alone program.
- ... be easily inserted in HTML files.
- ... be exported as animated GIF files.
- ... be exported in QuickTime video format.
- ... be exported in other formats that allow you to use Flash for many kinds of multimedia projects.

Flash – Art and Technical Skills

Learning how to use Flash (or any other authoring software program) is only one aspect of what is required to create a functional and professional looking multimedia program or Web site. Generally there are many different skill sets involved. These different skills may exist within a single individual or may be represented in the composite skills that exist among a team of people.

At a minimum, these skills may include proficiency in:

- · design and layout principals
- · artistic creativity and execution
- writing (text and narration)
- program / message / or instructional design
- audio / video techniques
- · use of the authoring software
- project management

Figure 1-1 Flash Applications Require Technical Skill

Figure 1-2 Flash Applications Require Artistic Talent

Although the focus of this book is to help you learn how to use the Flash authoring software program, the acquisition of these technical skills should be considered within the context of the other skills that may be required. The extent to which you may need these other skills will depend to a large extent upon the type of application you are creating, its intended use and how "professional" you want the end result to be.

We realize that many of you may not have an art background and may just want to have fun with Flash for your own personal use. Therefore, the exercises included in our book do not require an art background – although they can be enhanced on your own, if you do have artistic talent. In the beginning exercises, you will be asked to draw simple objects, as a means of introduction to the drawing tools. If you do have artistic talent, we encourage you to take "creative license" to modify and embellish the subject matter. In later exercises, "art work" will be supplied with the exercises so that you will be able to create more realistic and professional looking projects.

Instructional Approach

Because of the many features and functions, Flash may at first seem intimidating. We don't want to overwhelm you with lots of details "all-at-once" but instead will introduce the aspects of Flash that are the most practical and those that are most commonly used to build programs in today's "real-world."

We hope to help you learn Flash in an intuitive way while practicing some of the techniques and short cuts that are typical of what Web designers are using as they create Flash products for "real-world" applications. Each chapter builds upon the last, adding new features of Flash to your builder's toolbox.

The chapters within our book break up the material into "learning chunks" that are about right for most people during a single session, whether you are

4

5

learning on your own or using this book within a classroom setting. The Learning Strategies used within these chapters are centered around the concept of "learn-by-doing." These Learning Strategies represent the synthesis of teaching multimedia software programs for over nine years as an Authorized Macromedia Training Provider. Understanding the intent behind these Learning Strategies may help you to most effectively use what is provided here to learn and understand the Flash software program.

Learning Strategies

Introduction – each chapter starts off with a brief introduction to the topics to be covered, including a brief listing of learning objectives for those of you who find such things useful.

Conceptual Overviews – provides a "50,000-foot" overview of the subject matter before we get into the narrowly focused details of building something.

Guided Tour – some chapters may include a structured "walk-through" of how to do something like making menu / window selections or looking at the various properties or options listed. A Guided Tour is not really an exercise, but follows the notion of learning by actively "looking and doing."

Practice Exercise – most chapters will include hands-on experiences introducing the basic skills for using tools and techniques to build structures that are typical of "real-world" applications. The scope of the exercise is fairly narrow, focusing on the concepts and skills that have just been introduced in the chapter. The content is generally simple so that the emphasis remains on building the structures and using the techniques and is not dependent on pre-existing artistic talent. Again, if you do have artistic talent, please modify and embellish the content that you find within the exercises.

Figure 1-3 Hands-on Learning

CHAPTER I

Each Practice Exercise includes project elements that reflect aspects of the "real-world" development process:

Description – provides a general description of the purpose and components that will be used within the exercise. Generally "real-world" projects include a project description, although it will typically be much more detailed than what we include here.

Take-a-Look – asks you to make use of the CD-ROM supplied with the book, to load and play a file that is the completed version of the exercise that you are about to create. This section will help you visualize the goal of the completed exercise.

Storyboard: On-Screen – provides screen captures of what will be seen on screen when the exercise is completed, to serve as a printed reference. A Storyboard that includes on-screen descriptions or illustrations is a vital "real-world" project deliverable.

Storyboard: Behind-the-Scene – provides screen captures illustrating the authoring structures that are used in the completed version of the exercise. to serve as guideposts for development. A Storyboard that includes programming descriptions or illustrations is a vital "real-world" project deliverable.

Go Solo – You will see this Icon immediately following the Storyboard sections. At this point in an exercise, you should have the information necessary to complete the exercise on your own... and we encourage you to give it a try. If you need help, however... unlike the "real-world," you can use the Stepby-Step Instructions that follow.

Step-by-Step Instructions – are for those who would like structured help with the details of the tasks involved in the exercise. The numbered steps state "what" needs to be done, while the lettered sub-steps describe "how" to do it.

Summary – each chapter concludes with a bulleted list of the major concepts and topics presented.

Application Chapters – Project

Each Application Chapter focuses on an exercise that serves as a component of a "real-world" application, that when combined, will contribute to a complete Flash Application Project. Each Application Exercise provides hands-on experience in building structures that synthesize the concepts and skills learned across several preceding chapters.

The CD-ROM supplied with the book contains the completed version of each Application Exercise, so you may skip over some content areas and still be

6

· T/P·

7

CD-ROM

Shortcut

CAUTION

Go Solo

able to work on other parts of the Application Project. Each Application Exercise contains the same sub-sections as the Practice Exercise – with one difference. The Step-by-Step Instructions are not included so that you can master the material on your own. The Application Exercises do, however, include a list of the tasks that you will need to perform.

Icons for Quick Access

The Inside Macromedia Series uses the following Icons, appearing in the minor column, to provide quick, visual cueing to particular types of information.

CD-ROM Icon – indicates that material from the CD-ROM supplied with the book is necessary at this point in an exercise or tour.

Tip Icon – provides additional information related to an aspect of an exercise or tour. This falls into the "nice to know" but not necessary information.

Short Cut Icon – provides a more efficient method as an alternative to the steps described in the text.

Caution Icon – provides helpful suggestions for avoiding actions that might result in lost time and effort.

Go Solo Icon – indicates that at this point, you have enough information to take control of the exercise and attempt to complete the exercise on your own.

Using the Book – On Your Own

Each book in the Inside Macromedia Series has been designed to be used either on your own or within a classroom setting. For those of you who will be using this book to learn Flash on your own – don't worry, we will guide you through the process and give you the freedom to modify what you want.

We (the authors) have, over the years, learned many software programs on our own and think that the Learning Strategies we are using in the book have helped us the most – as learners.

Conceptual Overview – 50,000 foot level introduction

Guided Tour - actively look at options, preferences, etc.

Exercises - hands-on experience with the details of how to do something

Take-a-Look - "seeing" what the goal is

Storyboard – "pre-thinking" what will be on-screen and what will be necessary in terms of programming

Tips – separating the "nice to know" material from what is necessary

8

Go Solo – At this point you have enough information to complete the exercise on your own – go for it.

Keep in mind that there generally is not "one-way" to build something. You may end up creating the exercise using different steps than what we have included – and that's fine if your structure does what it needs to do.

Step-by-Step Instructions – more details for those who need or want them.

Numbered Steps – state "what" needs to be done

Lettered sub-steps - describe "how" to do it

Using the Book – Within a Classroom

As instructors for Flash, Authorware, Director, Dreamweaver, UltraDev, Fireworks (and others) – we also think these same Learning Strategies (presented somewhat differently) are equally effective in the classroom. In the classroom, we use the book as a point of reference and organizational guide for the presentation of material. As a "point of reference" we don't "read" from the book – nor ask students to do so. But we use the book to organize the classroom presentation. We encourage students to take notes, right in the book. With each chapter we provide:

Conceptual Overviews – presenting the highlights from the book and each instructor generally adds her/his own additional details or points of emphasis.

Guided Tours – using a projection device attached to the instructor's computer, as a class we "walk-through" the essence of the tour.

Exercises – again using a projection device, as a class we "walk-through" the beginning of an exercise.

Take-a-Look – look at the completed version of the exercise, pointing out noteworthy characteristics.

Storyboard – use the completed version to look at what is on-screen and what is programmed (making reference to the screen captures in the book).

Go Solo – ask students at this point to try to complete the exercise on their own. If students need help, we suggest looking first at the numbered steps that state "what" needs to be done, then try to figure out "how" to do it.

Instructor Help – we walk around the classroom providing help and additional information as needed.

Tips – each instructor contributes her/his own additional information based on professional experience.

Windows vs. Macintosh

Flash 5, like most of Macromedia's software, is virtually the same on both Macintosh and Windows based computers. The biggest variation stems from minor differences in a few keyboard keys and the absence of the right button on the Macintosh mouse. The chart below compares the Windows and Macintosh keyboard keys:

Windows

Macintosh

Alt in combination with another key	Opt in combination with another key
Ctrl in combination with another key	Cmd in combination with another key
Right mouse button click	Ctrl with mouse click

Throughout the book these difference are minimized in that we most often make selections through the use of Menu options, which are the same across both platforms – unless otherwise noted. As we progress through exercises, however, we will make use of one of our Icons – Short Cuts, providing both Macintosh and Windows versions of Keyboard Short Cuts.

In order to provide a consistent look for screen captures, most illustrations will depict the Windows version of Flash 5. When needed, Macintosh screen captures are also provided.

Getting Your Computer Ready

Prerequisite Knowledge

It is assumed that you already have the skills necessary to work in the basic Windows or Macintosh environment prior to undertaking learning Flash.

Specifically you should be able to:

- · use the mouse and keyboard for basic input and selection.
- · select and drag objects.
- · resize windows.
- locate directories (folders).
- · locate files within directories.
- · create and name directories.
- · copy files.

10

Preparing Your Computer's Hard Drive

Throughout the course of this book, you will be creating many Flash files you will want to save on your computer. In order to make it easier to locate these files and communicate to you about these files, it is strongly recommended that you create a new directory (folder) on your computer's hard drive to store these files.

- 1. On the root directory of your computer's hard drive, please create a directory (folder) named... SaveWork.
- 👄 Macintosh HD DE 40 items, 14,24 GB available Date Modified Picture 2 Thu, Dec 21, 2000, 3:49 PM Picture 3 Thu, Dec 21, 2000, 3:54 PM Picture 4 Thu, Dec 21, 2000, 3:59 PM Picture 5 Thu, Dec 21, 2000, 4:19 PM HICTURE 6 IDDAY, IU: IN AM Dia QuickTime VR Authoring Studio Mon, Jul 17, 2000, 2:11 PM ▶ QuickTime™ Folder Sat, Sep 16, 2000, 12:48 PM Sam's video files Mon, Oct 9, 2000, 12:39 PM SaveWork Today, 10:16 AM Snapz Pro 2.0.1 f Thu, Oct 12, 2000, 4:33 PM System Folder Mon, Jan B, 2001, 5:06 PM
- 2. Refer to the appropriate illustration below.

Figure 1-4 Create New Directory for Macintosh - SaveWork

🚍 Gw2k (C:)			- 0 ×
<u>File E</u> dit <u>V</u> iew <u>G</u> o F <u>a</u> vori	tes <u>H</u> elp		1
Back Forward Up	Lut	Сору	**
Address C:\			-
Name	S. Type		<u>_</u>
SaveWork Windows Windows Update Setup Files	File Folder File Folder File Folder		

Take a Look at the CD-ROM

This book makes use of numerous learning activities that include pre-existing Flash files and a variety of media elements. All of these files and elements are contained on the CD-ROM included with this book.

- Place the CD-ROM supplied with this book into your computer's CD-ROM player.
- 2. Use your computer to view the contents of the CD-ROM.
- 3. The illustration below shows the main directory structure of the CD-ROM.

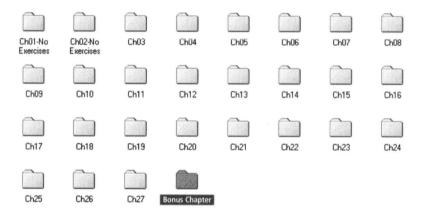

Figure 1-6 Main Directory Structure on CD-ROM

Notice there are two types of directories on the CD-ROM. They are: Chapters and the Bonus Chapter.

Chapters – There is a folder for each chapter in the book. Each Chapter folder contains all the files needed for the Guided Tours, Practice Exercises or Application Exercise for that Chapter.

The Bonus Chapter – Inside this folder are two files. The first file (Ch28.pdf) is a reference chapter that includes detailed illustrations of all the major elements of Flash's interface. We strongly suggest that you print this file right now, so you can use it as a reference as you work your way through the Practice and Application Exercises you will find within our book. We also think you will find this chapter an invaluable Job Aid when you are working on your own projects in the near future. The second file (rs405eng.exe) is the program file that will install Adobe's Acrobat Reader, allowing you to read and print the first file (Ch28.pdf).

File Extensions and Descriptions

Please note the following basic file extension names and descriptions that are used within the book. Other import and export file formats will be described in greater detail in a later chapter as we look at the options that use them.

.fla - Flash Movie file; editable Movie files.

.swf – Shockwave files; Exported Flash files that can not be edited, but can be played using the stand-alone Flash Player, or embedded into HTML files.

.swt – Generator Template; allows you to use the Flash Movie with Macromedia's Generator.

.mov – Movie file format; Flash allows Movies to be exported in QuickTime video format.

.gif – Animated gif; compressed graphic file format that can be used to export Movie animations without interactivity.

.bmp – Graphic file format; one of many that can be exported from Flash.

.tif - Graphic file format; one of many that can be exported from Flash.

.jpg – Graphic file format; one of many that can be exported from Flash.

.png – Graphic file format native to Macromedia's Fireworks; one of many that can be exported from Flash.

Opening a New File in Flash

Windows Computer

After you have successfully installed Flash on your computer, you can open it like any other Windows software program.

- 1. Open the Programs Menu in Windows.
- 2. Open the Macromedia Flash 5 Folder. See the illustration below.

Programs	Macromedia Flash 5	Flash 5
Programs	Microsoft Software	Flash License
* Favorites	McAfee VirusScan	🕨 🛃 Flash Readme
~	MindSpring 4.0	Players
Documents	MindSpring Internet Soft	tware 🔹 🔹 🕹 Standalone Player

Figure 1-7 Opening the Macromedia Flash 5 Folder (PC)

3. Select Flash 5. See Figure 1-8.

12

Programs		▶券 Flash 5
States of the second	Microsoft Software	Flash License
* Favorites	General McAfee VirusScan	Flash Readme

Figure 1-8 Selecting Flash 5 (PC)

4. As Flash opens, it presents an opening title screen. The exact appearance of this screen (see illustration below) will differ depending on whether you have a commercial version that can be used to develop and distribute Flash programs or an Educational version that can only be used in an educational institution and not for commercial distribution.

Figure 1-9 Flash's Title Screen

5. Once Flash has loaded, you should see Flash's main interface including the Tool Palette, Menu Bar, Stage, Timeline, Work Area and Inspectors. We will go through these elements of Flash's interface in greater detail in Chapter 2.

Macintosh Computer

After you have successfully installed Flash on your computer, you can open it like any other Macintosh software program

I. Double-click to open the Macintosh hard drive where you installed Flash 5.

Getting Started

If you accidentally close one of these interface windows, you can reopen it by selecting the appropriate Menu option.We'll practice doing this later. CHAPTER I

14

2. Open the Macromedia Flash 5 Folder. See the following illustration.

	Macintosh HD						
39 ite	ms, 14.24 GB available						
Name	Date Modified						
Fireworks 3	Tue, Sep 26, 2000, 1:13 AM						
🕨 试 iMovie	Fri, May 12, 2000, 12:26 PM						
Installer Log File	Wed, Jul 26, 2000, 12:27 PM						
🕨 试 Installer Logs	Sat, Sep 16, 2000, 12:26 PM						
🕨 🤍 installers	Thu, Oct 12, 2000, 4:32 PM						
👔 Late Breaking News	Tue, Feb 1, 2000, 1:46 PM						
🕨 🍓 Mac OS Read Me Files	Today, 11:57 AM	in the second					
🕨 🙀 Macromedia Flash 5	Today, 10:14 AM						
Media Cleaner Pro 4.0	Mon, Sep 18, 2000, 9:46 AM						
🕨 🐧 michellesimpson	Fri, Oct 20, 2000, 10:53 AM						
Nov16 Restore_Sherry	Thu, Nov 16, 2000, 10:34 AM						
· · · · · ·		4)					

Figure 1-10 Opening the Macromedia Flash 5 Folder (Mac)

3. Select Flash 5. See the illustration below.

4. As Flash opens, it presents an opening title screen. The exact appearance of this screen (see the illustration below) will differ depending on whether you have a commercial version that can be used to develop and distribute Flash programs or an Educational version that can only be used in an educational institution and not for commercial distribution.

Figure 1-12 Flash's Title Screen (Mac)

 Once the title screen has erased, you should see Flash's main interface including the Tool Palette, Menu Bar, Stage, Timeline, Work Area and Inspectors. We will go through these elements of Flash's interface in greater detail in Chapter 2.

What's New in Flash 5?

With every new release of Flash, more features are added to give you the most up-to-date tools to help you create a compelling multimedia experience for your Web site users. If you are new to Flash, these features will simply be part of the learning process for the rest of the program. If you have some experience with previous versions of Flash, you will find that many of the new features add convenience and power to Flash's design tools. Here are some of the outstanding new features in Flash 5.

Common User Interface

With the development of the Common User Interface, Macromedia has streamlined how Flash can be used in tandem with other Macromedia authoring programs. Customizable keyboard shortcuts as well as a more familiar Toolbox Layout, Menu Structures and Floating Panels make it easier to learn

Macintosh computers do not require file extensions, however, in order to create cross platform or Shockwave deliverable Movies, you should make sure to include the proper file extensions with all your Flash Movie files. and apply features in a variety of Macromedia products. The new Panel Management feature also allows you to customize your workspace by docking and snapping panels in any arrangement.

Bezier Pen Tool

The Bezier Pen Tool gives you added control over the creation of graphics for use in your Flash Movies. This tool is already a familiar fixture in many illustration programs such as Macromedia's Freehand. Designers familiar with the pen tool in other such programs will find that Flash's Bezier Pen Tool gives you the same precise anchor point control over drawing and manipulating graphics.

Movie Explorer

The new Movie Explorer allows you to view the structure of your Flash Movies and complex Web applications in one printable window. The Movie Explorer translates your Flash project into a nested (structured) map that can be searched and edited The ability to view your applications this way makes it easier for teams to manage complex Flash applications by providing a behind-the-scenes look at how projects are structured, without viewing the Timeline of the .fla file.

Enhanced ActionScript Development Tools

ActionScript Tools give developers used to more traditional programming environments an alternate interface for adding interactivity to Flash applications. This group of tools includes the ActionScript Editor, which reveals the Flash scripting language and allows programmers access to a language similar in syntax to JavaScript. The ActionScript Editor can be used in the Novice or Expert mode, to aid users of varied experience levels. Flash 5 also includes extensive documentation regarding ActionScripts in the Flash Help Menu. Another tool, the Debugger, helps developers check applications for glitches using ActionScript Variables.

MP3

16

With Flash 5, you can now import MP3 files into your Movies for use as sound files. This feature allows you to bring in high quality audio with small file sizes. You can also export audio files in the MP3 format when publishing your finished Movies.

HTML Text Support

Flash developers can now use HTML text along with Flash's familiar antialiased display text. The new Text Options Panel in Flash 5 gives users the option of formatting text with HTML 1.0 tags. Also, HTML text files created in Dreamweaver or other editors can now be used to automatically update text content on published Flash sites.

XML Support

XML – Extensible Markup Language – is a relatively new way of working with information on the Web. XML is a set of guides used to format structured data such as spreadsheets into text files. Although, loosely related to HTML, XML is used to create other languages specific to certain types of content or subjects. With Flash 5, XML structured data can now be used within Flash applications.

Summary

- Flash is a widely used authoring software program used for creating high-impact Web sites that include vector graphics, animation, audio and sophisticated interactivity.
- The Learning Strategies used within the book are designed to accommodate self-paced learning and classroom situations. They are:

A Guided Tour – a structured "walk-through" of how to do something like making menu / window selections.

A Practice Exercise – an introductory, hands-on experience in learning the basic tools and skills of Flash 5.

An Application Exercise – provides hands-on experience in building structures that combine the concepts and skills learned across several chapters.

- The Inside Macromedia Series uses a number of Icons, appearing in the minor column, to provide quick, visual cueing to particular types of information.
- All files that you work on in the exercises in this book will be saved in a directory you must create on the root directory of your computer's hard drive. This directory (folder) should be named SaveWork.
- This book makes use of numerous learning activities that include pre-existing Flash files and a variety of media elements. All of these files and elements, and a great deal more are contained on the CD-ROM that has been included with this book.
- There are a number of new features of Flash 5.0, which have been described in this chapter.

TER

2

Flash's Interface

Chapter Topics:

- Introduction
- Flash's Metaphor
- Flash's Interface
- Guided Tour Flash's Default Interface
- The Stage
- The Work Area
- The Timeline
- The Toolbox
- The Menus
- The Toolbar (Windows Only)
- The Panels
- The Library
- The Controller
- The Movie Explorer
- Flash's Help
- Summary

Introduction

With Flash, you can go well beyond creating two-dimensional animation. You can create Web-delivered content that allows your users to interact with the content. The current chapter is designed to introduce you to some of the most important aspects of Flash's interface and will help you begin to work with some of the basic tools. Chapter 28 contains all the elements of Flash's interface, including lots of illustrations. Chapter 28 is included as a file located on the CD-ROM in the folder named **The Bonus Chapter**. Please take the time right now to print this file so you can use this material as reference as you continue through the rest of the book. You will find that Chapter 28 will be very helpful to refer to as you begin working with Flash and later on for reference. By the end of this chapter, you will be able to:

- explain Flash's metaphor as it is reflected in the interface components.
- list Flash's major interface components.
- list Flash's tools.

Flash's Metaphor

Before we dive into looking at how Flash works, it would be useful to consider the metaphor that has been used to build the Flash interface. The metaphor and many of the interface elements are very similar to another Macromedia software program – Director.

Flash's metaphor is the key to understanding the program's interface, development process, and the language used to create projects. The metaphor is based on the theme of movie or theater production.

Think of it like this: You are creating a production – essentially creating a **Movie**. Each time you work on a project in Flash, we refer to it as a **Movie**. Your role is Executive Producer. It is your task to decide on the setting for the Movie, how the story line will play out, who the main characters will be, what actions they will take, and what kind of special effects will be needed to make your Movie appeal to audiences.

Everything that appears (or that is heard) in your Movie takes place on the **Stage** (like a Hollywood sound stage). The actors, scenery and props that will be used in the production are referred to as **Objects** within Flash. Just like on a sound stage, objects can appear on Stage, to varying degrees toward the front or back of the Stage. Although Flash works as 2-D animation, you can create the illusion of depth by placing objects in the foreground or back-ground of the Stage. Objects appear more toward the front or back of the Stage by placing them in different **Layers** that are either in front of or in back

of each other. The action on the Stage is captured in individual **Frames.** A Frame is like a "single moment of time" that includes everything in every Layer – at just that moment. As each one of these Frames are created, they are "strung together" to make up a **Timeline**, which consists of the entire Movie production from beginning to end. We will look at each one of these interface elements in more detail as we proceed through the chapter.

Flash's Interface

Flash's interface provides you with a complete workshop of authoring tools that you can use in the creation of your Movie. The major components of the Flash interface include:

- The Stage
- The Work Area
- The Timeline
- Layers
- The Toolbox
- The Menus
- The Tool Bar
- The Panels
- The Library
- The Controller

There are a number of windows that are part of this interface, containing tools for developing your Movie. During the development process, you will have the opportunity to either keep all of these windows open and available for immediate use, or close some of them for later use. As you begin to work with Flash, you will find that there will be a few of these windows that you will keep open most of the time, as they are central to development. All of the windows can be opened or closed at any time you wish by accessing the appropriate Menu option.

You can also customize the Flash interface to fit your specific needs and style of working. Your customized settings are saved in a Preferences file. If you have already opened your copy of Flash and looked at the interface, you may have already changed some of these default settings, perhaps without even knowing that you have done so. Changes to the default setting could include anything from moving the windows around, to changing unique controls.

Guided Tour – Flash's Default Interface

1. Open the Programs Menu (in Windows).

or

Double-click to open the Macintosh hard drive where you installed Flash 5.

- 2. Select the Macromedia Flash 5 Folder.
- 3. Select Flash 5.

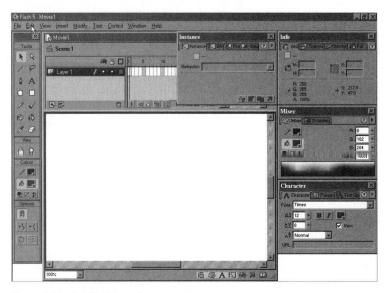

Figure 2-1 The Flash Interface

- 4. Six windows will open when the program is fully loaded. The placement of these windows or panels may vary slightly according to the resolution of your monitor, but should look similar to what is in Figure 2-1. To maintain consistency of appearance, the screen captures presented in this book will illustrate the Windows version of the Flash software. On occasion, Macintosh screen captures will also be provided.
- 5. You may want to keep Flash open to refer to as you continue through the rest of this chapter. In this way, you can refer to not only the screen captures provided in the book, but look at the actual software as well.

If Flash has been open before, your computer screen may initially look different from the screen captures in this book. If this is confusing to you, you can revert to a default screen layout by choosing Window / Panel Sets / Default Layout from the Window pull down menu. Selecting this option opens the panels that appeared when Flash was first launched and places them in their original location on the screen.

·T/P·

The Stage

When your program opens, the white rectangle you see in the middle of your screen is called the Stage. Following through with our metaphor of the theater or movie production, the Stage is the window that will display the finished program. Aptly named, the Stage is where your Movie is created and where all the action is played out. This is where you will place every element that you want to be seen by the user.

There are a number of ways to change the way your finished Movie looks just by changing certain attributes of the Stage. For example, you can change the size of the Stage and its background color by changing the Movie Properties, as you will learn in the next chapter. At 100%, the Stage will appear in the authoring mode as it will appear during playback through the Flash Player. See Figure 2-2. You will find that the need may arise to increase the viewable size of the Stage and "zoom-in" on different sections on the Stage. This will help you make precise visual edits with items placed on the Stage. You can use the Pull Down Menu on the Stage to select different Zoom settings. See Figure 2-3.

Because Flash can have multiple windows and tools open at the same time, your screen can get crowded pretty quickly. To help you better manage the screen real estate, you can zoom out, decreasing the size of the stage and providing more room on screen. This can also help you more easily view animations that start or end at positions off the viewable Stage.

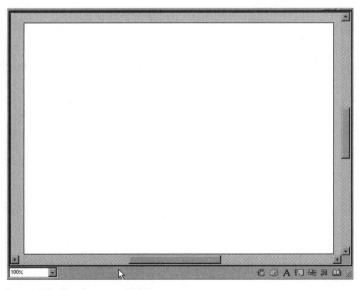

Figure 2-2 The Stage at 100%

Figure 2-3 Zoom Pull Down Menu

The Work Area

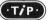

If you currently don't see the Work Area, you can turn the Work Area on and off by selecting the Menu option View / Work Area. The gray area surrounding the Stage is called the Work Area, similar to the backstage or wings of a theatre stage. See Figure 2-4. If you have a small screen, you may need to scroll to the left/right or up/down to see where the edge of the Stage ends and the Work Area begins. You can also zoom out using the pull-down menu (shown in Figure 2-3), decreasing the size of the Stage until the surrounding Work Area is visible. The Work Area allows you to view objects placed partly or entirely off the Stage, where they are no longer in the viewable region of the Movie. In a sense, objects placed on the Work Area are waiting in the wings to make their big entrance into the Flash Movie. The Work Area gives you the option of moving objects on and off the main Stage area while you are in the process of creating animated effects on the main Stage.

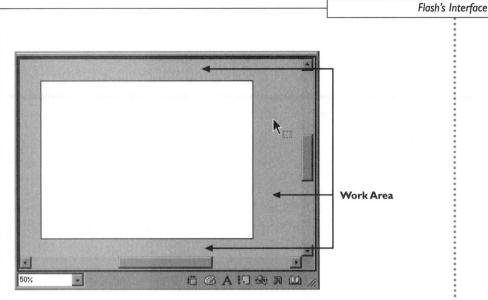

The Work Area always surrounds the Stage, however, the contents of the Work Area can be hidden using a simple Menu option. This is helpful if you would like to view only what your users will see as you develop your Movie. Using this option might help you better visualize how elements appear on the Stage. You can turn the Work Area on and off by selecting the Menu option View / Work Area as illustrated in Figure 2-5. A check mark indicates that the Work Area is on.

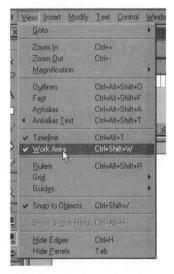

Figure 2-5 Using the View / Work Area Menu Option

CHAPTER 2

•**T/P**•

In Flash 5, the Timeline can become a floating window or can be "docked" at the bottom or top of the screen. To separate the Timeline from its docked position, click in the gray area above Layers in the Timeline, or in the gray area where the Scene Icon appears, and drag the Timeline away from its default location. When you release your mouse, the Timeline will become a free-floating window. To dock the Timeline, repeat these steps and drag the window to its desired position.

The Timeline

The next component of the interface that is essential in creating projects with Flash, is the Timeline. Any action that takes place on the Stage is controlled by what happens in the Timeline. The Timeline organizes all the objects involved in a Movie and determines how the different media elements will perform. The major components of the Timeline are **Layers, Frames**, and the **Playhead**.

As you look at the Timeline in Figure 2-6, you can see that we are looking at what appears to be a grid pattern of rows that have names (different Layers) and columns that are numbered (numbered Frames). The red square (and red line extending below it) represent the Playhead. The Playhead resides on the row that contains the Frame numbers and can be dragged from Frame to Frame. See Figure 2-6.

Figure 2-6 The Timeline – Layers, Frames and Playhead

Layers – Content placed in your Flash Movie is contained in a Layer. Layers are a common organizational feature in most graphics programs and work in a similar manner in Flash. They can be thought of as a stack of transparencies, each containing a graphic element. With the use of Layers, objects can be placed in front of or behind other objects. Layers can be given specific names that correspond with the objects placed on them. Placing an item on a Layer protects it from being altered by items placed on other Layers. As you will see in later chapters, you can add, delete, and control the attributes of Layers – including locking, hiding and outlining a Layer.

Frame – A Frame is a single point in time and a unit on the Timeline. The small rectangles that appear in the Timeline, as illustrated in Figure 2-6, delineate individual Frames. Each Frame is numbered in the Timeline and you can have multiple layers for each Frame. Whatever you see or hear on the screen at any one given point in time (in a particular Frame), is a result of combining the content in each Layer, for that particular Frame. For example, if we look

at Frame 7 on the Stage, what we see is the result of adding up all the content, in all Layers, in Frame 7.

Keyframe – A Keyframe is a specially defined Frame that contains either an action or a change in an animated sequence. When you insert a Keyframe, you are telling the Timeline that some kind of change will occur or begin with that particular Frame. A filled circle, as illustrated below, depicts Keyframes that are associated with content on a Layer in your Timeline.

Figure 2-7 The Keyframe Indicator

Playhead – The Playhead in Flash is analogous to the playback head on a video tape player, it "picks up" and displays whatever it is currently aligned with. You can drag (scrub) the Playhead back and forth along the Frames of the Timeline. As you drag the Playhead along the Timeline, you will see your Movie play out on the Stage.

Putting it Together

Here is another way to think about Layers, Frames and the Timeline. Think of the Timeline as an electronic strip of a movie film. When you hold up this strip of film (let's say from the movie's opening title screens) to a light source, you see a series of movie frames. Each frame is the final result of different layers that were put together to represent the "total movie" at that particular point in time. If we look at a movie frame from the opening title, there were a number of contributing layers – a layer for the background scenery; a layer for the text containing the title of the movie; and a layer for the sound track. In a like

manner, within Flash, a single Frame represents the "total movie" at a single point in time.

As a Flash **Movie** is viewed from beginning to end, the **Playhead** moves along the **Timeline**, from left to right, playing all the content from all **Layers**, as it reaches each **Frame**.

The Toolbox

The Toolbox is an assortment of drawing, paint and text tools that can be used to create objects for use in your Movies. The drawing tools found in the Flash Toolbox are very similar to the tools found in many other graphics programs, including Macromedia's Freehand and Director. With these tools you have a convenient way to create elements for use in your Flash projects, or to modify graphics that have been imported from other software programs. The Toolbox can also be used to manipulate elements on the Stage by positioning, scaling, and rotating objects, or changing their color attributes.

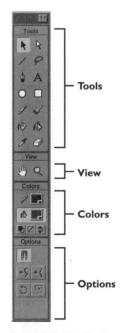

Figure 2-8 The Toolbox

The Toolbox is divided into four sections: Tools, View, Colors, and Options. In the pages that follow, we have provided a brief description of the tools found in each section of Toolbox. You'll get an opportunity to practice using these tools in later chapters.

28

The Tool Section

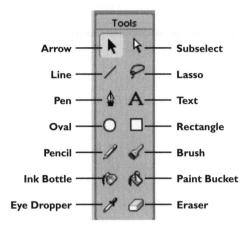

Figure 2-9 The Tool Section

The **Arrow Tool** is used to make selections, move or manipulate objects on the Stage.

The **Subselect Tool** is used to view and select anchor points that make up vector objects drawn on the Stage.

The **Line Tool** is used to draw straight lines. Holding down the shift key restricts the lines to a vertical or horizontal axis or to a 45-degree angle. The width, color, and style of the line is determined by the selections located at the bottom of the palette and in the Stroke Panel.

The Lasso Tool is used to make freeform selections of objects on the Stage.

The Pen Tool is used to draw Bezier paths on the Stage, using path points.

The **Text Tool** is used to add text to the Stage.

The **Oval Tool** is used to create elliptical shapes on the Stage. Holding down the shift key restricts the shape to a perfect circle.

The **Rectangle Tool** is used to create rectangular or square shapes on the Stage. Holding down the shift key restricts the shape to a perfect square.

The **Pencil Tool** is used to draw freeform outlines of shapes.

The **Brush Tool** is used to paint fluid shapes and apply color fills to objects on the Stage.

The Paint Bucket Tool is used to fill shapes and outlines with color.

The **Ink Bottle Tool** is similar to the Paint Bucket Tool, but instead is used to apply color and other stroke attributes to lines in your drawings.

The **Eyedropper Tool** is used to select colors and line styles for reuse in other objects.

The **Eraser Tool** is used to delete objects, or portions of objects on the Stage.

The View Section

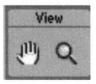

Figure 2-10 The View Section

The **Hand Tool** allows you to move the Stage around your screen instead of aeralling.

The **Zoom Tool** allows you to increase or decrease the magnification of objects on the Stage. You can double-click on the Zoom Tool to immediately change back to 100%.

The Colors Section

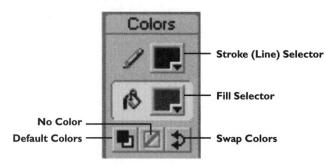

Figure 2-11 The Colors Section

The **Stroke Selector** allows you to change the stroke (line) color of an object selected on the Stage.

The **Fill Selector** allows you to change the fill color of an object selected on the Stage.

Default Colors changes the Stroke and Fill color swatches to the colors originally selected when Flash was launched.

30

No Color changes the Stroke or Fill swatches to transparent.

Swap Colors switches the colors of the selected Stroke and Fill swatches.

The Options Section

Options				
ព្រ				
+5	*{			
C				

Figure 2-12 The Options Section

The Options Section changes depending on the tool selected, but generally allows you to control additional attributes of the tool, or the selection on the Stage. You will see the details of some of these options as we encounter them during practice exercises in the chapters that follow.

The Menus

The Menus (and many of the options within the Menus) found in Flash are fairly typical in organization and function to those found in many software programs. See Figure 2-13. In Chapter 28 (on the CD-ROM), you will find a complete listing of each of Flash's Menus, including all the options for each Menu and keyboard shortcuts. We will take a closer look at many of the options in each Menu as we encounter them during the exercises. Below you'll find a brief description of the functionality of each Menu with a note about a few of the options.

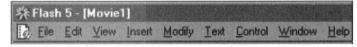

Figure 2-13 Menus in Flash

File Menu

The options listed in the **File Menu** pertain to things that you can do to Flash files. The common options include creating a **New** file, **Open** an existing file, and **Save** a file. You also use this Menu to **Import** graphics from other programs for use in Flash, as well as **Export** and **Publish** your Movie files in various formats.

Edit Menu

The options listed here are the same ones that you've used in most software packages: **Cut, Copy, Paste, Select All,** and of course the indispensable **Undo. Cut Frames, Copy Frames,** and **Paste Frames** allow you to use these same type of editing options in the Frames of the Timeline.

View Menu

The options in the **View Menu** provide the capability to turn on or off various display options. We will make use of these during the exercises. The **Grid**, **Guides**, and **Rulers** options are provided for use as layout tools when designing your Movies.

Insert Menu

The options listed here allow you to insert or delete **Frames, Keyframes** and other elements into the Timeline of the Movie. It also allows you to insert new **Symbols** into the Library of your Movie.

Modify Menu

The options listed under the **Modify Menu** provide the capability to change the characteristics of the Flash file as well as most of its major interface elements. There are options to change the **Instance, Frame, Layer, Scene** and **Movie** properties. You can also **Transform** shapes (scale or rotate) or **Group** objects on the Stage. Numerous other options allow you to change other attributes of objects on the Stage.

Text Menu

The options listed under the **Text Menu** control the formatting of text on the Stage. You can change the **Font, Size, Alignment** and other text attributes with the commands found under this menu.

Control Menu

All the options listed with the **Control Menu** are pertinent to running/ viewing either the entire file or a portion of it. We will make use of some of these options later.

Window Menu

The options listed within the **Window Menu** control the display (or absence) of a variety of different types of information windows. Of greatest interest will be the **Panels** and **Library** options.

Help Menu

The options listed within the Flash **Help Menu** offer a variety of different methods to obtain additional information including: Using Flash;ActionScript Reference; ActionScript Dictionary; Flash Support Center as well as other options.

The Toolbar (Windows Only)

The **Toolbar**, also called the Standard Toolbar, helps you navigate within Flash's interface. The Toolbar contains shortcuts to Flash's menus and windows. By clicking on the button icons in the Toolbar you have quick and convenient access to many of Flash's more frequently used functions and capabilities. See Figure 2-14, which includes descriptive labels for each button on the Toolbar.

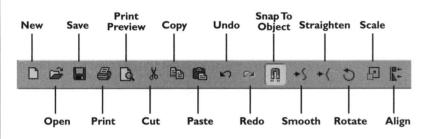

Figure 2-14 The Toolbar (Windows only)

The Panels

Panels are a new addition to Flash 5 and make modifying elements of your Flash Movie a snap! Panels enable you to view and edit elements of your Movie using simple, subject-based dialog windows. The addition of Panels makes the Flash interface much more similar to Fireworks, Freehand, and other frequently used graphics programs. These Panels, or floating windows, can be displayed and hidden using the Window Menu. There are 17 such Panels, each with specific capabilities. All of these Panels are described in greater detail in Chapter 28 (located on the CD-ROM). Figure 2-15 shows you the Default Panels that open when Flash is launched. The tabs at the top of each window allow you to activate different Panels within the set. In Flash, you can also create your own unique Panel Sets, based on the way you like to work, by dragging the Panel tabs and combining them into new sets.

Opening and closing Panels in Flash is easy when you make use of the Launcher. The Launcher contains a series of icons found at the bottom righthand corner of the Stage Window. These icons open and close commonly used Panels with just one click. See Figure 2-16.

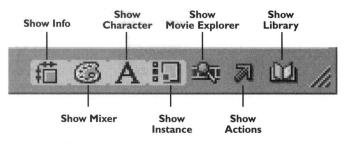

Figure 2-16 The Launcher

The Library

The **Library** is where certain types of objects used in a Flash Movie are stored. In Flash, some of these objects are referred to as **Symbols**. Symbols are elements that can be re-used throughout the Movie. There are three main types of Symbols used in Flash – Graphics, Buttons, and Movie Clips. When you drag one of these Symbols from the Library and place it on the Stage, you are creating an **Instance** of that Symbol. Flash allows you to edit these Instances without altering the original Symbol. This provides greater efficiency

TIP

as you create your Movies. Symbols and Symbol terminology will be covered in greater detail in a later chapter. Although the Library is mainly used for storing Symbols, it can also store bitmap images, sound files and fonts.

Using Symbols can also significantly reduce the size of your Flash file, because regardless of how many Instances of a Symbol you create on Stage, Flash stores the Symbol only once – in the Library. By storing these Symbols in the Library, Flash can keep your Movies smaller. This is an important factor when considering distributing your application across a narrow bandwidth (typical Internet modem connection).

Flash 5 includes a variety of useful Libraries that you can incorporate within your Movies or allows you to create a Library of your own. You can also use Libraries that have already been created in other Flash files. They can either be shared, or you can use the **File / Open as Library** Menu option to pull Symbols out of other Movies and use them in your current Movie.

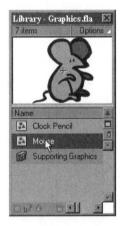

Figure 2-17 The Library

The Controller

The **Controller** contains all the controls needed to play, pause, rewind, fastforward and step through the Frames in a Movie Timeline and preview the action on the Stage. The Flash Controller has buttons that are similar to those found on a VCR. See Figure 2-18. Unlike most VCRs, however, with the Controller you can play the Movie using the Step Back and Forward feature, which allows you to preview one Frame at a time. Flash comes with six Common Libraries: Buttons, Graphics, Movie Clips, Sounds, Learning Interactions, and Smart Clips. These contain graphics and other Symbols that you can use in your Movies. To open one of these Libraries use the Menu option **Window** / **Common Libraries** to explore these built-in Libraries.

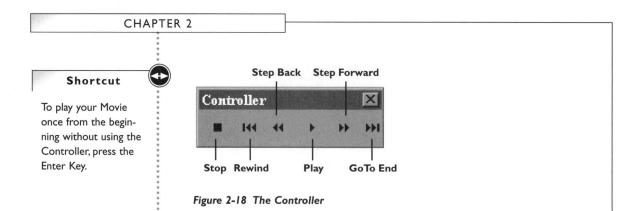

The Movie Explorer

The **Movie Explorer** is a new feature in Flash 5 that allows you to view all the elements of your Flash Movie in a branching list. This feature is designed specifically to aid development teams as they work collectively on Flash applications. Teams can more efficiently view the overall structure of a complicated Flash application – all in one window. Plus, work groups can print the Movie Explorer window and use it as reference. Teams can also choose to view all the elements in the Movie Explorer or only certain elements, such as Symbols, Scenes, Labels, bitmaps, or Actions.

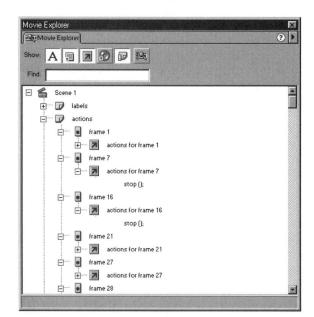

Figure 2-19 The Movie Explorer

36

Flash's Help

Flash has built-in help files that are both convenient and intuitive. These files are a great reference tool as you begin to work with Flash, and will also be useful in the future if you forget a technique or function previously learned. These files are formatted as HTML files that can be viewed in your browser without connecting to the Internet. The help files are located in the Menu option: **Help** / **Using Flash.** If you are connected to the Internet, you can join other Flash developers in the Flash Support Center on the Macromedia Web site.

Summary

In this chapter you have been introduced to the major components of the Flash interface. We have also reviewed some terms that you will find useful as you begin working with Flash.

Flash uses a metaphor analogous to movie production or the theater. Flash's interface windows are named and use some of the same terminology as elements of movie production.

Flash's Interface

The **Stage** – is where your Movie is created and displayed. Every element that you want to appear on screen, must be placed on the Stage.

The **Work Area** – is the gray area around the Stage. The Work Area allows you to view objects placed partly or entirely off the Stage where they are no longer in the viewable region of the Movie.

The **Timeline** – is comprised of individual Frames and Layers. The Timeline orchestrates all of the symbols, actions, and animated effects that take place in a Movie.

The **Toolbox** – is an assortment of drawing, paint and text tools that can be used to create graphic elements and text for your Movie.

The **Toolbar** – contains an assortment of icon-based shortcuts to Flash's menus and windows.

The **Panels** – are floating windows that allow you to create or modify elements of your Movie.

The Library – contains all the Symbols used in your Movie.

The **Controller** – contains all the controls needed to play, stop, rewind, and fast-forward through a Movie on the Stage.

Key Terms

Layers – are the horizontal rows in the Timeline. Content placed in your Flash Movie is contained in a Layer.

Frames – are the vertical columns in the Timeline. A Frame includes the content of all Layers, at a single point in time.

Keyframe – a Frame that contains either an action or a change in an animated sequence.

Playhead – The Playhead in Flash displays the Frame with which it is currently aligned. The Playhead automatically moves from left to right on the Timeline as the Movie is played on the Stage. However, it can also be manually dragged back and forth in order to view one Frame at a time, or to move your Timeline to a particular Frame.

PTER

3

Opening, Playback, and Control of Movies

Chapter Topics:

- Introduction
- Guided Tour The Controller and Playhead
- The Timeline
- Playback Speed
- Guided Tour Movie Properties
- Summary

CHAPTER 3

Introduction

The focus of this chapter is to introduce you to Flash's Controller, Playhead, Control Menu and Movie Properties so that you can preview Movies and become familiar with the basic features of Flash's Timeline. Using these control features will allow you to test your Movies as they are being created, preview any animation Frame-by-Frame, and enable buttons in the Stage area. If you are unfamiliar with the concept behind a timeline-based program, practicing with these controls will also give you a better understanding of how animations are created.

Later in this book you will learn about more advanced features of the Control Menu in order to use elements such as the Bandwidth Profiler to optimize your Movie files for efficient performance on a Web site.

By the end of the chapter you will be able to:

- · open Movies.
- control the playback of Movies.
- test Movies.

Guided Tour – The Controller and Playhead

In this Guided Tour, you will open an existing Flash Movie and learn how to preview the Movie using the Controller and the Playhead on the Timeline. These tools allow you to preview the Frames in the Timeline of a Movie as it is being developed. By the time you complete this Tour, you will have a better understanding of how these features help you preview a Flash Movie, and how you can step through the individual Frames of a Movie.

- 1. First we need to open the file named Lesson3.fla that is located in the Chapter03 Folder, on the CD-ROM supplied with this book.
 - a) Use the Menu option **File / Open.**
 - b) For PC In the Dialog Window that opens, use the pull down browse function within the Look In Field to locate and select the CD-ROM Drive.

For Mac – use the pull down browse function to navigate to the CD-ROM.

- c) Locate, select and look inside the Chapter03 Folder.
- d) Locate, select and **open** the **Lesson3.fla** file by either double clicking on the file name or by selecting it and then clicking on the Open Button.
- 2. Take a moment to look at the file.

CD-ROM

Opening, Playback, and Control of Movies

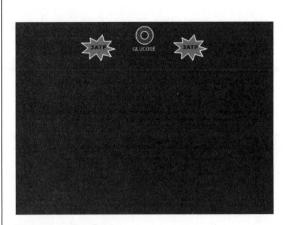

		-	9	6	5	10	15	20	25	30	35	40	45	50	55	60	65
ADP	1	•	•				, , , , , ,		*****	+++++							
🔊 starburst2		•	•				·····	•									
glucose + 2P		•	•							++++++							

Figure 3-2 The Timeline

- 3. Now it's your turn to take control of the Timeline of the Movie. Let's use the Controller and the Playhead to step through the completed Movie file. First, we need to open the Controller.
 - a) If you are using a Mac, with the **Lesson3.fla** file still open on the Stage, open the Controller by selecting **Window** / **Controller**.
 - b) If you are using a PC, with the Lesson3.fla file still open on the Stage, open the Controller by selecting Window / Toolbars / Controller.
- 4. The Controller Buttons look very similar to a VCR's buttons, and serve the same functions in the Flash environment.

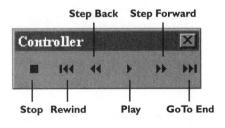

The Controller is found in different places on the PC and on the Mac. The Controller on a Mac is a floating palette that can be moved and positioned anywhere on the screen. On the PC, the Controller is a dockable window, which can be docked anywhere under the Menu or at the bottom of the Stage near the Launcher.

·TIP

CHAPTER 3

- a) Press the Play Button on the Controller to run through the entire Timeline of the Movie until it reaches the last Frame and stops. Notice that the Playhead in the Timeline moves through each Frame of the Movie in sequence, displaying the contents of every Frame on the Stage.
- b) Press the **Rewind Button** and then play the Movie again. This time, press the **Stop Button** before the Playhead reaches the end of the timeline.

Controller	×	Controller					
			144	44	•	**	•••
Rewind Button		itop But	ton				

c) Use the **Step Back** and **Step Forward Buttons** to step through individual Frames in the Movie Timeline. Notice how the Playhead moves in sequence with any action in the Controller.

Controller	×	Contr	oller				×
			IH	44	٠	*	•••
Step Back Button				s	ten F	orwar	d But

Figure 3-5 Step Back and Step Forward Buttons

5. Now, instead of using the Controller, move through each Frame by dragging the Playhead to the left or right along the Timeline. As the Playhead moves, the red line descending from the Playhead shows you which Frame you are on in each Layer of the Timeline.

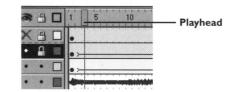

Figure 3-6 The Playhead

6. You can modify the playback of your Movie by using Control Menu options. To use these options you must also play the Movie by selecting the Menu option Control / Play.

Shortcut

If you want to play through all the Frames of your Movie without using the Controller, press the Enter Key. The Playhead will move down the Timeline and stop at the last Frame. Press Enter again to start the Movie from the beginning.

- a) To play the Movie in a continuous loop select the Menu option Control / Loop Playback.
- b) To play all the Scenes in a Movie select the Menu option Control / Play All Scenes.
- c) To play a Movie without sound select the Menu option Control / Mute Sounds.
- 7. We're finished here, let's move on. You can leave this file open, as we will use it in the next Guided Tour.

The Timeline

By now you probably realize that the Timeline is the central controlling element in a Flash Movie. The Stage displays all the objects and elements in a movie that the viewer sees. However, any action that takes place on the Stage is controlled by what happens in the Timeline. In the previous Guided Tour, as you moved the Playhead along the Movie Timeline, you saw how individual Frames triggered events displayed on the Stage. When working with the Timeline in Flash, objects, actions, or animations will be activated by the contents of these individual Frames in the Timeline.

Flash provides the capability to include multiple Layers in the Timeline so that you can create very complex Movies with many different animated objects. In addition, by using Symbols you can also place a "sub" – Timeline within the main Timeline – or in other words, "nest" Timelines within other Timelines. This is an advanced feature of Flash, which we will look at later in the book, as it is one of the features of Flash that makes it so versatile and powerful.

The basic concept and structure of the Timeline is rooted in the way traditional Frame-by-Frame animation was created in the early days of the movie industry. When animators first started creating cartoons, each Frame of action in the movie was drawn by hand. After the first Frame was drawn, animators placed translucent paper (onionskin paper) on top of the first Frame so that they could see the previous Frame and draw incremental changes on this second sheet of onionskin. They then overlaid another sheet of onionskin for the next Frame with incremental changes. Putting hundreds – or thousands – of these sheets together eventually made up an animated scene.

In a similar way, as children, many of us created our own "cartoons" by drawing a simple figure on the edge of many pages of a book, with each page containing a small change in the figure. When you "flipped" through these pages, you saw an animation of the figure. Although a crude form of animation, these "flip-books" use the same concept as traditional Frame-by-Frame animation. While the Timeline interface for Flash is based on this traditional Frame-by-Frame concept, Flash also has built-in features that allow you to work much faster than early animators. The Tweening features in Flash make it easier to create animation by taking the tedium out of creating each individual Frame within the animation. With the Tweening feature, you create the "beginning" and "end" figures, and let Flash create the *in-be"tween*" Frames, saving you a lot of time and effort.

A simple example might clarify the difference between Frame-by-Frame animation and Tweening. In our example below, the effect that we want to create is to make it appear like a large ball is moving away from us on a diagonal path. The "start" (or first Frame) and the "end" (last Frame) for both Frame-by-Frame and Tweening will be exactly the same. Take a look at the following illustrations.

Figure 3-7 First Frame

Figure 3-8 Last Frame

In the first Frame of the animation there is a large ball located in the lower lefthand side of the Stage. In the last Frame, the ball is much smaller and located in the upper right-hand corner of the Stage. In this example, let's assume that there will be 20 Frames between the first Frame and the last Frame. With **Frame-by-Frame** animation you would need to make modifications in the second and all other "in between" Frames. In each Frame you would need to draw the ball just a little bit smaller and move it slightly to the upper right. In other words, you end up drawing the ball in all 22 Frames.

With **Tweening**, you draw the first and the last Frames and use Frame Panel options to have Flash automatically create the necessary changes to all the Frames "in between" the first and last Frames. The term **Tween** is really a play on words with this concept – in be**TWEEN** Frames.

In one of the chapters a little later on, you will get into the details of Motion and Shape Tweening, with lots of hands-on practice with Tweening.

Playback Speed

The Playback Speed of a Flash Movie is controlled by the Frame Rate chosen in the Movie Properties. You can think of this as setting a "speed limit" of how fast the Playhead runs through the length of the Movie. Flash measures the speed of a Movie in terms of Frames Per Second (FPS). If the Frame Rate is set to 30, Flash displays 30 Frames Per Second. By increasing the Frames Per Second, you affect a Movie in two ways. First, the animation will play faster. And second, the animation will play more smoothly (assuming your computer's processor is fast enough to handle the faster FPS). It is important to understand that the Frame Rate does not control factors such as slow Internet connections or processor speed.

What Frame Rate is best for your application? There really isn't a "correct" generic answer that will work for every situation. There are several factors that will influence how well your Flash Movie will playback. These factors include: the user's computer CPU speed; the user's graphic card/monitor; the delivery medium (CD-ROM; Internet modem connection; Internet broadband connection, etc.); the animation itself – the size of the objects and complexity of motion; and whether additional media elements (audio / video) are involved in the presentation. Faster, newer computers will be able to handle higher Frame Rates.

Whatever Frame Rate you select, it should accommodate the typical user that you expect will access and view your application. You may find that a Frame Rate between 12 and 20 will serve as the best "lowest common denominator" for your target audience. However, the best advice is to experiment with different Frame Rates while you "test" these rates with various computers and connections that are typical of what your viewers will use.

Take a look at Figure 3-9. The Frame Rate is displayed at the bottom of the Layers in the Timeline. This portion of the Timeline is called the Status Bar,

because it displays the vital statistics of the current Movie. When your Movie begins to play, this Status Bar will tell you if the Frame Rate dips below the FPS setting because of complex animation that taxes your computer. Information such as the number of Frames, Frames Per Second and the estimated run-time of the Movie is displayed in this area.

Figure 3-9 The Status Bar - Including Frame Rate

Guided Tour – Movie Properties

This Guided Tour will show you how to control the basic elements of a Movie – the Movie Properties. It is important to remember that these settings are applied globally to the Timeline of the current Movie and are used only within the Movie in which they are set.

- I. In this Guided Tour we will continue to use the **Lesson3.fla** file that we first opened in the previous Guided Tour in this chapter.
- If you do not currently have the Lesson3.fla file open, please refer to the previous Guided Tour and follow the instructions in Step 1 (a-d) to open the Lesson3.fla file.
- 3. Now let's change the Movie Properties of this Flash file.
- Open the Movie Properties Window by selecting the Menu option Modify / Movie. The Movie Properties Window now opens. This window will give you several options to customize your Movie and Stage settings. See Figure 3-10.

Frame Rate:	12 fps		OK
Dimensions:	Width	Height K 400 px	Cancel
Match:	<u>P</u> rinter	Contents	Save Defaul
Background Color:			
Ruler <u>U</u> nits:	Pixels	-	<u>H</u> elp

Figure 3-10 The Movie Properties Window

46

Opening, Playback, and Control of Movies

- 5. Change the Frame Rate to **45 fps.** This will significantly speed up the rate in which the Playhead moves through the Movie.
- The Movie Properties Window also allows you to change the pixel dimensions of your Movie. Change the pixel dimensions to 300 x 300. This setting changes the physical size of the Stage.
- Customize your Stage further by changing the color of the background.
 Click on the Background Color Button to bring up the Color Well. Select any color from the Color Well as your background color.

Movie Properties		
Frame Rate:	12 fps	OK
Dimensions:	Width Height 550 px X 400 px	Cancel
Match:	Printer Contents	Save Default
Background Color:		
Ruler <u>U</u> nits:	#FFFFFF	þ

Figure 3-11 Background Color Button and Color Well

8. Click **OK** once you are finished editing the Movie Properties settings. Press the **Play Button** on the Controller to see the changes to the Playback Rate.

Summary

- In the first Guided Tour, you were introduced to the Controller: how to open it and use the basic buttons to Play, Stop, Rewind, Step Back and Step Forward. You also saw how you could use the Control Menu to Loop Playback and other options.
- Any action that takes place on the Stage is controlled by what happens in the Timeline. All objects, actions, or animations displayed on the Stage originate from the individual Frames that are contained in the Timeline.
- The basic concept and structure of the Timeline is rooted in the way traditional Frame-by-Frame animation was created in the early days of the Movie Industry.

The higher the number in the Frames Per Second setting, the faster the Movie will play. It is important to remember that slow processor speeds and a slow Internet connection may cause the Movie to pause or render slowly.

As you are creating your Movie, you may wish to alter the size of the Stage and make your Movie dimensions smaller or larger. It is important to understand how Flash re-sizes the Stage in order to avoid long production delays that can arise from this situation.

When you re-size the Stage, Flash uses the top and left as constant edges. **Any pixels** added or subtracted from the Stage will be taken from the bottom or right edge.

For example, if you make the dimensions of your Movie smaller, anything on the right or bottom that extends past the new dimensions will no longer be on the Stage. The Bottom line – if you are unsure of the final dimensions of your Movie, use the top and left as fixed sides of your Movie.

CHAPTER 3

48

 With Frame-by-Frame animation you need to make modifications to every Frame that is being used to depict a change in motion or shape.

 With Tweening, you draw the first and the last Frames and use Menu and Panel options to have Flash automatically create all the necessary changes to all the Frames "in between" the first and last Frames. The term Tween is really a play on words with this concept – in beTWEEN Frames.

- The Playback Speed of a Flash Movie is controlled by the Frame Rate chosen in the Movie Properties. You can think of this as setting a "speed limit" of how fast the Playhead runs through the length of the Movie.
- Whatever Frame Rate you select, it should accommodate the typical user that you expect will access and view your application.
- In the second Guided Tour, you saw how you can use the Modify / Movie options to customize your Movie and Stage settings.

PTER

4

Drawing

with Flash

Chapter Topics:

Introduction

.

.

- Graphic Formats
- The Benefits of Using Vector Graphics
- Practice Exercise Drawing Simple Shapes
- Practice Exercise Using the Tool Modifiers
- Guided Tour Introduction to Layers
- Summary

Introduction

While the animation tools in Flash are what really sets it apart from HTML authoring programs, Flash also has a powerful set of drawing and paint tools that make it possible for designers to create complex animations and interesting designs – all within one program. With the drawing and paint tools in Flash, you can create everything from objects to be animated to interface designs, without the aid of any other graphics program. In addition, as you will see in a later chapter, Flash also allows you to import artwork created in other vector-based programs like Macromedia's Freehand or a bitmap editor like Adobe's Photoshop.

With the release of Flash 5, veteran users of Flash will be pleased with the addition of the Bezier Pen tool, a tool similar to the pen tools in other programs like Macromedia's Freehand and Fireworks. Novice users will also discover that with Flash's drawing tools, you can easily create sharp looking designs, without much design experience.

As you open up the Flash Toolbox, get ready to explore all the design possibilities available to you with these powerful drawing tools.

By the end of this chapter, you will be able to:

- briefly describe the difference between Raster and Vector Graphic Formats.
- identify the drawing tools in Flash.
- use the drawing tools to create simple shapes.
- apply colors to your designs.
- identify the different parts of the Layers Panel.

Graphic Formats

When creating and using graphics, it is important to understand the difference between the two types of graphic file formats: Raster and Vector. The foundation of a Raster graphic lies within a two-dimensional matrix (basically rows and columns) composed of individual pixels that are defined by (mapped by) specific X (row) and Y (column) coordinates. Raster graphics (more frequently referred to as a bitmapped graphic) are created in "paint" programs that build an image by electronically defining specific pixels. For example, in order to create a line in a bitmap format, pixels are "painted" (electronically turned on) as the drawing tool moves over the surface. The line is composed

Drawing with Flash

of "painted" pixels laying side by side, defining the length and width of the line. The Raster file must store the location and properties of each one of these pixels. The strength of bitmapped graphics is that they are capable of very high resolutions, with brilliant colors. The downside is that bitmapped graphics tend to have large file sizes (because of all the information being stored) and are difficult to resize and otherwise manipulate. Bitmap graphics are the most common graphic type used on the Web today, since most Web graphics are in either the GIF or JPEG format which are both bitmap graphic types. Both of these bitmap file formats are compression formulas designed to reduce the size of specific types of graphics.

Figure 4-1 Normal Bitmap and Magnified Bitmap (Showing Individual Pixels)

In contrast, Vector graphic files contain algorithms (mathematical equations) that are used to generate the objects they represent. Algorithms can easily represent circles, arcs, lines, squares and other such objects. As you might guess, Vector graphics have file sizes that are much smaller than their bitmap cousins, but the downside is that they generally do not possess the brilliance of bitmaps that may contain complex color patterns with millions of colors. The Figures 4-2 and 4-3 clearly show the difference in how each format displays a circle. Note the jagged edge (due to the pixels) in the Bitmap.

Figure 4-2 Vector Graphic of Circle

: • T/P ·

> A pixel is the smallest unit of measurement when working with bitmap graphics. Each graphic is made up of lots of different pixels with varying shades of color. These pixels are so small that when the graphic is viewed at normal size, the pixels of various colors blend together to form an image recognizable to the human eye, such as a picture of a Duck. Your computer monitor's resolution is defined in terms of pixels: 800 pixels (along the X-Axis)

by 600 pixels (along the Y-Axis). The larger the number of pixels, the more information, or detail the image contains.

CHAPTER 4

Figure 4-3 Bitmapped Graphic of Circle

When working with vector graphics in Flash, what you see is the actual outline of the graphic object you created. Conversely, the software on your computer reads vector graphics as algorithms and then translates them into a display of lines and curves that are seen as recognizable shapes to you and me. Vector graphics differ greatly from bitmap graphics and will be discussed in detail in a later chapter.

Figure 4-4 Complex Vector Graphic With Many Anchor Points

The Benefits of Using Vector Graphics

One of the greatest benefits of using vector graphics in Flash animations is that vector graphics can be scaled proportionally to any size – larger or smaller – and still retain the same crisp shape and outline as their original size. This characteristic is not true of bitmap images. Since the vector format is the native graphic format of Flash Movies, Movies created in Flash can be scaled proportionally, depending on the size of the display window, without a loss of image quality. In the Web environment, this capability means that designing for multiple computer display resolutions is now much easier than it used to be.

Another benefit of vector graphics is that they tend to have a much smaller file size and usually perform faster (write-to-screen time) than bitmaps. The reason for this is that the information in a vector graphic contains mathematical equations, rather than large amounts of data describing each individual pixel. As any Web user knows, the smaller and more efficient the file size, the quicker it downloads over the Internet. The use of more efficient media translates to a better experience for the user.

Not only do graphics benefit from Flash's vector format, so does text. Text created in Flash (with the use of anti-aliasing) can be as crisp and clean as text used in a printed publication. We will talk more about text options in later chapters.

Practice Exercise – Drawing Simple Shapes

Description

This exercise will introduce you to the use of the drawing tools in the Flash Toolbox (see Figure 4-5) by creating simple objects of your own design. In later chapters, you will improve on these skills by creating more complex graphics. For now, let's concentrate on the fundamentals.

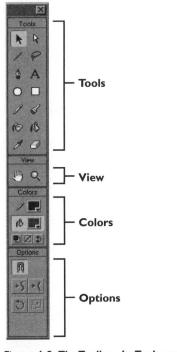

Figure 4-5 The Toolbox, Its Tools and Modifiers

CHAPTER 4

CD-ROM

Take-a-Look

First, let's take a look at the completed exercise by looking at the file named **Lesson4.fla** located in the Chapter04 Folder on the CD-ROM. The objects you draw may be different from what is illustrated here.

- 1. First we need to open the file named Lesson4.fla that is located in the Chapter04 Folder, on the CD-ROM supplied with this book.
 - a) Use the Menu option File / Open.
 - b) In the Dialog Window that opens, use the pull-down browse function within the **Look In Field** to locate and select the **CD-ROM Drive**.
 - c) Locate, select and look inside the Chapter04 Folder.
 - d) Locate, select and open the **Lesson4.fla** file by either double clicking on the file name or by selecting it and then clicking on the Open Button.
- 2. Take a moment to look at the file.

Please note the following properties of the completed exercise:

- With the use of each Tool in the Toolbox, please note that there are different modifier options available for that tool.
- b) The Arrow Tool will allow you to move objects. Be careful to select both the Stroke and Fill, if you want to move them both.
- c) Ungrouped and Grouped objects behave quite differently. Note the difference.

Storyboard: On-Screen

For this exercise, the end result of what you create is strictly up to you. As an example, here is what we came up with as we drew objects for this exercise.

Figure 4-6 Objects On-Screen

54

Storyboard: Behind-the-Scene

For this exercise, there is no "programming" to show you and thus no illustration. We have left this section header here to maintain consistency among the Practice Exercises in the book.

Step-by-Step Instructions:

- Let's start with a new file by selecting the Menu option File / New. ١.
- 2. Now take a look at the Toolbox. Let's get to work.
 - a) In the Toolbox select the Line Tool.

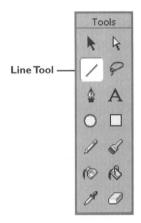

Figure 4-7 The Line Tool

- b) With your mouse button, click anywhere on the Stage and continue to hold down the mouse button. Drag out from where you have clicked, proceeding about 4 inches. Release the mouse button to form a line.
- c) Take a few moments and experiment with drawing lines and shapes using the Line Tool.
- d) Look at the Color Section on the bottom portion of the Toolbox. The first option is the Stroke Color Modifier. Click on the small box and continue to hold down the mouse button to bring up the Color Well. See Figure 4-8. Use the Eyedropper Cursor to select a color. Try drawing a few lines with this new color.

awing w	vith Flash
0 0 0 0 0	
6 6 6	
4	
	Go Solo
1	
4	
	Shortcut
	The Keyboard Shortcut
	for selecting the Line
	Tool is pressing the N
	Key on both the PC
	and Mac.
С·Т	(P.)
	Keyboard shortcuts
	are factory predefined
	during installation.
	Flash 5 gives you the
	opportunity to alter or
	set your own keyboard
	commands. Should you want to do this,
	select Edit / Keyboard
	Shortcuts to view, set
	or edit any keyboard
	shortcuts.
	If you decide to alter the
	existing commands, how-
	ever, be aware that your
	shortcuts may no longer correspond with those
	ever, be aware that your shortcuts may no longer correspond with those provided in this book.
	F. Strate III and book
	7 8 8
	• 6
	- •
	-
	9

Colors		
1.		
#D0D0D0		
		— Color Well

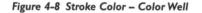

e) Let's make the line a little bit thicker. Select the Menu option Window / Panel / Stroke. This opens the Stroke Panel. Note that this panel has options for changing the type of line (solid or a variety of dashed lines) in the first field with a pull-down menu. See Figure 4-9. Change the line type. Draw a line or two.

f) The next option in the Stroke Panel is for line width. Click-on the pull-down arrow. A slider appears. Click on and drag the handle up and note how this makes the line thicker. You can also type in a number instead of opening the slider. Draw a line or two.

CHAP'

Drawing with Flash

- g) When you are done, select the Menu option Edit / Select All.
- h) We aren't going to save any of these basic drawings, so select the Menu option Edit / Clear.
- 3. Now let's try the Circle Tool.
 - a) In the Toolbox select the Circle Tool.

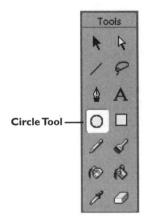

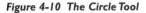

- b) With your mouse button, click anywhere on the Stage and drag out about 3 inches to form an oval. Release the mouse button. Notice that the spot where you first clicked is the point of origin for the oval that you have created. Also note that whatever Stroke modifiers you set previously – line thickness and line (Stroke) color – continue to be used as you draw.
- c) Look at the Color section of the Toolbox again but this time, look at the second option Fill Color. Click on the small box and continue to hold down the mouse button to bring up the Color Well. Use the Eyedropper Cursor to select a color. Try drawing a few circles with this different fill color.
- d) Now create another oval... but first hold down the Shift Key and continue to hold it down as you click anywhere on the Stage and drag the mouse away from the point of origin. Notice how the oval is now constrained to a perfect circle.

Shortcut

The Keyboard Shortcut for selecting the Circle Tool is pressing the O Key (O for Oval) on both the PC and Mac.

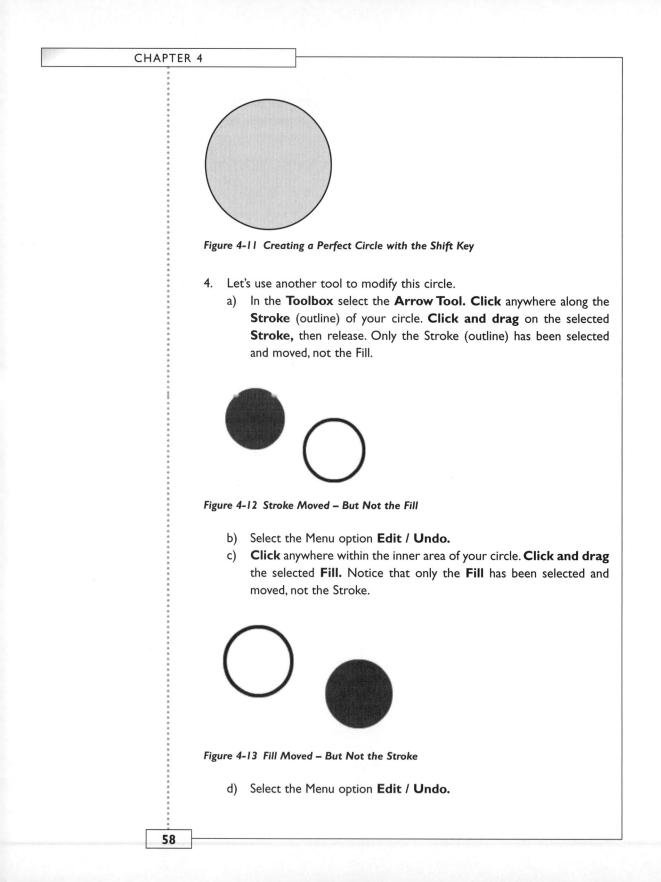

e) **Double click** within the **Fill** of the circle. Notice that both the **Fill** and the **Stroke** have been selected. **Click and drag** to move both the **Fill** and the **Stroke**.

Figure 4-14 Both Stroke and Fill are Moved

- f) Take a few moments to experiment with drawing ovals and circles using the Circle Tool, as well as the Stroke and Fill Modifiers. When you are done, select the Menu option Edit / Select All.
- g) Select the Menu option Edit / Clear.
- 5. Now for something a little different, the Pen Tool.
 - a) Select the **Pen Tool.**

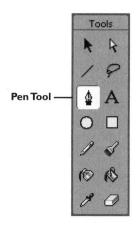

Figure 4-15 The Pen Tool

- b) With your mouse button, **click** anywhere on the Stage and **release.** This establishes an Anchor Point (that is, a point on the vector path that helps to define an angle or a curve).
- c) Click anywhere else on the Stage. This establishes a second Anchor Point. Note that Flash has automatically connected the first and second Anchor Points with a straight line.

Shortcut

Keyboard Shortcut for Select All

Windows -

simultaneously press the Ctrl and A Keys

Mac – simultaneously press the Cmd and A Keys

Shortcut

The Keyboard Shortcut for selecting the Pen Tool is pressing the P Key (P for Pen) on both the PC and Mac.

d) Click and hold anywhere else on the Stage. While holding the mouse button down, drag out from where you clicked and release the mouse button. This is how curves are drawn using the Pen Tool. Notice how the size of the curve is directly related to how far you've dragged away from the line.

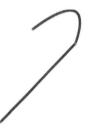

Figure 4-17 A Curved Line Created with the Pen Tool

- 6. Let's continue with this same line but with the use of a new tool, the Subselect Tool.
 - a) In the Toolbox select the Subselect Tool.

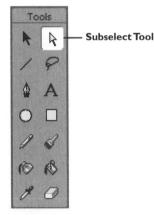

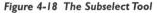

Shortcut

The Keyboard Shortcut for selecting the Subselect Tool is pressing the A Key on both the PC and Mac. Strangely enough, the Keyboard Shortcut for selecting the Arrow Tool is pressing the V Key.

60

- b) Click on the Anchor Point that is shared by both the straight and curved line segments and drag. Notice the effect on both the straight and curved lines.
- c) Click on the Anchor Point at the end of the curve. Notice the additional "handles" that appear. Click and drag on one of these handles to change the degree of curvature in the curved segment without affecting the straight-line segment.

Figure 4-19 Drag the "Handles" to Change Curvature

- d) Click and drag on the first Anchor Point at the end of the straight line. Notice how it changes the length and angle of the straight-line segment without affecting the curved segment.
- e) Take a few moments to experiment with drawing lines and curves using the **Pen Tool**, as well as the **Stroke** and **Fill** Modifiers. When you are done, choose the Menu option **Edit / Select All**. Note the characteristic "speckled" appearance of the selected lines and fills. This is a visual clue that lets you know that the fill and stroke have been selected.

Figure 4-20 Speckled Appearance of Selected Lines and Fills

- f) Select the Menu option Edit / Clear.
- 7. Now let's try another tool.
 - a) In the Toolbox select the Rectangle Tool. Note the Round Radius Rectangle Modifier below the Toolbox.

Shortcut

The Keyboard Shortcut for selecting the Rectangle Tool is pressing the R Key (R for Rectangle) on both the PC and Mac.

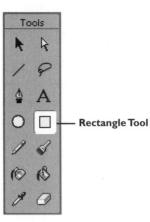

Figure 4–21

The Rectangle Tool

- b) With your mouse button, **click** anywhere on the Stage and **drag** out to form a rectangle. Notice that the spot where you first started is the point of origin for the rectangle that you are creating.
- c) Create another restangle, but this time proce and hold down the Shift Key prior to beginning the rectangle. Notice how the rectangle is now constrained to a perfect square. Release the mouse button when you are satisfied with the shape you have drawn. Take a few moments to experiment with drawing rectangles and squares using the Rectangle Tool.

d) Look at the very bottom of the Toolbox, at the Options section. The only option currently is the Round Rectangle Radius Modifier. Click on it. This opens up the Rectangle Settings dialog window, allowing you to set the Corner Radius for your rounded rectangle.

Drawing with Flash

- e) Type in ... 30 and click on the OK Button. Draw a few rounded rectangles. Change the Stroke and Fill modifiers, if you wish. When you are done, select the Menu option Edit / Select All, then select Edit / Clear.
- 8. Introducing ... the Pencil Tool.
 - a) In the Toolbox select the Pencil Tool. Note the Modifier at the bottom of the Toolbox under the Options heading. Click on it. See Figures 4-23 and 4-24. There are three modes of assistance for this option: Straighten, Smooth and Ink. Select the Modifier . . . Straighten.

Figure 4-23 The Pencil Tool

Figure 4-24 Pencil Mode – 3 Modifiers

b) With your mouse button, click anywhere on the Stage. Use your mouse to draw a curved line, while still holding down the mouse button. To stop drawing a line, simply release the mouse button. Notice that the Straighten Pencil Modifier automatically straightens the curved line or curved segments you drew.

Tool Modifiers are always located below the tools in the Toolbox under the Options heading. The display of Modifiers changes dynamically depending on what tool you have selected. Modifiers allow you to customize attributes of a tool and also provide assistance when using drawing tools such as the Pencil Tool.

Shortcut

The Keyboard Shortcut for selecting the Pencil Tool is pressing the Y Key on both the PC and Mac.

·T/P·

Drawing freehand shapes like a circle or a square is a snap in Flash. You will probably notice that "on your own" it's pretty easy to end up with a line that is jagged or a circle that is a bit lopsided. However, when drawing with the Pencil Tool, with the Straighten Modifier selected, if you release your mouse, Flash automatically straightens those jagged lines and turns your drawing into a perfect circle or oval. Try this trick when drawing squares and rectangles as well.

Shortcut

The Keyboard Shortcut for selecting the Eraser Tool is pressing the E Key (E for Eraser) on both the PC and Mac.

64

- c) Next, hold down the **Shift Key** and begin to draw another line. Notice how the line remains perfectly straight.
- d) Take a few moments to experiment with drawing other lines and shapes using the Pencil Tool, as well as using the Smooth and Ink Modifiers. When you are done, select the Menu option Edit / Select All and then select Edit / Clear.
- 9. Using the Circle and Eraser Tools.
 - a) Select the **Circle Tool**, select the **Stroke Color Modifier** and set the color to **Black**. Then **select** the **Fill Color Modifier** and set the color to **Yellow**. **Draw** a **circular shape** anywhere on the Stage.

Figure 4-25 The Eraser Tool

b) Select the Eraser Tool. See Figure 4-25. Look at the Options section of the Toolbox. Note that you now have the Eraser Mode, Faucet, and Eraser Shape Modifiers at the bottom of the Toolbox. Select the Eraser Mode Modifier and in the Pop-Up Menu that appears, select the Erase Normal option. See Figure 4-26.

-	Erase Normal
0	Erase Fills
0	Erase Lines
٢	Erase Selected Fills
0	Erase Inside

- c) Click and hold the mouse button as you drag the Eraser Tool across the shape. Notice how both the Stroke and Fill have been erased.
- d) The Faucet Modifier allows you to erase an entire area of color either a line or fill – with one click. With the Eraser Tool selected, click on the Faucet Modifier. Position the drop of water coming out of the faucet over the fill in the circle and click your mouse once. Presto! All of the fill color disappears.
- e) With the Eraser Tool selected, click on the Eraser Shape pulldown menu. Select a different size and shape for the Eraser. Click on the Eraser Mode and select Erase Normal. Try the Eraser now.
- f) Take a few moments to experiment with the Eraser Tool, as well as the effects of its various Modifiers. When you are done, select the Menu option Edit / Select All and then select Edit / Clear.
- 10. Now for a super combination of tools: the Circle, Paint Bucket, Ink Bottle and Brush Tools.
 - a) Select the Circle Tool. Now select the Stroke Color Modifier and set it to Black. Look at the Colors section of the Toolbar. Note that there are three additional Modifiers under Colors: Default Colors, No Color and Swap Colors. Default Colors returns both the Stroke and Fill Colors back to the default colors. No Color sets the Fill so that it will have no color. Swap Colors will exchange whatever colors are currently being used for the Stroke and Fill with each other.
 - b) Select the **No Color Modifier. Draw** a **circular shape** anywhere on the Stage.
 - c) Select the Paint Bucket Tool. See Figure 4-27. Note the Gap Size, Lock Fill and Transform Fill Modifiers at the bottom of the Toolbox. Select the Fill Color Modifier and then select Yellow from the palette.

Shortcut

To erase the entire contents of the Stage (all at once) double-click the Eraser Tool in the Toolbox.

Shortcut

The Keyboard Shortcut for selecting the Paint Bucket Tool is pressing the K Key (K for paint buc<u>K</u>et) on both the PC and Mac.

·T/P·

The Gap Size Modifier has four settings -Don't Close Gaps, Close Small Gaps, Close Medium Gaps, and Close Large Gaps. Adjusting these settings allows you to fill objects that were not drawn with an unbroken outline. If you are having trouble filling a shape with the Paint Bucket, try another Gap setting. Often adjusting the setting to fill with larger gaps will rohin the problem

Shortcut

The Keyboard Shortcut for selecting the Ink Bottle Tool is pressing the S Key (S for Stroke) on both the PC and Mac.

Figure 4-27 The Paint Bucket Tool

- d) Click anywhere within the circular shape to assign it the Yellow color.
- e) Take a few moments to experiment with the Paint Bucket Tool ... but do *not* delete the shape yet!
- f) Select the Ink Bottle Tool.

Figure 4-28 The Ink Bottle Tool.

- f) Select the Stroke Color Modifier and select red from the palette.
- g) Click anywhere within the shape to assign the red color to the stroke.
- h) Take a few moments to experiment with the **Ink Bottle Tool.** Do *not* delete the shape yet!

Drawing with Flash

TIP

 Select the Brush Tool. See Figure 4-29. Note the Brush Mode, Brush Size, Brush Shape and Lock Fill Modifiers at the bottom of the Toolbox. Select the Brush Mode Modifier and select Paint Normal.

Brush Tool

Figure 4-29 The Brush Tool

- j) Select the **Fill Color Modifier** and select a color that contrasts with the color you have been working with.
- k) Click and hold down the mouse button and drag the Brush Tool across the Stage to "paint" a line. As you have seen before with other tools, holding the Shift Key down will allow you to draw a perfectly straight line.
- Take a few moments to experiment with the Brush Tool, as well as the effects of its various Modifiers – including changing the brush size and shape. When you are done, select the Menu option Edit / Select All and then select Edit / Clear.

II. Finally, the last tool ... the Eyedropper Tool.

- a) Using the drawing tools we have already covered, draw two separate shapes on the Stage. Assign the first shape a red fill and the second shape a yellow fill.
- b) Select the Eyedropper Tool. See Figure 4-30.

Shortcut The Keyboard Shortcut for selecting the Brush Tool is pressing the B Key (B for Brush) on both the PC and Mac.

> Try out the Brush Tool Modifiers when using this tool. The Paint Normal, Paint Fills, Paint Behind, Paint Selection, and Paint Inside Modifiers allow you to adjust the way your paint strokes interact with particular objects on the screen. For example, selecting Paint Behind allows you to apply color behind objects on the Stage, rather than painting over them. Experiment by drawing a few shapes on the Stage, then change the Brush Tool Modifiers to paint on, in or around the shapes.

Shortcut

The Keyboard Shortcut for selecting the Eyedropper Tool is pressing the I Key (I for Eye) on both the PC and Mac.

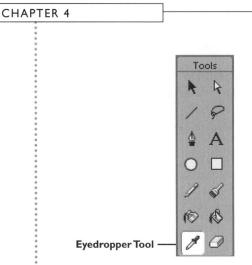

Figure 4-30 The Eyedropper Tool

- c) Place the Eyedropper Icon over the red Fill of the first shape and click. Notice how the Eyedropper Icon changes to resemble the Paint Bucket Icon.
- d) Place the **Paint Bucket Icon** over the **yellow Fill** of the second shape and **click**. Notice how the second fill (what was yellow) is now red. The Eyedropper has allowed you to take a color sample from one object and "pour" that color into another shape! Experiment with this tool.
- e) When you are done, select Menu option Edit / Select All and then select Edit / Clear. This concludes our introduction to the Tools and Tool Modifiers! For additional color control, you can use the Mixer Panel. See the Tip to the left and Figure 4-31.

Figure 4-31 Mixer Panel

To gain more control with the use of colors, before you select a color with the Eyedropper Tool, open the Mixer Panel by selecting Window / Panels / Mixer. With the Mixer Panel open. when you select a color with the Eyedropper, the RGB values of that color as well as a swatch of the sample color appear in the Mixer Panel. You can also change from RGB to HSB or HEX colors by using the pull down menu built into the Mixer Panel the triangle in the upper right corner of the Panel.

·T/P

Practice Exercise – Using the Tool Modifiers

Description

This exercise will allow you to improve your technique with the drawing tools in Flash by giving you practice using the Tool Modifiers that appear at the bottom of the Toolbox once a tool is selected. The Tool Modifiers change depending on the tool being used, but all have one thing in common – they all give you added control over the way your tools work.

Take-a-Look

Before we begin, take a look at the completed exercise. Open the file named **Lesson4_modify.fla** from the Chapter04 Folder on the CD-ROM.

- 1. First we need to open the file named Lesson4_modify.fla that is located in the Chapter04 Folder, on the CD-ROM supplied with this book.
 - a) Use the Menu option File / Open.
 - b) In the Dialog Window that opens, use the pull-down browse function within the Look In Field to locate and select the **CD-ROM Drive**.
 - c) Locate, select and look inside the Chapter04 Folder.
 - d) Locate, select and open the Lesson4_modify.fla file by either double clicking on the file name or by selecting it and then clicking on the Open Button.
- 2. Take a moment to look at the file.

Please note the following properties of this completed exercise:

- a) The graphic results produced made use of various modifier options available for each tool.
- b) The Stroke Color Modifier, the Fill Color Modifier and Stroke Dialog Window are common modifiers for several tools.
- c) Ungrouped and Grouped objects behave quite differently. Note the difference.

Storyboard: On-Screen

For this exercise, the result of what you create may vary somewhat from what you see here, but when the exercise is completed you should have something similar to what is shown in Figure 4-32.

CD-ROM

Figure 4-32 The Finished Graphic

Storyboard: Behind-the-Scene

For this exercise, there is no "programming" to show you and thus no illustration. We have left this section header here to maintain consistency among the Practice Exercises in the book.

Step-by-Step Instructions:

- 1. Let's start with a new file by selecting the Menu option File / New.
- 2. Let's start by creating a Sky.
 - a) Select the Rectangle Tool from the Toolbox.
 - b) Select the Stroke Color Modifier at the bottom of the Toolbox and then select the No Color Icon that is below. Select the Fill Color Modifier and then select a light blue.
 - c) **Draw** a **rectangle** large enough to cover the top two-thirds of the Stage. See Figure 4-33. This will become our Sky.

Go Solo

·T/P·

We certainly don't want the Sky to have a "border color" - that is why we selected No Color for the Stroke Color. However, another approach would have been to use the same light blue color for both the Stroke and the Fill. In general, there isn't just "one way" to create something, but several methods that end up accomplishing the same result.

70

Drawing with Flash

- 3. Now to add a Sun to the Sky.
 - a) Our Sky will need a Sun to look more natural. Select the Circle Tool from the Toolbox. Select the Stroke Color Modifier at the bottom of the Toolbox and select orange. Select the Fill Color Modifier and select yellow.
 - b) To change the width of the Stroke, select the Menu option Window / Panels / Stroke. In the Stroke Dialog Window, highlight whatever number is there and then type in a value of ... 4 and then press the Return/Enter Key.
 - c) Hold down the Shift Key and the Circle Tool to draw a small circle in the upper right-hand corner of the Sky Area.

Figure 4-34 The Sun Drawn on the Sky

·T/P

This "cookie cutter" problem is very commonly experienced when first drawing objects in Flash. What happens is that "ungrouped" objects, when placed on top of each other, will actually "merge" and become part of a larger composite graphic. When you try to move what used to be a separate object, you discover that when it became "merged," whatever used to be underneath it is lost in the "merger" and thus a "hole" appears when the object above is moved. You can solve this problem by "grouping" an object (even if it's just one object), or drawing on another Layer.

d) Select the Arrow Tool from the Toolbox. Click and drag the yellow fill of the circle you just drew. Note that the Stroke was not selected and did not move with the Fill.

e) You may have noticed another very common problem when you moved the Sun Fill. By drawing the Sun directly on top of the Sky, when you moved the Sun, the image acted almost like a cookie cutter and cut out part of the blue in the Sky. See Figure 4-35. Select Edit / Undo. Whew – that was one mistake narrowly missed.

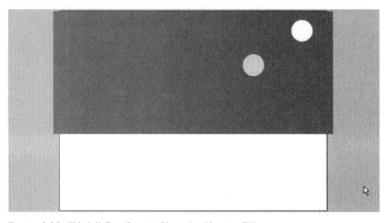

Figure 4-35 "Hole" Cut Out in Sky – by Moving Fill

- f) Don't worry we can fix both the Fill problem and the "hole" at the same time. First the Fill problem. Double click inside the circle to select both the Fill and the Stroke of the Sun graphic. Drag the Sun down to the bottom third of the Stage outside of the blue Sky. Click on the white area of the Stage to deselect the Sun. Note that we now have a "hole" where the Sun used to be. Double-click to select the Sun graphic again and then select Modify / Group to Group the Fill and Stroke of the Sun.
- g) Now, let's fix the Sky. Click on the Eyedropper Tool. Click the Eyedropper on the blue Sky to pick up this color. Position the Paint Bucket Cursor over the "hole" where the Sun once was and click inside the "hole" to fill it with the Sky color again. If you have more than one "hole" in the Sky, fill them all in.

- h) Now let's correct the second half of our "cookie cutter problem" by clicking on the Sky. Now select the Menu option Modify / Group. Note the rectangle that now surrounds the "grouped" object. Click on the Sun and drag it to the upper right side of the Sky graphic. By grouping the Sun and then grouping the Sky, you have protected each graphic from merging with any other objects that you place on top of them. By grouping the Sun, you can also now select the Stroke and Fill with just one click (because it is now a grouped object).
- i) But wait a second where did the Sun go? Since you are now working with two grouped objects – the Sun and the Sky – the Sky is probably covering the Sun. Objects on Layers have a stacking order. The rule is that the most recently grouped object goes to the top of the stacking order and covers whatever is underneath. Remember, the Sky was the last Grouped object, so it will be on top of the stacking order. Let's change the stacking order. Click to select the Sky. Select Modify / Arrange / Send to Back. The Sky is now underneath the Sun in the stacking order.

Figure 4-36 The Sun Positioned within the Sky.

- 4. Now on to the mountain range!
 - a) Select the Line Tool from the Toolbox. Click the Stroke Color Modifier and change the color to medium purple. The Stroke already has a value of 4, carried over from the changes we made to the yellow circle. There is no need to adjust any settings to the Fill Color Modifier prior to using the Line Tool.
 - b) Starting below the blue rectangle ... so that none of the drawing overlaps onto the blue ... start on the left of the Stage and draw a series of short, connected line segments ... a zig-zag. Continue this

TIP

By grouping the Sun and then grouping the Sky, we can prevent other graphic objects from altering their appearance or Stroke / Fill characteristics. Also, grouping objects makes it much easier to move them around the Stage, especially if the object contains both a Fill and Stroke. Using the Group command, you can avoid the problems we had in Step 3d & e. We will use this technique quite a bit as we continue our work in Flash.

The stacking order of objects can be confusing since we are working in a 2-dimensional space. Remember, that the most recently grouped object always goes to the top of the stack. Also, any objects that you add that are ungrouped, such as new drawings, go directly to the bottom of the stacking order. That's why when you try to draw something on top of the grouped Sky graphic, you won't be able to see it. It's there, but it's hidden underneath the grouped object.

·T/P

zig-zag until it has gone beyond the right side of the Stage. See Figure 4-37.

Figure 4-37 The Beginning of the Mountain Range

c) Click the end point of the zig-zag and draw a line straight down. Continue this line to the left side of the Stage, and then connect the end of this line to the starting point of the zig-zag to close the shape. We are ready to add a color for the Fill inside the outline. See Figure 4-38.

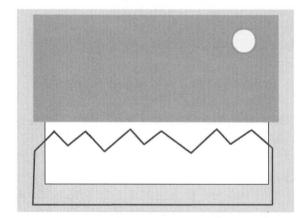

You can use the Arrow or Subselect Tool to reposition and refine the shape of your mountain range.

- d) Select the Paint Bucket Tool from the Toolbox. Select the Fill Color Modifier from the bottom of the Toolbox and select a light purple color. Click anywhere within the zig-zag shape with the Paint Bucket Tool to give it a light purple color. You have just created a mountain range!
- e) Let's now add a few snow-covered peaks. Select the **Eraser Tool** from the Toolbox.
- f) Select the Eraser Mode Modifier at the bottom of the Toolbox and set the Eraser Mode to Erase Fills. Click the Eraser Shape Modifier and select a medium, round eraser.
- g) Position the Eraser Tool over the peak of your first mountain and click and drag to Erase the light purple fill at the mountain peak. Notice how you can see right through the mountain-top to the Stage. See Figure 4-39.

Figure 4-39 Using the Eraser Tool to Create Room For Snow Caps

- h) Continue to Erase the other mountain-tops until they each have a space for a snow-cap. Even though it looks like we have snow at this point, it only appears white because the Stage is currently white. These "snow-caps" are now actually transparent. If we were to drag the mountain range up to overlap the Sky, you would see the blue from the Sky come through where we just erased. So ... we need to fill these areas in with a color.
- Select the Paint Bucket Tool from the Toolbox. Click the Fill Color Modifier at the bottom of the Toolbox and select white from the palette.
- j) Using the Paint Bucket Tool, click inside of each erased area until you have filled each with white. Instant Snow! Even though it may not look any different, we now have a "solid" white color for the snow caps.

Remember to check your Paint Bucket Modifiers if you are having trouble filling the mountain range. Change the Modifier to Close Large Gaps just in case you have some gaps in your drawing that you can't see at the current magnification.

If you are having trouble seeing what you are doing because the background is white and the color fill is white, try changing the background color of the Stage by selecting Modify / Movie to open the Movie Properties Window. Use the Background Color Well to choose a contrasting color. Once you are finished filling in the snow caps, choose Modify / Movie again to change the background color back to white.

·T/P·

- k) Select the Arrow Tool from the Toolbox and double click the light purple fill of the mountain graphic. Notice that both the light purple Fill of the mountain, as well as the corresponding Stroke, were selected – but not the snow caps. To select the entire mountain graphic you must position the Arrow Tool at the upper corner on one side of the mountain range. Hold the mouse button down as you drag the expanding marquis (dotted line) completely around the entire mountain image (including the snow-caps). Now release the mouse button. Once the entire mountain graphic is selected, Group it together as we have done earlier in this exercise (Modify / Group).
- With the Arrow Tool still selected, drag the mountain graphic to the center of the Stage.
- m) If the mountain range isn't long enough to overlap both sides of the Stage, don't worry, we'll fix that. Make sure the mountain graphic is still selected, then click the Scale Modifier at the bottom of the Toolbox. Click on one of the Scale Handles and drag the I landle to change the size of the mountain range. Adjust the size of the mountain graphic by clicking and dragging the Scale Handles. See Figure 4-40.

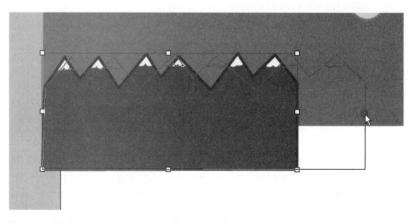

If you click and drag a Scale Handle on either the top or bottom, you will change the height without affecting the width. If you click and drag on either side, you will change the width without affecting the height. If you click and drag one of the corner Scale Handles, you will change both the height and the width at the same time.

Drawing with Flash

 Now drag the Mountains up so that they overlap on top of the Sky. When you are finished, your graphic should look similar to what is shown in Figure 4-41.

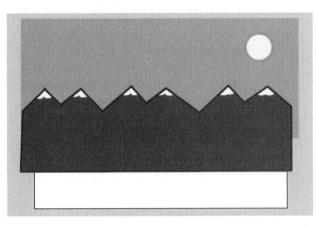

Figure 4-41 Our Mountain Range: Complete, Scaled and in Place

- 5. We already have the Sky, Sun and Mountains. Now let's create the ground.
 - a) Select the Rectangle Tool from the Toolbox. Click the Stroke
 Color Modifier and select a dark green color. Set the Stroke to
 5 in the Stroke Window. Click the Fill Color Modifier and choose a medium green from the palette.
 - b) Click and drag the **Rectangle Tool** to draw a rectangle in the Work Area... one that is large enough to cover the bottom third of the Stage. If you cannot see the **Work Area** select **View / Work Area**.
 - c) Select the Arrow Tool from the Toolbox. As you move the Arrow tool over the *Fill area* of the rectangle note the *four-headed arrow symbol*. This symbol indicates that if you click and drag now, you will move the Fill.

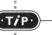

When working with multiple objects, you may find it easier to draw and assemble objects off Stage in the Work Area and then when ready, drag them on to the Stage. If you are working with objects that overlap, you may find this technique especially helpful. However, this "off Stage construction" is definitely not necessary, you may prefer to create right on the Stage. It is really a personal work preference.

If there isn't enough room to draw on the side of the Stage, you can always use the Scrollbars at the bottom or side of the Stage Window to adjust your view! Once you start animating objects in later chapters, you can also use the Work Area to position objects off the Stage in certain Frames.

Shortcut

You can turn on the Arrow Tool by holding down the Ctrl Key (on both the Mac and PC) when you have any other tool selected. The Arrow Tool will remain active – allowing you to move and select objects on the Stage – as long as you keep the key pressed down.

If you position your Arrow tool over the corner of the rectangle you will get an angle symbol instead of a curve. This will allow you to push and pull the right angle of the rectangle without altering the curvature of the lines. d) Position the cursor right on the top of the top line (the Stroke) of the rectangle. With your cursor positioned over the Stroke, a curved line symbol appears next to the Arrow. See Figure 4-42. This shows that you can now push and pull the line to change its curvature.

e) Click and drag the Stroke upward to form a hill. See Figure 4-43.

- f) **Double click** the **hill graphic** and **Group it** as we have done before.
- g) Drag the hill graphic onto the Stage. If needed, click the Scale Modifier at the bottom of the Toolbox and re-adjust the size of the hill graphic as we did with the mountains. Great! This landscape now has some land! See Figure 4-44.

Shortcut

The Keyboard Shortcut to Group objects is:

Windows – simultaneously press the Ctrl & G Keys

Mac – simultaneously press the Cmd & G

78

Drawing with Flash

Figure 4-44 Hill in Place on the Stage.

- 6. Now let's add a few trees to finish it up.
 - a) Select the Pencil Tool from the Toolbox. Select the Stroke Color Modifier and then select a dark green from the palette. Select the Pencil Mode Modifier and then select Smooth from the options. Change the size of the Stroke to 3 in the Stroke Window.
 - b) To the side of the Stage, click and drag the Pencil Tool to draw a tree shape ... don't be too concerned with what it looks like at this point!
 - c) Select the Arrow Tool from the Toolbox. Use the Arrow Tool to "spruce up" the tree shape. If you want to change an angle, click and drag the angle until it is where you want it to be. To adjust a curve, click and drag a line in the center until the curve is more appealing. See Figure 4-45.

Figure 4-45 The "Tree"... Before and After Use of the Arrow Tool

- d) Select the Paint Bucket Tool from the Toolbox. Click the Fill Color Modifier and select a medium green (lighter than the tree Stroke, darker than the hill Fill).
- e) Click inside of the tree shape to assign the color.

CAUTION

If you select a line by clicking it, then click and drag, you will move the selected line instead of adjusting the curve!

- f) **Select** the **entire tree** graphic and **Group** it.
- 7. Here's how to use a shortcut to create a forest out of our one tree!
 - a) While holding down the Alt Key (Mac Option), click and drag the tree graphic, then release. You have just created a duplicate of the tree graphic! Repeat this step until you have five trees.
 - b) Using the **Arrow Tool** and the **Scale Modifier**, change the scale, height and width of the individual trees so that each one appears a little different.
 - c) Next, arrange the tree graphics into a little grove. Select all of the tree graphics and **Group** them.

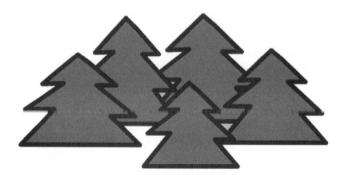

- d) Click and drag the group of trees onto the left side of the hill graphic. Resize them if necessary by using the Arrow Tool and Scale Modifier.
- e) With the trees still selected, create a duplicate of them as we did before (PC – Alt & Drag; Mac – Opt & Drag) and position them on the right side of the hill. Use the Arrow Tool and Scale Modifier to make them smaller, then position them close to the top stroke of the hill graphic to make them appear further away.
- f) Simultaneously press the Ctrl & Enter Keys Windows (Mac Cmd & Return Keys) to get a quick preview of the completed lesson.
- 8. Save this file in the **SaveWork folder** that you previously created on your hard drive. Type in the name for the file ... **Exer4.fla.**

The image will be automatically cropped to fit the Stage when the file is Published. Anything that lies outside of the Stage will no longer be visible!

Guided Tour – Introduction to Layers

Figure 4-47 Layers on Left Portion of Timeline

Layers can be thought of as a stack of transparencies, each containing a graphic element. Graphics that exist on the bottom sheets are visible through the top sheets. If, however, a graphic on a top sheet lies directly over a graphic contained on lower sheets, the lower sheets will be blocked from view. Once you've had some practice working with Layers, this concept will become second nature for you! Layers are a helpful design tool, because you can place individual elements (for example: a tree, rock, bird) that will make up a larger graphic (landscape) on their own individual Layers. By placing individual elements on separate Layers, we can adjust what objects are in front of or behind other objects (for example, hide the tree Layer and place rock behind the bird).

1. Take a look at the Timeline. In the Layer Panel, to the left of the Layer name, you will find the Layer Properties Icon (kind of looks like a stack of paper with a corner folded up). Double click on the Layer Properties Icon and the Layer Properties Window opens. See Figure 4-48. In this one window you have full control over the Layer it corresponds with. In this window, you can rename the Layer, Show or Lock it, change the Type of Layer, show the graphics on the Layer as outlines, or even change the height of its Timeline. Pretty convenient!

<u>N</u> ame:	Layer 1	OK
	Show 🗖 Lock	Cancel
Туре:	 Normal Guide Guided Mask Masked 	<u>H</u> elp
)utline Color:		

Figure 4-48 The Layer Properties Window

- 2. The most common Layer control options are now in front of you, available with the click of your mouse. If you were to click the box by Show, you could toggle on or off the visibility for that Layer. Click the **UK Button** to close this window.
- 3. You don't actually have to open the Layer Properties Window to toggle the hide/show option. Look at the Layer Panel, in the upper right hand corner. There are three icons. The icon on the left looks like an "Eye." This is the Show / Hide All Layers Icon. See Figure 4-49.

Figure 4-49 The Show / Hide All Layers Icon

4. There is a "dot" under this icon – again indicating that this Layer is currently visible. Click right on this "dot." You should now see a red X, indicating that the Layer is now hidden. Click on the red X to turn it back into a "dot" – making the Layer visible again. See Figure 4-50.

CHAPTER 4

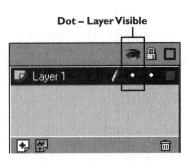

Figure 4-50 The Dot Indicates This Layer Will be Visible

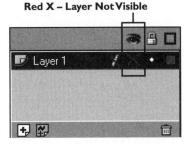

Figure 4-51 The Red X Indicates This Layer Will Not Be Visible

- 5. Clicking directly on the Show / Hide All Layers Icon (the Eye) will toggle the visibility of all Layers at the same time.
- 6. Right next door is the Lock / Unlock All Layers Icon (looks like a Padlock). See Figure 4-52. It is also activated and deactivated by clicking the "dot" (single Layer) or the icon itself (all Layers). Locking a Layer or Layers allows you to see the graphics on the Layer, but you cannot select, move or otherwise manipulate them. A Padlock Icon identifies a Locked Layer, while an unlocked Layer is identified by the dot. Locking a Layer is a great way to prevent an accident from happening to the artwork on a completed Layer!

Lock/Unlock All Layers Icon

Figure 4-52 The Lock / Unlock All Layers Icon

7. The Show All Layers As Outlined Icon (a square) is adjacent to the Lock / Unlock All Layers Icon. See Figure 4-53. It also is toggled by mouse clicks. This feature will show the artwork on a Layer (or Layers) as outlines, so you can view the graphics on lower Layers. An outlined Square Icon identifies an outlined Layer, while a normal Layer is identified by a solid Square Icon.

Show All Layers as Outlines Icon

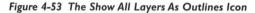

 Look at the lower left corner of the Layer Panel. The Insert Layer Icon is the easiest way to add additional Layers. Clicking this icon will add a new Layer above the selected Layer. See Figure 4-54.

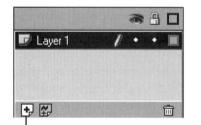

Insert Layer Icon

Figure 4-54 Add Layer Icon and a New Layer

9. Right next door is the Add Guide Layer Icon. See Figure 4-55. This icon will add a Layer above the selected Layer just like the Insert Layer Icon. The big difference between the two is that this option links the newly added Layer to the one below it and can only be used to establish a Motion Guide for an animated Symbol. Both Guide Layers and Animation will be covered in depth in a later chapter.

84

Add Guide Layer

Figure 4-55 The Add Guide Layer Icon

10. Over to the right a little, you will find a Trash Can Icon, which designates the Delete Layer Icon. See Figure 4-56. By selecting a Layer and then clicking this icon, you will delete that Layer and all of the graphic information it holds. You can also drag-and-drop any Layer onto the Delete Layer Icon and it will be deleted.

		3		
🕏 Layer 1	1	•	•	
•				Φ
	Delete			T

Figure 4-56 The Delete Layer Icon

Summary

- With the drawing and paint tools in Flash, you can create everything from objects for animation to interface designs without the aid of any other graphics program.
- With the release of Flash 5, veteran users of Flash will be pleased with the addition of the Bezier Pen tool, a tool similar to the pen tools in other programs like Macromedia's Freehand and Fireworks.
- The foundation of a Raster graphic lies within a two-dimensional matrix (basically rows and columns) composed of individual pixels that are defined by (mapped by) specific X (row) and Y (column) coordinates. Raster graphics (more frequently referred to as bitmapped graphics) are created in "paint" programs that build an image by electronically defining specific pixels.

- The strength of bitmapped graphics is that they are capable of very high resolution, with brilliant colors. The downside is that bitmapped graphics tend to have large file sizes and are difficult to resize and otherwise manipulate.
- In contrast, vector graphic files contain algorithms (mathematical equations) that are used to generate the objects they represent.
- As you might guess, the file sizes for vector graphics are much smaller than their bitmap cousins, but the downside is that they generally do not possess the brilliance of bitmaps that may contain complex color patterns.
- One of the greatest benefits of using vector graphics in Flash animations is that vector graphics can be scaled proportionally to any size – larger or smaller – and still retain the same crisp shape and outline as their original size.
- In the first Practice Exercise we worked with the Line Tool, the Stroke Color Modifier, the Stroke Panel, the Circle Tool, the Fill Color Modifier, moving objects (Fill and Stroke), the Pen Tool, the Line Tool, the Arrow Tool, the Subselect Tool, the Rectangle Tool, the Round Radius Rectangle Modifier, the Pencil Tool and modifiers, the Eraser Tool and modifiers, the Paint Bucket Tool, the Ink Bottle Tool, the Paint Brush Tool, and the Eyedropper Tool.
- In the second Practice Exercise we worked in more detail with the tool modifiers and experimented with the use of the Group option, looking at how un-grouped and grouped objects behave differently. We created simple graphics to practice using the tools.
- In the Guided Tour, we took a look at Layers and all the control options associated with them.

PTER

5

Creating

Frame-by-Frame

Animations

Chapter Topics:

- Introduction
- Guided Tour Frames, Keyframes and the Timeline
- Practice Exercise Creating a Frame-by-Frame Animation
- Onion Skinning
- Guided Tour The Onion Skin Tools
- Summary

Introduction

In a previous chapter, you were introduced to the movie or theater production metaphor used in the Flash authoring environment. This movie production theme will become clearer in this chapter, as we work with a fundamental concept in Flash . . . Frame-by-Frame animation. Now that you have learned some basic drawing techniques, it's time to start adding some action! After all, we've got our characters (objects). Now, we need to make them perform! Let's start animating the objects we've created!

By the end of this chapter you will be able to:

- add and delete Frames in your Timeline.
- add an object to specific Frames in your Timeline.
- · describe and use Keyframes.
- create a basic Frame-by-Frame animation.
- · preview your Movie.
- use the Onion Skin Tools.

Guided Tour – Frames, Keyframes and the Timeline

Until now, we have only drawn objects in the first Frame of the Movie Timeline. In previous exercises, we were not concerned with which Frame of the Movie Timeline our objects were placed in. With static drawings, the Timeline in Flash is not important because no time-based animation occurs. Everything you see on the Stage takes place in one Frame.

Think again about the movie metaphor used in Flash. When you sit down to watch a movie, everything takes place within a certain period of time. Each second of a movie that you see at home or in the theater was filmed Frameby-Frame. When you create a Flash Movie, everything that happens on the Stage is scripted in the Timeline and is contained within a certain number of Frames, just like a conventional movie.

For many new users, the hardest part of Flash is getting used to working within the convention of a Timeline-based program. Sometimes this concept can be confusing when you first begin moving between different Frames in your Timeline.

Let's take a closer look at the Timeline and examine the different types of Frames in Flash, and then see how to control the length of your Movie. This will help you to better understand how to create a Frame-based Movie. 1. Open a new file by selecting the Menu option **File / Open.** Take a look at the Timeline on your screen, as well as the one in Figure 5-1.

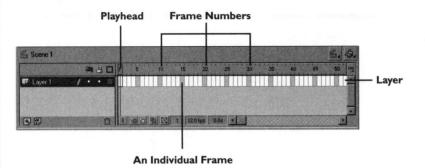

Figure 5-1 The Timeline

- a) Particularly notice the Layer (the horizontal row of white and gray blocks), the Frame Numbers (the top row of numbers ... 10... 20...30...etc.), and the Playhead (the red square and red line below it). Paying attention to the Playhead and the Frame Numbers can be very helpful as you create your Movies, as they provide visual clues to where you are.
- b) As you begin to design and create your own Flash Movies, it is very important to place content in particular Frames. Learning how to read the location of the Playhead and recognize Frame Numbers will help you avoid trouble.
- c) The red line that vertically extends from below the Playhead becomes even more helpful when you have multiple Layers in your Movie. This will help you keep track of where you are in your Movie Timeline – with one glance.
- It's easy to add Frames to your Timeline. All new Flash files start with one Layer and one Frame in the Timeline. The Playhead of your Movie should now be directly above the first Frame, as illustrated in Figure 5-1.
 - a) Select the Menu option **Insert / Frame** to add Frames to Layer I in your Timeline. See Figure 5-2. Go ahead and try it.
 - b) You have now added one Frame.

·TI

Figure 5-2 Insert Menu – Frame

- 3. You can also add several Frames at once to your Timeline.
 - a) First highlight the section of the Timeline where you want to insert Frames. Olick and drug across Layer 1, from Frame 3 to Frame 25, as shown in Figure 5-3. You can tell Frames are selected when they are highlighted.

	A	80	11	5	10	15	20	25	30	35	H
🕏 Layer 1	1.	• 🔳	Π								-

Figure 5-3 Selecting Frames 3 – 25

b) Use the Menu option Insert / Frame to insert multiple Frames at once. See Figure 5-4.

	a 6	1	5	10	15	20	25	30	35	H
🖻 Layer 1	1.	1.1								_

Figure 5-4 New Frames Added to the Timeline

Another way to easily select multiple Frames is to hold down the Shift Key and click in the first and then the last Frame that you want to select. This will select all the Frames in between these two Frames without dragging across all of them. This trick also works with multiple Layers. Let's say you want to select Frames 1-20 on four Layers in your Timeline. Hold down the Shift Key and select Frame I in Layer I. Then click on Frame 20 in Layer 4. All the Frames in between will be highlighted Cool!

90

Creating Frame-by-Frame Animations

- 4. Deleting Frames is a very similar procedure to adding them. You can select multiple or individual Frames and then use the Insert Menu, or just press the Delete Key.
 - a) Select Frame 25 by clicking on it. Press the Delete Key.
 - b) Highlight Frames 21 24 by clicking and dragging the cursor across these Frames. Then select the Menu option Insert / Remove Frames, as illustrated in Figure 5-5.

Insert Modify Text	Control	Windo
Convert to Symbol.	. F8	
New Symbol	Ctrl+f	-8
Layer		
Motion Guide		
<u>F</u> rame	F5	
R <u>e</u> move Frames	Shift-	+F5
Keyframe 13	F6	
Blank Keyframe	F7	
Clear Keyframe	Shift	+F6
Create Motion <u>T</u> we	en	
Scene		
Remove Scene		

Figure 5-5 Insert Menu – Remove Frames

c) Your Timeline should now look like Figure 5-6, with only 20 Frames.

					and the second second		
🕼 Layer 1 👘 🖉	• •						
			 	<u></u>			

Figure 5-6 Timeline With 20 Frames

d) Select Frame 10 by clicking on it. Notice that in Figure 5-7, Frame 10 is selected. When a Frame is selected, it is highlighted in black and the Playhead moves to the corresponding Frame number on the Timeline.

Shortcut

Insert Frame - F5

Delete Frame – Shift & F5

CH	AP'	TER	٤ 5
----	-----	-----	-----

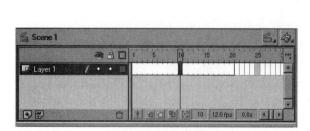

Figure 5-7 Frame 10 Selected in the Timeline

- 5. Notice that a thin black line surrounds all the Frames on the bottom and right edges. See Figure 5-7. As you add Frames to your Timeline, this line expands to the right to include the new total number of Frames. Notice that the available Frames look different from the empty Timeline. All available Frames (within the black lines) no longer have a solid gray line dividing each unit from another instead they have small hash marks separating Frames. Also, in the empty Timeline, every fifth empty unit is a solid gray box, whereas all Frames are solid white. These visual cues will help you glance at Timeline and know how many Frames you have in it.
- 6. Flash also differentiates between basic Frames and another type of Frame – Keyframes. Keyframes are an important concept in Flash and will be used extensively in most of your Movies. A Keyframe is a Frame in which some type of action, animation or an event begins, ends or changes. When you see a Keyframe in your Timeline, it indicates that some kind of change is about to occur.
- 7. In order to help you unlock the mysteries of Keyframes, we are going to change Flash's Preferences to make Keyframes visible in your Timeline. In Flash 5, Keyframes are by default invisible. This is a change from previous versions of the Flash program.
 - a) Select the Menu option Edit / Preferences to open your Preferences Dialog Window. With the General Tab selected, under the Timeline Options, check the box next to Flash 4 Frame Drawing as shown in Figure 5-8. Select the OK Button.

·T/P·

Flash 4 Frame Drawing

b) Once you turn this option on, you will now be able to see which Frames are designated as Keyframes in your Timeline. Keyframes are represented by two different symbols. Blank Keyframes (Keyframes with no content in them) are indicated by a white circle. See Figure 5-9 which shows that the first Frames in two Layers are both blank Keyframes. The first Frame of every Layer automatically has a Blank Keyframe inserted into it.

Figure 5-9 Blank Keyframes Represented by a White Circle

c) A black circle represents Keyframes with content in them. See Figure 5-10 which shows that the first Frames in two Layers both contain content.

- 8. As you will see in a later chapter, you can *add Layers to your Timeline* to keep objects separated or to add multiple Layers of animation. When you add Frames to one Layer, you must also add them to another if you want the animations on each Layer to run the same length of time. Let's add a Layer and see if the number of Frames match. You will learn more about customizing Layers in a later chapter.
 - a) Insert a new Layer by selecting the **Insert Layer Icon** that is located in the lower left of the Timeline Window. See Figure 5-11.

Figure 5-11 Insert Layer Icon

94

b) Since we previously added Frames to Layer I (with a total of 20 Frames), the new Layer automatically takes on the same number of Frames. See Figure 5-12.

Creating F	rame-b	y-Frame /	Animations
------------	--------	-----------	------------

		3	3		1	5	10	15	25	30	35	-
🗷 Layer 2	1	•	•	鼦	0							
D Layer 1		•	•		0							

Figure 5-12 Two Layers - Each With 20 Frames

- 9. If you want to simultaneously add more Frames to both Layers of the Timeline, you must first select Frames in each Layer. Let's try it out.
 - a) Select Frame 21 in Layer 2 by clicking on it. Click and drag from this location to Frame 25 in Layer 1.
 - b) Select the Menu option **Insert / Frame** and notice that five Frames are added to each Layer at the same time. See Figure 5-13.

	3 8 0	1 5 10 15 20 2	5 30	35 H
D Layer 2	•••	0		-
E Layer 1	·/·· 1	0		

Figure 5-13 Two Layers - Each With 25 Frames

- Next, let's consider Inserting and Deleting Keyframes. We can follow the same procedure for inserting and deleting Keyframes that we used when inserting and deleting empty Frames in the Timeline.
 - a) Click on Frame 10, Layer 2. Select the Menu option Insert / Keyframe. Click on Frame 15, to move the Playhead. Note that the new Keyframe has a white circle in it and a solid black line to the left. See Figure 5-14.

Image: A state of the	-
o boot and the second s	

Figure 5–14 New Keyframe 10 – Playhead in Frame 15

b) To delete a Keyframe, select Keyframe 10, Layer 2 and select the Menu option Insert / Clear Keyframe. This will not delete the Frame where the Keyframe resides or shorten the Timeline, but it will remove the Keyframe marker so the Frame becomes a "regular" Frame. Shortcut

Here are some useful Keyboard Shortcuts for adding and deleting Keyframes in your Timeline. You will use these shortcuts often, and learning them now will greatly speed up your production time. Insert Keyframe – F6

Insert Blank Keyframe – F7

Clear (Delete)

Keyframe – Shift & F6

Shortcut

You can also use the Menu option Insert / Blank Keyframe or the Keyboard Command F7 on both Mac and PC.

11. That concludes our tour of Frames and the Timeline. You're ready to get to work on an exercise.

Practice Exercise – Creating a Frame-by-Frame Animation

Description

In this exercise, you will apply what you've already learned about Frames to create a simple Frame-by-Frame Animation. By changing a graphic in each Keyframe, you will create a looping animation of a light bulb turning on and off.

In this exercise you will:

- Insert Keyframes in appropriate places on the Timeline.
- · Alter artwork in different Keyframes to create a simple animated effect.
- Work with objects on different Layers.
- Learn to Loop Playback for a continuous animation.

Louin to use the Enter Key for a quick preview of animation.

Take-a-Look

Before beginning the exercise, let's take a look at the exercise in its completed state so that you can clearly see what it is that you are about to build.

- Use the Menu option File / Open and locate on the CD-ROM the folder named Chapter05 and locate the file named Lesson5.fla. Doubleclick on Lesson5.fla to open the file.
- 2. The file Lesson5.fla should now appear in your copy of Flash.

Please note the following properties of this completed exercise:

- a) Keyframes are necessary in order to change the artwork or Symbol Instances within the Timeline.
- b) Multiple Frames are necessary to create an animated effect.
- c) Animation isn't restricted to Motion effects.

Storyboard: On-Screen

96

The following illustration shows you what the Stage will look like when you finish this exercise.

CD-ROM

Figure 5-15 The Stage When Complete

Storyboard: Behind the Scene

Figure 5-16 shows you what the Stage and Timeline will look like once you finish your Frame-by-Frame animation.

Figure 5-16 The Stage and Timeline When Complete

Step-by-Step Instructions:

- I. Let's make use of a file located on the CD-ROM.
 - a) Select the Menu option File / Open and use the browse function to locate the Chapter05 Folder on the CD-ROM. Locate, select and open the file light bulb.fla.
 - b) Select the Menu option File / Save As to save a copy of the file in the SaveWork Folder on your computer, typing in the name my_lightbulb.fla.

98

c) Take a look at the Layers and Timeline in this file. Right now, there is one Frame with two Layers named Radial Fill and Bulb Layer. See Figure 5-17.

		3	8	1	5
🕝 Radial Fill		•	•		
🛡 Bulb Layer	1	•	•	•	

Figure 5-17 Timeline – Two Layers

- 2. In order to create the illusion of a light bulb turning on and off, we need to add some Frames and change the Yellow Fill in the light bulb.
 - a) First we need to highlight the Frames we want to add. Click and drag from Frame 2 to Frame 50, highlighting the empty Frames in both Layers. See Figure 5-18.

🔓 Scene 1															6.	4
	-	3		1 5	 10	15	20	25	30	35	40	45	50	55	60	4
🕝 Radial Fill		•														
🕫 Bulb Layer	1 .	•	100									08555				1

Figure 5-18 Frames 2-50, Both Layers - Highlighted

b) Select the Menu option Insert / Frames to add the Frame Numbers you have selected to the Timeline. You should have 50 Frames in each Layer. See Figure 5-19.

a fattal and the	a	1	1	5		10	1	5	20		25		30	1.1	35	 40		45	1 - 6 1	64	 55	 60	H
🕼 Radial Fill	•	•																			I		
🐨 Bulb Layer 🛛 🖊	•	•																				T	_
•			þ	6	1 1		50	12.0) fps	4.1:	5 4	T					1			Т		1	ŕ

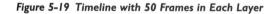

Creating Frame-by-Frame Animations

- 3. The next step is to add a Keyframe.
 - a) Select Frame 5 in both Layers by holding down the Shift Key as you click on Frame 5 in each Layer. See Figure 5-20.

Figure 5-20 Frame 5 Selected in Both Layers

 b) Select the Menu option Insert / Keyframe to turn Frame 5 in both Layers into Keyframes. Note that there is now a black circle in Frame 5, on both Layers. See Figure 5-21.

		3 3	8	1 5 1
🕞 Radial Fill		•	•	•
🗾 Bulb Layer	/	•	•	
•				1000

Figure 5-21 Keyframes Inserted in Frame 5

c) Repeat steps a & b to insert Keyframes in Frames 10, 15, 20, 25, 30, 35, 40, 45 and 50. See Figure 5-22.

		<i>(</i> 33);		1	5	10	15	20	25	30	35	40	45	59 5
🕝 Radial Fill		•	•		•		•		•	•	•	•	•	
🕼 Bulb Layer	1	•	•	•	•	•	•	•		•	•	•	•	
•			ĺ	¢.		1.5	0 12.0 f	ps 4.1:						

Figure 5-22 Timeline with All Keyframes Inserted

- 4. Now let's make some changes to the light bulb so it appears to turn off.
 - a) Click on Frame 5 of the Radial Fill Layer, and click on the yellow Fill. The yellow fill is a grouped object that when selected will look like Figure 5-23.

If you are having trouble understanding how to select Frames that are in-between certain Keyframes, try changing your Preferences. Select Edit / Preferences and then click on Flash 4 Selection Style. This will allow you to highlight individual Frames that are in-between Keyframes.

For those of you who worked with Flash 4, you may have noticed that Flash 5 handles this type of selection differently. Instead of highlighting individual Frames that are set between two Keyframes, Flash 5 highlights all the Frames inbetween in black. You must use the Playhead to keep track of which Frame you have selected. If this is confusing to you, change your preference to Flash 4 Selection Style.

Remember, you can recognize Groups by the rectangular bounding box that appears around the object when the object is selected. Conversely, when an object is ungrouped and then selected, the Fill and Stroke take on a "speckled" appearance.

If you have trouble selecting small fill areas, don't forget to use your Magnifying Glass in the Toolbox to enlarge detailed areas. To zoom in (get closer) to object on the Stage, select the Magnifying Glass Tool and click on the object on the Stage. To zoom out (get farther away) from the object on the Stage, select the Magnifying Glass Tool and hold down the Alt Key (PC) or the Opt Key (Mac). A minus sign will appear in the Magnifying Glass and you can now click and zoom out on the object.

Shortcut

As you have seen in Step 4e, you don't have to select the Paint Bucket Tool in order to change the color of an object. Just select the object with the Arrow Tool and pick a new Fill or Stroke color in the Color Well in the Toolbox to change it automatically. Be sure to deselect the object in order to see the color change.

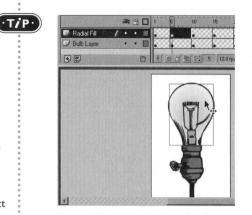

Figure 5-23 Yellow Bulb Color Selected

- b) Ungroup this shape by selecting the Menu option **Modify** / **Ungroup.**
- c) Change the Fill to White. See Figure 5-24.

Figure 5-24 The Bulb Fill Changed to White

- d) Hold down the **Shift Key** and select the remaining **Yellow Fill** inside the filament area of the bulb.
- e) Change the Fill to White.
- f) Repeat steps a-e in Frames 15, 25, 35, and 45.
- 5. Get the popcorn! It's time to Preview the Movie.
 - a) Drag the **Playhead** to **Frame I** of your Timeline.
 - b) Select the Menu option Window / Toolbars / Controller. (On a Mac, use Window / Controller). See Figure 5-25.

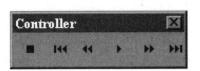

- c) Select the Menu option Control / Loop Playback.
- d) Click the Play Button on the Controller, to play through your Movie. Since the Controller is set to Loop, it will continue to play until you stop it.
- e) Click the **Stop Button** on the **Controller** to stop your Movie from playing.
- f) Drag the Playhead back to Frame I and press the Enter / Return Key to play through your Movie Timeline just once.
- g) Save your file in your SaveWork Folder on your hard drive.

Onion Skinning

Although it sounds like a culinary term, Onion Skinning is actually a very old technique used by traditional cell animators back in the days when each Frame of a cartoon was drawn by hand. In order to create realistic, fluid movement between each Frame of a cartoon, animators needed a way to see what they had drawn in the previous Frame while drawing the next movement. They used something called onionskin paper – a thin, translucent paper that allowed the animators to see through to the sheet underneath. These sheets are very thin – like an onion skin. Animators found that they could stack many of these sheets on top of each other, and because of the translucence, they could see multiple layers of a drawing. This allowed them to create a real sense of the fluidity of a movement from Frame to Frame.

Guided Tour – The Onion Skin Tools

Flash uses its own form of digital Onion Skinning. Unlike the previous exercise, some forms of Frame-by-Frame animation will actually require slight changes to a drawing in order to create movement, or a transition. This is not an easy task to accomplish if you cannot see the drawing in the previous Frame.

Let's explore the Onion Skinning options in the Flash Timeline and see how they can be used.

- I. Select the Menu option File / Open.
- 2. Find the Lesson05 Folder on the CD-ROM and open Onionskin.fla.

Shortcut

You can use your Enter / Return Key as a shortcut to play through the Frames of your Movie any time during the development. Press the Enter/Return Key and the Playhead will start from the currently selected Frame and move Frame-by-Frame through your Movie, stopping at the last Frame. Press it again and the Movie will begin again from Frame 1.

С	н	A	Ρ	Т	E	R	5

3. Take a look at the Timeline on your screen, as well as the one in Figure 5-26.

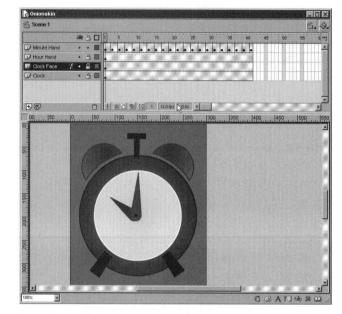

4. Press the Enter / Return Key to see the minute hand of the clock run.

Figure 5-26 The Timeline and the Stage

 Notice at the bottom of the Timeline (below Frames 1–12) that there are four blue and white icons. These are the Onion Skin tools. From left to right they are: Onion Skin, Onion Skin Outlines, Edit Multiple Frames, and Modify Onion Markers. See Figure 5-27.

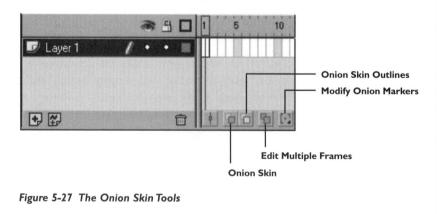

102

6. Click on the Onion Skin Button. See Figure 5-27. Notice the highlighted handle bars that appear at the top of the Timeline along the Frame Numbers. This is the Onion Skin Marker. You can expand or contract this Marker in order to see any number of Frames in the Timeline.

					(Dni	on	Ski	n M	1arl	ker							
Timeline															i din			Þ
		3	8		Į	3	5		10	1	5	20	• •	25	 30	 35	 40	 45 H
D Minute Hand		•	•		Ţ							•						
D Hour Hand		•	9															
📝 Clock Face	1	•	-															T
Clock		•	8															
₽				Î	1	19	0	-		1	12.	0 fps	0.0	5				·

Figure 5–28 The Onion Skin Marker

- 7. The Modify Onion Markers Tool allows you to quickly toggle between several different Onion views without dragging the Marker handle. Click on the Modify Onion Marker pull down menu and select Onion All in order to view all the Frames in the Timeline with Onion Skin. You must have one of the Onion Skin options turned on in order to view Onion All, Onion 2, or Onion 4. Onion 2 and Onion 4 turn on 2 and 4 Frames respectively.
- 8. **Drag** the **left side** of the **Onion Marker** so it **extends farther down** the length of the Timeline, as in Figure 5-29. Notice how you can see on stage the progression of the minute hand on the clock.

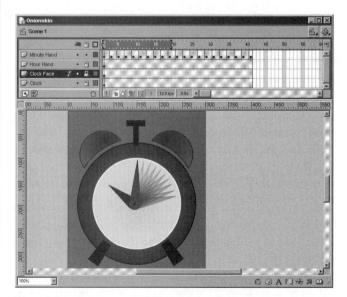

Figure 5–29 The Onion Skin Feature Revealing Multiple Frames in the Timeline

104

- 9. Turn off the Onion Skin Button by clicking on it again.
- 10. For some, turning the Onion Skin view on can be distracting, especially since you see the fills and outlines of all the objects in each Frame. Most traditional animators actually started with line drawings when creating Frame-by-Frame animation. With Flash you can have the best of both worlds. You can go ahead and add all the fills to objects on your Stage, but then choose to display only the Onion Skin Outlines when working on Frame-by-Frame animation.
 - a) Click on the Onion Skin Outlines Button (2 white squares). Notice how the minute hands in Onion Skin Frames turn to outline instead of a solid shape. See Figure 5-30.

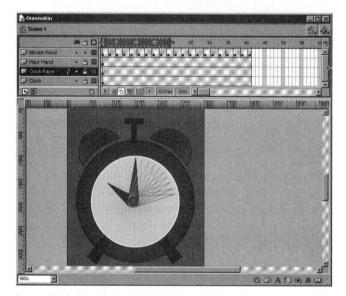

Figure 5–30 The Onion Skin Outlines Button

- b) Move the Onion Marker along the Timeline so you can see as many Frames as possible. Notice that this is very similar to the Onion Skin Button that we worked with earlier, however, all you see are outlines!
- c) Turn off the Onion Skin Outlines Button by clicking on it again.
- 11. Now for something really exciting. The Edit Multiple Frames Button not only allows you to see all the Frames you choose in your Timeline, but it also allows you to edit all the Frames simultaneously – as if all the objects were in one Frame! Let's try it.
 - a) **Turn on** the third Onion Skin Button the **Edit Multiple Frame Button** (two blue squares). Drag the Onion Marker over the Frame

Numbers so that you can see most of the Frames in the Timeline. Notice that the objects are not grayed out or in outline form. You can see them in full color! See Figure 5-31.

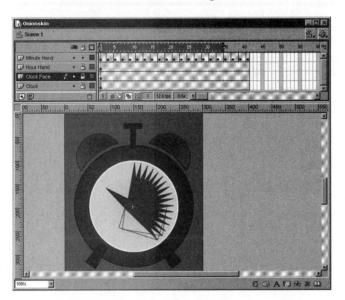

Figure 5-31 The Edit Multiple Frame Button

b) **Try to edit** the **minute hands** on the screen. Notice that no matter what Frame those objects are in, you can still edit them. All the other Layers in the file are locked, so you will not be able to edit anything other than the Minute Hand Layer unless you unlock the other Layers.

Summary

- In the first Guided Tour, you got a closer look at Frames, Frame Numbers, KeyFrames and the Playhead. You practiced adding Frames with the Menu option Insert / Frame and then saw how to add several Frames at once. You also saw how to delete Frames.
- Still within the Guided Tour, you were introduced to the Keyframe. A Keyframe is
 a Frame in which some type of action, animation or an event begins, ends or
 changes.
- You saw how to make Keyframes visible by changing Flash's Preferences by selecting the Flash 4 Frame Drawing option within the Edit / Preferences Menu.
- A white circle represents blank Keyframes and a black circle represents Keyframes with content.

- Add a New Layer by selecting the Insert Layer Icon that is located in the lower left of the Timeline Window. You can also simultaneously add multiple Frames to multiple Layers.
- In the first Practice Exercise, you got an opportunity to: Insert Keyframes in appropriate places on the Timeline; alter artwork in different Keyframes to create a simple animated effect; work with objects on different Layers; learn to Loop Playback for a continuous animation; and learn to use the Enter Key for a quick preview of an animation.
- Onion Skinning is a very old technique used by traditional cell animators back in the days when each Frame of a cartoon was drawn by hand. In order to create realistic, fluid movement between each Frame of a cartoon, animators needed a way to see what they had drawn in the previous Frame while drawing the next movement.
- In the last Guided Tour, you got an introduction to using the Onion Skin Button, the Onion Marker, the Onion Skin Outlines Button, and the Edit Multiple Frame Button.

PTER

Application Chapter: Designing

the Interface

Chapter Topics:

- What are the Application Project Exercises?
- Application Project Description
- Application Exercises An Overview
- Application Exercise Designing the Interface
- Summary

What are the Application Project Exercises?

Throughout this book you will find a number of Application Chapters. These chapters differ from the others in that they will challenge you to combine the knowledge and techniques acquired from several previous chapters and apply these skills to create part of a "real-world" Web site.

Each Application Chapter will focus on creating one of nine Application Exercises, that when combined, will make up a fully functional **Application Project** entitled **Route 67 – America's Other Scenic Highway.** Each Application Exercise is a separate and distinct element of the overall Application Project. Each Exercise, in its completed form, can be found on the CD-ROM that is included with this book. In this way, you can choose to complete an Application Exercise or a combination of Application Exercises and integrate your work with the completed Exercises that we supply. Or you can complete all of the Application Exercise on your own. The choice is yours.

We have designed the overall Application Project, **Route 67 – America's Other Scenic Highway**, and all of the component Exercises found in each of the Application Chapters, to reflect "real-world" structures and project objectives. The kind of structures you would be likely to find if you worked in a Web Design firm creating Web-based applications for corporate business customers.

More and more companies are using Flash for marketing, advertising, informational, and educational purposes. So, after you have completed the entire Application Project, you will have a "portfolio project" that is typical of a Flash application created in the "real-world" of web development. The content of the Application Project does include a little of our tongue-in-cheek humor. We hope that you will find the Application Project to be a valuable opportunity to practice what you have learned and will also have fun as you do so.

Application Project Description

The Application Project involves creating a Web site for an online travelogue touting the beauty and character of an imaginary highway through the American southwest – **Route 67...America's Other Scenic Highway.** All towns, names, and events described are obviously fictitious – any resemblance to any real town, person or event is completely unintentional and purely coincidental.

This Web site is meant to be playful, so don't mind our attempt to poke a little fun at those horribly long vacation drives that many of us endured as children. Remember the billboard signs that promised Amazon Wildlife at such-and-such an exit and it turns out to be nothing more than a Grass Snake

108

in a dirty aquarium? This site is our homage to mis-directed and under-whelming roadside exits everywhere . . . welcome to Route 67!

Route 67... America's Other Scenic Highway

Historic Route 67 is a scenic drive through America's beautiful and rugged Southwest. It was originally conceived as a coast-to-coast highway that would open a new corridor to travel and commerce. Unfortunately, the project came to a halt when someone in Washington decided that it bypassed all of the socalled "interesting" features of the Southwest. Take our word for it ... there's a lot to be excited about on Route 67! You will build a Travel Site to visit:

Bulldozer, Texas

In August 1978, Sissy Glabella entered a dish at the Annual Town Fair that started the culinary movement known as "Texahoma Cuisine." Stop and enjoy such delectables as Fried MeatTidbits with Salt, Cheesy Noodle Bake, No-Fuss Cheesecake, and the dish that started it all ... Sissy's Steamed Squash Medley on Rice. When you say Bulldozer, you've said "Good Eating."

Wagonrut, New Mexico

Come face-to-face with wild animals at Colonel Steve's Wild Game Reserve! Colonel Steve has scoured the earth to gather the most exotic and incredible animals ever assembled in North, Northeastern New Mexico. Your children will no doubt gain valuable natural insights that will make them much more intelligent and successful in their adult lives!

Chikapee, Arizona

Bring the family to Chikapee for a trip to the mysterious Invisible Ocean, discovered in 1952 by Lester "Tequila" Hopkins. Or, stay awhile and marvel at the aerobatic hijinks of Lester Hopkins (the Third) and his Flying Cropduster Circus! Lester has been known to let lucky children fly his plane while he shouts authentic flight instructions from the ground.

Underdale, Nevada

The town motto here is "Too close too be far, too far to be convenient!" Even on the blackest night the glowing lights and the jingling sounds of Las Vegas won't bother you. Your family will grow closer as you forage for food and shelter when you explore the Underdale Family Fun Wilderness Trail, a former Desert Survival Training Area for the U.S. Army!

Application Exercises – An Overview

Chapter 6 – Designing the Interface

In this first Application Exercise, you will build the interface elements that will be used throughout your Web site. Since we are creating an on-line travel experience, the elements will include the scenery along the way. This exercise creates the look and feel for the design of your site.

Chapter 11 - Creating Re-usable Symbols

This Application Exercise focuses on creating a few graphic elements that you will re-use throughout your Movie and within a variety of other Symbols. We will also add the descriptive text that goes along with each "stop" of our online travelogue.

Chapter 13 – Adding Animation

Next, you will go back and add some animated effects to your main Movie interface by applying what you have learned about Motion and Shape Tweens.

Chapter 17 – Movie Clip and Button Content

In this Application Exercise you will now create the buttons for your Movie interface. You will also create some additional Movie Clips that will be used elsewhere in the site.

Chapter 19 – Creating Sound Effects

Now that you have your interface built along with most of your attractions, you can add sounds for your buttons.

Chapter 21 - Setting Up Scenes

The next Application Exercise allows you to play the "Director" and add a couple of Scenes that will enhance the feel and function of the site. When you finish this exercise, you will have the basis of a connected Web site.

Chapter 23 – Building a Pre-Loader

In this Application Exercise, you will learn to add a Pre-loader to your main Movie site. This exercise will teach you how to use Frame Actions to control how your Movie is initially loaded and displayed.

Chapter 26 – Information Form

Now that you have the bulk of your site built you can add some bells and whistles. First, you will build a form for the visitors to your site to fill out and then will add it to your Movie.

Chapter 27 – Publishing the Site

Finally, you will put it all together and publish your site. You will also simulate posting your Movie and the accompanying HTML file to a server.

Application Exercise – Designing the Interface

Description

When you first enter a Flash Web site, the first thing that strikes most visitors is how appealing and fun the interface for a Flash site can be if some time is taken in creating the interface elements. The time you spend building the look and feel of your site can really pay off in a positive user experience. Grabbing the attention of a site visitor is the first order of business when developing a high profile site, or when creating a site that is meant to entertain or educate.

In this first Application Exercise, you will build the interface elements that will be used throughout your Web site. Since we are creating an online travel experience, the elements will include the scenery along the way.

Take-a-Look

Before beginning the exercise, let's take a look at the exercise in its completed state so that you can clearly see what it is that you are about to build.

- Use the Menu option File / Open and locate on the CD-ROM the folder named Chapter06 and locate the file named application-_6.fla. Double-click on application_6.fla to open the file.
- 2. The file application_6.fla should now appear in your copy of Flash.
- 3. Take a moment to look at the file.

CD-ROM

Storyboard: On-Screen

Route America's Other Scenic Highwayt

Figure 6-1 shows what will be seen on Stage when the exercise is completed.

Figure 6-1 The Completed Stage

Storyboard: Behind-the-Scene

Figure 6-2 shows how the Timeline will look when the exercise is complete.

	*	5		1	5	10	15	20	25	30	35	40	45	50	55	60	65	H
🕼 Headlines 🛛 🖊	•	•	100															
Photos	•	•																
🕞 Route Sign	•	-			0													
Background	•	8			D													-
+ 2			A	4	66	m	1 12	0 fps 0	.0s 4	[T

Figure 6-2 The Completed Timeline

Application Project Steps

Complete this exercise on your own, guided by following the general steps provided below. You can always refer back to the completed example that you viewed in the Take-a-Look section of this exercise.

Please Note: The following steps are intended as a guide. This is your project so please feel free to make whatever variations you would like.

Application Chapter: Designing the Interface

- Open application_start.fla. Ensure the Movie has the following settings: a white Background Color, a Frame Rate of 12 fps and a size of 640x480 pixels.
- 2. Rename the existing Layer I as Background. Rename Scene I as Index.
- Select Frame I of the Background Layer. Drag a copy of the Total Background Graphic Symbol out of the Graphic Images Folder in the Library and position it to cover the Stage (X=320,Y=140).
- With the first Frame of the Background Layer still selected, drag a copy of the Highway Graphic Symbol out of the Graphic Images Folder and position it at X=414.1,Y=326.4.
- 5. Add 4 more Frames to the Background Layer, for a total of 5 Frames.
- 6. Lock the Background Layer.
- 7. Add a new Layer and name it Route Sign.
- 8. Select Frame I of the Route Sign Layer. Drag a copy of the Road Sign Graphic Symbol out of the Graphic Images Folder and onto the Stage.
- 9. Resize it to W=208.8 and H=483.5. Position it at X=112.3, Y=221.2.
- 10. Lock the Route Sign Layer.
- Add a new Layer and name it Photos and position it above the Route Sign Layer.
- 12. Add a Blank Keyframe to Frames 1-5 of the Photos Layer.
- 13. Select Frame I of the Photos Layer.
- Drag an Instance of the PD Truck Symbol out of the JPEG Images Folder in the Library. Resize it to W=88.2 and H=88.2. Reposition it to X=275.9, Y=202.4.
- Drag an Instance of the PD Road Symbol out of the JPEG Images Folder in the Library. Resize it to W=136.0 and H=90.0. Reposition it to X=416.3,Y=222.2.
- Drag an Instance of the PD Stop Symbol out of the JPEG Images Folder in the Library. Resize it to W=91.0 and H=91.0. Reposition it to X=562.1, Y=183.2.
- 17. Select the Rectangle Tool from the Toolbox. Set the Fill Color to White, the Stroke Color to #333333 and the Stroke Height to 4. Make sure that Snap to Objects is selected.
- 18. Draw a rectangle over each of the photographs in Frame I of the Photos Layer, making sure that each rectangle is the same size as the photograph that it is drawn over.

- 19. Select Frame 2 of the Photos Layer.
- 20. Drag an Instance of the Underdale I Symbol out of the JPEG Images Folder in the Library. Resize it to W=154.0 and H=108.0. Reposition it to X=336.0,Y=205.9.
- 21. Drag an Instance of the Underdale 2 Symbol out of the JPEG Images Folder in the Library. Resize it to W=140.0 and H=94.0. Reposition it to X=505.9,Y=220.9.
- 22. Select the Rectangle Tool from the Toolbox and use the same settings from the previous steps.
- 23. Draw a rectangle over each of the photographs in Frame 2 of the Photos Layer, making sure that each rectangle is the same size as the photograph that it is drawn over.
- 24. Select Frame 3 of the Photos Layer.
- Drag an Instance of the Chikapee I Symbol out of the JPEG Images Folder in the Library. Resize it to W=89.0 and H=134.9. Reposition it to X=300.0,Y=209.5.
- Drag an Instance of the Chikapee 2 Symbol out of the JPEG Images Folder in the Library. Resize it to W=178.0 and H=119.3. Reposition it to X=476.4,Y=210.9.
- 27. Select the Rectangle Tool from the Toolbox and use the same settings from the previous steps.
- 28. Draw a rectangle over each of the photographs in Frame 3 of the Photos Layer, making sure that each rectangle is the same size as the photograph that it is drawn over.
- 29. Select Frame 4 of the Photos Layer.
- Drag an Instance of the Wagonrut I Symbol out of the JPEG Images Folder in the Library. Resize it to W=130.0 and H=86.0. Reposition it to X=286.0,Y=232.9.
- Drag an Instance of the Wagonrut 2 Symbol out of the JPEG Images Folder in the Library. Resize it to W=131.0 and H=83.2. Reposition it to X=429.5, Y=186.6.
- Drag an Instance of the Wagonrut 3 Symbol out of the JPEG Images Folder in the Library. Resize it to W=110.0 and H=86.0. Reposition it to X=563.0,Y=203.9.
- 33. Select the Rectangle Tool from the Toolbox and use the same settings from the previous steps.

Application Chapter: Designing the Interface

- 34. Draw a rectangle over each of the photographs in Frame 4 of the Photos Layer, making sure that each rectangle is the same size as the photograph that it is drawn over.
- 35. Select Frame 5 of the Photos Layer.
- Drag an Instance of the Bulldozer I Symbol out of the JPEG Images Folder in the Library. Resize it to W=167.0 and H=108.0. Reposition it to X=314.0,Y=200.9.
- Drag an Instance of the Bulldozer 2 Symbol out of the JPEG Images Folder in the Library. Resize it to W=149.0 and H=101.2. Reposition it to X=501.9,Y=216.6.
- Select the Rectangle Tool from the Toolbox and use the same settings from the previous steps.
- 39. Draw a rectangle over each of the photographs in Frame 5 of the Photos Layer, making sure that each rectangle is the same size as the photograph that it is drawn over.
- 40. Add a new Layer and name it Headlines. Position it above the Photos Layer.
- 41. Add a Blank Keyframe to Frames 1-5 of the Headlines Layer.
- 42. Select Frame I of the Headlines Layer.
- 43. Drag an Instance of the America's Other Headline Symbol out of the Graphic Images Folder in the Library. Position it at X=207.2, Y=96.0.
- 44. Select Frame 2 of the Headlines Layer.
- 45. Drag an Instance of the Underdale Headline Symbol out of the Graphic Images Folder in the Library. Position it at X=419.1,Y=108.8.
- 46. Select Frame 3 of the Headlines Layer.
- 47. Drag an Instance of the Chikapee Headline Symbol out of the Graphic Images Folder in the Library. Position it at X=396.3,Y=108.6.
- 48. Select Frame 4 of the Headlines Layer.
- Drag an Instance of the Wagonrut Headline Symbol out of the Graphic Images Folder of the Library. Position it at X=391.9,Y=108.8.
- 50. Select Frame 5 of the Headlines Layer.
- Drag and Instance of the Bulldozer Headline Symbol out of the Graphic Images Folder in the Library. Position it at X=383.6,Y=108.7.
- 52. Save your file as application_06.fla.

Summary

You have created the interface design that will grab the attention of your site's visitors. Spending some time crafting the graphics that you will use throughout your site is the basis of a fun and interesting user experience – and a successful Web site. The Application Exercises that follow in later chapters will help you present this additional content in an interesting and creative way.

PTER

Importing Artwork into Flash

/

Chapter Topics:

- Introduction
- Importing Files from Other Programs
- Practice Exercise Importing Artwork from Freehand
- Bitmap vs. Vector
- Common Bitmap File Formats
- Practice Exercise Importing & Converting Bitmap Images
 - Summary

Introduction

In Chapter 4, you learned how easy it is to draw in Flash. While Flash is a vector-based program, you can still use bitmap images generated in popular programs such as Macromedia's Fireworks or Adobe's Photoshop to add visual interest to your Flash Movies. In this chapter you will learn the difference between vector and bitmap images in order to use both graphic types effectively in your Flash Movies.

By the end of this chapter, you will be able to:

- describe the difference between vector and bitmap graphic formats.
- import artwork from other programs.
- identify graphic file types that are appropriate for import.
- convert bitmap images to vector graphics using Flash's Tracing feature.

Importing Files from Other Programs

The drawing and paint tools in Flash make it possible to create any artwork you need for your Movies without the aid of other graphics programs. However, the Import feature in Flash also allows you to bring in vector artwork from illustration programs such as Macromedia's Freehand, as well as bitmap images from image editors such as Macromedia's Fireworks and Adobe's Photoshop.

Image File Formats Valid for Import into Flash

These image file formats can be imported into Flash on both the **Mac** and **PC** platforms even if QuickTime 4.0 is **not** installed:

- Adobe Illustrator (.ai) The Adobe Illustrator format. This format can also be used to export files from Freehand.
- AutoCAD DXF (.dxf) This file format is used to export files created with CAD software.
- Flash Player (.swf) Shockwave Flash format. The standard format for exporting Flash Movies. Files exported from Flash can be imported into a new Flash Movie as long as they were not protected when published. This means that Flash Movies on the Web can potentially be downloaded and edited by other users.
- Freehand (.fh, .ft) Files imported from Freehand versions 7, 8, and 9 can be imported directly into a Flash Movie with Layers and Groups intact.
- FutureSplash Player (.spl) FutureSplash was the precursor to Macromedia's Flash. You can still import FutureSplash files for use in Flash 5.
- GIF and animated GIF (.gif) The Graphics Interactive Format is a proprietary compression format from CompuServe. GIF and JPEG images are the two

·T/P

most common file formats used on the Web and are supported by both major browsers. The GIF format is commonly used for images with less than 256 colors or images that require transparency. GIF files also support multiple frames for animation, as well as interlacing. GIF supports only one level of transparency.

- JPEG (.jpg) The Joint Photographic Experts Group is a compression format that contains continuous-tone image coding. The JPEG format is usually used for 24-bit color images such as photographs. GIF and JPEG images are the two most common file formats used on the Web and are supported by both major browsers. JPEG is considered a "lossy" compression formula. It does not support transparency, although it does support progressive downloads.
- PNG (.png) A file compression format that was originally developed by Adobe. Although it is not used or supported as frequently as GIF or JPEG, this format is also used on the Web. PNG is also the native file format for files created in Macromedia's Fireworks. PNG files combine the characteristics of GIF and IPEG files and support multiple levels of transparency.

These file formats can be imported into Flash on **only** the **PC** platform even if QuickTime 4.0 is **not** installed:

- **Bitmap** (.bmp) This image format can be exported from a wide variety of image editing programs and is considered the native file format for Windows users.
- Enhanced Windows Metafile (.emf) Common Windows file format in 32-bit applications created to replace Windows Metafiles (.wmf).
- Windows Metafile (.wmf) Common Windows 3.x file format.

This file format can be imported into Flash on **only** the **Mac** platform even if QuickTime 4.0 is **not** installed:

 PICT (.pct, .pic) – This bitmap format can be exported from a wide variety of image editing programs and is considered the native file format for bitmaps generated on a Macintosh (originally Quickdraw).

These file formats that can be imported into Flash **only** if **QuickTime 4.0** is installed:

- MacPaint (.pntg) Images created in the MacPaint program can be imported directly into Flash Movies.
- Photoshop (.psd) Images created in Photoshop can be imported directly into Flash Movies without saving to other forms (ie: bitmap, jpeg) first.
- **PICT** (.pct, .pic) This bitmap format can be exported from a wide variety of image editing programs and is considered the native file format for bitmaps generated on a Macintosh. With QuickTime 4.0 installed, PICT files can be imported into Flash 5 on the PC as a bitmap.
- QuickTime Image (.qtif) QuickTime format used for compressed still images.
- QuickTime Movie (.mov) Standard QuickTime movie format.

QuickTime 4.0 and Flash 5 are a powerful combination. Once a QuickTime movie is imported into Flash, titles, text and interface controls can then be added. This allows you to stream QuickTime movies in your Flash applications, or add .swf files to tracks in your QuickTime movies.

- Silicon Graphics (.sai) Images created on a Silicon Graphics platform can be imported directly into a Flash 5 Movie.
- TGA (.tgf) Also known as TARGA. This widely used file format is used for storing 24-bit color images.
- TIFF (.tiff) Stands for Tag Image File Format. Raster format, often used for exporting high-resolution images in desktop publishing.

Importing Artwork from Freehand

Seasoned designers who depend on a vector-based illustration program like Macromedia's Freehand or Adobe's Illustrator may still want to create their artwork in these more full-featured design programs rather than using the Flash drawing tools. With Flash's Import capability, bringing these other file formats into Flash is a simple and quick process. Plus, if you use the Layer Panel in Freehand to separate elements of complex illustrations, Flash will import those Layers intact and add them to its own Layer Panel.

Practico Exercice Importing Artwork from Freehand

Description

In this exercise, you will import artwork created in Freehand and place it into your Flash Movie.

In this exercise you will:

- Import a vector graphic.
- Use the Hide Layer Icon and Lock Layer Icon.

Take-a-Look

- First we need to open a file that is located in the Chapter07 Folder, on the CD-ROM supplied with this book.
 - a) Use the Menu option File / Open.
 - b) In the Dialog Window that opens, use the pull-down browse function within the Look In Field to locate and select the CD-ROM Drive.
 - c) Locate, select and look inside the Chapter07 Folder.
 - d) Locate, select and open the Lesson7_vector.fla file by either double clicking on the file name or by selecting it and then clicking on the Open Button.
- 2. Take a moment to look at the file.

Please note the following property as you complete this exercise: a) Imported vector graphics maintain their Layering capability

CD-ROM

Storyboard: On-Screen

Figure 7-1 shows how the file will look once you've completed this exercise.

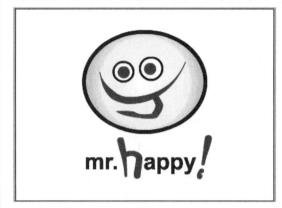

Storyboard: Behind-the-Scene

Figure 7-2 shows what happens to the Layers Panel once the Freehand file is imported.

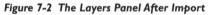

Step-by-Step Instructions:

- 1) Let's import vector artwork from Freehand!
 - a) Select the Menu option File / New.
 - b) Now select File / Import. Select the file named Lesson07_ mrhappy.fha from the Chapter07 Folder on the CD-ROM. Select the Open Button.
 - c) Take a look at the **Layers Box.** When you imported the Freehand artwork, Flash recognized the Layers and kept them separate for you!

2) Now let's work with the Layers!

С	Н	A	P	ΓE	R	7

	A	9	1
D Layer 1	•	•	Π
Text	×	•	•
🖻 Graphics 🛛 🖉	•	•	•
• 🔛			4

Figure 7-3 Layer Icons

- a) Select the **Hide Layer Icon** on the **Text Layer**. Everything on the **Text Layer** has been hidden, leaving the **Graphics Layer** visible.
- b) Select the **Hide Layer Icon** on the **Text Layer** once again and this Layer will become visible again.
- c) Click the Lock Layer Icon for the Graphics Layer.
- d) Select the **Paint Bucket Icon** from the Toolbox.
- e) Select the **Fill Modifier** and select a **medium blue**. Now **click** anywhere **within** the smiley-face graphic and try to change the color from yellow to blue. Why doesn't this work? We can't change the color (or make any other modifications for that matter) because this Layer has been **Locked!** This is a great way to protect your completed Layers from unintentional changes!
- f) Close the file (without saving it) by using the Menu option File / Close.

Bitmap vs. Vector

In Chapter 4, you learned that vector graphics are made up of paths that are defined by lines and curves. You also discovered that some of the benefits of using vector graphics are smaller, more efficient file sizes and scalable graphics. In this chapter we have worked with vector graphics imported from other programs, such as Macromedia's Freehand. However, you will now discover how to work with the most common file type on the Web – bitmap graphics.

Bitmap graphics are fundamentally different from vector graphics. Bitmaps are not composed of paths that define an object. Instead, bitmaps are composed of tiny blocks called pixels. Each pixel contains specific color information about that particular part of the image. These pixels fit together to create a complex pattern that forms a recognizable image to the human eye. Figure 7-4 shows a digital image of a duck, as we would normally view it. Figure 7-5 shows a magnification of this same image, only this time we can see the pixels that blend together to create the image.

Importing Artwork into Flash

Figure 7-4 Digital Image of Duck

This magnification of a digital bitmap image shows the individual pixels that combine to form the overall image. See Figure 7-5.

Figure 7-5 Magnification of Digital Image

Common Bitmap File Formats

Bitmap files are the most common type of image file used on the Web today. The term bitmap refers to a wide variety of file formats. A few examples of bitmap file formats include GIF, JPEG, PICT, TIFF, BMP, PNG, and PCX. Originally these file formats were developed for different kinds of applications. GIF and JPEG are probably the most common type of graphic found on the Web. The BMP format was first made popular within Windows-based "paint" programs. While these formats were developed for different purposes, the common thread tying all these formats together is that they all create images based on the use of pixel-based graphic information.

Scaling Bitmap Images

Vector graphics can be scaled to any size without a loss of image quality. This can be handy if you are creating a corporate logo or other design that must be enlarged or reduced to various sizes. With bitmaps, however, the same rules do not apply. Look at the images below to see a comparison between the quality of bitmap and vector graphics scaled to 300% of normal size. We will use a circle as the "content" to more dramatically point out the differences.

Figure 7-6 Vector Graphic of Circle at Normal Size

Figure 7-7 Vector Graphic Enlarged to 300% of Normal Size.

Figure 7-8 Bitmap Image of Circle at Normal Size

124

Figure 7-9 Bitmap Image of Circle at Enlarged to 300% of Normal Size

These images demonstrate what happens to a bitmap image when it is resized and scaled beyond its original size. As a bitmap image is scaled larger, an effect known as pixelization occurs. This term refers to the jagged edges that appear on the enlarged circle image as seen in Figure 7-9. The reason for this distortion is that the computer is forced to add pixels to an image when it is enlarged. In the absence of data to identify what these pixels should look like, the computer must "make up" the information to fill in gaps. Thus, the pixels added do not correspond to the actual image. Since vector graphics are not based on the pixel formula, they can be enlarged without worrying about missing information.

Practice Exercise – Importing and Converting Bitmap Images

Description

In this exercise you will import a bitmap image created in Adobe's Photoshop. While bitmap images can be used as-is in Flash, you can also convert bitmap images into vector graphics. This lesson will also show you how to complete the conversion process.

In this exercise you will:

- Import a bitmapped graphic.
- Make a copy of the graphic.
- Use the Trace Bitmap option.

Take-a-Look

- First we need to open a file that is located in the Chapter07 Folder, on the CD-ROM supplied with this book.
 - a) Use the Menu option File / Open.
 - b) In the Dialog Window that opens, use the pull-down browse function within the **Look In Field** to locate and select the **CD-ROM Drive**.
 - c) Locate, select and look inside the **Chapter07 Folder**.
 - d) Locate, select and open the Lesson07_bitmap.fla file by either double clicking on the file name or by selecting it and then clicking on the Open Button.
- 2. Take a moment to look at the file.

Please note the following properties as you complete this exercise:

- The new image was automatically added to the Library as you imported it.
- b) The original bitmapped image and the "traced" image appear quite different.

CD-ROM

Storyboard: On-Screen

Figure 7-10 shows you what the Stage Area will look like once you've completed this exercise.

Figure 7-10 The Completed Stage

Storyboard: Behind-the-Scene

Figure 7-11 shows you an example of what the Layers Panel looks like after a bitmap image has been imported and converted.

Step-by-Step Instructions:

Go Solo

- 1) Let's see how to convert bitmap images to vectors!
 - a) Select the Menu option File / New.
 - b) Now select the Menu option File / Import.
 - c) Select the file named **Duck.bmp** from the **Chapter07 Folder** on the CD-ROM.
 - d) Notice the thin blue outline around the duck image ... this indicates that the image is already selected after you imported it.

126

Importing Artwork into Flash

- e) While holding down the Alt Key (on the PC), or the Opt Key (on the Mac), click and drag the duck image to create a duplicate image. Position the two images side by side. We will keep one copy of the duck as is so we can compare it to what we will end up with after converting the other copy to a vector graphic.
- f) Make sure one of the duck images is still selected. Select the Menu option Modify / Trace Bitmap (this option will only work on the selected image). The Trace Bitmap Window now appears. See Figure 7-12.

		X
30		OK
5	pixels	Cancel
Very Tight	•	
Few Corne	rs 🔽	Help
	5 Very Tight	5 pixels

Figure 7-12 The Trace Bitmap Window

- g) Set the Color Threshold to...30, the Minimum Area to...5 pixels, the Curve Fit to...Very Tight, and Corners to...Few Corners.
- h) Click OK. The Tracing Bitmap Progress Indicator now appears. When the Tracing is finished, deselect the freshly "vectorized" duck to see the results and compare it to the original duck bitmap. You might conclude that the duck bitmap looks like a photograph, whereas the duck vector looks more like a painting. Close the file (without saving it) by selecting the Menu option File / Close.

Figure 7-13 Duck - as a Bitmap

·T/P

Take a look at the Library of your Movie after you Import the bitmap graphic. Open the Library by selecting the Menu option Window / Library. The new image was added to your Library automatically when it was imported. Even if you modify the image on Stage, you can always drag another copy of the original onto the Stage since it is now stored in the Library.

You don't have to convert bitmap images to vector in order to use them in your Movies. You can use them as-is without applying the Trace Bitmap command. Just remember that they will not be as scalable as vector graphics are, and they will add to the file size of your Movie.

127

Summary

- The drawing and paint tools in Flash make it possible to create any artwork you need for your Movies without the aid of other graphics programs.
- Flash's Import feature also allows you to bring in vector artwork from illustration programs such as Macromedia's Freehand, as well as bitmup images from image editors such as Macromedia Fireworks and Adobe's Photoshop.
- The following image file formats can be imported into Flash on both the Mac and PC platforms if QuickTime 4.0 is not installed: Adobe Illustrator (.ai); AutoCAD DXF (.dxf); Flash Player (.swf); Freehand (.fh, .ft); FutureSplash Player (.spl); GIF and animated GIF (.gif); JPEG (.jpg); and PNG (.png).
- The following file format can be imported into Flash on only the PC platform if QuickTime 4.0 is not installed: Bitmap (.bmp); Enhanced Windows Metafile (.emf); and Windows Metafile (.wmf).
- The following file format can be imported into Flash on only the Mac platform if QuickTime 4.0 is not installed: PICT (.pct, .pic).
- The following file formats can be imported into Flash only if QuickTime 4.0 is installed: MacPaint (.pntg); Photoshop (.psd); PICT (.pct, .pic); QuickTime Image (.qtif); QuickTime Movie (.mov); Silicon Graphics (.sai); TGA (.tgf); and TIFF (.tiff).
- In the first Practice Exercise, you imported a graphic that was created in Freehand, and noted that it maintained its Layering functionality.
- Bitmap files are the most common type of image files used on the Web today. The term bitmap refers to a wide variety of file formats. A few examples of bitmap file formats include GIF, JPEG, PICT, TIFF, BMP, PNG, and PCX.
- Vector graphics can be scaled to any size without a loss of image quality. With bitmaps, however, scaling images to a larger size creates a loss of image quality.
- In the second Practice Exercise, you imported a bitmap image that was created in Adobe's Photoshop. You saw that the image was automatically added to the Library, as it was imported. You then saw how easy it is to use the Trace Bitmap option within Flash.

·T/P·)

If you don't want to use the Trace Bitmap command but want to modify part of a bitmap image in Flash, try out the Break Apart command. Even without converting the bitmap, by breaking it apart you can use the Eraser Tool to modify the image. Select the Menu option **Modify** / **Break Anart** to apply this command.

PTER

8

Organizing Movies with Layers and

Groups

Chapter Topics:

- Introduction
- Grouping Objects
- Guided Tour Group Editing Mode
- Creating Nested Groups
- Practice Exercise Grouping and Ungrouping Objects
- Working with Layers
- Practice Exercise Adding Objects to Layers
- Summary

Introduction

As you move through the exercises in this book, we are certain that you will become more comfortable drawing and customizing simple objects for your Movies. While learning to use the drawing tools is very important, another critical aspect of creating complex applications in Flash is learning to organize the elements in your Movie. In this chapter, you will begin to work with Groups and Layers. Understanding how to work with Layers will allow you to create Movies with many animated objects that interact with one another.

By the end of this chapter you will be able to:

- group individual shapes.
- create nested Groups.
- · modify Grouped objects.
- arrange items on a Layer.
- set up new Layers.
- add objects to Layers and move objects between Layers.
- · change the Stacking Order of Layers.

Grouping Objects

In Chapter 4, we first encountered the "cookie cutter" problem with objects within Flash. The problem is that ungrouped objects, when placed on top of each other, will actually merge and become part of a larger composite graphic. When you try to move what used to be a separate object you discover that when it merged, whatever used to be underneath is lost in the merger. If you attempt to move one of the objects, a hole appears, or you break apart the merged object.

Guided Tour - The "Cookie Cutter" Problem

Let's review this problem. You can either...(1) open Flash and follow along by drawing and moving the objects or (2) just read through the steps and refer to each illustration.

1. A simple way to do this is by drawing a circle and a square on your Stage, using the same color for both objects. See Figure 8-1.

Figure 8-1 Before - Two Separate Objects

2. Now move one of the shapes until the two objects overlap. Click a blank area of the Stage to deselect the objects. At this point the objects have "joined" to become one shape that consists of the combination of a circle and a square. While each shape was drawn independently of the other, once they come in contact with each other and "join," it becomes impossible to select the individual shapes again. See Figure 8-2.

Figure 8-2 After - One "Joined" Object

3. If you double click on the rectangle (selecting both the Fill and the Stroke) and move it ... you break apart the joined image, but the images are not what you originally started with. See Figure 8-3.

Figure 8-3 Broken Apart Images

By using the Menu option, Modify / Group, to "Group" each object by itself, you will be able to overlay multiple objects without losing the properties of the individual objects. This makes it much easier to move individual objects

The Keyboard Shortcut for Group is: PC – Ctrl & G Mac – Cmd & G The Keyboard Shortcut for Ungroup is: PC – Shift & Ctrl & G Mac – Shift & Cmd & G around on the Stage, change the layout in your Movie, as well as keep shapes independent of one another.

Artwork that is imported from other vector-based programs like Freehand, is automatically "Grouped" when it is placed on Stage. In order to modify these imported objects in Flash, you will need to use the Ungroup option that you will work with in the next Practice Exercise.

Modifying Grouped Objects

Manipulating artwork in Flash is very different from manipulating artwork in other vector-based programs like Freehand. Instead of being confined to editing anchor points, you can modify the shape of objects by pushing and pulling on the outlines, without regard to the positioning of anchor points.

Although you will discover that after you have "Grouped" an object, you are **no longer** able to change the shape, fill, line, or any other artistic attribute, with the exception of scale or rotation. A Grouped object **cannot** be edited in the normal editing mode of the Stage.

Group Editing Mode

Flash provides an easy-to-use Ungroup function that breaks a "Group" into separate objects. Each object can then be modified with the drawing and paint tools. However, an alternative to the Grouping and Ungrouping process is provided with the use of the Group Editing Mode. Instead of using the Ungroup option to break a Group apart into its original objects (in order to modify the fill, stroke or shape), you can double-click the Group to activate the Group Edit Mode.

The following Guided Tour will walk you through entering and exiting the Group Editing Mode. While at times it may seem that you are still working in the main Stage area, you will be actually entering an alternative editing mode that allows you to modify a Group without breaking that Group apart, and without altering any other elements on the main Stage.

The ability to recognize when you are leaving one editing mode and are entering another editing mode is an important concept in Flash. Throughout this book you will be introduced to alternate editing modes that will increase the efficiency of your work.

Guided Tour – Group Editing Mode

One of the quickest ways to become side-tracked when first working within the Flash Workspace is to accidentally double-click on a Grouped object. Suddenly,

Organizing Movies with Layers and Groups

the screen changes appearance: some of the artwork appears selected while the rest appears to be dimmed and impossible to select or manipulate.

What happened? When you double-click on a Grouped object, Flash enters into the Group Editing Mode. Look at the following illustrations.

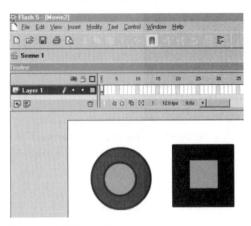

Figure 8-4 "Normal" Flash Interface

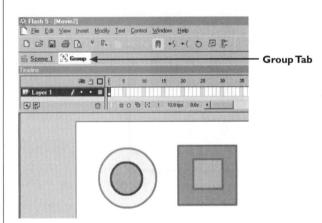

Figure 8-5 Group Editing Mode

There are a couple of visual cues that will help you more easily recognize when you enter Group Editing Mode. Use Figure 8-5 as a reference.

- There is a new Tab titled "Group" at the top of the Stage.
- The object that you double-clicked appears to be both Ungrouped and selected (a speckled appearance).
- All other objects appear dimmed and are not selectable or editable.

Let's take a quick tour of the Group Editing Mode to understand it more completely.

- 1. First let's draw something that we can Group!
 - a) Select the Rectangle Tool from the Toolbox.
 - b) Using the Stroke Color and Fill Color modifiers, assign a Black Stroke and a Yellow Fill.
 - c) Draw a small Rectangle on the Stage.
 - d) Select the Menu option Edit / Select All.
 - e) Select the Menu option **Modify / Group.**
 - f) Select the Menu option Edit / Deselect All.
 - g) Select the **Oval Tool** from the Toolbox. Using the Stroke Color and Fill Color modifiers, **assign** a **Green Stroke** and an **Orange Fill**.
 - h) **Draw** a small **Oval** on the Stage, making sure not to overlap the Rectangle.
 - i) Select the Arrow Tool from the Toolbox.
 - j) **Double-click** the **Orange Fill** within the Oval to select both the Fill and Stroke
 - k) Select the Menu option **Modify** / **Group.**
 - Select the Menu option Edit / Deselect All. We now have two Grouped objects to work with!

Figure 8-6 Two Grouped Objects

- 2. Next, let's take a closer look at the overlapping issue.
 - a) With the Arrow Tool still selected, drag the Oval until it overlaps the left side of the Rectangle.
 - b) Release the Oval and click anywhere else on the Stage to deselect it. Notice that the Oval is on top of the Rectangle. This is because it was Grouped after the Rectangle was. The most recent Grouped object will always lie on top of previously Grouped objects.
 - c) **Double-click** the **Rectangle** and notice the changes within your work area. See "Before" and "After" in Figures 8-7 and 8-8.

Shortcut

The Keyboard Shortcut for Edit /

Select All is:

PC – Ctrl & A

Mac – Cmd & A

Shortcut

The Keyboard Shortcut for Modify / Group is: PC – Ctrl & G

Mac – Cmd & G

Shortcut

The Keyboard Shortcut for Edit / Deselect All is: PC – Ctrl & Shift & G Mac – Cmd & Shift & G

- There is a new tab titled "Group" at the top of the Stage.
- The Rectangle appears to be both Ungrouped and selected.
- The Rectangle now appears to lie on top of the Oval.
- The Oval appears dimmed and is not "clickable" or editable.

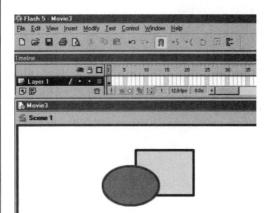

Figure 8-7 "Before" - Normal Editing Mode

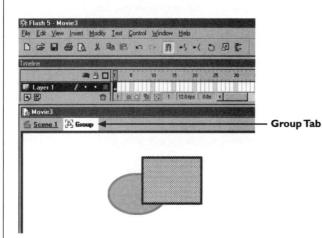

Figure 8-8 "After" - Group Editing Mode

- d) We are now in the Group Editing Mode. This will allow us to isolate a particular object and manipulate it as though it were Ungrouped! Meanwhile, the rest of our Grouped objects are protected from accidental changes. Use the Arrow Tool and click anywhere on Stage to deselect the rectangle.
- e) Using the **Arrow Tool, click and drag** on the right **side (Stroke)** of the **Rectangle** to change its shape. See Figure 8-9.

Shortcut

You can also edit a Group by Right-Clicking on the Group (Mac – Ctrl & Click) and choosing Edit Selected from the pop-up menu. This will take you directly into the Group Editing Mode.

As the Arrow Tool moves over the Stroke, the cursor changes from its normal appearance to an Arrow with a curved line appendage – indicating that the Stroke (line) can be modified.

- f) Click and drag the Yellow Fill so that it is no longer within the Stroke.
- g) Let's return to our normal work mode and see what has happened.
- h) To return to normal Editing Mode, **select** the **Scene I Tab** next to the Group Tab (or Double-click anywhere on the Stage).
- i) You will notice that the Oval is back where we positioned it earlier

 back on top of the Rectangle.
- j) Select the Rectangle. Notice that it behaves like a Grouped Object once again. See Figure 8-10.

Figure 8-10 Completed Group Editing

k) Close the file without saving the Artwork.

136

Organizing Movies with Layers and Groups

·T/P

Creating Nested Groups

Grouping is not limited to individual objects. You can also create Groups with previously Grouped objects, essentially forming one large Group that contains multiple sub-Groups. You can think of these as Groups **nested** within Groups. This is a handy feature when it is necessary to select and move many items around on the Stage, or when you would like to scale or rotate everything on a Layer all at once.

You will notice, however, that in order to Ungroup sub-Groups on a Layer, you may have to select the Ungroup option several times in order to break apart all the Grouped objects so that they return to their original "single object" states.

Layers vs. Groups

In previous chapters you worked with files that contained multiple Layers, but only drew objects on one Layer. By creating multiple Layers in Flash, you can separate objects on the Stage so that they each have their own position in the Stacking Order of your Movie. Using multiple Layers also means that each object can be modified separately from other objects on the Stage. This has the same effect as Grouping objects, but has even greater importance once we get into more detail about the animation features of Flash.

Layers allow you to animate multiple objects in Flash by giving each its own Layer within the Timeline. We will explore the other benefits of Layers in greater depth later in this chapter. However, for the first practice exercise we will concentrate on organizing objects by Grouping them while working in only one Layer.

Arranging Objects on a Layer

Multiple objects drawn on a single Layer are stacked (back to front) in the order they were drawn. This means that the last object drawn within a single Layer will always appear on top. Try visualizing it this way: imagine you have a deck of playing cards and you are placing them in a stack on a table, one card at a time. The first card put down on the table will always end up as the bottom card in the stack, while the most recent card placed on the stack, appears on top. See Figure 8-11.

You can also break down all objects in a Group into vector artwork that can be modified by using the Break Apart option found under the Modify pull-down menu. For Grouped objects with many nested sub-Groups, you may have to apply this option more than once. Break Apart is most often used to break apart text and bitmap images, but can also be used in place of the Ungroup option.

Shortcut

The Keyboard Shortcut for Break Apart is: PC – Ctrl & B Mac – Cmd & B

Figure 8-11 "Stacking Order of Layers"

It's exactly the same with objects drawn in Flash. Whatever you draw first will always end up being at the bottom of the Stacking Order within a single Layer. If these objects are placed on top of one another, whatever object was created or imported last will appear in front of whatever objects it overlaps. Remember, objects drawn in Flash that are not Grouped will be "merged" together if they overlap.

Once an object is Grouped, it will appear on top of any Ungrouped objects that are present or that are subsequently added. However, by using the Arrange option found under the Modify pull-down menu, you can make Grouped objects appear in front of or behind other Grouped objects. Figures 8-12 and 8-13 show you the before-and-after effect of the **Modify / Arrange / Bring to Front** function.

Figure 8-12 Before: Circle Appears Underneath

Figure 8-13 After: Circle Moves to the Foreground

Practice Exercise – Grouping and Ungrouping Objects

Description

We're going to start with the basics about Grouping and Ungrouping objects. You will soon see the benefits of Grouping even single objects. We will then move on to create nested Groups of multiple objects that are located in the same Layer. Please note that we will **not** spend a lot of time on creating artwork but just enough time to give you some extra practice working with the tools. You can spend more time on your own later to create more refined artwork.

In this exercise you will:

- Practice using Flash's tools to create simple objects.
- · Practice using modifiers for the tools.
- · Group single objects.
- Arrange the Stacking Order of multiple Grouped objects within a single Layer.
- · Ungroup objects to modify objects.

Take-a-Look

Before beginning the exercise, let's take a look at the exercise in its completed state so that you can clearly see what it is that you are about to build.

- Use the Menu option File / Open and locate on the CD-ROM the folder named Chapter08, then locate the file named Lesson8.fla. Double click on Lesson8.fla to open the file.
- 2. The file Lesson8.fla should now appear in your copy of Flash.

Please note the following properties of this completed exercise:

- a) The artwork on the Stage is composed of separately Grouped elements.
- b) Each Grouped element can be repositioned without affecting the other elements.
- c) All elements are placed within the same Layer.

Storyboard: On-Screen

Figure 8-14 shows what the Flash Movie will look like once you've completed the exercise.

CD-ROM

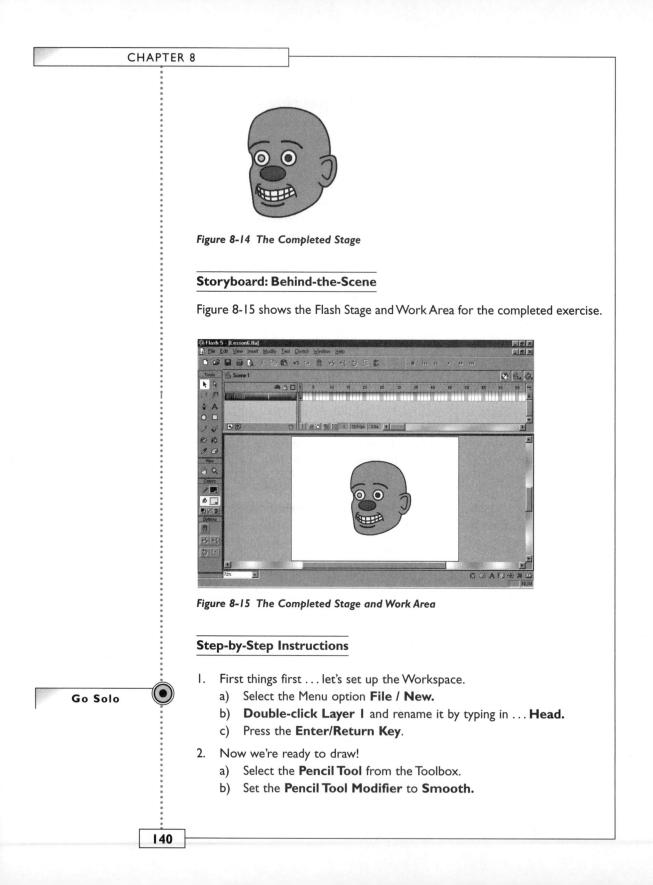

Organizing Movies with Layers and Groups

- c) Select the Menu option Window / Panels / Stroke and assign a 3-point Black Stroke.
- d) **Draw** a shape to represent the basic shape for a Head. We'll add the eyes, mouth, etc. in a minute.
- e) Select the **Paint Bucket** from the Toolbox. Using the **Fill Color Modifier,** select a **Medium Blue** for the Fill.
- f) Click within the Head shape to assign the Medium Blue color.
- g) Select the Arrow Tool from the Toolbox.
- h) Select the Menu option Edit / Select All.
- i) Select the Menu option **Modify / Group** to Group the Fill and the Stroke, thus forming a Grouped object.
- j) Select the Menu option Edit / Deselect All.
- 3. Let's add some personality with a few facial features.
 - a) Select the **Oval Tool** from the Toolbox.
 - b) Using the Modifiers, assign a Black Stroke and a White Fill.
 - c) To add Eyes, draw a small oval off to the side of the Head shape.
 - d) Select the Arrow Tool from the Toolbox. Double-click the oval to select it all.
 - e) Select the Menu option **Modify / Group. Click** on any **blank area** of the Stage to deselect.
 - f) Select the **Oval Tool** from the Toolbox.
 - g) Go to the Fill Color Modifier and change the Fill Color to Blue.
 - h) To add an iris to our Eye, draw a very small circle adjacent to the white oval (hold down the Shift Key to constrain this oval to a perfect circle).
 - i) Select the **Arrow Tool** from the Toolbox. **Double-click** the **circle** to select it all.
 - Select the Menu option Modify / Group. Click on any blank area of the Stage to deselect.
 - k) Drag the circle to the center of the white oval to form an Eye.
 - Click and drag a Marquee ("elastic band") around the entire Eye to select both the oval and the circle.
 - m) Select the Menu option Modify / Group.
 - n) **Drag** the **Grouped Eye** to an **appropriate position** on the Head and release.
 - o) With the Eye still selected, select the Menu option Edit / Duplicate.
 - p) Drag the Duplicate Eye to its appropriate position on the Head.
 - q) Click on any blank area of the Stage to deselect.

•**T**/P•

You can also change the Fill or Stroke by selecting the object with the Arrow Tool and changing the color in the Color Well on the Toolbox. This automatically changes the color of the object without using the Paint Bucket, or Ink Bottle.

Shortcut

The Keyboard Shortcut for Edit / Duplicate is: PC – Ctrl & D

Mac – Cmd & D

- 4. Now, we add a Nose.
 - a) Select the **Oval Tool** from the Toolbox.
 - b) Using the Modifiers, assign a Black Stroke and a Red Fill.
 - c) **Draw** an **oval** off to the side of the Head shape.
 - d) Select the Arrow Tool from the Toolbox. Double-click the oval to select it all.
 - e) Select the Menu option Modify / Group.
 - f) Drag the Grouped Nose to an appropriate position on the Head.
 - g) Click on any blank area of the Stage to deselect.
- 5. And finally, some Teeth.
 - a) Select the **Pencil Tool** from the Toolbox.
 - b) Using the **Stroke Modifier** in the Toolbox, assign a **Black Stroke** (pre-setting the Fill Color has no effect on the Pencil Tool).
 - c) **Draw** a **smiley-shaped mouth** off to the side of the Head shape (or a scowl if you are so inclined).
 - d) Set the Pencil Mode Modifier to Straight.
 - e) Add some straight lines to create the Teeth.
 - f) Select the Paint Bucket Tool from the Toolbox. Change the Fill Color Modifier to White.
 - g) Assign the White Fill to each of the Teeth.
 - h) Select the Arrow Tool from the Toolbox. Click and drag a Marquee around the entire Mouth to select both the Smiley-shape and the individual Teeth. If each of the Teeth doesn't appear "speckled" after you release the Marquee, it was not assigned the White Fill Color. Re-apply the Fill if necessary, then re-select.
 - i) Select the Menu option **Modify** / **Group** and **drag** the **Grouped Mouth** to a position on the Head.
 - j) Click on a blank area of the Stage to deselect.
 - k) Behold ... your artistic creation!
 - Suppose we now want to make a change to a Sub-Group (the Blue Circle) without having to move it off of the White Oval. Let's see how the Group Editing Mode will help us make the necessary changes without unnecessary risk.
 - a) Select the Arrow Tool from the Toolbox.
 - b) Double-click one of the Blue Circles we used to create the Eyes.

If we were unable to control how objects overlap within a Layer we would find ourselves very frustrated indeed! Fortunately, the Group function provides the control needed with a simple option from the Menu.

Shortcut

The Keyboard Shortcut for Bring to Front is:

PC – Ctrl & Shift & Up Arrow

Mac – Opt & Shift & Up Arrow

Organizing Movies with Layers and Groups

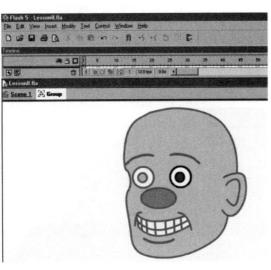

Figure 8-16 Eye Groups in Group Editing Mode

- 7. Let's go deeper.
 - a) **Double-click** the **Blue Circle** once again. This "opens" the eye/pupil Group.
 - b) Notice that we now have another Group Tab along the top of the Stage, the White Oval is now dimmed and the Blue Circle is now behaving like an Ungrouped object.
 - c) Select the Paint Bucket Tool from the Toolbox.
 - d) Select a Bright Green Color from the Fill Color Modifier. Since the Fill was already selected for us, the Color change is applied automatically.
 - e) **Click** the **Scene I Tab** to return to the Main Work Area. Our Face now has a little more character one blue eye and one green eye.
 - f) Experiment with Group Editing Mode on your own.
 - g) Select the Menu option File \ Save. Use the browse function to locate and select the SaveWork Folder on your local computer.
 Type in the name ... Ex8_1.

Working with Layers

Layers are a common feature in many graphic programs. In Flash, Layers work in a fashion similar to many other programs. The Layers feature is often used to organize complex images, or in the case of Flash, complex animated Movies. Layers can be given specific names (or labels) that correspond with the objects placed in them. Another handy feature of Layers is that items placed in Layers cannot be affected by items placed in other Layers. By Grouping individual objects we were able to position them on top of each other without having the individual objects "merge" together (as we now know Ungrouped artwork will do). Furthermore, because we Grouped the White Oval with the Blue Circle to form the Eye, we were able to create one Group out of two Sub-Groups. This composite Group now behaves like a regular Group in that we can select and position it without having to select each individual Sub-Group.

Notice those tell-tale visual clues on the Stage: The Group Tab at the top, the dimmed-out facial artwork...this can only mean that we are in the Group Editing Mode! At this point, we can select the White Oval and the Blue Circle separately (even though they are Grouped together in the Main Timeline). It might be helpful to think of the Stage not as a two dimensional surface, as it appears on your flat computer screen, but instead as more like the threedimensional stage of a playhouse theatre – width, height and depth (from Front Stage to Back Stage). By visualizing the Flash Stage with depth, you can think of Layers as actors and props that are located at different positions (relative to Front Stage and Back Stage), all inside the curtains that are located on the sides and top.

By placing objects in different Layers, you can organize the elements in your Movies much more effectively. In addition, using Layers will give you a much more complex and textured, animated Movie. Note that in Figure 8-17, each "body part" corresponds to a Layer in the Timeline.

	8			1	5	10	15	20	25	30	35	40	45	50	55	60		55 H
D Nose	•	•																
D Mouth		•														11		ΠĨ
D Eyes		•																
🕑 Head	1.	•																ΗŘ
•			đ		00	80	1 12	0 fps 0.	05 4		0.000		0.000	1110	2000	0.00	2000	(P

Figure 8-17 The Layer and Timeline View

In Flash, **unlike** other graphics programs, Layer capabilities extend far beyond using them to organize graphics or create complex images with special effects. In Flash, Layers have the added dimension related to movement. Multiple Layers corresponding to the Timeline can be used to create animations that take place on discreet Layers within the boundaries of the Stage. Potentially, you can have multiple Layers, with multiple animations taking place in the same Frames, on each Layer in the Timeline.

Practice Exercise – Adding Objects to Layers

Description

In this exercise you will learn how to add objects to Layers, create new Layers, and move objects to different Layers.

In this exercise you will:

- Learn to create and edit Layers.
- Change the Stacking Order of Layers.
- Move objects from one Layer to another.

CD-ROM

Take-a-Look

Before beginning the exercise, let's take a look at the exercise in its completed state so that you can clearly see what it is that you are about to build.

- Use the Menu option File / Open and locate on the CD-ROM the Chapter08 Folder. Locate and select the file named Lesson8_ layers.fla. Double click on Lesson8_layers.fla to open the file.
- 2. The file Lesson8_layers.fla should now appear in your copy of Flash.

Please note the following properties of this completed exercise:

- a) Each set of graphic elements is given its own Layer.
- b) The Stacking Order of each object is dependent upon the Stacking Order of the Layers

Storyboard: On-Screen

Figure 8-18 shows how the Stage will look once you've completed the exercise.

Figure 8-18 The Completed Stage

Storyboard: Behind-the-Scene

Figure 8-19 shows the Flash Stage and Work Area for the completed exercise.

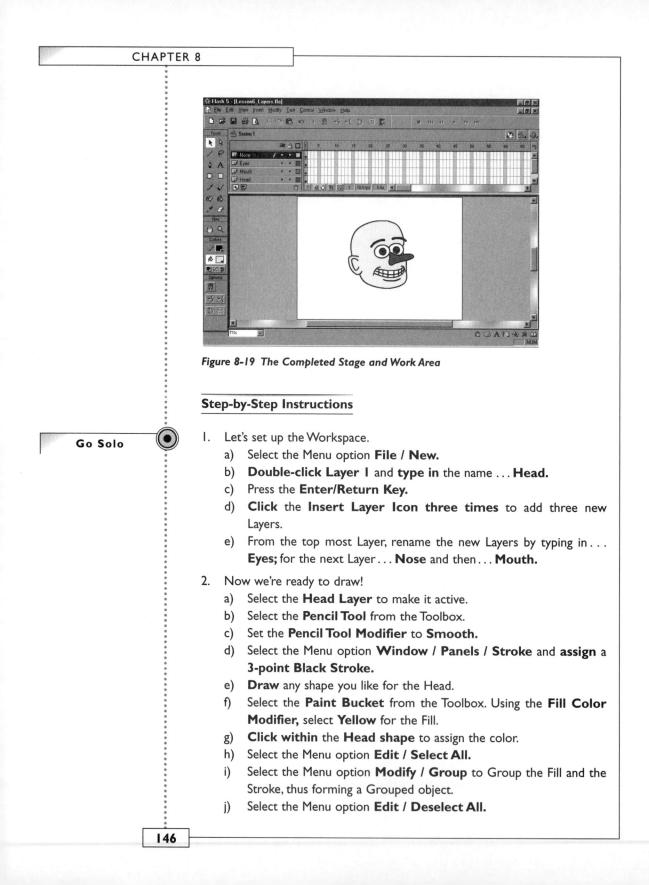

Organizing Movies with Layers and Groups

TIP

- 3. A face needs features.
 - a) Select the **Oval Tool** from the Toolbox.
 - b) Using the Modifiers, assign a Black Stroke and a White Fill.
 - c) **Draw** a **couple** of **Eyes** off to the side of the Head... like we did in the last exercise.
 - d) Select the Menu option **Modify / Arrange / Bring to Front** and bring the **Eye** on the **left in front** of the other Eye.
 - e) Select the Arrow Tool from the Toolbox. Click and drag a Marquee around both Eyes to select them.
 - f) Select the Menu option Modify / Group and drag the Grouped Eyes onto the Head.
 - g) Click on any blank area of the Stage to deselect.
- 4. Next comes the Nose.
 - a) Select the **Oval Tool** from the Toolbox.
 - b) Using the Modifiers, assign a Black Stroke and a Red Fill.
 - c) Draw an oval off to the side of the Head shape.
 - d) Select the Arrow Tool from the Toolbox.
 - e) Drag one end of the Nose to create a Cone-shape. Adjust the shape as needed to create a nose that seems appropriate for the head you drew.
 - f) **Double-click** the **Nose** to select both the **Fill** and the **Stroke**.
 - g) Select the Menu option Modify / Group.
 - h) **Drag** the **Grouped Nose** to an appropriate position on the Head. Make sure that the Nose is partially covering the Eyes!

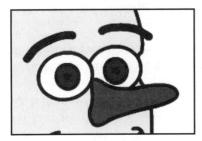

Figure 8-20 The Nose Partially Covering Eyes

- i) Click on any blank area of the Stage to deselect.
- 5. And finally, some Teeth.
 - a) Select the **Pencil Tool** from the Toolbox.
 - b) Using the **Stroke Modifier** in the Toolbox, **assign** a **Black Stroke** (pre-setting the Fill Color has no effect on the Pencil Tool).
 - c) Draw a mouth-shape off to the side of the Head.
 - d) Set the Pencil Mode Modifier to Straight.

Normally when creating artwork on separate Layers, we would select a particular Layer and then create or import the appropriate artwork directly to that Layer. However, in Step 6 we are going to show you how easy it is to copy a graphic from one Layer and paste it into another Layer.

You may want to temporarily change the background color in order to help you check and see if you have applied the white fills to *all* the teeth. Select **Modify / Movie** to change the Background Color.

Edit / Cut removes the eyes from the Stage and places a copy in Flash's "clipboard memory."

Edit / Paste in Place will take whatever is in Flash's "clipboard memory" and place a copy of it in the same position as the object was located when it was copied.

·T/P·)

You can also Hide, Lock, and Delete Layers by selecting the respective lcons in the Timeline Window.You can also re-arrange the stacking order of objects on a Layer and continue to work with Grouped objects as we did previously.

- e) Add some straight Lines to create the Teeth.
- f) Select the Paint Bucket Tool from the Toolbox. Change the Fill Color Modifier to White.
- g) Assign the White Fill to each Tooth.
- h) Select the Arrow Tool from the Toolbox. Click and drag a Marquee around the entire Mouth to select both the borders of the Mouth and the individual Teeth. If each one of the Teeth doesn't appear "speckled" after you release the Marquee, it was not assigned the White Fill Color! Re-apply the Fill if necessary, then Re-Select.
- i) Select the Menu option **Modify** / **Group** and **drag** the **Grouped Mouth** to a position on the Head.
- j) Click on any blank area of the Stage to deselect.
- 6. Let's reposition the pieces into their new Layers.
 - a) Select the Arrow Tool from the Toolbox.
 - b) Select the Eyes and select the Menu option Edit / Cut.
 - c) Select the **Eyes Layer** to make it active.
 - d) Select the Menu option Edit / Paste in Place to paste the Eyes into the Eyes Layer...in exactly the same position as they were before!
 - e) Select the Nose and select the Menu option Edit / Cut.
 - f) Select the **Nose Layer** to make it active.
 - g) Select the Menu option Edit / Paste in Place to paste the Nose into the Nose Layer.
 - h) Select the Mouth and select the Menu option Edit / Cut.
 - i) Select the Mouth Layer to make it active.
 - j) Select the Menu option Edit / Paste in Place to paste the Mouth into the Mouth Layer.
- 7. Now we need to correct the Stacking Order of the Layers.
 - a) Next to the Timeline, **click** the **Nose Layer** to make it the active Layer.
 - b) Drag the Nose Layer to a position above the Eyes Layer. As you drag it above the Eyes Layer, a fuzzy gray line appears over the Eyes Layer.
 - c) Release the Nose Layer when the fuzzy gray line appears. If we look at the Stage, our Nose now overlaps the Eyes again. See Figures 8-21 and 8-22.

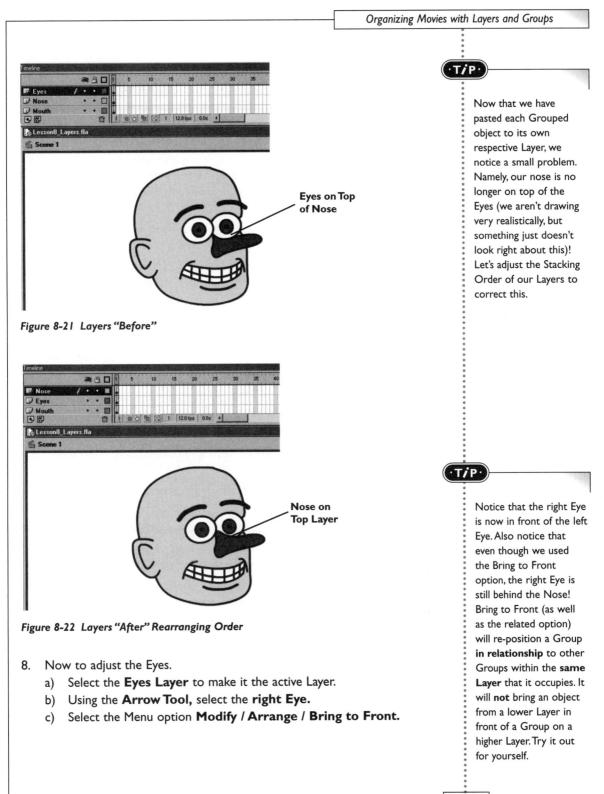

Summary

- In an earlier chapter we first encountered the "cookie cutter" problem with objects within Flash. The problem is that ungrouped objects, when placed on top of each other, will actually merge and become part of a larger composite graphic.
- By using the Modify / Group option, to Group each object by itself, you are able to overlay multiple objects without losing the properties of the individual objects. This also makes it much easier to move individual objects around on the Stage.
- Artwork that is imported from other vector-based programs like Freehand, is automatically Grouped when it is placed on Stage
- Flash provides an easy-to-use Ungroup option that breaks a Group into separate objects. Each object can then be modified with the drawing and paint tools.
- An alternative to the Grouping and Ungrouping process is provided with the use of the Group Editing Mode.
- In a Guided Tour, you worked with the Group Editing Mode. Accidentally entering this Mode can comptime course confusion, aspecially as you are first working with Flash.
- There are a couple of visual cues that will help you more easily recognize when you enter the Group Editing Mode.
 - There is a new Tab titled Group at the top of the Stage.
 - The object that you double-clicked appears to be both Ungrouped and selected (a speckled appearance).
 - All other objects appear dimmed and are not selectable or editable.
- You can also create Groups out of previously Grouped objects, essentially forming one large Group that contains multiple sub-Groups. You can think of these as Groups nested within Groups.
- Multiple objects drawn in a single Layer are stacked (back to front) in the order they were drawn.
- In the first Practice Exercise you worked the basics of Grouping and Ungrouping objects located in the same Layer.
- In the second Practice Exercise you worked with adding objects to multiple Layers.

150

PTER

9

Text and

Layout Tools

Chapter Topics:

- Introduction
- Control of Text in Flash
- Guided Tour Text Options in Flash
- Practice Exercise Formatting and Inserting Text
- Guided Tour Text as Graphic Elements
- The View Menu

.

- Guided Tour Controlling the Display View
- The Info Palette
- Guided Tour Working with Rulers, Guides, and Grids
- Summary

Introduction

In previous chapters, you practiced using the drawing and paint tools in Flash and learned to create simple Frame-by-Frame animations. All of these basic skills have given you a glimpse of the breadth and depth of Flash 5's capabilities. We will continue to explore more of Flash's design features in this chapter by working in-depth with text. Within the exercises in this chapter, as you learn to insert and format text, you will also be introduced to some of Flash's layout tools.

By the end of this chapter you will be able to further customize your Movie by using:

- Text Tool modifiers to apply fonts, colors, alignment, and paragraph formatting.
- the Anti-alias Text command.
- the Break Apart command.
- Rulers, Grids and Guides for layout.
- the View menu.

Control of Text in Flash

When working with text in Flash there are several points to remember. First, the characteristics of standard text in Flash are very different from standard text found on most Web pages written with HTML. In fact, text in Flash has more in common with the appearance, characteristics and control of text in a page layout program (like PageMaker or QuarkxPress) because of the degree of precise control you have over the appearance and placement of text.

As you will see in this chapter, text in Flash can also be treated as a graphic element as well. Those of you who have worked with Freehand or Illustrator are familiar with converting text to paths so that the letterforms can then be manipulated as graphic objects. Flash allows you to treat text in a similar manner by breaking down the letterforms into vector objects.

However, these are not the only text options available in Flash. Text in Flash can be inserted and formatted using all of the tools available to designers when laying out pages for print publications. Flash allows control over typical elements such as font, font size, text alignment and styles such as bold and italic. The Paragraph Window, as illustrated in Figure 9-1, also gives you control over typographic elements such as leading (the space between lines of text); left and right paragraph margins; and line indentation. Additionally, the Kerning option shown in Figure 9-2, allows you to control the space between letters.

Figure 9-1 The Paragraph Window

In Flash 5, you can also use HTML tags to format text that appears in your Flash Movie. If you are familiar with HTML, you know that these tags allow you to apply preset attributes to text in an HTML document. These tags give Web developers a certain amount of control over text elements on their Web pages. We'll take a closer look at some of these tags within the following Guided Tour. Now let's take a closer look at the different text options in Flash.

Guided Tour – Text Options in Flash

There are two general types of text fields that you can create in Flash – Static Text Fields and Editable Text Fields. In order to understand the difference between these two, let's explore the Text Options Panel and the Character Panel. The Text Options Panel allows you to set parameters for the text boxes that you insert in your Flash document.

- I. Let's take a look at the Text Options Panel.
 - a) Open the Text Options Panel by selecting the Menu option **Window** / **Panels / Text Options.**

In Flash 5, Fonts can also be stored in the Library as Font Symbols. These Font Symbols are actually more like style sheets that can be applied to selected text throughout your Movie.

Text and Layout Tools

·T/P·

b) Once the Text Options Panel opens, take a look at the pull-down menu on the panel and note the three types of text that you can choose from: Static, Dynamic, and Input Text. See Figure 9-3.

Static Text	
Use Device Fonts	
Selectable	

Figure 9-3 The Text Options Panel

- c) Select **Static Text** from the pull-down menu. Static Text is one of the most commonly used text forms in Flash applications that do not require dynamically updated information or input from the user. The Static Text option sets up a text field that contains specifically formatted text, similar to the text found in a page layout program. Unlike text formatted with HTML, in Flash you can choose from a large variety of fonts that can be embedded into the final *.swf* file that you export. This embedding process preserves the original outlines of the font you have applied to your text and insures that the font will display accurately in the user's Flash Player. Those of you who have designed HTML pages and have wrestled with the varied (and frequently undesired) ways that your text displays on different computers, will appreciate the control that embedded text gives you over the display of text elements in Flash.
- d) Notice that there are two checkboxes under the Static Text pulldown, Use Device Fonts and Selectable. Checking Use Device Fonts allows you to override the Embed Fonts options when you publish your final *swf* file. Instead of embedding the outlines of a font in your Flash Movie, choosing Use Device Fonts directs your Movie to pull the fonts that most closely resemble the Device Fonts specified in your Movie. As you can imagine, using Device Fonts can reduce your file size because you do not have to embed the font outlines in your published *.swf* file. But, you will also run the risk that the font your user ends up with may not look exactly as you originally planned.
 e) The Selectable checkbox allows you to specify that text can be selected, copied and then pasted into another document by a user

viewing your Movie on the Web.

Embedding fonts in your exported Flash Movie is a great option. However, beware that not all font outlines can be exported. To find out if the font you are using can be exported, select the Menu option View / Antialias Text. If this option does not smooth out the edges of the font you selected, then Flash cannot correctly export the outlines of that particular font.

- 2. The Character Panel allows you to see the Device Fonts that can be specified for use in your Movie file.
 - a) Open the Character Panel by selecting the Menu option Window / Panels / Character. See Figure 9-4.

×
? 🕨
Kern

Figure 9-4 The Character Panel

b) The Font pull-down menu in the Character Panel allows you to specify a particular Font to apply to selected text in your Movie. As you select a Font, an attached floating window will show you an example of what the selected Font looks like. There are three Device Fonts that are installed with Flash 5 from which you can choose. At the top of the Font pull-down menu you will see _sans, _serif, and _type-writer. Note that these Device Fonts all begin with an underscore. These Device Fonts resemble certain commonly used fonts:

_sans	Arial, Helvetica
_serif	Times
_typewriter	Courier

- As we mentioned earlier in this Guided Tour, there are two types of text fields in Flash – Static and Editable. You were just introduced to the Static Text Field, now let's take a look at the first Editable Text Field – Dynamic Text.
 - a) From the Text Options Panel, select Dynamic Text. Dynamic Text gives you the following Options: Single-Line, Multi-Line, Variable, HTML, Border and Background, Selectable, and Embed Fonts. See Figure 9-5.

	? >
Dynamic Text	
Single Line Variable:	HTML Border/Bg
Embed fonts:	Selectable

Figure 9-5 The Dynamic Text Option in the Text Options Panel

CAUTION

Only certain HTML tags are supported in Editable Text Fields: <A> Anchor, Links Bold <I> Italic <P> Paragraph <U> Underline Specifying Text Color Specifying Text Font Specifying Text Size

- b) The Variable option will help you understand why Dynamic Text is considered an Editable Text Field. Normally, when we think of Editable Text Fields, we think of the user typing in information, such as text fields on a form. This is not the case with Dynamic Text. Dynamic Text is updated by information from a server-side application that feeds new information to the text field. This is useful in applications where frequently updated information is valuable, such as with stock quotes. Dynamic Text is updated by specifying certain Variables. A Variable is like a "cubby-hole" in Flash's memory that stores information specific to it. The "cubby-hole" is labeled with a specific name and stores the changing values of this information. In our earlier example, these changing values might be the numbers for stock quotes that are constantly being updated, or fed to the Dynamic Text Field.
- c) Use the Single-Line or Multi-Line option from the pull-down menu to choose how many lines your Dynamic Text Field will contain. This obviously depends on the type of content that you will be updating.
- d) The last option under Dynamic lext that we will look at is the HTML checkbox. Flash allows you to format your text using standard HTML tags. This is especially useful if you are updating this information from a server-side application. That way, HTML tags such as BOLD, or can be used to format the text in a document that will be displayed in a Dynamic Text Field. Figure 9-6 shows an example of HTML tags applied to text in a Web document.

When writing in HTML, it is important to remember to use your BOLD TAGS when necessary.

Figure 9-6 HTML Tags to Begin and End Bold Style

- 4. Now that you've seen the first Editable Text Field, Dynamic Text, Let's take a look at **Input Text.**
 - a) From the Text Options Panel, select Input Text. Input Text gives you most of the same options as Dynamic Text, with a few exceptions. These options include: Single Line, Multiline, Password, HTML, Border and Background, Variable, Maximum Character, and Embed Fonts. See Figure 9-7.

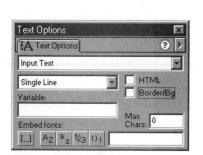

Figure 9-7 Input Text

- b) Input Text is the second type of Editable Text Field in Flash, however, Input Text allows you to set up text fields that require user interaction. So, instead of editing the text field from a server-side application, the visitors to your site have an opportunity to give feedback with forms, buy stuff (e-commerce), and otherwise interact by typing information into these text fields.
- c) Take a look at the **Password** option in the Single Line pull-down menu. This allows you to set an Editable Text Field as a Password field for users to submit a specified password.
- d) Now, let's take a look at the Max Char (Maximum Character) option on this Panel. With this field you can specify a limit to the number of characters that can be typed into this text field by the user. You might use this option if you are asking for things like phone numbers that have 10 digits.

Practice Exercise – Formatting and Inserting Text

Description

This exercise will show you how to insert and format text in Flash. Using files found on the CD-ROM, you will cut text from a plain text file and paste it into your Flash document. You will also learn to type text directly into your document and format it accordingly.

In this exercise you will:

- Copy and paste text from an external file.
- Create your own text within Flash.
- Modify and distort text.
- · Change Font characteristics.
- · Turn text into hyperlinks.
- Learn to use the Resizing Handle to create Single-Line and Paragraph Text.

- Learn to use the Paragraph Panel.
- · Convert text into editable vector paths.

Take-a-Look

CD-ROM

Before beginning the exercise, let's take-a-look at the exercise in its completed state so that you can clearly see what it is that you are about to build.

- Use the Menu option File / Open and locate on the CD-ROM the Chapter09 Folder. Locate and select the file named Lesson9.fla. Double click on Lesson9.fla to open the file.
- 2. The file **Lesson9.fla** should now appear in your copy of Flash.

Please note the following properties of this completed exercise:

- a) Text can be copied and pasted from files created in other programs.
- b) Text can be formatted in many ways within a single paragraph.
- c) You can easily adjust the size of your text boxes.

Storyboard: On-Screen

Figure 9-8 shows you what the completed Stage will look like on screen.

Of course in metrospect it all seems each with bits of flotsom and jetsom, with exception, of course, to the extramptics modilings of these vegue vessels. How incredible! Naturally we couldn't wait to place them within our eager lunch-pails and carry them off to some fantastic conclusion. How Mother and Uncle Barnister would chartle with effluxient glace as we conjoined ourselves to the dusty Chesapeake trails. Nh... the pelusive mercicles of a complete and higpocratic adclessence. What joy we had at the time. But time is floet facted.

Figure 9-8 The Completed Exercise

Storyboard: Behind-the-Scene

Figure 9-9 shows you what the Stage and Work Area will look like when the exercise is completed.

_ # × Flash 5 - [Movie1] Modify Lext Control Window Held ADB NH A HYO DE Scene 1 26.4 k a 3 0 1 10 D law 1 1 . . = \$ A 0 □ 1 E 1 0 0 % 1 1 120/ps 0.0s 4 13 OB / 8 6 n GGADO

Figure 9-9 The Completed Stage and Work Area

Step-by-Step Instructions

- 1. First, let's do a little preparatory work and copy some text from a text file.
 - a) Use your computer's browse function to locate the file named Sample_Text.txt in the Chapter09 Folder on the CD-ROM.
 Double-click on the file to open it in your computer's default text/word processor. Choose Edit / Select All from the Menu, then Edit / Copy. You have just copied the text that we wish to use into your computer's clipboard. Close the text/word processor.
 - b) Now open Flash and create a new Movie by selecting the Menu option File / New.

2. Now let's get down to business!

- a) Select the Menu option **Edit / Paste** to paste the text stored in the clipboard onto the Stage.
- b) Select the Arrow tool from the Toolbox and then select the Scale Modifier.
- c) Click and drag the Right Scale Handle to the right.
- d) Release the handle. Notice how the text has been distorted!
- e) Select the Menu option Edit / Undo.
- f) **Select** the **Text Tool** from the Toolbox.

Shortcut

Go Solo

The Keyboard Shortcut for selecting the Text Tool is to press the T key.

Text and Layout Tools

·T/P·

·T/P

Remember that the _**typewriter Font** is at the very top of the Font list ... it is a Device Font.

Panels are organized into groups or sets of panels with similar functions. Notice that when you open the Character Panel, by default this panel is grouped with other text-related panels like the Text Options and Paragraph Panel. If you have separated your panels, or changed their default arrangement, select the menu option Window / Panel Sets / Default Layout. This option returns your Panel Sets to their original groupings and arrangement on the screen.

- g) If your Character Window is not visible, select the Menu option Window / Panels / Character.
- h) In the Font Selection Window, change the Font Selection to ... _typewriter.
- i) In the Font Height Window, change the Font Height to ... 10.
- j) In the Leading Window, change the Leading to ... -2.
- With the Text Tool, click anywhere within the paragraph. You will notice a few changes in the appearance of the Text Block:
 - The Text no longer has a smooth, anti-aliased appearance.
 - There is a little square in the right corner of the Text Box.
- 3. Anti-aliasing is automatically turned off as you edit text. This is to conserve your system's memory resources. The little square in the right corner is the Resizing Handle. See Figure 9-10. When the Resizing Handle is present, it indicates that the text will always break at this point in the paragraph and will "wrap" to the next line. In other words, the paragraph will never be wider than is indicated by the Resizing Handle. However, by dragging the Resizing Handle, you can change the width of the paragraph.

anash with hits of of course, to the wasels. How ait to place them ry then off to some J TZ-1 - Theresi -----

Figure 9-10 The Resizing Handle

4. Let's take a moment to experiment with this. Double-click on the Resizing Handle. This will turn the paragraph of text into Single Line Text. Single Line Text is indicated by a circular handle. See Figure 9-11. Single Line Text eliminates "word-wrap." This means that text will go on forever (or thereabouts) to the right as you type... until you press the Enter/Return key. An Enter/Return will drop the cursor down a line so that you can continue typing text below the previous line (just like the carriage return on an old-fashioned typewriter!). Dragging the Single Line Text Circular Handle will convert it to the Resizing Handle.

uhe Joe sleepy. uhe Joe sleepy. uhe Joe sleepy. uhe Joe sleepy.

Figure 9-11 The Single Line Text Handle

Each of these changes has had a global effect on all of the text in the Text Block. You can also make selective changes to text within the paragraph by using the Text Tool to highlight and apply changes to particular letters, words, or phrases (similar to how you might do it in a word processor).

- 5. So...let's get specific. Before you begin...if your text to this point is still readable...continue with the following steps. If, on the other hand, you would like to start "fresh," you can delete the existing text block, paste in a "fresh" copy of the text and then continue.
 - a) Use the **Text Tool** to **select** the **first sentence** of the paragraph (click and drag to highlight just like in a word processor). Select the **Bold Button** in the **Character Window** to make the text bold.
 - b) Use the **Text Tool** to **select** the **last sentence** of the paragraph. Click the **Italic Button** in the **Character Window** to italicize the text.
 - c) Use the Text Tool to select all text between the first and last sentences. Select the Font Color Icon in the Character Window and select Red to change the Font Color to red.
- 6. We're not finished yet! Let's add a hyperlink to our text block.
 - a) Select the **Text Tool** and **click** at the **end** of the paragraph. Press the **Enter/Return** key to move the cursor to a new line.
 - b) Type in the following text ... This Web site was created with Macromedia Flash.
 - c) Once you finish typing, **highlight** the words ... Macromedia Flash.
 - d) In the Character Panel, in the URL Field, type the Web address ... http://www.macromedia.com as illustrated in Figure 9-12. Press the Enter/Return key to set the hyperlink.

Chara	acter						
A	Charao	cter	П Р	aragr	A	Text Op	?
Font:	_type	ewrite	r				
AI	10	-	B	I			
AY	-2	-				Kern	
44	Nor	nal		-			

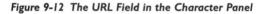

- e) Select the Menu option **Edit / Deselect All.** Your text should have a dashed line under it signifying that it is a hyperlink.
- f) If you are connected to the Internet, select the Menu option Control / Test Movie.
- g) When you click on the text ... Macromedia Flash, your default browser will launch and you will be taken to the Macromedia Web site.
- 7. Now, let's make some changes to the paragraph alignment.
 - a) Open the Paragraph Panel by selecting the Menu option Window / Panels / Paragraph.
 - b) With the **Arrow Tool** selected, **select** the **text block** you've been working with.
 - c) In the Paragraph Panel, click on the **Center Alignment Icon.** If you aren't sure which icon this is, take a look at Figure 9-13.

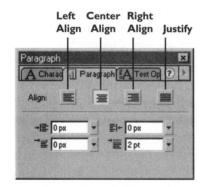

Figure 9-13 Alignment Options in the Paragraph Panel

- d) By selecting the whole text block, you can change the alignment of all text in a text block, all at once!
- e) To change the alignment of one paragraph, select the **Text Tool** and **insert** your **cursor** anywhere **within** the line that reads...**This Web site was created with Macromedia Flash.**

- f) Select the Center Alignment Icon on the Paragraph Panel. This centers that specific paragraph while leaving the other paragraphs left aligned.
- 8. We can also use the indentation and line space tools in the Paragraph Panel.
 - a) With the Arrow Tool, select the Text Tool and set the whole text block to left alignment.
 - b) Indent the left margin of the text block 20 pixels by typing in ... 20 in the Indent Left Margin Field as illustrated in Figure 9-14. Press the Enter/Return key and watch as the left margin of the entire text block moves 20 pixels to the right.

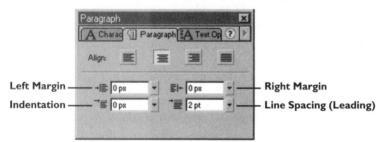

Figure 9-14 The Margin, Indent, and Spacing Fields

- c) To indent only the first line of text, **type in . . . 10** pixels into the **Indent Field.**
- d) Now, let's change the right margin of the text block. Click on the Down Arrow to the right of the Right Margin Indent Field and use the slider bar to change the pixel number to 50.
- e) Finally, let's change the line spacing on this text block. To decrease the space (or leading) between each line, click on the **Down Arrow** to the right of the **Line Spacing Field** and use the slider bar to **change it** to **-5 points.** To increase the space (or leading) between each line, let's use the other method, by just **typing in ...20**.
- 9. Time to finish up.
 - a) With the **Text Tool** selected, **click on** a **blank** (non-text) **area** of the Stage.
 - b) A small bounding box appears with the Single Line Text Handle and a blinking cursor. Type in ... All work and no play makes Joe sleepy. You can then adjust the Text as we have previously discussed. Great job!
 - c) No need to save this exercise, unless you would like to.

•**T**/P•

You can also increase or decrease the space (leading) between individual lines rather than entire paragraphs or blocks of text. Just select your Text Tool and insert it anywhere within the selected line and then increase or decrease the space using the Leading field in the Paragraph Panel.

Guided Tour – Text as Graphic Elements

The Text Tools in Flash allow considerable typographical control over the placement and formatting of text in your Movies. In addition to normal text objects, however, text can also be converted to graphic elements by using the Break Apart option. After using this option, however, the Text Tools can no longer be used because the letterforms are no longer "text" but have been converted to vector graphic objects. However, as a graphic object, all the drawing and paint tools can now be used on the converted text, and the letters can be modified to any shape. Let's give it a try.

- I. We will start with a new file.
 - a) Select the Menu option File / New.
 - b) Select the **Text Tool** in the Toolbox.
 - c) Click anywhere on the Stage and type in your name.
 - d) Select the Arrow Tool in the Toolbox.
 - e) Select the Menu option **Modify / Break Apart** to convert your name, from text into graphic objects.
- 2. You may want to Zoom In for the rest of this step.
 - a) With the **Arrow Tool** still selected, **click** and **drag** along the edge of any of the "letter" shapes (they are shapes that have the form of a letter, but they are no longer true, editable letters).
 - b) Since the text has been converted into graphic elements, you can now manipulate them as any other graphic element. See Figure 9-15. Experiment and have fun!

Figure 9-15 Text Converted into a Graphic Element

The View Menu

The View Menu contains four options that control the display quality of objects on the screen, including text. The View Menu allows you to change these display qualities so that as you are working on items, they can be redrawn on screen more quickly. These settings do not affect the final Export

·**T**/P·)

Use the Magnifying Glass in the Toolbox to zoom in and out on objects on the Stage, or use the percentage menu at the bottom left of the Stage to toggle between magnifications.

Shortcut

Double-click the magnifying glass in the Toolbox to return to 100% magnification. Settings in the Movie. Essentially, these options help you work faster and view objects on the Stage in a variety of helpful ways.

The highest quality display for objects and text is the Anti-alias or Anti-alias Text view. Computer displays are defined by tiny squares called pixels. As we discovered in an earlier chapter, when a bitmap image is scaled to a larger size, an effect known as pixelization occurs. This term refers to the jagged edges of the enlarged images that appear on screen. These jagged edges show the building blocks – or pixels – that make up the images. In order to simulate curves on the computer screen, a technique called anti-aliasing is used. A gradation of pixels is used to make the lines appear smoother to the human eye, and in the case of text, more readable.

The four display views are:

Outline View – Converts all objects on the screen to lines (outlines) with transparent fills. This option allows you to see the outlines of objects that are stacked on top of each other.

Fast View – Shows all the lines and fills of objects and text on the screen, without any Anti-aliasing.

Anti-alias View – Creates a smoother edge on all objects (except text) on Stage.

Anti-alias Text View – Creates a smoother edge on all elements on Stage.

Guided Tour – Controlling the Display View

- 1. Let's take a closer look and try out these different View options.
 - a) Select the Menu option **File / New.**
 - b) Select the Text Tool from the Toolbox.
 - c) Click on the Stage and type in your name. Using the options we covered earlier, change the Font Size to ... 36.
 - d) Select the Menu option Edit / Deselect All.
 - e) Select the **Oval Tool** from the Toolbox and **draw** an **oval** below your name.
 - f) Select the Menu option View / Outlines. Both the Text and the Object appear as light blue outlines. See Figure 9-16. Outline View uses minimal memory to show you the images on-screen and can be helpful when you have many objects to work with. Anything that is on the Stage can still be edited in the Outline View.

Figure 9-16 Outline View

g) Select the Menu option View / Fast. Both the Text and the Object appear in full color but have jagged edges. This is because their edges are not being anti-aliased (or "smoothed") by the computer. By not anti-aliasing the view, your computer can redraw and refresh the view on the screen much faster than when it applies anti-aliasing.

Figure 9-17 Fast View

h) Select the Menu option View / Anti-alias. The object appears smooth (anti-aliased) but the Text does not. This is just another option to conserve memory!

Figure 9-18 Anti-alias View

166

 Select the Menu option View / Anti-alias Text. Both the text and the object appear smooth and anti-aliased. This particular view gives you the most appealing display and is great to work in – if your system resources will allow it.

Figure 9-19 Anti-alias Text View

The Info Palette

As the name implies, the Info Palette gives you basic information about selected objects on the Stage of your Movie. You can use this palette to view the dimensions of an object, to change the dimensions of an object, and to see a preview of the object.

The Info Palette can also be used for controlling placement of objects on the Stage area by typing-in the X and Y coordinates into the corresponding areas of the Info Palette. These coordinates represent the placement of the selected object in relation to the horizontal (X) and vertical (Y) edges of the Stage area. These coordinates can be measured from the top left-most edge of the object, or from the center point of the object, depending on the settings established in the Info Palette. You can also use the Flash layout tools to help arrange text elements and graphics on a page, as you will see in the Guided Tour that follows.

Info	
ft Info 🖅 Trans	fo Stroke 🚯 Fill 🧿
🛃 Shape	
₩: 117.0	000 X: 227.5
₩: 117.0 H: 51.0	Y: 182.5
R: 102	u 200.0
G: 204 B: 204	+ X: 268.6 Y: 171.5
A: 100%	

Figure 9-20 The Info Palette

Guided Tour - Working with Rulers, Guides, and Grids

When working on the Stage, layout tools such as Rulers, Guides, and Grid lines will help you place items in precise positions. All three of these functions can be used together to align elements, to draw objects with specific sizes, and to create a guiding framework for laying out elements on the Stage. Let's take a closer look.

 Rulers are helpful additions to the Stage because they provide a visual reference for positioning your graphic or text elements. Let's put a simple graphic onstage and see how Rulers can help us to work more efficiently.

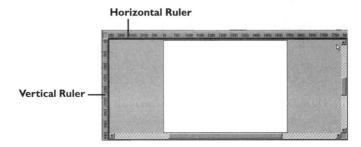

- a) Select the Menu option File / New.
- b) Select the Menu option View / Rulers.
- c) Select the **Oval Tool** from the Toolbox. Without clicking, move the cursor around the desktop. Notice how the Horizontal and Vertical Rulers track the position of the cursor with a black line.
- d) Since the **Oval Tool** is selected, let's **draw** a simple **oval** anywhere on Stage.
- e) Select the Arrow Tool from the Toolbox and double-click the oval you just drew. Just to avoid any potential accidents, select the Menu option Modify / Group.
- f) With the Arrow Tool still selected, click and drag the oval around the Stage. Each Ruler now has two lines that track the position of the active object. The Vertical Ruler on the left of the Stage tracks the top and bottom edges of the object, while the lines in the Horizontal Ruler track the left and right edges of the object. With the use of this function, we can very precisely position graphics and text on Stage.
- g) To change the unit of measurement used by the Rulers, select the Menu option Modify / Movie and then change the unit in Ruler Units. See Figure 9-22.

Shortcut

The Keyboard Shortcut for turning Rulers on and off is:

PC – Ctrl & Alt & Shift & R

Mac – Option & Shift & Cmd & R

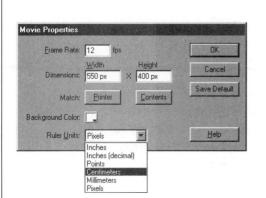

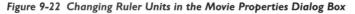

- h) To hide the Rulers, simply choose **View / Rulers** from the Menu once again (this option acts like an on/off switch).
- Another benefit of the Rulers is using them to create Guides. Guides are of great value if you would like to establish boundaries for your artwork. Let's take a look at using Guides.

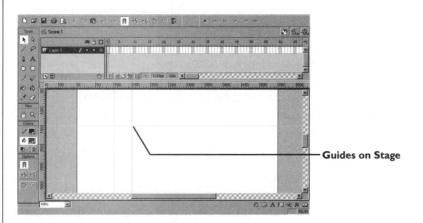

- a) Your Rulers must be visible in order to create a Guide. If your Rulers are not visible, select the Menu option View / Rulers. The Rulers will track the Vertical or Horizontal position of the Guide, depending on whether it is a Vertical or Horizontal Guide.
- b) Click on the Vertical Ruler and drag a Vertical Guide on to the Stage.
- c) **Release** the **Mouse** to place this Guide.
- d) **Click on** the **Horizontal Ruler** and **drag** a **Horizontal Guide** on to the Stage.

Shortcut

The Keyboard Shortcut for turning Guides on and off is: PC – Ctrl & ;

Mac - Cmd & ;

- e) **Release** the **Mouse** to place this Guide.
- f) Once you have dropped a Guide in place you can reposition it by placing your cursor over the Guide and then click and drag the Guide to a new position.Try it!
- g) Using your **Arrow Tool**, **drag** the **oval** you created earlier and position its **top** and **left edges** with your Guides.
- h) There are also a number of options available for Guides. They are accessed by selecting the Menu option View / Guides / Edit Guides. Here is an overview of the choices:

Guide Color – changes the color of the Guides (a blue Guide does you no good against a blue Stage...you have to see it to use it).

Show Guides – toggles Guide visibility. You can temporarily hide the Guides if you want them out of the way for a moment, but aren't ready to clear them for good. Show Guides is also available by selecting the Menu option View / Guides / Show Guides.

Snap to Guides – will "snap" your artwork to line up with the Guides you have placed on the Stage. This allows for accurate positioning of your artwork. Snap to Guides is also available by selecting the Menu option **View / Guides / Snap to Guides.** Try aligning your oval with the Guides while this option is active and watch how it will "snap" to the Guides.

Lock Guides – is of utmost importance once you have placed your Guides and want to avoid accidental repositioning. This command "freezes" your Guides in place so they are no longer affected by the mouse. Lock Guides is also available by selecting the Menu option **View / Guides / Lock Guides**.

Snap Accuracy – allows you to control how much "pull" the Guides have when the Snap to Guides option is in effect. You essentially control how close the selected Object must be to the Guide before it will "snap" to it (Close, Normal or Distant).

Clear All – is the one-step method of getting rid of all Guides on the Stage.

3. The Grid is another option available to help you align and orient artwork on the Stage. It is essentially an interwoven series of guides that form an intersecting pattern of horizontal and vertical lines that cannot be adjusted individually, only together as a unit.

	A	8	2	1					+5 +(0	*7 C* N		Scene 1	
	141	65	00	55	15 50	40	0 35	20 25	10 15		2		R [
	-	1111									1	Layer 1	P
													A
	E								and and the second				
		<u></u>	2222	Loso I	22223	2.2.2	1000	ps 0.0r 4	and some			9 😰 0 150	2
			1. 1. 1. 1.	Sou	450	- Labor	350	250 3	150 200	0	0	0	10 1
	3					11							0
	8		198			-							-
	8		-	+++		++-				++++			Q.
	8			_									iors
													199.
-Grid on Stage	2												ions
Grid on Stage	2		100						1111				Inne
	2				_					_			+{

Figure 9-24 The Grid on the Stage

 a) As with the Guides, there are also a number of options available for the Grid. They are accessed by selecting the Menu option View / Grid / Edit Grid. Here is an overview of your choices:

Grid Color – changes the color of the Grid (a blue Grid does you no good against a blue Stage...you have to see it to use it).

Show Grid – toggles Grid visibility. You can temporarily hide the Grid if you want it out of the way. Show Grid is also available by selecting the Menu option **View / Grid / Show Grid.**

Snap to Grid – will "snap" your artwork to the Grid when it is visible on the Stage. This allows for accurate positioning of your artwork. Snap to Grid is also available by choosing **View / Guides / Snap to Grid** from the Menu. Try aligning your oval to the Grid while this option is active and watch how it will "snap" to the Grid.

Horizontal and **Vertical Gap** – increments can be set in their respective fields. The unit of measurement is dependent upon the Ruler Units setting. Ruler Units are changed in the Movie Properties Dialog Box and are accessed by selecting the Menu option **Modify / Movie**.

Snap Accuracy – allows you to control the "snapping power" of the Grid when the Snap to Grid option is in effect. With this option, you can control how close the selected object must be to the Grid before it will "snap" to it (Close, Normal, Distant or Always).

- b) Use the oval we created earlier to try out these Grid options.
- 4. The Info Window provides a few more options for the placement and manipulation of text and graphics, as well as a wealth of information concerning cursor position and graphic elements. You will be able to use the Info Window to help you with precise movements during the animation process.

Shortcut

The Keyboard Shortcut for turning the Grid on and off is:

PC – Ctrl & '

Text and Layout Tools

Mac - Cmd & '

-				 	
С	ч	Δ	\mathbf{P}	- R	Q
\sim				 . IN	

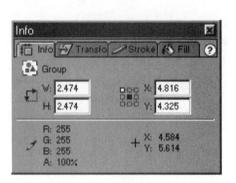

Figure 9-25 The Info Window and Attributes

- a) Go ahead and open the Info Window by selecting the Menu option Window / Panels / Info.
- b) With the Info Window visible, select the oval on Stage. The Info Window becomes active for the selected object (in this case, the oval).
- c) Change the size of the oval by typing-in new numbers into the Width and Height Fields. Their unit of measurement is dependent upon the Ruler Units setting. (Ruler Units are changed in the Movie Properties Dialog Box and are accessed by selecting the Menu option Modify / Movie.)
- d) Change the position of the oval by typing-in new numbers into the X Location and Y Location Fields. Their unit of measurement is dependent upon the Ruler Units setting. (Ruler Units are changed in the Movie Properties Dialog Box and are accessed by selecting the Menu option Modify / Movie.) An additional feature of these fields is that you can specify whether you change position relative to the center of the object or to the top-left of the object. This is achieved by clicking the appropriate icon adjacent to the X Location and Y Location Fields.
- e) With the **oval selected**, select the Menu option **Modify** / **Break** Apart.
- f) Select the Menu option Edit / Deselect All.
- g) Place your cursor over the center of the oval. The Info Window gives you the color value of the Fill, as well as the position of the cursor.
- h) We are finished here. Save your work only if you want to.

Summary

- The characteristics of standard text in Flash are very different from the standard text found on most Web pages written with HTML. Flash provides the appearance, characteristics and control of text similar to that found in a page layout program because of the degree of precise control you have over a variety of text characteristics.
- Flash allows control over typical attributes such as font, font size, text alignment and styles such as bold and italic.
- The Paragraph Window also gives you control over typographic elements such as leading (the space between lines of text); left and right paragraph margins; and line indentation. Additionally, Kerning provides control of the space between letters.
- There are two general types of text fields that you can create in Flash Static Text Fields and Editable Text Fields.
- The Text Options Panel allows you to set many parameters for the text boxes that you insert into your Flash document.
- · Flash allows you to format your text using standard HTML tags.
- Text in Flash can also be converted and then treated as a graphic element.
- In the first Practice Exercise you saw how you can copy and paste text from an external file; create your own text within Flash; change font characteristics; and use the Resizing Handle to create Single-line or Paragraph text.
- In the next Guided Tour, you saw how you can use the Modify / Break Apart menu option to covert text into a graphic object that can then be modified and distorted using the drawing tools.
- The View Menu contains four options that control the display quality of objects on the screen, including text. The View Menu allows you to change these display qualities so that as you are working on items, they can be displayed in a form that is more effective for you at the moment.
- The Info Window gives you basic information about selected objects on the Stage of your Movie. You can use this window to view the dimensions of an object, to change the dimensions of an object, and to see a preview of the object. The Info Window can also be used for controlling placement of objects on the Stage.
- The last Guided Tour showed you how you can use Rulers, Guides, and Grids to help gain more precise control over the placement of objects on the Stage.

PTER

Symbols, Instances, and Libraries

0

Chapter Topics:

- Introduction
- Guided Tour Exploring the Library
- Symbols
- Symbols and Behaviors
- Symbol Editing Mode
- Practice Exercise Creating and Editing Symbols
- Practice Exercise Modifying Instances of a Symbol
- Guided Tour Font Symbols
- Summary

Introduction

The Flash Library functions somewhat like an electronic library where we can check out copies of objects. Instead of books, Flash's Library is a place where an original object is stored, allowing a "reference-copy" to be "checked-out" and placed in different Frames of the Timeline. The object really only physically exists in one place – in the Library. Each time the object is placed and appears in the Timeline, it is called an Instance and it actually only references (and re-uses) the original object stored in the Library. In this way, Library objects can be re-used many times, helping the development process become much more efficient, organized and streamlined. The use of the Library also significantly reduces file size and improves performance. By the end of this chapter you will be well on your way to creating more complex Flash Movies by taking advantage of Symbols and Instances.

By the end of this chapter you will be able to:

- briefly describe the purpose and structure of the Library.
- add Symbols to the Library.
- use the Common Libraries in Flash.
- · create and modify Symbols.
- briefly describe all three Symbol behaviors.
- define an Instance of a Symbol.
- · modify an Instance of Symbol.

Guided Tour – Exploring the Library

The Library is a general storage area for media elements that are used in your Flash Movies. The Library is mainly used for storing specialized elements called Symbols, the function and purpose of which will be discussed in detail later in this chapter. In short, Symbols are objects created in Flash that are added to the Library and designated with different behaviors. There are three main types of Symbols – Movie Clips, Graphics, and Buttons. Each one of these Symbols has certain characteristics and behaviors that dictate how these Symbols operate, what they can do, and how they should be used in your Movie Timeline. While Symbols are the most common media element stored in the Flash Library, they aren't the only objects stored there. Other items like bitmaps and sound files that have been imported into Flash are also automatically added to the Library.

The purpose of the Library goes way beyond the storage and organization of elements in your Movies, although these are helpful features of the Library. In Flash, the Library also plays an important role in the efficient functioning of your Flash Movie. Once a Symbol is stored in the Library, it can be used over and over again in the Frames of your Movie. Each time an Instance of the Symbol appears in the Timeline, it actually references (and re-uses) the original object stored in the Library. By referencing Library objects – instead of creating a new object for each Frame – the file size is kept far smaller and the download performance is significantly improved.

Let's take a quick tour of the Library to understand it more completely.

- I. We'll start by opening the Library.
 - a) Select the Menu option Window / Library.
 - b) If you have a blank document open and have not added anything to your Library, your Library will look like the empty Library illustrated in Figure 10-1.

Figure 10-1 An Empty Library

- Notice that the Library is divided into two areas, the Preview Area (the gray area at the top of the Library), and the File List (white area) that shows the Name, Kind, Use Count, Linkage, and Date Modified of the Symbol stored in the Library.
- 3. Here is some useful background information.
 - a) Every new Flash file has an empty Library associated with it. As you build your Movie you can create new graphics or import existing graphics and place them in the Library.
 - b) You can open Libraries you've already created and re-use these objects in your new Movie.
 - c) You can include Symbols in a shared Library and link to items in the shared Library from any Flash Movie.

Shortcut

The Keyboard Shortcut for Window / Library is: PC – Ctrl & L Mac – Cmd & L

In order to see all the columns of information available to you in the Library (Name, Kind, Use Count, Linkage, and Date Modified), you may need to scroll (to the left or right) to make your Library window larger.

- d) You can create Font Symbols in Flash that serve much like what other programs call "styles."
- e) Once you export your Flash Movie, the Library will be exported as well.
- f) As mentioned earlier, keeping objects in the Library helps to keep the file size down. Using the Library can also help you keep organized. You can set up folders within the Library to keep different types of Symbols used in your Movie separate from each other. These folders are similar to the folders you use on your computer's hard drive. They can be named and organized in any way, and can also be nested inside of one another.
- 4. Let's create a new Folder within the Library.
 - a) Click on the New Folder Icon on the bottom left edge of the Library Window to insert a new Folder, as illustrated in Figure 10-2.

Figure 10-2 Inserting a New Folder

- b) Notice that there are several icons found on the bottom border of the Library Window. We will go over each of these in a minute.
- 5. The display of Folders can be expanded or collapsed by double-clicking on a Folder lcon in the file list. Figure 10-3 shows an example of a Library with multiple Folders. One of these folder has been expanded to show the Symbols (sound files) it contains.

Symbols, Instances, and Libraries

Figure 10-3 A Library with Multiple Folders and One Expanded

- 6. Symbols can be added to the Library by using different methods.
 - Symbols are easily added into a Folder just by dragging and dropping them on top of the Folder.
 - b) Symbols are easily added to the Library by clicking on the New Symbol Icon.
 - c) Folders and Symbols can also be added by using the Options pull-down menu located on the upper right hand corner of the Library Window. (See Figure 10-3.) Click on this menu and then select New Symbol. The Option menu gives you a list of options that can be used to control the way your Library Symbols and Folders behave. Among some of these options are: Edit, Delete, Duplicate and Rename Symbols.
- 7. Let's look at the other Library Window Icons.
 - a) The Trash Can Icon as illustrated in Figure 10-4, allows you to delete Symbols and entire Folders from the Library. Just highlight the item you want to discard and click on the Trash Can. You can also delete Symbols and Folders using the Options menu.

CAUTION

An important thing to remember about deleting Symbols is that this action can NOT be reversed using the Undo command. Think twice before deleting.

4

- b) The Info Icon (See Figure 10-4.) By clicking on this Icon (which looks like a lower case *i*) you can look at or change the properties of each Symbol in your Library. When you highlight a Symbol in the Library and click on the Info Icon, the Symbol Properties dialog window appears. This window allows you to either designate what kind of Symbol you want to add to the Library or change a Symbol's properties.
- 8. And now a word about Common Libraries. Most Libraries you use in Flash will probably be built from original objects you created for yourself in each Movie, however, Flash also has some built-in Libraries that can be used as media resources.
 - a) Select the Menu option **Window** / **Common Libraries** to view the different types of Common Libraries available.
 - b) Select the Menu option Window / Common Libraries / Movie Clips.
 - c) A new Library window will appear on your screen. Highlight one of the Movie Clips in the File List and notice that a preview of this Movie clip appears in the Preview area above the File List.
- Later in this chapter, you will learn more about the different types of Symbols that can be stored in the Library.

Symbols

In Chapter 4 you learned that the graphics created in Flash are vector graphics. Just to refresh your memory, one of the benefits of vector graphics is that they tend to have smaller file sizes and usually perform faster (write-to-screen time) than their bitmap cousins. This is because the information in a vector graphic only contains the object's path (outline), rather than large amounts of data describing each individual pixel. As any Web user knows, the smaller and more efficient the file size, the quicker it downloads over the Internet.

Streaming Media

Streaming media is a term that is often used lately in relation to Internet technology, especially referring to large files containing multimedia (video and audio). With traditional file downloading procedures, the entire file must be downloaded before it can be accessed or played. With very large files, this is a very long process and tends to rapidly discourage many Internet users.

With streaming technology, instead of waiting for the entire file to download, you can view/hear the media as it is downloaded "in chunks." As soon as enough data gets through the Internet pipeline with a streamed file, it immediately starts playing and continues to download the rest of the information in the background as you watch.

·T/P

This process is not always seamless, as anyone who has viewed streaming video or audio with QuickTime or RealPlayer knows. Occasionally, you get pauses when Internet traffic is heavy, if you have a slow connection, or if you have a slow internal processor.

Using Symbols

Flash also has another way of keeping files sizes smaller by using Symbols. Symbols are one of the primary reasons why Web sites and applications built with Flash are such efficient examples of streaming media. A Symbol is like an electronic "original" file stored in the Library that can be copied and placed on the Timeline anywhere and as many times as you wish. Each copy of the Symbol on the Timeline is called an **Instance** and is linked to the original Symbol stored in the Library. As we mentioned earlier in this chapter, the Library is a media storage area where these "original" objects or Symbols are kept. Symbols stored in the Library carry the bulk of the file size, while the Instances (copies) of the Symbols add only a negligible amount to your file size. Symbols also have predefined behaviors. There are three types of Symbols – Movie Clips, Buttons, and Graphics. You will learn more about the characteristics of each of these shortly.

Using Symbols is a fundamental step in creating efficiently built Flash projects. In contrast to Flash's streamed delivery, you probably have waited for other types of pages to load into your browser window, watching items appear oneby-one on the screen as they download. Frequently graphics placed on a Web page will be represented on the page by image placeholders until they are completely downloaded from the server. See Figure 10-5.

Figure 10-5 An Image Placeholder

Using Symbols from the Library

The Library acts as storage for graphics, buttons, animation, sound, fonts, imported bitmaps and other media elements that you will use in your Flash Movie. As you continue the development of your Movie, you will place copies of these Symbols in different Frames in the Movie Timeline.

As you browse through different Web pages, you may have noticed that when you go back to pages that you have already viewed, the download time is typically shorter. That's because most browsers temporarily store pages that have been previously viewed. This cache, or temporary storage, is purged periodically when it reaches a certain size. In Netscape and Internet Explorer the user can customize the cache settings and set up the parameters for when the cache should be purged or updated.

Placing Symbols on the Stage from the Library is Easy

Highlight the Symbol you would like to use, and drag the icon next to the file name from the Library window directly onto the Stage.

or

Drag-and-drop the Symbol from the Preview area of the Library directly onto the Stage.

Let's work with one of the Movie Clips from the Common Library.

- I. First open the Common Library.
 - a) Select the Menu option Window / Common Libraries / Movie Clips.
 - b) Drag any one of the Movie Clips onto the Stage.
 - c) Once the Movie Clip is added to the Stage, select the menu option Window / Library to open the Library associated with this Movie, if you don't already have it open.
- ? You can tell which Library holongs to the current Movie because of the name found at the top of the Library Panel. Notice that the Movie Clip you just inserted from Flash's Common Library has been automatically added to the current Movie's Library.

Instances

·T/P·

182

An Instance is a copy of a Symbol that has been dragged from the Library and placed in the Movie Timeline. Every time you drag a Symbol from the Library to the Stage you have created a new Instance (copy) of that Symbol. If you reuse a Symbol frequently, you will have multiple Instances of that Symbol in your Movie Timeline. In the Library, you can keep track of how many Instances of a Symbol you have in your Movie by looking at the column titled **Use Count** in the Library Window. See Figure 10-6.

Library - Moviel ount Lin Clock Pencil Graphic Mouse Graphic Push Button Green Button 2 Push Button Red Button Push Button Yellow Button x Part-Clock Face Graphic x Part-Clock Pencil Graphic

Figure 10-6 The Use Count Column in the Library

Use Count Column

Although the elements in the Common Libraries can be used in any of your Movies, after a Symbol has been placed on Stage, this object is stored in the current Movie's Library. The relationship between a Symbol and its Instances is analogous to printing multiple photographs from a single positive transparency. The original transparency contains all the information needed to print a photograph. Each print is basically a copy of the information stored on the transparency.

Whenever the Playhead encounters an Instance ("print") in the Timeline, Flash always refers to the Symbol ("transparency") stored in the Library. The fact that the Library stores the single original becomes especially handy if you decide to change a Symbol. If you edit the Symbol stored in the Library ("the transparency"), Flash will automatically update each Instance (replace each "print" based on the updated "transparency") – throughout your entire Movie, to reflect the changes you made. In this case you are actually changing the original or "transparency" in the Library.

But what if you want to make a small change to a particular Instance of a Symbol (change a particular "print") without affecting the image in the Library? For example: Let's say you have a Symbol ("transparency") of a medium-sized, red circle stored in your Library. What if you want one Instance of this circle ("a print") to be blue instead of red, and the size reduced 50%. Does this mean you have to create an entirely new Symbol? The answer is no!

Let's go a little further with our transparency and print analogy. In the darkroom, we can overexpose / underexpose a particular print; use special filters; or reduce / increase the image size during the printing process to alter the way a particular print will look. You can apply all these special effects without altering the original transparency.

In Flash, you can also apply effects that change the look of a particular Instance, without affecting the Symbol stored in the Library. Symbols are so flexible that you can make cosmetic modifications to an Instance of a Symbol and still maintain the link between that particular Instance and the original Symbol in the Library. In a Practice Exercise later in this chapter, you will get hands-on experience doing this, as you modify an Instance of a Symbol that you will create.

Symbols and Behaviors

There are three types of Symbols that can be stored in a Library: Movie Clips, Buttons and Graphics. Each Symbol is represented in the Library by a different icon, as you will see in the following pages. The name of each Symbol type is important because it is descriptive of the behaviors that are attributed to each type of Symbol.

Movie Clips

Movie Clips are mini-Movies that are stored as Symbols in the Library. See Figure 10-7. Movie Clips are perhaps the most versatile type of Symbol and are frequently used by Flash developers. Movie Clips have their own Timeline that is independent from the Timeline of the main Movie. This means you can have animations that are not tied to the main Movie's Timeline. As the name implies, adding a Movie Clip to the Timeline of your main Movie is like making a **Movie**within-a-Movie, or nesting a Movie Clip within the Timeline.

Name	à
🐹 Sailing	
	0
	-
	×

Figure 10-7 The Movie Clip Icon in the Library

Anytime a Symbol in a Library contains more than one Frame, a Play and Stop Button will appear in the upper right corner of the Preview Window. See Figure 10-8. If you click on this Play Button in the Preview Window, you will be able to view all the Frames of that Movie Clip (or Button or Graphic Symbol). This button will also appear with and will allow you to play through the Frames within Button Symbols, Graphic Symbols, or Sounds that are stored in the Library.

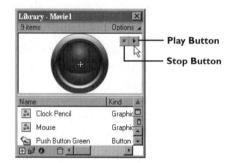

Movie Clips Share These General Characteristics

- Movie Clips have their own Timeline that is completely independent of the main Movie Timeline.
- Movie Clips are mini-Movies that can have any of the features that you might include within a "main" Movie created in Flash.
- An Instance of a Movie Clip can include interactivity.
- Movie Clips can be nested inside other Symbols.

184

Guided Tour – Movie Clips

Let's set up a Movie Clip and add it to the Library.

- 1. Open the Library by selecting the Menu option Window / Library.
- Click on the New Symbol Icon (looks like a plus sign) at the lower left corner of the Library. Review the Library Icons illustrated in Figures 10-2, 10-3, and 10-4 if you need to.
- The Symbol Properties Window has now opened. Select the radio button next to Movie Clip and in the Name field, type in ... My Movie Clip. Click OK.
- Take a look at your Library. You have just added a new Movie Clip Symbol to the Library! See Figure 10-9. When you click on the My Movie Clip Symbol in the Library List, there is no preview because it's an empty Symbol.

Figure 10-9 My Movie Clip Symbol Added to the Library

Smart Clips

New to Flash 5 are Symbols called Smart Clips. Smart Clips are Movie Clips with Clip Parameters assigned to them. Clip Parameters allow you to customize Actions that are pre-defined within a Smart Clip. ActionScript is Flash's "programming / scripting" language. Actions are "pre-written" chunks of ActionScript that perform specific functions. (We will formally introduce ActionScripts and go into much more detail in Chapter 16.)

Instead of writing the script yourself, you can customize a "Smart" Clip that already contains a particular behavior, almost like a "template." Smart Clips are

You can easily change the behavior associated with a Symbol after it has been added to the Library. In the Library Window, click on the Properties Icon (the *i* Icon), then click on the appropriate radio button in the Symbol Properties Window. often used as re-useable interface elements, such as drop down menus with Clip Parameters that can be easily changed based on your particular application. Flash 5 comes with a Smart Clip Library that can be opened by selecting the Menu option **Window / Common Libraries / Smart Clips.** While we call Smart Clips Symbols (they are similar to Movie Clips), they are actually a specialized type of Symbol. You will work with Smart Clips in a later chapter.

Button Symbols

Button Symbols are a fast and easy way to create re-usable buttons in your Movies. When you add a Button to the Library, the Button Timeline automatically has only four Frames. This is very different from the Timeline for both the Graphic Symbol and Movie Clip Symbol. The button's four Frames are labeled **Up**, **Over**, **Down**, and **Hit** and they correspond to four different mouse actions, or **Button States.** For example, when your mouse moves **Over** an Instance of a Button Symbol it would show the contents of the **Over Frame** and would play any associated sounds. **Up** – corresponds to the normal Up Position of a button; **Down** – to the normal Down Position of a button when pressed; and **Hit** – the "target" or "hot spot" area that is activated by the mouse action.

Button Symbols Share These General Characteristics

- ActionScripts can be attached to Button Instances to control the Instance's behavior.
- Sounds can be added to different Button States (you can hear a "click" as a button is depressed).
- Movie Clips can be nested in Button Frames to animate the button (it will have animation associated with a mouse action).
- The Hit Frame is an invisible Frame that defines the Button's "hot area," or the area that responds to mouse activity.

Name	<u>#</u>
Red Button	
	*
	×
· · · · ·	•

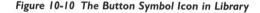

Guided Tour – Button Symbols

Let's set up a Button Symbol and add it to the Library.

186

- Open the Library by selecting the Menu option Window / Library. (It may already be open.)
- 2. Click on the New Symbol Icon at the bottom of the Library.
- 3. The Symbol Properties window has now opened. **Select** the **radio button** next to **Button** and in the **Name field**, **type in**...**My Button**. Click **OK**.
- 4. Take a look at your Library. You have just added a new Button Symbol to the Library along with the My Movie Clip Symbol you created earlier! See Figure 10-11. When you click on the My Button Symbol in the Library List, there is no preview because it's an empty Symbol. We will add objects to these Symbols in later exercises.

Figure 10-11 My Button Symbol Added to the Library

Graphic Symbols

Graphic Symbols can consist of either static images or simple animations that are re-used throughout a Movie. An example might be something like a company logo that is re-used frequently, but Graphic Symbols are generally not used for lengthy animations (this is what Movie Clip Symbols are for).

Graphic Symbols Share These General Characteristics

- The Graphic Symbol Timeline is dependent on the main Movie Timeline and will not play beyond the end of the main Movie, unlike Movie Clips.
- ActionScripts do not work within a Graphic Symbol Timeline.
- Sounds on the Graphic Symbol Timeline cannot be activated from the main Movie Timeline.

·T/P·

Guided Tour – Graphic Symbols

Let's add a Graphic Symbol to our list in the Library.

- 1. Open the Library by selecting the Menu option **Window / Library.** (It may already be open.)
- 2. Click on the New Symbol Icon at the bottom of the Library.
- The Symbol Properties Window has now opened. Select the radio button next to Graphic and in the Name field, type in ... My Graphic. Click OK.
- 4. Take a look at your Library.You have just added a new Graphic Symbol to the Library along with the My Button and My Movie Clip Symbols! See Figure 10-13.When you click on the My Graphic Symbol in the Library List, there is no preview because it's an empty Symbol.

Figure 10-13 My Graphic Symbol Added to the Library

Symbol Editing Mode

Once you create a Symbol, you can take full advantage of a unique editing mode that allows you to modify and make global changes to every Instance of

Once you have added a lot of Symbols to your Library, you might want to create some Folders to organize the Symbols into categories. Select the Folder Icon in the Library Window and then give your Folder a new name. You can now drag Symbols on top of the folder to put them inside. Click on the Folder to expand or collapse the Symbol list.

41

a particular Symbol in your Movie. Since Movie Clips, Graphic Symbols, and Button Symbols have their own Timelines, using the Symbol Editing Mode opens a new Stage and a new Timeline, devoted strictly to the selected Symbol.

In an earlier chapter, you worked with another alternate editing mode – the Group Editing Mode. The Symbol Editing Mode is very similar in concept. The difference is that when you are working with Symbols, you actually open a new Stage and a new Timeline.

What is often confusing to novice Flash users is that the Symbol Editing Mode looks very much like the main Movie Stage and Timeline. The Timeline, Stage, Panels and Tools – are all available for use in the Symbol Editing Mode, just as they are in the main Movie. It's easy to lose your bearings. The best way to tell whether or not you are in the Symbol Editing Mode is to look above the Timeline, at the Tabs. If you are in the main Movie Timeline, the only Tab visible will be a Scene Tab, even if you have more than one Scene in your Movie. If you are in the Symbol Editing Mode, you will see a Tab with the name of the Symbol and the icon to match the Symbol Behavior: Movie Clip, Graphic, or Button. See the Figure 10-14.

Symbol Editing Mode Tab

Figure 10-14 The Symbol Editing Mode Tab - for Circle

Exiting the Symbol Editing Mode is easy, just click on the Scene I Tab to return to your main Movie.

Practice Exercise – Creating and Editing Symbols

Description

In this exercise you will see how to add and modify Symbols in your Library. You will then convert existing graphics to Symbols.

In this exercise you will:

Add a Symbol to the Library.

CAUTION

It is easy for new Flash users to lose their bearings and confuse the Symbol Editing Mode with the main Movie Stage and Timeline. Our suggestion – pay attention to the tabs that appear above the Timeline. These tabs will help orient you as to what Mode you are in. Go Solo

- · Edit a Symbol.
- · Rename a Symbol.
- Detach an Instance from a Symbol.

Take-a-Look

Before beginning the exercise, let's take a look at the exercise in its completed state so that you can clearly see what it is that you are about to build.

- Use the Menu option File / Open and locate on the CD-ROM the folder named Chapter 10. Locate the file named Lesson 10.fla. Double-click on Lesson 10.fla to open the file.
- 2. The **Lesson10.fla** file should now appear in your copy of Flash. Take a look around.

Please note the following properties of this completed exercise:

- a) Symbols are stored in a Library.
- b) Instances of a Symbol are what we work with on the Stage.
- c) Changes to a Symbol in the Library are updated in all of its Instances.
- d) Instances can be detached from Symbols in the Library.

Storyboard: On-Screen

Figure 10-15 shows you how the Stage will look once you've finished this exercise.

Figure 10-15 The Completed Stage

Storyboard: Behind-the-Scene

Figure 10-16 shows you what the Library looks like after you've added Symbols to it.

190

Symbols, Instances, and Libraries

Figure 10-16 The Library

Step-by-Step Instructions:

- I. Let's see how to add a Symbol to the Library.
 - a) First create a new file by selecting the Menu option File / New.
 - b) In the **Toolbox**, select the **Circle Tool**. Change the **Fill** to **blue** and the **Stroke** to **none**.
 - c) Draw a medium-sized circle anywhere on the Stage.
 - d) Make sure your Library is open by selecting the Menu Option
 Window / Library.
 - e) Select the circle and then select the Menu option Insert / Convert to Symbol.
 - f) The Symbol Properties Dialog Window now appears. Click to select the Radio Button next to Graphic. Type in a new name for your Symbol ... Blue Circle. Click OK.
 - g) You've just added a Symbol to the Library! Click on the Blue Circle Symbol in your Library to see a preview of the Symbol. Your Library should now look similar to Figure 10-17.

Figure 10-17 Movie Library with Blue Circle Symbol

Go Solo To make a perfect circle, hold down the Shift Key as you draw. Shortcut The Keyboard Shortcut for Convert to Symbol is: PC & Mac - F8. You can drag Symbols from the Library by clicking and dragging the icon next to the name in the Symbol List, or by dragging the object from the Library's Preview Window.

Shortcut

The Keyboard Shortcut for opening the Library Options Menu is:

PC – Right Click on the Symbol

Mac – Ctrl & Click on the Symbol

·T/P·

The crosshair that appears in the middle of the Symbol marks the center point of the Symbol.

- 2. Now that we've added a Symbol, let's add another Instance of this Symbol to the Stage.
 - a) Select the Blue Circle Symbol in the Library.
 - b) Click and drag the Blue Circle Symbol from the Library onto the Stage. You now have two Instances of the same Symbol. The first Instance is the circle you converted into a Symbol. The second Instance is the circle you dragged onto the Stage from the Library. In the next exercise you will learn how to modify the Instances of these Symbols individually.
- 3. Let's edit the Symbol in the Library using the Symbol Editing Mode.
 - a) Using the **Library Options Menu** (located in the upper right corner of the Library Window), **select Edit** from the list.
 - b) You have now entered Symbol Editing Mode. Notice that the other Instance of this Symbol has disappeared from view and a Tab labeled Blue Circle with the Graphic Symbol Icon has been added above the Timeline. See Figure 10-18.

Figure 10-18 Symbol Editing Mode Tab - Blue Circle

- c) If your circle is selected, **deselect** it by clicking on the **Arrow Tool** and **click anywhere** in the white space outside the circle.
- d) Let's now change the shape of the circle by first selecting the Arrow Tool. Now click and drag the edge of the circle inward to form a crescent shape. See Figure 10-19.

Remember, when you hold the Arrow Tool over the edge of the circle, you will see a semi-circle appear next to the arrow cursor. This means you can now alter the shape of a curve. See the cursor in Figure 10-19.

·T/P

- e) After changing the shape of the circle, select the **Paint Bucket Tool** and change the **Fill Modifier** to **Yellow. Click inside** the **crescent shape** to fill it with the Yellow color.
- f) Now let's exit Symbol Editing Mode and return to the main Movie Stage and Timeline – click on the Scene I Tab at the top left of the Timeline to return to the main Stage.
- 4. Take a look at the changes that have been made to the Symbols on your Stage! Imagine if you had a Symbol that was used many times throughout a Movie. Using the Symbol Editing Mode, it's a snap to globally change each Instance of a Symbol by editing the Symbol in the Library.
- 5. Now that you've learned to edit a Symbol, let's rename it in the Library.
 - a) Select the Blue Circle Symbol in the Library.
 - b) Double-click on the Blue Circle text. A blinking cursor will appear. See Figure 10-20.

Figure 10-20 Renaming a Symbol in Library

- c) Type in the name ... Yellow Crescent ... in place of Blue Circle.
- d) Press the **Enter/Return Key** to complete the renaming of the Symbol.
- 6. Let's make a copy of this Symbol. Symbols can be duplicated in the Library so that you don't have to re-create objects with similar shapes.
 - a) Select Yellow Crescent in the Library.
 - b) From the Library Options Menu, choose Duplicate.
 - c) The Symbol Properties Dialog Window now appears. See Figure 10-21. Change the name of the Symbol to . . . Green Crescent and click OK.

Symbol Prope	rties	X
Name:	Green Crescent	ОК
<u>B</u> ehavior:	Movie Elip Button	Cancel
	• Graphic	Help

Figure 10-21 The Symbol Properties Dialog Window

- d) Enter the Symbol Editing Mode by **double-clicking** on the **Graphic** Symbol Icon next to the **Green Crescent Symbol** in the Library.
- e) With the **Green Crescent selected**, change the **Fill Modifier** in the Toolbox to a **medium Green**. This will automatically change the color as long as an object is selected.
- f) Exit Symbol Editing Mode by clicking on the Scene I Tab above the Timeline.
- g) Drag a copy of the Green Crescent Symbol to the Stage.
- 7. Now that you've learned to edit a Symbol, let's see how to detach an Instance of a Symbol from the symbol in the Library so that it is protected from any further editing and so that it becomes an independent graphic.
 - a) Select a copy of the Yellow Crescent that is already on your Stage. If you've deleted all of your Yellow Crescents, add a few to the Stage from the Library.
 - b) Select the Menu option Window / Panels / Info to open the Info Panel. See Figure 10-22. The Info Panel gives you information about items that are selected on the Stage such width and height, X and Y coordinates (location) of an object on the screen, RGB values (with ungrouped objects), and cursor coordinates (location).

Info		X
fi Info		?
Yellow Crescent		
€ ^{₩:} 114.5 H: 114.2	HOO X: 131.4	
H: 114.2	666 Y: 120.3	J
R: 255	% 472.0	
G: 255 B: 255	+ ^{%:} 472.0 Y: 326.0	
A: 100%		

Figure 10-22 The Info Panel

c) With the Yellow Crescent selected, take a look at the information in the Info Panel. Notice that the Info Panel now identifies the Symbol name as Yellow Crescent and uses the Graphic Symbol Icon to iden-

CHAPTER 10

Symbols, Instances, and Libraries

tify the Symbol Behavior. It also gives the dimensions and position of the Symbol on the screen.

- d) To detach this Instance of the Yellow Crescent from the Symbol in the Library, select the Menu option Modify / Break Apart. As you do this, keep an eye on the Info Panel. Once the option is applied, the name Yellow Crescent and the Graphic Symbol icon disappear. Now that you have broken the Symbol apart, it is no longer attached to the Symbol in the Library.
- e) Select another Yellow Crescent Symbol on the Stage. Double-click on this Symbol on the Stage to enter the Symbol Editing Mode.
- f) Select the crescent, and choose the Scale Modifier from the Toolbox. See Figure 10-23.

Figure 10-23 The Scale Modifier in the Toolbox

- g) To scale the crescent without distorting the shape, hold down Shift Key and drag one of the handles around the crescent inward to make the Symbol approximately 50% smaller.
- h) Exit the Symbol Editing Mode by clicking the Scene I Tab above the Timeline. Each Instance of the Yellow Crescent that is still linked to the Symbol in the Library is now 50% smaller, except the crescent where we used the Modify / Break Apart option to detach it from the Symbol in the Library.
- 8. There is no need to save this exercise unless you want to (and in this case, make sure to save it into the SaveWork Folder on your computer).

Practice Exercise – Modifying Instances of a Symbol

Description

We will continue in this exercise to see how we can modify an Instance of a Symbol in other ways.

In this exercise you will:

If you would like a particular Instance in the Timeline to remain independent of any future changes that might be made to the Symbol from which it originated, you can detach this Instance from the Symbol by selecting it and then choosing the Menu option Modify / Break Apart.

Shortcut

The Break Apart Keyboard Shortcut is: PC – Ctrl & B Mac – Cmd & B

•**T**/P·

You can also use the Transform Panel (Window / Panels / Transform) to Scale an object. The benefit of using the Transform Panel is that you can scale an object proportionally using a percentage. You can also Rotate and Skew an object.

- Modify an Instance of a Symbol.
- · Make changes using the Brightness, Alpha, and Tint options.

Take-a-Look

Before beginning the exercise, let's take a look at the exercise in its completed state so that you can clearly see what it is that you are about to build.

CD-ROM

- Use the Menu option File / Open and locate the Chapter 10 folder on the CD-ROM. Find the file named Lesson10_instance.fla. Doubleclick on Lesson10_instance.fla to open the file.
- 2. The file **Lesson10_instance.fla** should now appear in your copy of Flash. Take a look around.
- 3. Some of the objects you are asked to draw may look different than what is illustrated here.

Please note the following properties of this completed exercise:

- You can modify an instance of a Symbol without affecting the actual Symbol.
- b) Changes to a Symbol won't affect altered Instances when effects have been applied.

Storyboard: On-Screen

Figure 10-24 shows you what the Stage will look like once you've finished this exercise.

Figure 10-24 The Complete Stage Area

Storyboard: Behind-the-Scene

Figure 10-25 shows you what the Library will look like once you've finished this exercise.

196

Symbols, Instances, and Libraries

Figure 10-25 The Complete Library

Step-by-Step Instructions:

- 1. Let's start by creating a new file.
 - a) Select the Menu option File / New.
 - b) Let's add a new Symbol to the Library. Select the Menu option Insert
 / New Symbol.
 - c) In the Symbol Properties Dialog Window, select the Movie Clip Radio Button. Click OK. You will immediately be taken into the Symbol Editing Mode. Notice there's nothing on the Stage! That's because using the Insert / New Symbol command inserts a blank Symbol in the Library.
 - d) Save the file by selecting the Menu option File / Save and selecting the SaveWork Folder on your computer. Type in the name . . . Instance.
- It's time to draw our new Symbol. In Symbol Editing Mode, you just inserted a blank Symbol. You can now use the tools from the Toolbox to draw a new object onto the Stage – right here in Symbol Editing Mode!
 - a) Select the **Pencil Tool** from the Toolbox and set the **Stroke to Black.**
 - b) Select the Smooth Modifier from the Options in the Toolbox. See Figure 10-26.

Shortcut

You can also Cut/Copy objects that you've drawn on the Stage, insert a blank Symbol, and Paste the object into the blank Symbol within the Symbol Editing Mode.

Figure 10-26 Smooth Modifier

c) **Draw** an **"Amoebae"** on the Stage similar to the one in Figure 10-27.

Figure 10-27 "Amoebae"

- d) Select a **Pink Fill** in the **Fill Modifier** and fill the **Amoebae** using the **Paint Bucket Tool.**
- e) Using the Arrow Tool, select the Stroke surrounding the shape and press Delete. (You may need to select several segments or double-click to select all of the line.)
- f) Select the Amoebae and center it on the crosshair in the Library.
- g) Exit the Symbol Editing Mode by clicking on the Scene I Tab.

3. Make sure your Library is open and take a look at the file list. Notice that an untitled Symbol has been added to the Library. This occurred when you selected **Insert / New Symbol.** Double-click the unnamed Symbol and type in the name ... **Amoebae.**

- 4. It's time to modify an Instance of a Symbol!
 - a) Drag three copies of the Amoebae Symbol onto the Stage and position them similar to what is illustrated in Figure 10-28.

The Instance Panel, among other things, allows you to give a unique name to each Instance of your Symbols. This is a good habit to get into, especially if you are planning to add ActionScripts to your Movies.

198

·T/P·

- b) Open the Instance Panel by selecting the Menu option Window / Panels / Instance.
- c) Click on each Instance and type in a name in the Instance Panel. You can use the names... Amoebael, Amoebae2, Amoebae3.
- d) Let's open the Effect Panel by selecting the Menu option Window
 / Panels / Effect.
- e) Select **Brightness** from the Effect pull-down menu.
- f) Select the Amoebael Instance.
- g) Using the Brightness slider on the Effects Panel, choose . . .
 -50%. See Figure 10-29.

This will darken the color of your image. Notice that when you make this change, the other Instances of this Symbol remain unchanged.

(), Install, Effect (), Ftar (4: Soun) ?				
Brightness	, <u>0</u> , – 16	- 0%	Ĭ	
			1-	

Figure 10-29 Brightness Slider on the Effects Menu

- 5. Let's take a look at an object's Alpha or Opacity attribute.
 - a) Select Amoebae2 on your Stage.
 - b) From the Effects Panel choose Alpha.
 - c) Use the Alpha Slider to change the opacity of your object to ... 30%.
 - d) Move Amoebae2 so that it overlaps other objects on your Stage.
 - e) If you need to, choose **Modify / Arrange / Bring to Front** to move **Amoebae2** to the **top** of the **Stacking Order** on the Layer.
 - f) Since Amoebae2 is now semi-transparent, you can see the shape underneath it.
- 6. Let's change the color of an Instance.
 - a) Select Amoebae3 and choose Tint.
 - b) Take a look at the Tint options. See Figure 10-30. You can select a new color from the Color Well, or from the Color Spectrum. You can also specify RGB values.

•**T**/P·

The Effect Panel allows you to control the appearance of an Instance using four attributes: Brightness, Tint, Alpha, and Advanced.

Opacity deals with the transparency, or lack of transparency of an object. In Flash, the Alpha number of an object determines its degree of transparency. The higher the percentage of the Alpha, the more opaque an object is.

Both Tint and Advanced in the Effects Panel allow you to change the color of an object. The difference is, the Advanced category also allows you to control the object's Alpha (opacity).

Effect	?
Tint	▼ 100% •
Tint Color:	R: 0
	G: 0
	B: 0

- c) **Select** a **Blue** from the pop up **Color Well.** You've just changed the color of an Instance without editing the Symbol in the Library!
- Now let's see what happens when we modify the original Symbol from the Library.
 - a) **Double-click** on the icon next to **Amoebae** in the **Library** to enter Symbol Editing Mode.
 - b) Select the **Paint Bucket** and **change** the **Fill** of your shape to **Purple**.
 - c) Make sure the Symbol is deselected. Then, using the Arrow Tool, modify the shape of your Symbol slightly, similar to what is illustrated in Figure 10-31.

Figure 10-31 Modify the Symbol

- d) Exit Symbol Editing Mode by clicking on the Scene I Tab.
- 8. Each Instance of the Symbol changes shape. However, the Instance of the Symbol that we applied a new Tint to, does not change color like the others.
- 9. Select the Menu option File / Save.

Guided Tour – Font Symbols

Font Symbols are an interesting addition to the Flash 5 Library, especially since calling them Symbols is actually a misnomer. More precisely, Font Symbols could be called Styles. Font Symbols allow you to set up a Font in the Library and apply that Font Symbol, like a style to any text in your Movie. Since the selected text is linked to the Font Symbol, changing the font of the Font Symbol would change any text linked to that Symbol.

- 1. Let's set up a Font Symbol in the Library to see how these Symbols work.
 - a) Open your Library by using the Menu option Window / Library.
 - b) Use the **Options pull-down menu in the Library** and **select New Font.**
 - c) Give your Font Symbol a unique name like My Font. Do not name this Font Symbol after the Font you are going to use because it will appear in the Font list on the Character Panel and could be confusing.
 - d) Select **Arial** for the Font and place a checkbox next to **Bold**. Click **OK**.
- 2. Now apply your new Font Symbol to some text.
 - a) Select the Text Tool and type...When life gives you lemons, make lemonade!
 - b) Highlight the word lemons.
 - c) Open the Character Panel by using the menu option Window / Panels / Character.
 - d) On the Character Panel, select My Font from the font list.
 - e) Change the size to 48 point.
 - f) Lemons will be changed to Arial bold, as set in the Font Symbol.
- 3. Let's edit the Font Symbol.
 - a) **Double click** on the icon next to **My Font** in the Library list.
 - b) Change the font to Courier. Click OK.
 - c) Your font style applied to the word lemons has been updated to Courier.

Summary

- The Library acts as storage for graphics, buttons, animation, sound, fonts, imported bitmaps and other media elements that you will use in your Flash Movie. The Library is mainly used for storing specialized elements called Symbols.
- There are three main types of Symbols Movie Clips, Graphics, and Buttons. Each one of these Symbols has certain characteristics and behaviors that dictate how these Symbols operate, what they can do, and how they should be used in your Movie Timeline.

You will nee

You will need to look for your "My Font" Font Symbol...alphabetically ...also note that there is an * by it in the list.

- The Library is divided into two areas, the Preview Area (the gray area at the top of the Library), and the File List (white area) that shows the Name, Kind, Use Count, Linkage, and Date Modified of the Symbol stored in the Library.
- The display of Folders in the Library can be expanded or collapsed by doubleclicking on the Folder Icon.
- Symbols can be added to the Library by using different methods: 1) Symbols are easily added into a Folder just by dragging and dropping them on top of the Folder.
 2) Symbols are easily added to the Library by clicking on the Add Symbol Icon.
- Using Symbols is a fundamental step in creating efficiently built Flash projects.
- An Instance is a copy of a Symbol that appears in the Movie Timeline. Every time you drag a Symbol from the Library to the Stage you have created a new Instance (copy) of that Symbol.
- Movie Clips are mini-Movies that are stored as Symbols in the Library. Movie Clips have their own Timeline that is independent from the Timeline of the main Movie. This means you can have animations that are not tied to the main Movie's Timeline.
- New to Flash 5 are Symbols called Smart Clips. Smart Clips are Movie Clips with Clip Parameters assigned to them. Clip Parameters allow you to customize ActionScripts that are pre-defined within a Smart Clip. Smart Clips are often used as re-useable interface elements, such as drop down menus with Clip Parameters that can be easily changed based on your particular application.
- Button Symbols are a fast and easy way to create re-usable buttons in your Movies. When you add a Button to the Library, the Button Timeline automatically has only four Frames. These four Frames are labeled Up, Over, Down and Hit and they correspond to four different Button States and mouse actions.
- Graphic Symbols can consist of either static images or simple animations that are re-used throughout a Movie. An example might be something like a company logo, but Graphic Symbols are generally not used for lengthy animations (this is what Movie Clip Symbols are for).
- Once you create a Symbol, you can take advantage of the Symbol Editing Mode that allows you to modify and make global changes to every Instance of a particular Symbol in your Movie. The Timeline, Stage, Panels and Tools – are all available for use in the Symbol Editing Mode, just as they are in the main Movie. The best way to tell whether or not you are in the Symbol Editing Mode is to look above the Timeline, at the Tabs.
- In the first Practice Exercise you saw how to add a Symbol to the Library; edit a Symbol; rename a Symbol and detach an Instance from a Symbol.
- In the second Practice Exercise you saw how to modify an Instance of a Symbol and make changes using Brightness, Alpha, and Tint options.
- In the last Guided Tour you were introduced to Font Symbols which allow you to set up a Font in the Library and apply that Font Symbol, like a style to any text in your Movie.

PTER

Application Chapter: Creating Re-usable Symbols

Chapter Topics:

- Introduction
- Application Exercise Creating Re-usable Symbols
- Summary

Introduction

In this chapter, you will continue to build the pieces of our site's interface as well as some of the Symbols that will be re-used in many parts of the site. It's important to spend the time planning and creating these Symbols in the initial design phase of any project because the efficient use of Symbols in your Movie can significantly improve how well your Movie plays back over the Internet.

Remember that Symbols are a fundamental reason why Flash Movies are considered such efficient streaming media. Even though you may have many Instances of a Symbol appearing in your Movie Timeline, the "physical" Symbol only exists once – in the Library, and thereby significantly reduces file size and download time. So what may seem like a long pre-production process will actually pay off with better performance when the Movie is accessed and played.

Application Exercise – Creating Re-usable Symbols

Description

This Application Exercise focuses on creating a few re-usable graphic elements that you will use throughout the Application Project and within a variety of other Symbols. Some of these elements were created in the previous Application Chapter. Others are new graphics that you will build in this exercise. You will also add the descriptive text that goes along with each "stop" of our online travelogue. Finally, you will add basic Frame-by-Frame animation to some of the Graphic Symbols.

Take-a-Look

Before beginning the exercise, let's take a look at the exercise in its completed state so that you can clearly see what it is that you are about to build.

- Use the Menu option File / Open and locate on the CD-ROM the folder named Chapter 11. Locate the file named application_11.fla. Doubleclick on application_11.fla to open the file.
- 2. The file application_I I.fla should now appear in your copy of Flash.
- 3. Preview the Movie. Take a moment to look around.

Storyboard: On-Screen

Figure 11-1 shows what will be seen on Stage, when the program file is complete.

CD-ROM

Application Chapter: Creating Re-usable Symbols

Figure 11-1 The Completed Stage

Storyboard: Behind-the-Scene

Figure 11-2 shows how the Timeline will look when the exercise is complete.

	10		2		1 5	10	15	20	25	30	35	40	45	50	55	60	68	
Text	1.	•	•	11														
Headlines	•	. [9															
Photos	•	• {	9															
Route Sign	•	• {	9		• 0													
Background	•	• {	9		• 0													4.00
₽ Ø			f	7	A Galain	al coll	1 12	0 fps 0	0s 4	1								M

Figure 11-2 The Completed Timeline

Applications Project Steps

Complete this exercise on your own, guided by following the general steps provided below. You can always refer back to the completed example that you viewed in the Take-a-Look section of this exercise.

Please Note: The following steps are intended as guide. This is your project so please feel free to make whatever variations you would like.

 Open application_06.fla. You can either use the copy you created and saved in the SaveWork Folder on your computer or you can use the copy in the Chapter06 Folder on the CD-ROM supplied with this book.

CHAPTER II

- 2. Create a new Graphic Symbol named Yellow Glow. In its Symbol Editing Window, draw a Circle (W=9.5, H=9.5) using any Radial Gradient as the Fill Color and a Black Stroke (Stroke Height=2). Change the innermost Gradient Color to #FFFF33 and the outermost Gradient Color to #FFF033.
- 3. Position the complete circle at X=0.0,Y=0.0.
- 4. Return to the main Movie and move the Yellow Glow Symbol to the Graphic Images Folder of the Library.
- Create a new Graphic Symbol named Exit Sign. In its Symbol Editing Window, draw a Rectangle (W=56.5, H=34.0, Radius Corners=5) using a Fill Color of #006633 and no Stroke. Position it at X=0.0,Y=0.0.
- 6. Draw another Rectangle (W=53.3, H=30.7, Radius Corners=3) using no Fill Color and a White Stroke with a Height of I. Position it at X=0.0, Y=0.0 and above the Green Rectangle you just drew. We will use this symbol extensively when we create our Buttons in a later chapter.
- Return to the main Movie and move the Exit Sign Symbol to the Graphic Images Folder of the Library.
- 8. Add a new Layer and name it Text. Position it above the Headlines Layer.
- 9. Add a Blank Keyframe to Frames 1-5 of the Text Layer.
- 10. Select Frame 1 of the Text Layer.
- II. Assign the following Text Properties:

Font	_sans
Font Height	10
Bold	selected
Color	Black
Kerning	deselected
Left Justified Paragr	aph
Static Text	
Use Device Font	selected

- 12. Type in the following Text with hard returns at the end of each line: Historic Route 67 is a scenic drive through America's beautiful and rugged Southwest. It was originally conceived as a coast-to-coast highway that would open a new corridor to travel and commerce. Unfortunately, the project came to a halt when someone in Washington decided that it bypassed all of the so-called "interesting" features of the Southwest. Take our word for it ... there's a lot to be excited about on Route 67!
- 13. Position this Text at X=360.8, Y=420.9.

Application Chapter: Creating Re-usable Symbols

- 14. Select Frame 2 of the Text Layer. Use the same Text Properties as before and type in the following Text with hard returns at the end of each line: Our motto here is "Too close to be far, too far to be convenient!" Even on the blackest night you won't be bothered by the glowing lights and the jingling sounds of Las Vegas. Your family will grow closer as you forage for food and shelter when you explore the Underdale Family Fun Wilderness Trail, a former Desert Survival Training Area for the U.S. Army!
- 15. Position this Text at X=360.8, Y=414.1.
- 16. Select Frame 3 of the Text Layer. Use the same Text Properties as before and type in the following Text with hard returns at the end of each line: Bring the family to Chikapee for a trip to the mysterious Invisible Ocean, discovered in 1952 by Lester "Tequila" Hopkins. Or, stay awhile and marvel at the aerobatic hijinks of Lester Hopkins the Third and his Flying Cropduster Circus! Lester has been known to let lucky children fly his plane while he shouts authentic flight instructions from the ground.
- 17. Position this Text at X=363.1,Y=414.1.
- 18. Select Frame 4 of the Text Layer. Use the same Text Properties as before and key the following Text with hard returns at the end of each line: Come face-to-face with wild animals at Colonel Steve's Wild Game Reserve! Colonel Steve has scoured the earth to gather the most exotic and incredible animals ever assembled in north-northeastern New Mexico! Your children will no doubt gain valuable natural insights that will make them much more intelligent and successful in their adult lives!
- 19. Position this Text at X=363.5, Y=414.1.
- 20. Select Frame 5 of the Text Layer. Use the same Text Properties as before and key the following Text with hard returns at the end of each line: In August 1978, Sissy Glabella entered a dish at the Annual Town Fair that started the culinary movement known as "Texahoma Cuisine." Stop and enjoy such delectables as Fried Meat Tidbits with Salt, Cheesy Noodle Bake, No-Fuss Cheesecake, and the dish that started it all ... Sissy's Steamed Squash Medley on Rice. When you say Bulldozer, you've said "Good Eating!"
- 21. Position this Text at X=363.5, Y=420.9.
- 22. Save your file as application_II.fla.

Summary

You have added to the design of your interface by creating many of the Symbols that will be used throughout your Movie. By creating these Symbols in the initial stages of design, you have also begun preparation for later steps in the development process when you will add Motion Tweens to these Symbols. You have also added text elements to your interface.

PTER

12

Shape and Motion Tweens

Chapter Topics:

- Introduction
- What is Tweening?
- Motion Tweens
- Motion Guides
- Shape Tweens
- Guided Tour The Frame Panel
- Practice Exercise Motion Tweens and Motion Guides
- Practice Exercise Shape Tweens
- Summary

.

Introduction

After all that work in Chapter 5 to create a short and very simple Frame-by-Frame animation, it might seem like a daunting task to build an animation that has complex, fluid movement. Looking at some of your favorite Flash sites that have subtle shape and color transitions as well as complex movement on the screen, you may be asking yourself, "How did they do that?" To help you work more productively and create sophisticated two-dimensional animation, Flash added the Tween command, which allows you to create transitional effects in your Timeline without manipulating every Frame. What this means in plain English is – Tweening will save you tremendous time and effort.

By the end of this chapter, you will be able to:

- define the concept of Tweening.
- use the Frame Panel.
- add animation to a Symbol.
- create a Motion Tween.
- set up a Motion Guide.
- create a Shape Tween.

What is Tweening?

Tweening may sound like a strange term, but once you have seen it in action you will never forget what it is. The easiest way to remember what Tween means is to think of it as the action that takes place in be-**tween** Keyframes in an animation.

In Chapter 5, you learned how to create Frame-by-Frame animations; animations in which change occurred only in each Keyframe (i.e., the turning on and off of a light bulb). With Frame-by-Frame animation, in order to move an object a short distance, you must incrementally move it in each Frame in order to make the movement seem natural when it is played back. This type of Frame-by-Frame animation is very time intensive and difficult to edit. In addition, certain types of animated effects cannot be easily achieved with Frame-by-Frame animation – effects like fluid movement, morphing of shapes, gradual transitions, and motion on a path.

Shape morphing (example – transforming a circle into a square) would be very time consuming to accomplish using the Frame-by-Frame method. You would have to slowly redraw the circle's shape, guessing at the shape changes in each Frame until it has been re-shaped into a square. For a fluid transition between these shapes, these changes would have to be very small and would probably stretch over many hundreds of Frames.

Working in the fast-paced world of Web development requires more efficient methods to reduce the tedium and time-consuming process of Frame-by-Frame animation. Thankfully, with Tweening, Flash does all the work and uses only as many Frames as you designate in your Timeline. In fact, Flash provides two types of Tweening that can be easily applied to objects and Symbols: the Motion Tween and the Shape Tween.

Motion Tweens

Motion Tweens allow you to easily move an object around the Stage, make it bigger/smaller, or rotate it on an axis. The process is pretty easy:

- set up a beginning Keyframe and an ending Keyframe
- · convert the object to be moved into a Symbol or a Grouped object
- position the object in the first Keyframe, indicating where it should first appear on the Stage
- position the object in the last Keyframe, indicating where it should end up on the Stage
- apply Motion Tweening

Flash takes the beginning and ending positions, as well as the number of Frames that exist between the two Keyframes, and automatically creates the incremental movement for these "in-between" Frames. The result is a fluid transition from the beginning location to the end location. As the object moves, you can also scale and rotate it at the same time. You will get a chance to try it out ... shortly.

The Timeline in Flash gives you visual clues to what commands have been applied in each Frame. When you apply a Motion Tween between two Keyframes, you will see an arrow stretching across all of the Frames, highlighted in blue. See Figure 12-1.

Figure 12-1 Motion Tween – Between Frame 1 and 18 (Indicated by Arrow)

On the other hand, a dotted line indicates that the Tween is inactive. See Figure 12-2. An inactive Tween can result from the following: one of the

CHAPTER 12

·T/P·

Keyframes is blank; one or both of the objects are Ungrouped; or the object has not been converted to a Symbol.

Figure 12-2 An Inactive Motion Tween - Indicated by Dotted Line

Motion Guides

The use of a Motion Guide is an excellent way to make a more complex path for your objects to follow during a Motion Tween. You will discover that in an ordinary Motion Tween, Flash operates by the old axiom – the shortest distance between two points is a straight line. If you want a more complicated or meandering path for your animation to follow, you must use a Motion Guide. When you add a Motion Guide, you can draw a specific path for your object to follow – including whatever curves you may want. Motion Guides actually reside in a separate Layer from the object you are trying to move, but they are linked to the object's Layer. Motion Guides are inserted by selecting the Add Guide Icon on the lower left portion of the Layers Window, as illustrated in Figure 12-3.

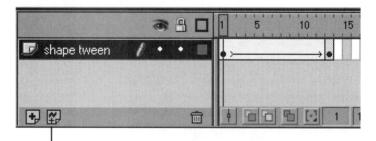

Add Guide Icon

Figure 12-3 Add Guide Icon

A Motion Guide Layer is inserted directly **above** the Layer you currently have selected. When it is inserted, it will have the Motion Guide Symbol and will be labeled **Guide: Layer Name.** The Layer Name portion of this label changes to the name of the Layer that the Guide is linked to. See Figure 12-4. Once

When working with Motion Tweens it's handy to remember the following tips:

Always insert Keyframes for the beginning and ending Frames of a Motion Tween.

All objects involved in a Motion Tween must either be Grouped or converted to a Symbol.

Shape	e and	Motion	Tweens
-------	-------	--------	--------

·T/P·

the Guide Layer is inserted you can draw a path with any of the drawing tools. This is the path that the object will move along. After the path has been created, you then attach the object to the path using its center point. You'll get some "hands-on" practice in doing this during a Practice Exercise that follows.

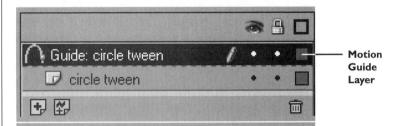

When you apply a Motion Guide, you will be able to see the Guide when you preview the Movie. Once you test or export your movie, the contents of the Motion Guide Layer will become invisible.

Figure 12-4 Motion Guide Layer - Linked to Circle Tween Layer

Shape Tweens

A Shape Tween actually allows you to morph (transform) one object into another. As you will see during an exercise that follows, this can be a very interesting effect that can be used with simple or complex shapes. Shape Tweens can incorporate movements, as well as color and alpha (transparency) changes. A Shape Tween is applied in much the same way as a Motion Tween. However, unlike Motion Tweens, you must always either Break Apart a Symbol or Ungroup an object in order to apply Shape Tweening.

As mentioned previously with Motion Tweening, the Timeline in Flash gives you visual clues to what commands have been applied in each Frame. When you apply a Shape Tween between two Keyframes, you will see an arrow stretching across all of the affected Frames. However, instead of being highlighted in blue as is the case with a Motion Tween, the Shape Tween will be highlighted in green. If your Shape Tween does not work, this is usually an indication that one of the Keyframes is blank, the objects are Grouped, or they have been converted to a Symbol and must first be detached from the Symbol.

Guided Tour – The Frame Panel

The Frame Panel is a very important part of using Motion and Shape Tweens. Think of it as "command central" for adding and controlling Tween effects. For those of you who are experienced users of Flash, the Frame Panel is a new addition to the Flash interface. As one of the Panel options, the Frame Panel streamlines the animation process. You no longer have to open additional windows to add or edit Motion or Shape Tweens. Plus, editing is a breeze since you can keep the Frame Panel open at all times.

When working with Shape Tweens, it's handy to remember the following tips:

Always insert Keyframes for the beginning and ending Frames of a Shape Tween.

Ungroup or Break Apart any of the shapes or Symbols that are to be used in a Shape Tween.

CHAPTER 12

Shortcut

The Keyboard Shortcut for opening the Frame Panel is: PC- Ctrl & F

Mac – Cmd & F

- 1. Let's open the Frame Panel and check out its features.
 - a) Select **Window / Panels / Frame.** Notice that the Tweening pull down menu is currently grayed out.
 - b) Open a blank document by selecting the Menu option File / New.
 - c) Select Frame I in Layer I (which is already designated as a Keyframe) to make the Panel active. After this selection, note that the previously grayed out Tweening pull down menu in the Frame Panel has now become active. See Figure 12-5.

Frame		X
S. Frame		?)
Label:		
Tweening:	None	-

Figure 12-5 The Frame Panel

- d) Take a look at the Label field in the Frame Panel. This field provides you with the capability to label any Keyframe with a descriptive name. This feature will come in handy, especially once you start using ActionScripts in later chapters.
- e) **Click and hold** open the **Tweening pull down menu** in the Frame Panel. This is where you will select Shape and Motion Tweens.

🖁 🔒 Frame	9		?
Label:			
Tweening:	Shape	-	
Easing:	0 -		
Blend:	Distributive	-	

Figure 12-6 Shape Tween Settings on the Frame Panel

- 2. Take a look at the Shape Tween settings.
 - a) In the Tweening pull down menu, **select** the **Shape Tween.** See Figure 12-6.
 - b) **Click** on the **Easing Arrow.** Note that it opens an Easing Slider Bar. The Easing Slider Bar allows you to control the rate of acceleration

in your animation. **Click and drag** the **handle** on the Slider Bar. Note the corresponding numerical values appearing in the Easing field window. A negative number means a slower start. The larger, positive number means a more rapid start to the animation. **Click anywhere** to close the Slider Bar.

- c) Click on the Blend Arrow. Note you have two Blends to choose from with Shape Tweening: Distributive and Angular. The Blend options control the way that the Tweening is applied to the middle Frames in your animation. Distributive is generally smoother, and Angular works well with shapes that have straight lines and sharp corners.
- 3. Now take a look at the Motion Tween.
 - a) With the **Keyframe still selected**, select **Motion Tween** from the **Tweening pull-down menu** in the **Frames Panel.** Take a look at the Motion Tween settings. See Figure 12-7.

Frame	X
Frame	● ►
Label:	
Tweening:	Motion 🚽 🔽 Scale
Easing:	0 •
Rotate:	Auto 👻 0 times
Options: [Orient to path Synchronize Snap

Figure 12-7 Motion Tweening on the Frames Panel

- b) The Easing field with a Slider Bar works the same way as in the Shape Tween setting by controlling the rate of acceleration of the Motion Tween.
- c) Select the Rotate pull-down menu. The Rotate option allows you to spin the object being moved during the execution of the Motion Tween. Auto will rotate the object once in the direction requiring the least motion. CW will rotate the object Clock Wise. CCW will rotate the object Counter ClockWise. If you select either CW or CCW, you will note that the Times field becomes active. This field is where you can type a number to specify how many times the object should be rotated.
- d) Note the remaining options at the bottom of the panel.
 Synchronization place a check mark here if the number of Frames in the animation sequence inside the Symbol is not an even multiple of the number of Frames the graphic instance occupies in the Movie.
 Snap place a check mark here to attach the Tweened element to

CHAPTER 12

You can move the center point of a Symbol by entering the Symbol Editing Mode and moving the graphic in relation to the crosshair on the Stage. the motion path by its registration point. **Orient to Path** – moves the object along a Motion Guide more naturally by tilting the object at its center point to correspond with the angle of the path.

4. The tour is finished - let's build something.

Practice Exercise – Motion Tweens and Motion Guides

Description

In this exercise you will create a Motion Tween and a Motion Guide. After creating and animating a Symbol, you will see how to apply a Motion Tween to move this Symbol across the screen. You will also draw a path for your Symbol to follow by using a Motion Guide.

In this exercise you will:

- Create a new Symbol.
- Animate your Symbol's Timeline.
- Use your Symbol in a Motion Tween.
- Rotate and Scale the Motion Tween Symbol.
- Add a Motion Guide.

Take-a-Look

Before beginning the exercise, let's take a look at the exercise in its completed state so that you can clearly see what it is that you are about to build.

CD-ROM

- Use the Menu option File / Open and locate on the CD-ROM the folder named Chapter 12. Locate the file named motion.fla. Double-click on motion.fla to open the file.
- 2. The file **motion.fla** should now appear in your copy of Flash. Press the Enter/Return Key to see a preview of the file.

Please note the following properties of this completed exercise:

- a) Graphic Symbols have their own Timelines that are tied to the main Movie Timeline.
- b) Motion Tweens can only be applied to Symbols or Grouped objects.
- c) Motion Guides are used to control the path and orientation of an object.

Storyboard: On-Screen

Figure 12-8 shows you what the finished exercise will look like on the Stage.

216

Shape and Motion Tweens

Figure 12-8 The Stage - Completed

Storyboard: Behind-the-Scene

Figure 12-9 shows your Timeline and Stage, once the exercise is finished.

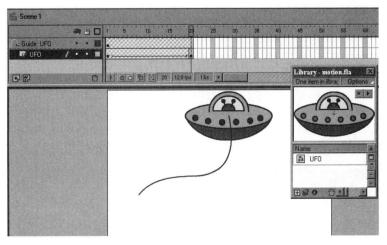

Figure 12-9 The Complete Timeline and Stage

Step-by-Step Instructions:

- To begin, let's start with the Symbol we want to use in the Motion Tween. We are going to use a very simple spaceship.
 - a) Please select one of the following choices.
 If you would like to draw the spaceship yourself, you can look at the Figure 12-10 as a "model." Select the menu File / New to open a new file. Use the drawing tools and create a simple spaceship.

CHAPTER 12

Go Solo

Or

If you don't want to draw the ship, select the Menu option File / Open. Use the browse function to locate the Chapter 12 Folder. Locate, select and open the file ... spaceship.fla.

Figure 12-10 A Simple UFO

- b) With either one of the choices above, save your file by selecting File
 / Save As, naming the file motion.fla and save it into the SaveWork Folder on your computer.
- c) Using the Arrow Tool, select all the objects that make up the UFO by clicking and dragging the marquee around all the objects on the screen as illustrated in Figure 12-11, or by selecting the Menu option Edit / Select All.

- d) Select the Menu option Insert / Convert to Symbol to add the UFO to the Symbol Library.
- e) Select the Graphic Radio Button in the Symbol Properties Window and name the Symbol by typing in ... UFO. Click OK.
- f) Open your Library by selecting the Menu option Window / Library and take a look at the new UFO Symbol.

Shape and Motion Tweens

Figure 12-12 UFO in Library

- 2. Now let's Edit the Symbol to add a short animation before applying the Motion Tween.
 - a) Double-click on the UFO graphic icon in the Library to enter Symbol Editing Mode.
 - b) Click on the Insert Layer Icon (see Figure 12-13) to add a Layer to the Timeline. Double-click on the Layer you just added and type in ... Running Lights.

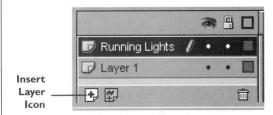

Figure 12-13 Insert Layer Icon

- c) Rename Layer I containing the spaceship by **double-clicking** on the **Layer name** and **typing in ... Spaceship.**
- d) Lock the Spaceship Layer by **clicking on** the **Lock Layer Icon** (turning the "dot" to a "lock"). See Figure 12-14.

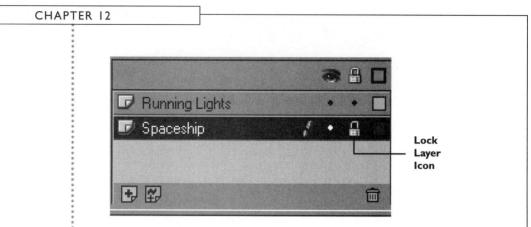

Figure 12-14 Lock Layer Icon

- e) Select the **Circle Tool** from the Toolbox and pick a **medium gray Fill** with a **2 point black line** around it.
- f) Select the **Running Lights Layer.**
- g) **Draw** a series of **small circles** in an arc on the base of the spaceship as illustrated in Figure 12-15.

Figure 12-15 Running Lights Added to Spaceship

- h) Add one Frame to both Layers by selecting Frame 2 in the Running Lights and Spaceship Layers. Select the Menu option Insert / Frame.
- i) Select Frame 2 in the Running Lights Layer and select the Menu option Insert / Keyframe.
- With Frame 2 still highlighted, select the Menu option Edit / Select All to select the circles on the spaceship.
- k) Change the Fill in the Toolbox to a bright red to automatically change the Fill of the selected circles.
- To check your work, use the Menu option Control / Loop Playback to set the playback to continuous loop. Press Enter/Return to play through the two Frame Timeline. Press Enter/Return again to stop the looping playback.

- m) Exit Symbol Editing Mode by **clicking on** the **Scene I Tab.** You've just created a two-Frame animation for your Symbol that will loop throughout the main movie Timeline!
- Now that you have your Symbol set up you can add the beginning and ending Keyframes for your Motion Tween.
 - a) **Drag** the **UFO Symbol** to the bottom left hand side of the **Stage.** You might have to drag the UFO from the Library if it is not already inserted on your Stage.
 - b) Highlight Frames 2-20 and select the Menu option Insert / Frame to add 19 Frames to the Movie Timeline.
 - c) Click on Frame 20 and select the Menu option Insert / Keyframe. When you added the additional Frames to the Timeline, the UFO in Frame I was automatically added to each additional Frame.
- 4. Now that you have your Keyframes set, you can move your UFO to its end location.
 - a) Make sure you have **Frame 20 selected. Move** the **UFO** from the left side of the screen to the upper middle portion of the screen.
 - b) Now scrub (drag) the Playback Head to scroll through the Movie Frames. Notice that the UFO stays in its initial location until Frame 20 and then jumps to the middle of the screen.
- 5. Now let's apply the Motion Tween to make a more fluid movement.
 - a) Select any of the Frames between I and 19.
 - b) Open the Frame Panel by selecting the Menu option Window / Panels / Frame.
 - c) From the **Tweening** pull down menu select **Motion Tween.** See Figure 12-16.

Frame	X
Frame	() Þ
Label:	
Tweening:	Motion 💽 🔽 Scale
Easing:	0 -
Rotate:	None 🔹 0 times
Options: 🔽	 Orient to path Synchronize Snap

Figure 12-16 Motion Tween Selected in Frame Panel

d) Your Frames will be highlighted in blue and a solid line with an arrow will appear. See Figure 12-17.

Figure 12-17 UFO in End Position

- e) Press the **Enter/Return Key** to play through the animation. Notice that the animation that we set up in the Symbol's Timeline loops as the UFO moves across the Stage.
- 6. We can also make the UFO larger as it moves.
 - a) Move the **Playback Head** to **Frame 20** and **select** the **UFO** Instance in **Frame 20**.
 - b) Open the Transform Panel by selecting the Menu option Window / Panels / Transform.
 - c) To scale the UFO proportionally without distorting it, check the Constrain box and type in ... 150% for the width and height. You only have to type 150% in one box with Constrain turned on. See Figure 12-18.

Transform	X
	3 🕨
** 150% \$ 150%	Constrain
● Rotate	
C Skew Z7 0.0	0.0
	田田

Figure 12-18 Transform Panel

d) Play through the animation by pressing the **Enter/Return Key.** The UFO gradually gets larger as it moves!

222

- 7. Now let's rotate the UFO as it moves.
 - a) Select **any** of the **Frames** in your **Motion Tween** (highlighted in blue) and take a look at the Frame Panel. (If the Frame Panel is not open, select Window / Panel / Frame).
 - b) Select CCW (Counter-clockwise) from the pull down menu and type in ... I in the Times field.

Frame	X
Frame) ())
Label:	
Tweening:	Motion 💽 🔽 Scale
Easing:	0 🔹
Rotate:	CCW 🚽 1 times
Options:	Orient to path Synchronize Snap

Figure 12-19 Adding Rotation to a Motion Tween

- c) Press the **Enter/Return Key** to play through your animation Timeline to watch the UFO spin as it moves across the Stage.
- 8. Let's add a Motion Guide to control the movement of our UFO more closely.
 - a) Rename the Spaceship Layer by **double-clicking** on the **Layer name** and typing in ... **UFO.**
 - b) Click on the Add Guide Icon to add a Guide Layer above the UFO Layer.

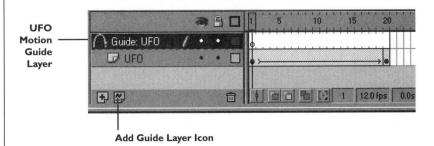

c) Select your Pencil Tool and Smooth Modifier from the Toolbox.

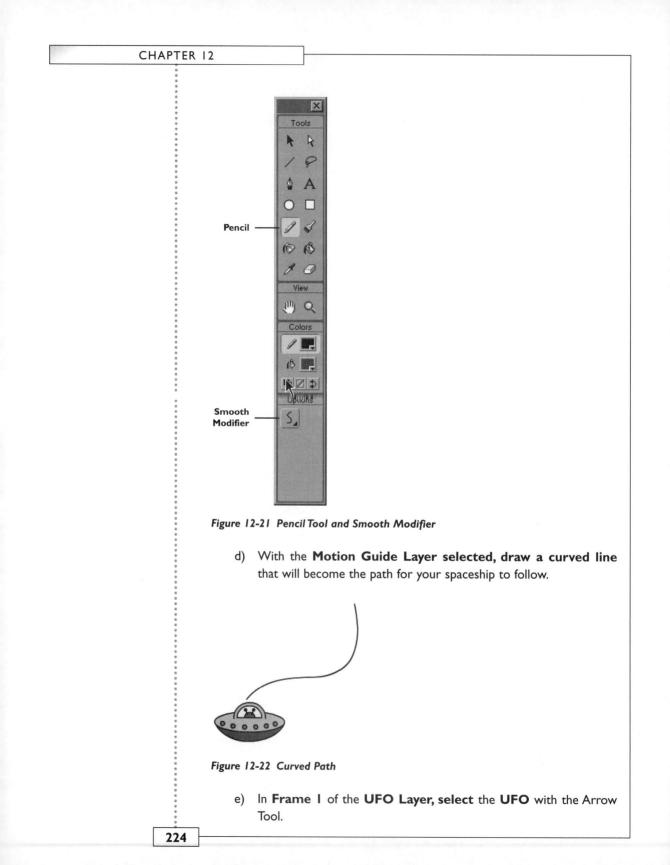

Shape and Motion Tweens

f) Using the crosshairs as guides, drag the UFO over the left end of the guideline until a hollow circle appears and the object snaps to the end of the Guide. Use the Menu option View / Snap to Objects to turn snapping on, if you can't see the hollow circle.

Figure 12-23 Center Crosshairs of UFO

- g) Repeat Step F in Frame 20, but this time put the UFO in Frame 20 at the other end of the Guide.
- 9. Let's add a few final touches and then test the Movie.
 - a) In the **Frame Panel**, change the **Rotate** option to **None** and **check** the option **Orient to Path.** See Figure 12-24. Orient to Path will tilt the spaceship at its center point to conform more closely to the shape and angle of the path's curves.

Frame	×
Frame	?)
Label:	
Tweening:	Motion 🚽 🔽 Scale
Easing:	0 -
Rotate:	None 💽 0 times
Options: [Orient to path Synchronize Snap

- b) In order to make the UFO hover for a little while at the end of the Movie let's add some more Frames, highlight Frames 21-35 and select the Menu option Insert / Frame.
- c) Preview your Movie by pressing the Enter/Return Key. Notice that the path drawn for the Motion Guide Layer is still visible. You will learn to hide this later.
- d) Adjust the shape of your Motion Guide until you get your UFO path exactly as you want it.
- 10. Let's finish up with some special effects!

• • **T**/ P •

> If an object will not snap to the end of the Motion Guide select the Menu option View / Snap to Objects to turn this feature on.

CAUTION

In order to apply a Motion Guide, you must convert your object to a Symbol first. Just grouping it will not work in this case.

CHAPTER 12

When you test a Movie, Flash creates a sample .swf file in the same folder that your .fla Movie is located. This is the same type of file that you will Export later for use in your Web page.

If you want to get rid of the Motion Guide path without testing the Movie, just hide the Motion Guide Layer in the Timeline!

- a) Select Frame 25 in the UFO Layer and insert a Keyframe by using the Keyboard Shortcut F6.
- b) Create another Keyframe in Frame 35 of the same Layer.
- c) Open the Effects Panel by using the Menu option Window / Panels
 / Effects.
- d) Select the UFO Instance in Frame 35 and choose Alpha from the Effects Panel. Use the Alpha slider to set the percentage to 0. This will make the Instance of the UFO Symbol completely transparent.
- e) Play through your Timeline and notice how the UFO disappears abruptly in Frame 35. Let's make this a gradual transition instead.
- f) Click anywhere between Frames 25-35. In the Frames Panel, select Motion from the Tweening options. Press Enter to play through the Timeline again. Wow! The UFO gradually disappears from view.
- g) For a final effect, click anywhere between Frames 25-35 again. On the Frames Panel, select CW (Clockwise) from the Rotate option and fill in the number 2.
- h) Move the **Playhead** to **Frame I** and **press Enter** to play through the Timeline and watch the effect!
- i) To view the Movie as your users would see it (with the guide path invisible), select the Menu option **Control / Test Movie.**
- A new window will open with the looping animation. Close the window at any time to go back to the Flash movie.
- 11. Now, that you've finished this exercise, for additional practice try creating a space scene like the one pictured in Figure 12-25. Try to adjust your Motion Guide and your additional Layers so that the spaceship appears to come from behind the planet.

Figure 12-25 Space Scene with Visible Guide Path

226

·T/P

Practice Exercise – Shape Tweens

Description

In this exercise you will learn to morph (transform) one shape into another by using a Shape Tween. This procedure is very similar to adding a Motion Tween, however, instead of dealing with paths for an object to follow from point A to point B, Shape Tweens gradually change the physical shape of an object into another shape. You will also notice some special color effects that can be used with Shape Tweens.

In this exercise you will:

- · Create two objects for morphing.
- Break Apart text.
- Apply a Shape Tween.
- Apply a Distributive Blend.

Take-a-Look

Before beginning the exercise, let's take a look at the exercise in its completed state so that you can clearly see what it is that you are about to build.

- Use the Menu option File / Open and locate on the CD-ROM the folder named Chapter12. Locate the file named shape.fla. Double-click on shape.fla to open the file.
- 2. The file **shape.fla** should now appear in your copy of Flash. Press the Enter/Return Key to see a preview of the file.

Please note the following properties of this completed exercise:

- a) Text cannot be used in a Shape Tween without being Broken Apart.
- b) You cannot apply a Shape Tween to Symbols or Grouped objects.

Storyboard: On-Screen

Figure 12-26 shows you what the Stage will look like when you finish this exercise.

CD-ROM

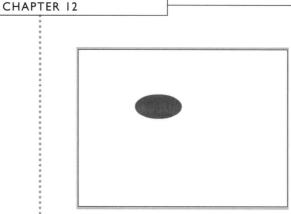

Figure 12-26 The Completed Stage.

Storyboard: Behind-the-Scene

Figure 12-27 shows you what the Stage and Timeline will look like when you finish this exercise.

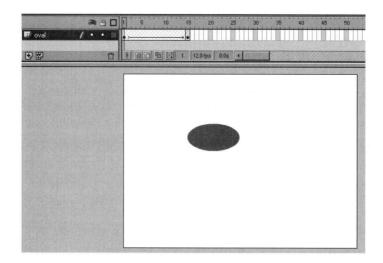

Step-by-Step Instructions:

I. First, let's create a new file for our Shape Tween.

- a) Select the Menu option **File / New** to open a new Movie.
- b) Select the Menu option File / Save and type in the file name ... shape.fla and save it in the SaveWork Folder on your computer.
- 2. Now we will draw the first shape to use in the shape transition.

Go Solo

228

(•

- a) Select the **Circle Tool** in the Toolbox.
- b) From the Fill Modifier choose a medium green with No Stroke.
- c) Draw an oval shape in the middle of your screen. See Figure 12-28.

Figure 12-28 Oval Shape for use in your Shape Tween

- 3. Now let's add the second shape for the shape transition.
 - a) Highlight Frames 2-15 and choose Insert / Frame.
 - b) In Frame 15, choose Insert / Keyframe to add a Keyframe to the last Frame of the Movie.
 - c) **Delete** the **oval** from **Frame 15**.
 - d) Select the **Text Tool** in the Toolbox.
 - e) Select the Menu option Window / Panel / Character.
 - f) In the Character Panel, change the Font to Arial Black and the size to 125 point. Change the Fill color to blue. See Figure 12-29.

Character	X
A Character	?▶
Font: Arial Black	*
At 125 • B I	
	m
A Normal	
URL:	

Figure 12-29 The Character Panel

g) Click on your screen and type in ... C.

CHAPTER 12 Figure 12-30 The Letter C in Frame 15 4. Now we need to break the letter apart in order to use it in the Shape Tween. In Flash, a letter is treated the same way as a Grouped object. In order to morph the oval into the C, we have to Break Apart the letter. Select the C and choose the Menu option Modify / Break Apart. 5. Now let's apply the Shape Tween. a) Select Frame I and open the Frame Panel by choosing Window / Panels / Frame. b) From the pull down menu select Shape Tween. c) From the options, choose **Distributive.** See Figure 12-31. Frame 8. Frame (?)Label: Tweening: Shape + Easing: 0 Blend: Distributive Figure 12-31 Shape Tween Options in the Frame Panel d) Press the Enter/Return Key to Preview your Shape Tween. The oval shape transitions to the letter C and also gradually shifts in color. e) You've just learned to apply a Shape Tween! Think of all the interesting things you can do with this effect!

Summary

- With Frame-by-Frame animation, in order to move an object a short distance, you must incrementally move it in each Frame in order to make the movement seem natural when it is played back. This type of Frame-by-Frame animation is very time intensive and difficult to edit. In addition, certain types of animated effects cannot be easily achieved with Frame-by-Frame animation.
- To help you work more productively and create sophisticated two-dimensional animation, Flash includes the Tween command, which allows you to create transitional effects in your Timeline without manipulating every Frame.
- The easiest way to remember what Tween means is to think of it as the action that takes place in be-tween Keyframes in an animation.
- Motion Tweens allow you to easily move an object around the Stage, make it bigger/smaller, or rotate it on an axis.
- When working with Motion Tweens it's handy to remember the following tips: Always insert Keyframes for the beginning and ending Frames of a Motion Tween; All objects involved in a Motion Tween must either be Grouped or converted to a Symbol.
- When you add a Motion Guide, you can draw a specific path for your object to follow – including whatever curves you may want. A Motion Guide actually resides in a separate Layer from the object you are trying to move, but it is linked to the object's Layer. A Motion Guide Layer is inserted directly **above** the Layer you currently have selected, and is linked to the Layer below.
- A Shape Tween allows you to morph (transform) one object into another. Shape Tweens gradually change the physical shape of on object into another shape.
- When working with Shape Tweens, it's handy to remember the following tips: Always insert Keyframes for the beginning and ending Frames of a Shape Tween; Ungroup or Break Apart any of the shapes or Symbols that are to be used in a Shape Tween.
- In the first Guided Tour you were introduced to the Frame Panel, which is "command central" for adding and controlling Tween effects. You saw the options for Shape and Motion Tweens.
- In the first Practice Exercise, you created a Motion Tween and a Motion Guide, learned how to rotate and scale the Motion Tween Symbol, and added special effects.
- In the second Practice Exercise, you saw how you can morph (transform) one shape into another by using a Shape Tween. You created two objects, applied a Shape Tween and saw the difference between Distributive and Angular Blends.

PTER

3

Application Chapter: Adding Animation

Chapter Topics:

Introduction

Application Exercise – Adding Animation

Summary

Introduction

What sets Flash apart from most Web design tools is its sophisticated twodimensional animation tools. For example, the Motion and Shape Tween features allow you to produce smoother and faster animation, without having to rely on Frame-by-Frame animation, where you must manipulate every Frame in your Movie. You provide the graphics and the ideas and Flash does most of the animation work for you.

In this chapter we are still working on the interface elements. However, this time, you will be working on the main Movie Timeline to set your interface in motion. Try to imagine that you are a choreographer and are designing how the many objects on your Stage will interact throughout this Movie. Flash sites often have highly dynamic interfaces that draw-in and capture the interest of Web surfers. It's time to apply these techniques to your own interface and see how interesting you can make this site for your visitors.

Application Exercise – Adding Animation

Description

In this exercise you will go back and add some animated effects to your main Movie interface by applying what you have learned about Motion and Shape Tweens. You will also add some of the Symbols you created earlier to the Movie Timeline.

Take-a-Look

Before beginning the exercise, let's take a look at the exercise in its completed state so that you can clearly see what it is that you are about to build.

- Use the Menu option File / Open and locate on the CD-ROM the folder named Chapter 13 and locate the file named application_13.fla.
 Double-click on application_13.fla to open the file.
- 2. The file **application_13.fla** should now appear in your copy of Flash.
- 3. Preview the Movie. Take a moment to look through the Timeline.

Storyboard: On-Screen

Figure 13-1 shows what will be seen on Stage, when the program file is complete.

CD-ROM

Application Chapter: Adding Animation

Figure 13-1 The Completed Stage

Storyboard: Behind-the-Scene

Figure 13-2 shows how the Timeline will look when the exercise is completed.

	(B)	8		1	5	10	15	20	25	30	35	40	45	50	55	60	65	H
Actions and Labels	•	•		đ	aaaa													
🥑 Locators 🛛 🖊	•	•																
🗇 Text	•	•																
Headlines	٠	•																
Photos	•	٠																
Route Sign	٠	٠			D													
Background	•	•			D													-
•			Ō			6	1 12	2.0 fps ().0s 🚺				8.8.8	1.10	1.1.1	000	001	•

Figure 13-2 The Completed Timeline

Applications Project Steps

Complete this exercise on your own, guided by following the general steps provided below. You can always refer back to the completed example that you viewed in the Take-a-Look section of this exercise.

Please Note: The following steps are intended as a guide. This is your project so please feel free to make whatever variations you would like.

- 1. Open application_11.fla. You can either use the copy you created and saved in the SaveWork Folder on your computer or you can use the copy in the Chapter11 Folder on the CD-ROM supplied with this book.
- Create a new Movie Clip Symbol named Locale MC. In its Symbol Editing Window, drag a copy of the Yellow Glow Graphic onto the Stage and position it at X=0.0, Y=0.0. Add additional Keyframes at Frames II and 21 of the Locale MC Timeline.

- 3. Rename the existing Layer Yellow Glow.
- 4. Select the Yellow Glow Instance in Frame 11 and resize it to W=18.7, H=18.7.
- 5. Create a Motion Tween between Frames 1-11, and another between Frames 11-21.
- 6. Create a new Layer above the Yellow Glow Layer and name it Actions.
- 7. Insert a Keyframe at Frame 21 of the Actions Layer and assign the following Action Script to it: gotoAndPlay (1);

(OK, so we haven't gotten into ActionScript yet ... but don't worry ... There isn't much to do here. You will get into the details of ActionScript in Chapter 16 – but it is so intertwined with the animation that we couldn't leave it out of this exercise.

- a) Select the Menu option **Window / Actions.**
- b) Click on the blue **Basic Actions Symbol** on the left side of the panel to expand it.
- c) The correct ActionScript is assigned automatically!
- d) Take a deep breath that wasn't too hard, was it?
- Recurn to the Main Movie and move the Locale MC 3ymbol to the Movie Clips Folder of the Library.
- 9. Create a new Layer above Text Layer and rename it Locators. Add Keyframes to Frames 1-5 of this Layer.
- Drag an Instance of the Locale MC Symbol to Frame 2 of the Locators Layer and position it at X=218.7,Y=334.1.
- Drag an Instance of the Locale MC Symbol to Frame 3 of the Locators Layer and position it at X=276.1,Y=353.4.
- Drag an Instance of the Locale MC Symbol to Frame 4 of the Locators Layer and position it at X=396.1,Y=329.6.
- Drag an Instance of the Locale MC Symbol to Frame 5 of the Locators Layer and position it at X=499.3,Y=329.5.
- 14. We don't see the immediate effect of dropping these Movie Clips into the Main Movie Timeline. Later, once we have set up the navigational controls through the use of Buttons and ActionScript, we will see these Movie Clips play whenever we go to the Frame that they are nested in.
- 15. Save your file as application_13.fla.

Summary

You have almost completed your interface design. In this chapter you learned how to set things in motion using Flash's animation tools. You can think of this exercise as creating the choreography for the elements of your site interface. With the completion of this exercise, you have produced an active and interesting visual experience for your users.

236

PTER

Working with Movie Clips and Smart Clips

14

Chapter Topics:

- Introduction
- Characteristics of Movie Clips
- Movie Clips and Graphic Symbols
- Practice Exercise Creating a Movie Clip
- Guided Tour Testing Movie Clips & The Bandwidth Profiler
- Smart Clips
- Practice Exercise –
 Customizing Smart
 Clips
- Summary

Introduction

Earlier in the book you learned that Symbols provide for very efficient re-use of objects and behaviors within Flash. We saw that there are three types of Symbols – Graphic, Button and Movie Clip – each with specific functions within Flash. In addition to these, Flash 5 has introduced a new secondary Symbol – the Smart Clip.

You have previously worked with Graphic Symbols, so in this chapter we will focus on the Movie Clip and the Smart Clip. The Movie Clip is like a minimovie with its own independent Timeline. Smart Clips are reusable just like other Symbols, and most closely resemble the Movie Clip. In fact the icon for Smart Clips is a modified Movie Clip Icon. The difference is that Smart Clips include ActionScripts and have clip parameters that can be customized for different applications such as drop down menus and radio buttons.

By the end of this chapter, you will be able to:

- describe the characteristics of Movie Clips.
- describe the difference between a Movie Clip and a Graphic Symbol.
- · create Movie Clips.
- insert Movie Clips into the Timeline.
- describe Smart Clips.
- · customize Smart Clips.

Characteristics of Movie Clips

Let's review the characteristics of Movie Clips that you learned in Chapter 10:

- Movie Clips have their own Timeline that is completely independent of the main
- Movie Timeline.
- Movie Clips are mini-movies that can have any of the features of other Movies created in Flash.
- ActionScripts can be used with Instances of Movie Clips to create interactivity.
- Movie Clips can be nested (placed) inside other Symbols.

Movie Clips have their own Timeline and Stage, just like Graphics Symbols. However, an important difference is that a Movie Clip Timeline is completely independent from the main Movie where it is inserted. Movie Clips can contain sound, interactivity and any other feature that can be included in the regular Flash Timeline.

There are many common uses for Movie Clips. In Chapter 15, you will learn to embed a Movie Clip inside a Button Symbol in order to make the button appear animated – in response to a user's mouse actions. Later in this book, you will also learn how to use Movie Clips in "drag and drop" interactions. This type of interaction requires that the user click the mouse on an object and then drag it across the screen, over to a specified target area. This "drag and drop" interaction is frequently used in gaming, e-commerce, and educational applications.

In addition, you can also use Movie Clips to set up "empty" Movies that perform based on the user's actions (you'll see more about this in the next chapter). Movie Clips are not limited solely to animation, but can also be powerful authoring tools to help you more efficiently build and control your project applications.

Movie Clips and Graphic Symbols

Movie Clips are inserted into a Keyframe in your main Movie Timeline and will start to play once the Movie reaches that particular Frame. After a Movie Clip Symbol has been encountered, it plays until it reaches the end of its own Timeline, unless an Action stops it from playing. In a previous chapter, you created a Graphic Symbol with a simple Frame-by-Frame animation. At first, it might seem confusing trying to understand the difference between a Graphic and Movie Clip Symbol. After all, both have their own Timelines in which you can add Layers, use Tweening, and apply many other animated effects.

On the surface, these Symbols may seem similar; however, they perform very differently from one another.

In order to illustrate this difference, let's review the general characteristics of Graphic Symbols that you learned in Chapter 10:

- The Graphic Symbol Timeline is **dependent** on the main Movie Timeline and will not play beyond the end of the main Movie, unlike Movie Clips.
- · ActionScripts do not work within a Graphic Symbol Timeline.
- Sounds on the Graphic Symbol Timeline will not play within the main Movie Timeline.

When a Graphic Symbol is inserted into the main Movie Timeline it is completely *dependent* on the Frames in the main Timeline. A Graphic Symbol will *not* move from Frame to Frame within its own Timeline unless there are corresponding Frames in the main Timeline. Graphic Symbols are very useful for creating animations that are precisely orchestrated to correspond to the actions taking place in the main Timeline, or for static images that are re-used throughout a Movie, like a company logo. In contrast with this behavior, if a Movie Clip is inserted into a Keyframe, *it will* play all the way through its own Timeline regardless of the length of the main Timeline it was inserted into.

CAUTION

Although you can insert Sounds into a Graphic Symbol Timeline and play them in Symbol Editing Mode, don't be fooled! Once the Graphic Symbol is inserted in the main Movie Timeline, the sound will not play.

Practice Exercise – Creating a Movie Clip

Description

In this exercise we will create a fairly complex animation. We will work with Symbols that look like Text and use Flash to make them move, re-scale, fade in and out and combine to make a pretty dazzling animated sequence. Sound tough? Don't worry! Even the most complex looking animation is easy when you realize that most often a complex animation is simply a large group of smaller, simpler steps.

In this exercise you will:

Create multiple Timelines.

Animate Symbols within their own Timelines.

Apply Tweening to Symbols.

• Adjust Scale in an animation.

Adjust Alpha in an animation.

Take-a-Look

Before beginning the exercise, let's take a look at the exercise in its completed state so that you can clearly see what it is that you are about to build.

- Use the Menu option File / Open and locate on the CD-ROM the folder named Chapter 14. Locate the file named total_sound.fla. Doubleclick on this file to open it.
- 2. The file total_sound.fla should now appear in your copy of Flash.
- Select the Menu option Control / Test Movie to see the Movie playback.

Please note the following properties of this completed exercise:

- a) Each animated element requires its own Layer.
- b) Keyframes are necessary in order to insert artwork or Symbol Instances within the Timeline.
- c) Multiple Frames are necessary to create an Animated effect.
- d) Animation isn't restricted to motion effects.

Storyboard: On-Screen

Figure 14-1 shows you what the Stage will look like once you've finished this exercise.

Working with Movie Clips and Smart Clips

Figure 14-1 Completed Exercise on the Stage

Storyboard: Behind the Scenes

Figure 14-2 shows you how the Stage and Timeline should look when you complete the exercise.

Step-by-Step Instructions

- I. Let's get started!
 - a) Select the Menu option File / Open. Locate and select the file named sound_new.fla from the Chapter I 4 Folder on the CD-ROM.
 - b) Double-click Layer I and rename it ... F.

- c) Select Frame I of the F Layer.
- d) **Drag** an Instance of the **F Symbol** from the **Library** and **drop it** on the **Stage**.
- e) If the Info Panel isn't visible, select the Menu option Window / Panels / Info. Set the Registration to Center by clicking the Center Square of the Grid in the middle of the Info Panel.
- f) Using Center Registration, click the mouse on the Instance of the F Symbol on the Stage and reposition it to X=120.2 and Y=186.4.
- g) Select Frame 5 in the F Layer. Press the F6 Key to Insert a Keyframe.
- h) Select Frame 10 in the F Layer. Press the F6 Key to Insert a Keyframe.
- i) Select Frame 5 in the F Layer. Select the Instance of the F Symbol on the Stage.
- j) Using the Info Panel, re-scale the Instance to W=24.4 and H=39.6.
- k) Using the Info Panel and Center Registration, reposition the Instance in Frame 5 to X= 1/20./2 and Y=178.4.
- Right Mouse Click (Mac Ctrl & Mouse Click) anywhere on the F Layer Timeline between Frames 2-4. Select Create Motion Tween from the pop up menu.
- m) Right Mouse Click (Mac Ctrl & Mouse Click) anywhere on the F Layer Timeline between Frames 6-9. Select Create Motion Tween from the pop up menu.
- 2. Now, let's add the Alpha Effect.
 - a) Right Mouse Click (Mac Ctrl & Mouse Click) the Instance of the F Symbol in Frame I of the F Layer.
 - b) Select Panels / Frame from the pop up menu.
 - c) Click on the Effect Tab and set the Effect Type to Alpha and the Value of the Alpha Effect to 0%.
 - d) Right Mouse Click (Mac Ctrl & Mouse Click) the Instance of the F Symbol in Frame 10 of the F Layer.
 - e) Select Panels / Frame from the pop up menu.
 - f) Click on the Effect Tab and set the Effect Type to Alpha and the Value of the Alpha Effect to 75%.
 - g) Select Frame 84 in the F Layer. Press the F6 Key to insert a Keyframe.
 - b) Using the Controller (see Figure 14-3), press the Rewind Button and then press the Play Button to preview your Movie up to this point.

If you have your Frame Panel open, you can also select Motion from the Tweening pull down menu.

·T/P

T/P

Remember, Alpha Effect deals with the opacity of an object. The higher the Alpha number, the more opaque (or the less transparent) an object. The lower the Alpha number, the less opaque (or the more transparent) an object.

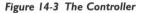

- Save the file in the SaveWork Folder on your own computer, naming it...sound_final.fla.
- 3. Now to set up the rest of the Layers.
 - a) **Press** the **Insert Layer Icon II times** (that's right ... I !!).
 - b) Drag the F Layer to the top of the new Layers. You can resize the Timeline by clicking and dragging downward on the bottom border. See Figure 14-4.

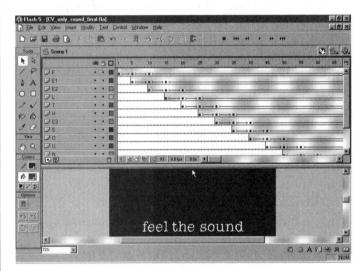

Figure 14-4 Resizing the Timeline.

- c) Starting with the Layer directly below the F Layer, rename each Layer ... EI, E2, L, T, H, E3, S, O, U, N, D.
- d) It's generally best to place each animated object on its own Layer. Trying to get more than one Instance to animate within a single Layer frequently produces unpredictable and undesirable results. Also, you cannot animate more than one Instance within the same Frame Numbers on a single Layer.
- 4. Now it's time to spell it out.
 - a) Select Frame 5 of the El Layer.
 - b) Press the F7 Key to insert a Blank Keyframe.

Shortcut

To quickly insert a Layer without using the Layer lcon, **Right Mouse Click** (Mac – Ctrl & Mouse Click) on a selected Layer and choose Insert Layer. This will insert a Layer above the selected Layer in the Timeline.

CH	IAP	TER	14
U 1	.,		

- c) **Drag an Instance** of the **E Symbol** from the Library and **drop it** on the Stage.
- d) Using the Info Panel, change to **Center Registration and reposi**tion the Instance of the E Symbol to X=139.5 and Y=190.9.
- e) Select Frame 10 in the EI Layer. Press the F6 Key to insert a Keyframe.
- f) Select Frame 15 in the E1 Layer. Press the F6 Key to insert a Keyframe.
- g) Select Frame 10 in the E1 Layer. Select the Instance of the E Symbol on the Stage.
- h) Using the Info Panel, re-scale the Instance to W=27.3 and H=29.9.
- i) Using the Info Panel and Center Registration, reposition the Instance to X= 139.5 and Y=182.9.
- j) Right Mouse Click (Mac Ctrl & Mouse Click) anywhere on the EI Layer Timeline between Frames 5-9. Select Create Motion Tween from the pop up menu.
- k) Right Mouse Click (Mac Ctrl & Mouse Click) anywhere on the EI Layer Timeline between Frames II-I4. Select Create Motion Tween from the pop up menu.
- 5. Now for the Alpha Effect.
 - a) Select the Instance of the E Symbol in Frame 5 of the EI Layer.
 - b) Click on the Effect Tab and set the Effect Type to Alpha and the Value of the Alpha Effect to 0%.
 - c) Select the Instance of the E Symbol in Frame 15 of the E1 Layer.
 - d) Click on the Effect Tab and set the Effect Type to Alpha and the Value of the Alpha Effect to 75%.
 - e) Select Frame 84 in the EI Layer. Press the F6 Key to insert a Keyframe.
- 6. Use the following guidelines to add Animated Keyframes to all of the remaining Layers (don't forget to Tween them!):

In Layer E2:

Add a Keyframe to Frame 10

Position an Instance of the E Symbol at X=166.5,Y=190.9.

Set the Alpha Value to 0%.

Insert Keyframes in Frames 15 and 20.

Change the Alpha Value in Frame 15 to 75%.

Re-scale the Instance in Frame 15 to W=27.3, H=29.9.

Reposition the Instance in Frame 15 to X=166.5, Y=182.9.

Set the Alpha Value to 100%.

To quickly select an Instance and open the Instance Panel, **Right Mouse Click (Mac – Ctrl & Mouse Click)** on the Instance. Then, select Panels / Instance from the pop-up menu.

Shortcut

All the Symbols you will need in Step 6 can be found in the Library. The Info Panel and the Effect Tab will be used through out the following steps.

Working with Movie Clips and Smart Clips

Add a Keyframe to Frame 84. In Layer L: Add a Keyframe to Frame 15. Position an Instance of the L Symbol at X=188.6, Y=186.1. Set the Alpha Value to 0%. Insert Keyframes in Frames 20 and 25. Change the Alpha Value in Frame 25 to 75%. Re-scale the Instance in Frame 20 to W=17.7, H=39.4. Reposition the Instance in Frame 20 to X=188.6, Y=178.1. Set the Alpha Value to 100%. Add a Keyframe to Frame 84. In Layer T: Add a Keyframe to Frame 20. Position an Instance of the T Symbol at X=218.5, Y=187.1. Set the Alpha Value to 0%. Insert Keyframes in Frames 25 and 30. Change the Alpha Value in Frame 30 to 75%. Re-scale the Instance in Frame 25 to W=20.9, H=38.3. Reposition the Instance in Frame 25 to X=218.5,Y=179.1. Set the Alpha Value to 100%. Add a Keyframe to Frame 84. In Layer H: Add a Keyframe to Frame 25. Position an Instance of the H Symbol at X=244.0,Y=186.4. Set the Alpha Value to 0%. Insert Keyframes in Frames 30 and 35. Change the Alpha Value in Frame 35 to 75%. Re-scale the Instance in Frame 30 to W=35.5, H=40.1. Reposition the Instance in Frame 30 to X=244.0, Y=178.4. Set the Alpha Value to 100%. Add a Keyframe to Frame 84. Hang in there... you're doing great! In Layer E3: Add a Keyframe to Frame 30. Position an Instance of the E Symbol at X=271.4, Y=190.9. Set the Alpha Value to 0%. Insert Keyframes in Frames 35 and 40.

Change the Alpha Value at Frame 40 to 75%.

Re-scale the Instance in Frame 35 to W=27.3, H=29.9.

To insert a Keyframe, you can also Right Mouse Click (Mac – Ctrl & Click) on the appropriate Frame and select Insert Keyframe or Insert Blank Keyframe from the pop up menu.

Shortcut

Reposition the Instance in Frame 35 to X=271.4,Y=182.9. Set the Alpha Value to 100%.

Add a Keyframe to Frame 84.

In Layer S:

Add a Keyframe to Frame 35.

Position an Instance of the S Symbol at X=312.1,Y=190.4.

Set the Alpha Value to 0%.

Insert Keyframes in Frames 40 and 45.

Change the Alpha Value in Frame 45 to 75%.

Re-scale the Instance in Frame 40 to W=24.4, H=32.0.

Reposition the **Instance** in **Frame 40** to **X=312.1,Y=182.4**.

Set the Alpha Value to 100%.

Add a Keyframe to Frame 84.

In Layer O:

Add a Keyframe to Frame 40.

Position an Instance of the O Symbol at X=338.1,Y=190.1. Set the Alpha Value to 0%.

Insert Keyframes in Frames 45 and 50.

Change the Alpha Value in Frame 50 to 75%.

Re-scale the Instance in Frame 45 to W=26.3, H=29.9.

Reposition the Instance in Frame 45 to X=338.1,Y=182.1.

Set the Alpha Value to 100%.

Add a Keyframe to Frame 84.

In Layer U:

Add a Keyframe to Frame 45.

Position an Instance of the U Symbol at X=367.4,Y=190.9. Set the Alpha Value to 0%.

Insert Keyframes in Frames 50 and 55.

Change the Alpha Value in Frame 55 to 75%.

Re-scale the Instance in Frame 50 to W=35.3, H=30.1.

Reposition the **Instance** in **Frame 50** to **X=367.4**, **Y=182.9**.

Set the Alpha Value to 100%.

Add a Keyframe to Frame 84.

In Layer N:

Add a Keyframe to Frame 50.

Position an Instance of the N Symbol at X=399.7,Y=190.4.

Set the Alpha Value to 0%.

Insert Keyframes in Frames 55 and 60.

Change the Alpha Value in Frame 60 to 75%.

Re-scale the Instance in Frame 55 to W=35.8, H=29.9.

Working with Movie Clips and Smart Clips

Reposition the Instance in Frame 55 to X=399.7,Y=182.4. Set the Alpha Value to 100%. Add a Keyframe to Frame 84.

And finally...

In Layer D:

Add a Keyframe to Frame 55. Position an Instance of the D Symbol at X=431.1,Y=186.8. Set the Alpha Value to 0%. Insert Keyframes in Frames 60 and 65. Change the Alpha Value in Frame 65 to 75%. Re-scale the Instance in Frame 60 to W=31.3, H=40.9. Reposition the Instance in Frame 60 to X=431.1,Y=178.8. Set the Alpha Value to 100%. Add a Keyframe to Frame 84.

Your Timeline should now look like Figure 14-5. Use the Controller to Rewind the Movie and then press the Play Button to preview your Movie up to this point. Looking good! You're well on your way to becoming the envy of your peers! Let's add just a couple of other fading animations to make the Movie a little more dynamic.

		(d)	8		15	10	15	20	25	30	35	40	45	50	55	60	65	H
□ F	N2	•	• [• > • >	• >					<u></u>							-
🕞 E1		•	• [• >	• >												
D E2		•	• [• >												
Dι		•	• [• >		→•≻		<u></u>			<u></u>		<u></u>		
🕞 T		•	• [•>	→ • >					<u></u>	0000	<u></u>		_
₽н		٠	• [• >	→ • ≻		<u> </u>	<u></u>		<u></u>			_
🕞 E3		٠	• [• >		, •, ≻	<u> </u>	<u></u>	<u> </u>	<u></u>	<u> </u>	4
🕞 s		٠	•								•							4
0		•	• [• >		• >		<u></u>	<u></u>	
ΟU		•	• [• >			<u></u>		
D N		•	• [•				20
DD		•	• [• >	<u>→•≻</u>	→• ≻	-+
•			6	3	100	6	83 8	8 fps 9.	3s 🖣								•	·ſ

- 7. Now to add finesse.
 - a) Create two new Layers and drag them to the bottom of the existing Layers. Name them (from top to bottom)...Fade In and... Fade Out.
 - b) Select Frame 65 in the Fade In Layer and press the F6 Key to insert a Keyframe.

C	н	Α	P	Г	F	R	1	4

c) Drag an Instance of the Sound MC Symbol onto the Stage to insert it into Frame 65 of the Fade In Layer. Re-scale the Instance to W=2082.3 and H=221.9. Position it (using Center Registration) at X=1050.7 and Y=120.7, then change the Alpha Value to 0%.

- d) Insert a Keyframe (F6) at Frame 83 of the Fade In Layer. Rescale the Instance to W=335.0 and H=35.7. Position it (using Center Registration) at X=277.1 and Y=186.8, then change the Alpha Value to 100%.
- e) Right Mouse Click (Mac Ctrl & Mouse Click) anywhere between Frames 66-82 and choose Create Motion Tween.
- f) Select Frame 65 of the Fade Out Layer and press the F6 Key to insert a Keyframe.
- g) Drag an Instance of the Sound MC Symbol onto the Stage to place it into Frame 65 of the Fade Out Layer. Re-scale the Instance to W=335.0 and H=35.7. Position it (using Center Registration) at X=277.1 and Y=186.8. Keep the Alpha Value at 100%.
- h) Insert a Keyframe (F6) at Frame 83 of the Fade Out Layer. Re-scale the Instance to W=2082.3 and H=221.9. Position it (using Center Registration) at X=1050.7 and Y=120.7, then change the Alpha Value to 0%.
- i) Right Mouse Click (Mac Ctrl & Mouse Click) anywhere between Frames 66-82 and choose Create Motion Tween.
- 8. Finishing up...

Now it would be perfectly all right to leave our Movie just as it is ... if this animated sequence was all we wanted to create. But what if there is more to our Movie? Do we keep adding Frames and Layers to the existing Timeline? We could do this ... but here's another approach that is better – convert the animation we just created into a Movie Clip Symbol and then place the Movie Clip in the Main Movie Timeline. Let's give it a try.

- a) Right Mouse Click (Mac Ctrl & Mouse Click) in the main Movie Timeline and choose Select All from the pop up menu to Select all Frames in the Timeline.
- b) Right Mouse Click (Mac Ctrl & Mouse Click) on the selected Frames and choose Copy Frames from the pop up menu.
- c) Select the Menu option Insert / New Symbol.
- d) Name the new Symbol FinalSound MC and make sure the Symbol Behavior is set to Movie Clip, then press OK.

Working with Movie Clips and Smart Clips

- e) Select Frame I of Layer I in the FinalSound Timeline and choose Paste Frames from the pop up menu.
- f) **Click** the **Scene I Tab** to return to the main Movie Timeline. **Click** the **Delete Layer Icon** until all Layers are deleted.
- g) Click the New Layer Icon to add a new Layer to your main Movie Timeline, and drag an Instance of the FinalSound Movie Clip Symbol onto the Stage in Frame 1 of the new Layer.
- h) Use the Info Panel to reposition it at X=277.1 and Y=199.6 using Center Registration.

Our new Timeline looks much less formidable, doesn't it? That was some work, but well worth it! You have just completed the type of exercise that makes Flash such a valuable tool. Understanding how to structure animation like the one we just completed gives you the skills you'll need to improve your marketability and value as a designer. Outstanding!

Guided Tour – Testing Movie Clips and the Bandwidth Profiler

Test and Preview may on the surface seem to be the same function within Flash but they are actually quite different. When you Preview a Movie, you are previewing your Timeline, while still within the authoring mode on the Stage. You will generally press the Enter/Return Key to step through your Timeline. You can also use your Controller to Preview your Movie on the Stage. During a Preview, Motion Guides, Grids, Guides, and anything in the Work Area will still be visible as the Timeline plays. In general, Preview allows you to check your work but is not an exact representation of what the user will see.

On the other hand, Testing your Movie allows you to view your Movie exactly as the user will see it, without any Guides, Grids, or anything outside of the Stage area visible. When you select the Menu option Control / Test Movie (or use the keyboard shortcut, Ctrl & Enter on the PC or Cmd & Return on the Mac) to test a Movie, Flash generates a sample **.swf** file that will be stored in the same folder as your original **.fla** Movie file. The new window that opens plays back the Movie and allows you to use tools such as the Bandwidth Profiler (which you are going to learn about now), and the Debug tool.

- I. Let's now test the Movie Clip we just completed.
 - a) Select the Menu option **Control / Test Movie.** The **.swf** file should now be open and playing.
 - b) As the Movie is playing, select the Menu option View / Zoom In. This will, of course, Zoom In closer to the image. Next, select View / Zoom Out to return to a 100% preview size.

You cannot Preview a Movie Clip on the Stage. You must use the Test Movie option in order to preview Movie Clips. Since Movie Clips have a Timeline that is independent from the main Movie Timeline, they don't respond to normal commands (like using the Enter/Return Key or the Controller). Select the Menu option Control / Test Movie. Or, you can use the Keyboard Shortcut Ctrl & Enter (Mac – Cmd & Return) to test your Movie as your users would see it.

· T/P

- c) As the Movie continues to play, select the Menu option View / Bandwidth Profiler. This very helpful panel displays your Movie settings, the playback settings, and even gives you a graphic representation of the Frame-by-Frame data load of the Movie. Looks like no Frame is larger than 400 bytes in size... not too bad! The lower the data load, the faster the download and playback. Select View / Bandwidth Profiler again to remove the check mark in the menu... and the profiler from the screen.
- d) As the Movie continues to play, select the Menu option View / Quality / Low. This will preview the Movie with no anti-aliasing (bitmap-smoothing). This maximizes playback speed. Medium will anti-alias everything but Text (actual Text, not shapes that look like letters like we've been using) and High will anti-alias everything (and can potentially slow down playback as the computer tries to keep up with the Movie speed). Try them out!
- Note that the nested Movie Clip plays in a continuous looping manner. In Chapter 15 we will explore the Actions Panel to see some of the playback commands we could potentially add to our Movie Clip or main Movie.

Smart Clips

Smart Clips are a new type of secondary Symbol available in Flash 5. They are reusable just like other Symbols, and most closely resemble Movie Clips. The icon for Smart Clips looks like a modified Movie Clip Icon. See Figure 14-6.

Library - Movie1 One item in librar	Options ∡
	Options a
Name	4
Name	Á
Name	á

Figure 14-6 The Smart Clip Icon

Smart Clips are like Movie Clips that contain their own Timeline, but also have ActionScripts with customizable parameters built into them. These

parameters are frequently used as templates for items such as pull down menus and multiple choice forms. The Smart Clip Library in Flash 5 contains some general clips that are designed to be used in a variety of situations, including a customizable pull down menu. Since these parameters can be customized to fit the application you are building, it may not be necessary for you to actually learn how to build Smart Clips.

As a "rule-of-thumb," Smart Clips are generally created by more experienced programmers, but they can be easily used and customized by anyone. This is just another example of how different types of Web professionals (designers to programmers), at many different levels (novice to advanced), can all use Flash 5.

Practice Exercise – Customizing Smart Clips

Description

In this exercise you will create and customize a row of radio buttons using Smart Clips.We'll cover the basics of how to insert, customize, and use Smart Clips without getting too deep into detail.

In this exercise you will:

- Insert Smart Clips into the Timeline and place three Radio Buttons on Stage.
- Make use of the Smart Clip Panel to change parameters.

Take-a-Look

Before beginning the exercise, let's take a look at the exercise in its completed state so that you can clearly see what it is that you are about to build.

- Use the Menu option File / Open and locate on the CD-ROM the folder named Chapter 14 and then locate the file named enroll_final.fla.
 Double-click on this file to open it.
- 2. The file enroll_final.fla should now appear in your copy of Flash.
- Select the Menu option Control / Test Movie to see a playback of the Movie.

Please note the following properties of this completed exercise:

- a) In the editing mode, the Radio Buttons show up as dotted target areas.
- b) In the Play mode, the Radio Buttons show how you will customize the Clip Parameters.

Storyboard: On-Screen

Figure 14-7 shows you how the Stage will look once you've finished this exercise.

Figure 14-7 The Completed Exercise - On Stage

Storyboard: Behind the Scenes

Figure 14-8 shows you how the Stage and Timeline will look when you complete the exercise.

Figure 14-8 Completed Stage and Timeline

252

Step-by-Step Instructions

- I. Let's get started!
 - a) Select the Menu option File / Open. Locate and select the file named enroll_start.fla from the Chapter14 Folder on the CD-ROM. Save it to the SaveWork Folder on your own computer and rename it enroll_1.fla.
 - b) Create a new Layer in the Timeline. Name the Layer...Smart Clips and make sure it is at the top of the Layer stacking order.
 - c) Select the Menu option Window / Common Libraries / Smart Clips. The Smart Clips Library now appears. See Figure 14-9.

Go Solo

CD-ROM

Figure 14-9 The Smart Clip Library

d) Drag an instance of the Radio Button Smart Clip to the Stage. Use your Info Panel to reposition the Smart Clip at X=41 and Y=236. Drag three more instances of the Radio Button Smart Clip and position them on the Stage as follows:

 Smart Clip #2:
 X=41
 Y=261

 Smart Clip #3:
 X=41
 Y=286

 Smart Clip #4:
 X=41
 Y=311

e) The Stage should look similar to the Stage shown in Figure 14-10. Test the Movie by selecting the Menu option **Control / Test Movie**. Hmmm...not too impressive.To make the Smart Clips functional we need to change a few of the properties for each instance. **Close** this Test Movie file and return to the main Movie.

Figure 14-10 Four Smart Clips Positioned on the Stage.

- 2. Let's now edit our Smart Clips.
 - a) Right Mouse Click (Mac Ctrl & Mouse Click) on the top instance of the Radio Button Smart Clip. Select the pop up Menu option Panels / Clip Parameters. The Clip Parameters Panel now appears. See Figure 14-11.

👫 Clip Parameters	()
Name	Value
name	radioBox1
checked	false
label	defaultValue

Figure 14-11 The Clip Parameters Panel

b) By dragging the bottom of the Clip Parameters Panel you can expand it and reveal more information about the Smart Clip that you have selected on the Stage. See Figure 14-12. Take a moment to review the information you find here.

Clip Parameters allow you to customize Smart Clips for your particular application. The Clip Parameters settings are what make Smart Clips such a versatile Symbol since they can contain general Actions that can be altered to suit your particular purposes.

CHAPTER 14

·T/P

Working with Movie Clips and Smart Clips

Name	Value
_name	radioBox1
checked	false
label	defaultValue
style	Auto
nstance name checked - set to tru label - the word	re is set to unique le to start out checked ing that the end user
nstance name checked - set to tru label - the word sees API Method Summ	e to start out checked ing that the end user ary (ex:
Instance name checked - set to tru label - the word sees API Method Summ _name.setLabel("Th	e to start out checked ing that the end user ary (ex: iis is cool");)
instance name checked - set to tru label - the wordi sees API Method Summ. _name.setLabel("Th Name	e to start out checked ing that the end user ary (ex:
instance name oheoked - set to tru label - the word sees API Method Summ _name.setLabel("TP Name getLabel()	e to start out checked ng that the end user ary (ex: is is cool");) Description
Instance name ohecked - set to tru label - the word sees API Method Summ. _name.setLabel("Th Name	e to start out checked ng that the end user ary (ex: is is cool");) Description Gets the label of this Determines boxt is in the "on" or
instance name oheoked - set to tru label - the word sees API Method Summ. _name.setLabel("Th Name getLabel() otheok box. getState() whether this check to "off" state. isRadioButton() objects which are ra	e to start out checked ng that the end user ary (ex: is is cool");) Description East the label of this Determines pox is in the "on" or Returns true for dio buttons.

Figure 14-12 The Expanded View of the Smart Clip Parameters Panel

- c) Make sure the top instance of the Radio Button is selected on the Stage. In the Clip Parameters Panel, double-click default Value in the label section to edit it. Rename the label section ... Winter 2004. Leave the rest of the settings at their default values.
- d) **Select** the **second instance** of the Radio Button Smart Clip. In the Clip Parameters Panel, change the values as follows:

_name:	radioBox2
checked:	false
label:	Spring 2004
style:	auto

e) **Select** the **third instance** of the Radio Button Smart Clip. In the Clip Parameters Panel, change the values as follows:

_name:	radioBox3
checked:	false
label:	Summer 2004
style:	auto

f) Select the fourth instance of the Radio Button Smart Clip. In the Clip Parameters Panel, change the values as follows:

_name:	radioBox4
checked:	false
abel:	Fall 2004
style:	auto

- g) Test the Movie by selecting the Menu option **Control / Test Movie.** Each Smart Clip is now showing a different value and the radio buttons are clickable. Way to go!
- 3. Save your work.

Summary

- Movie Clips are mini-movies. Movie Clips have their own Timeline and Stage just like Graphic Symbols. However, an important difference is that the Movie Clip Timeline is completely independent from the main Movie where it is inserted. Also, unlike Graphic Symbols, Movie Clips can contain sound, interactivity and any other feature that can be included in a regular Movie Timeline.
- If a Movie Clip is inserted into a Keyframe, it will play all the way through its own Timeline regardless of the length of the main Movie Timeline
- A Movie Clip cannot be previewed on the Stage. You must use the Menu option Control / Test Movie in order to see a Movie Clip playback.
- In the first Practice Exercise, you created a Movie Clip based on using fairly complex animation; multiple Timelines; nested Symbols; applying Tweening to Symbols; and adjusting the scale and alpha values.
- You then took a Guided Tour and tested your Movie Clip using the Bandwidth Profiler.
- Smart Clips are a new type of secondary Symbol, now available in Flash 5. They are reusable just like other Symbols, and most closely resemble Movie Clips.
- Smart Clips have parameters that can be customized and are generally used as templates for items such as pull down menus and multiple choice forms. Smart Clips are like Movie Clips that contain their own Timeline, but also have sophisticated customizable Clip Parameters built into them.
- In the second Practice Exercise you customized your first set of Smart Clips as Radio buttons.

PTER

15

Using Button Symbols

Chapter Topics:

- Introduction
- The Characteristics of Button Symbols
- Enabling Buttons
- Guided Tour The Button States
- Practice Exercise Creating Button Symbols
- Practice Exercise Creating Animated Buttons
- Adding Actions to Button Instances
- Guided Tour The Actions Panel

•

.

- Practice Exercise Adding Actions to Button Instances
 - Summary

Introduction

Button Symbols are an easy way to add interactivity and navigational control to your Flash Movies. This type of Symbol is specifically designed to correspond with the user's mouse actions and will make your life much easier by removing a lot of the programming work out of creating buttons that appear to "go up and down." Button Symbols make it very easy to create the different "button states" that include the normal button position (Up); the condition when a user's mouse moves over the button (RollOver); and when the user clicks on the button (Down).Without Flash, these "button states" are frequently programmed with JavaScript.

In order to add even more interesting visual effects, you can place a Movie Clip inside a button to create an eye-catching animated button. Later in this chapter, we will give this a try.

By the end of this chapter, you will be able to:

- describe the Button Timeline.
- · describe the characteristics of Button Symbols.
- · enable Button Instances on the Stage.
- nest Movie Clips in a Button Symbol.
- test animated Buttons.
- describe the basic purpose of the Actions Panel.
- · add an Action to a Button Instance.

The Characteristics of Button Symbols

Button Symbols are very different from both Graphic and Movie Clip Symbols. As you learned in previous chapters, both Graphic and Movie Clip Symbols have their own Timelines and Stages where you can add animation. Movie Clips act as mini-Movies that can play independently of your main Movie Timeline, while Graphic Symbols are tied more closely to the main Movie Timeline.

Let's review what we learned in Chapter 10 about the general characteristics of Button Symbols:

- ActionScripts can be attached to Button Instances to add interactivity.
- Sounds can be added to different Button States.
- Movie Clips can be placed within Button Frames to provide animation for a button.
- The Hit Frame is a non-visible Frame that defines the Button's "hot area," or the area that responds to mouse activity.

Button Symbols have a very unique Timeline with only four Frames. These Frames correspond to the "mouse states" of – Up, Over, Down, and Hit. Each Frame is named according to its state. These different button states combine to provide a visual response to a user's mouse actions. It's important to understand that a Button Symbol cannot actually be animated like Graphic and Movie Clip Symbols. Button Symbols "jump" to one of four Frames depending on the mouse action that occurs. So, the Button Symbol Timeline is tied directly to the user's activity. Here's a description of each Frame's purpose in the Timeline:

- The Up Frame contains the image of the button as it appears in the normal "up" position with no user interaction. This would be considered the "default" state of the Button and what the user sees when the Movie loads initially.
- The Over Frame contains the "rollover" image that appears when a user places the mouse cursor over the Button Instance's hit area.
- The Down Frame contains the "down" image that appears for a brief time when the user clicks on the Button Instance's hit area.
- **The Hit Frame** is an invisible Frame where you can define the boundaries of the active area of the button. This is basically like defining a "hot spot" or click-able active area for your button.

At first, it may seem limiting to have only four Frames in your button Timeline as you begin to design buttons. In practice, however, these four states actually do provide the illusion of the button moving up and down in response to the user's mouse actions. Remember as you design your buttons, that you can always add extra Layers as you work. And to create even more "active" effects, later in this chapter you will learn to place Movie Clips in a Button Symbol to provide animation within your Button designs. Think of the elaborate buttons you can make using Layers and Movie Clips!

Enabling Buttons

When you drag a Button Symbol onto the Stage, you will *not* be able to see the Symbol "in action" unless you Enable the button. Enabling a button will allow you to preview each of the four button states right on your Stage as you work. To Enable a Button means any Button Instances on the Stage will now respond to your mouse actions (Up, Over, Down, Hit). This gives you a Preview of your Buttons. You will also notice, however, once Enable Buttons is turned on, you will no longer be able to select the button to move it or alter it in any way.

You can Enable a button by selecting the Menu option **Control / Enable Simple Buttons.** See Figure 15-1. To turn Enable Buttons off, just repeat the

Control / Enable Simple Buttons selection. The check mark next to the Enable Buttons option in your pull down menu will disappear to signify that this command is now inactive.

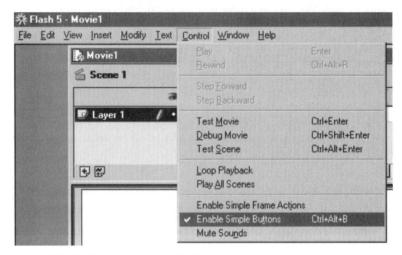

Figure 15-1 Enabling Buttons on the Stage

Guided Tour - The Button States

During this tour you will take a first-hand look at the four button states that can be used to create buttons within your Flash Movie. We will be looking at a completed version of a Button so that we can get a better understanding of these different button states.

- I. Select the Menu option File / Open.
- Locate and open the button_01.fla file in the Chapter15 Folder on the CD-ROM.
- 3. **Double-click** the Instance of the **red_glow_button** that is on the **Stage** in the Main Timeline to enter Editing Mode. See Figure 15-2.

260

- 4. Take a look at the Timeline within the red_glow_button. The Timeline of every Button is composed of the same four Frames: the Up Frame, the Over Frame, the Down Frame, and the Hit Frame. Scroll through and preview these four Frames.
 - The Up Frame has an image of a metal rimmed red button, which provides a strong visual cue to the viewer that this is a clickable object.
 - The Over Frame contains the same image with an added feature: the button appears to be "lit-up" when the viewer rolls the mouse cursor over the button.
 - The Down Frame has the same Button image but the interior light is even brighter, providing affirmation to the viewer that something is happening when they click the button.
 - The **Hit** Frame contains a green spot. This green spot is invisible to the viewer and serves only to map out the area of the button that is actually clickable (therefore it is the same shape and size as the part of the Button that the viewer sees on-screen).
- 5. Save the file to the SaveWork Folder on your computer
- 6. Select the Menu option Control / Test Movie to test the Movie.
- 7. Roll over the Button to see the Over Frame, then click the Button to see the Down Frame. Note that you never see the green spot that is in the Hit Frame ... it only defines what part of the Button is clickable.
- 8. Close the preview and then close the button_01.fla file without saving any changes.

Practice Exercise – Creating Button Symbols

Description

In this exercise you will create a button that responds to mouse actions by creating a Button Symbol. You will first add artwork to each Frame (Button State) in the Button Timeline, and then see how to Enable buttons for preview on the Stage.

In this exercise you will:

- · Create a new Button Symbol.
- Assemble each button state in Symbol Editing Mode.
- Enable the button for preview on the Stage.

Take-a-Look

Before beginning the exercise, let's take a look at the exercise in its completed state so that you can clearly see what it is that you are about to build.

Shortcut

The Keyboard Shortcut for Test Movie is: PC – Ctrl & Enter Mac – Cmd & Return

·T/P

lf you don't turn off Enable Simple Buttons, you will not be able to select or edit your Button Instances on the Stage. When Buttons are Enabled. the Button Instances respond only to mouse actions and will display the corresponding Frames in their Button Symbol Timeline – Up, Over, and Down. **Enabling Buttons** allows you to preview the action of the buttons but you will not be able to edit them while Enabled.

- Use the Menu option File / Open and locate the Chapter I 5 folder on the CD-ROM. Find the file named red_glow_button.fla. Double-click on the file to open it.
- 2. The file red_glow_button.fla should now appear in your copy of Flash.
- 3. Make sure that the button is not Enabled by selecting the Control Menu and looking to see if there is a check mark next to Enable Simple Buttons. If there is a check mark – select Enable Simple Buttons, which will remove the check mark and turn off button enabling on the Stage. If there is no check mark – simply click on the background to close the Menu.
- 4. **Double-click** the Instance of the **red_glow_button** that is on the **Stage** in the Main Timeline to enter the Editing Mode.
- 5. Take a look at the Timeline within the **red_glow_button**. The Timeline of the Button is composed of four Frames: the **Up** Frame, the **Over** Frame, the **Down** Frame, and the **Hit** Frame. Select each Frame to look at these four button states while in the Editing Mode.
- Now Enable the Button by selecting the Menu option Control / Enable Simple Buttons...And then use your mouse to view the different button states in play.

Please note the following properties of this completed exercise:

- a) The Up, Down, and Over Frames each contain a different graphic of the button.
- b) The Hit Frame contains the clickable area that will trigger button actions.
- c) The Menu option **Control / Enable Simple Buttons** determines whether the button will respond to mouse actions on the Stage (Enabled), or if it can be selected and/or edited (not Enabled).

Storyboard: On-Screen

Figure 15-3 shows you how the Stage will look when you finish this exercise.

Figure 15-3 Button as Viewed On Stage

262

Storyboard: Behind-the-Scene

Figure 15-4 shows you how the Stage and Timeline will look once you finish your button.

	🗞 red_glow_button.fl	x1	
© Graphics / • • ■	🖆 <u>Scene 1</u> 🔄 rec	Lglow_button	e , 4 ,
		C L Up Over Down Hit	щ
	🕼 Graphics		_
	₽₽		fps 0.0s 4
+			<u>*</u>
-			
+			
			(+))
00% • 6 rems • U			Library - red_glow_butt

Figure 15-4 The Completed Stage and Timeline

Step-by-Step Instructions:

- 1. First we will tackle the basics for creating a new Button Symbol.
 - a) Select the Menu option File / Open. Locate and open the practice_button.fla file in the Chapter15 Folder on the CD-ROM.
 Save this file to the SaveWork Folder on your own computer, using the current file name.
 - b) Select the Menu option Insert / New Symbol. Name the Symbol ...red_glow_button and choose Button as the Behavior.
 - c) Click OK. The red_glow_button Timeline appears. Double-click on Layer I and rename it ... Graphics.
 - d) Select Frame I (the Up Frame) in the Graphics Layer.
 - e) Use the Keyboard Shortcut (PC Ctrl & L; Mac Cmd & L) to view the Library.
- 2. Now . . . we've got some work to do.
 - a) Select the Up Frame.
 - b) Drag an instance of the button_bg Symbol to the Stage. Select the Menu option Window / Panels / Info and click the center position in the Registration Icon next to the X and Y position boxes. Reset both the X and Y coordinates of the button_bg Symbol to ... 0. This centers the Symbol on the Stage.

Go Solo

· T/P·

Notice that we are inserting Graphic Symbols into the Frames in the Button Timeline. This concept is often called "nesting Symbols," and we will use it often throughout this book. It is not necessary to nest Symbols inside the Button Frames to create your Buttons. You can also draw directly on the Stage with the Flash drawing tools to create the content for each Button State.

- c) Select the Over Frame in the Timeline. Press the F6 Key to insert a Keyframe.
- d) Select the Down Frame in the Timeline. Press the F6 Key to insert a Keyframe.
- e) Select the Up Frame in the Timeline. Drag an Instance of the red_disk_up Symbol onto the Stage.
- f) Reset both the X and Y coordinates of the red_disk_up Symbol to ... 0 in the Info Panel.
- g) Select the Over Frame in the Timeline. Drag an Instance of the red_disk_over Symbol onto the Stage.
- h) **Reset** both the **X** and **Y** coordinates of the **red_disk_over Symbol** to ... 0 in the Info Panel.
- i) Select the Down Frame in the Timeline. Drag an Instance of the red_disk_down Symbol onto the Stage.
- Reset both the X and Y coordinates of the red_disk_down Symbol to ... 0 in the Info Panel.
- k) Select the Hit Frame in the Timeline. Press the F7 Key to insert a Blank Keyframe.
- Drag an Instance of the hit_area Symbol to the Stage. Reset both the X and Y coordinates of the hit_area Symbol to ... 0.
- m) **Select** the **Scene I Tab** at the top of the Timeline to return to the main Movie.
- n) Drag an Instance of the red_glow_button onto the Stage. You'll notice that the button doesn't behave like a button yet. At this point, a Button will behave like any other graphic while on the Stage.
- 3. We could test our Movie at this point (Control / Test Movie), but there is a shortcut that allows you to preview Button Instances on the Stage without testing the Movie. Let's try it.
 - a) Select the Menu option **Control / Enable Simple Buttons.**
 - b) Move your mouse cursor over the red_glow_button. It shows you the Over Frame! Next, Click the red_glow_button. Now we see the Down Frame! The Hit Frame is evidenced every time we roll over or click the Button (if we didn't have anything in the Hit Frame, the Button wouldn't have an active, clickable area). Outstanding!
 - c) Select the Menu option Control / Enable Simple Buttons once again to disable Button actions. Now we can select and edit the Button like any other Instance.
- Save your work ... but keep this file open ... we will use it in the next exercise.

Practice Exercise – Creating Animated Buttons

Description

In the previous exercise you learned to set up a button that responds to mouse actions. In this exercise we are going to take a few additional steps to animate a Button by nesting Movie Clips Symbols inside a Button Timeline.

In this exercise you will:

- Use the Swap Symbol function to replace a nested Graphic Symbol with a Movie Clip Symbol.
- Test the button in order to view the embedded Movie Clip.

Take-a-Look

Before beginning the exercise, let's take a look at the exercise in its completed state so that you can clearly see what it is that you are about to build.

- Use the Menu option File / Open and locate the Chapter15 folder on the CD-ROM. Find the file named animate_button.swf. Double-click on file to open it.
- 2. The file animate_button.swf should now be playing on your screen.
- 3. Try out the button.

Please note the following properties of this completed exercise:

- a) Mouse actions activate different Frames (Up, Over, Down, and Hit) in the Button Symbol.
- b) There is an animated Movie Clip that plays continuously as long as the mouse remains within the target area.
- c) Clicking the button results in the display of the Down Frame.

Storyboard: On-Screen

Figure 15-5 shows you how the Stage will look when you finish this exercise.

TP

- d) Select the Menu option Window / Panels / Instance if the Instance Panel isn't already visible.
- e) Click the Swap Symbol Icon on the Instance Panel. See Figure 15-7.

Instance			×
[]] Instan	ce		? >
	red_disk_over		
Behavior:	Graphic		•
	Loop		-
First:	1		
		10 2	F 7
		<u>= 01 [G]</u>	

Swap Symbol Icon

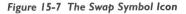

f) The Swap Symbol Dialog Window appears. See Figure 15-8.

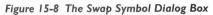

- g) Select the over_morph Movie Clip Symbol from the list of Symbols and click OK.
- h) The red_disk_over Symbol has now been replaced by the over_morph Movie Clip symbol.
- 2. Let's test it out!
 - a) Click the Scene I Tab.
 - b) Select the Menu option Control / Enable Simple Buttons.

The red disk over Symbol was the Graphic Symbol that we added to the Over Frame in the previous exercise. An alternate approach to what we just did ... would have been to open the red glow button Symbol in Symbol Editing Mode. Then, you could delete the red_disk_over Symbol in the Over Frame and drag the over_morph Movie Clip Symbol into the Over Frame in its place. We had you use the Swap Symbol option because it is the quickest and most efficient method.

·**T**/P·

Don't despair if your Movie Clips don't work on the Stage. Just remember that you must Test your Movie in order to play the Movie Clips. Since Movie Clips have a Timeline that is independent from the main Movie Timeline, they don't respond to normal commands (using the Enter/ Return Key or the Controller) for stepping through the main Movie's Frames Select the Menu option Control / Test Movie. Or, you can use the **Keyboard Shortcut** Ctrl & Enter (Mac -Cmd & Return) to Test your Movie as your users would see it.

- c) Move the mouse cursor over the Button and...hey! Why doesn't the Movie Clip that we nested in the Over Frame appear to work...even with Buttons Enabled? This is because a Movie Clip, regardless of where it is nested, cannot be previewed on the Stage, at any time. In other words, you must Test your Movie in order to see a Movie Clip in action.
- d) Select the Menu option **Control / Enable Simple Buttons** once again to *disable* the Button.
- e) Select the Menu option **Control / Test Movie** to preview the Movie. Move the mouse cursor over the button and away we go! As impressive as it appears, isn't an animated button pretty simple to construct? Try one in your next project!

Adding Actions to Button Instances

You have had a lot of experience in previous exercises modifying Instances of Symbols on the Stage. As a quick review, remember that an Instance refers to a copy of a Symbol that has been placed on the Timeline. Each time you add a Symbol to the Timeline you are adding an Instance of that Symbol. With Button Symbols, this concept becomes even more important when we start talking about adding Actions to a button.

Up to this point we haven't given our button any instructions about what to **do** after the user clicks on it. Flash provides the capability to add lots of Actions to buttons, thereby allowing you to create Movies with lots of interactivity.

It is important to note, however, that when you add an Action to a button, you will always be adding the Action to a particular Instance of the button, and *not* the Button Symbol. In other words, you are adding the Action to a particular copy of the button and not to the "original." Remember this because it may help save you lots of time scratching your head later on, wondering why your button does not work!

Adding Actions to an Instance of a Button rather than the Symbol itself is actually a very powerful feature of Flash. By doing this, you can re-use a Symbol in many situations in your Movie, without having to create an entirely new Symbol to reflect each new Action.

Guided Tour – The Actions Panel

The Actions Panel allows you to quickly add ActionScripts to objects and Frames in your Movies. As you will discover throughout the rest of this book, ActionScripts are the key to adding interactivity to your Flash applications. In this regard, the Actions Panel is like "mission control." In Chapter 16, you see more details about the Actions Panel, but for now, let's explore the basic structure and features in this very important Panel.

- First, let's open the Actions Panel by selecting the Menu option Window / Actions. Notice that the Actions Panel is not grouped with the other Panels we have used under the Window menu.
- The Actions Panel should now be visible on your screen and look similar to Figure 15-9. The title on your Panel may be Object Actions or Frame Actions, depending on what you have selected in your Movie. If you have a Frame selected it will read Frame Actions. If you have an object selected, it will read Object Actions.

Diject Actions	? •
F -	7 -
Basic Actions	
Actions	
Derators	
> Functions	
Properties	
Dijects	

White Triangle to Expand

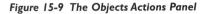

3. The Action Panel illustrated in Figure 15-9 has a white triangle on the bottom right corner. Click on this triangle to expand the panel to what is illustrated in Figure 15-10. Expanding this portion of the panel shows you any additional parameters that correspond with whatever Action you have selected.

Frame Actions	× ?
+ = Frame Actions	7 -
Basic Actions Actions Operators Functions Properties	
No action selected. No Parameters.	
	⊕ △

Figure 15-10 The Expanded Frame Actions Panel

4. Let's take a look at the basic structure of the Actions Panel. On the left side of the Panel are different "folders" that can be expanded or collapsed. Click on the Basic Actions "folder" to expand it. We will use some of the Actions inside this folder in our next Practice Exercise.

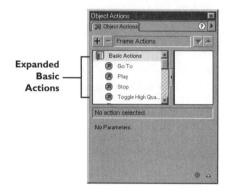

Figure 15-11 The Basic Actions "Folder" Expanded

5. You can also select Actions by clicking on the Add Statement Icon (plus sign) on the top of the Panel and making a choice from the resulting pop up menus, as illustrated in Figure 15-12. The Delete Statement Icon (minus sign) lets you delete Actions you've already added to your Movie.

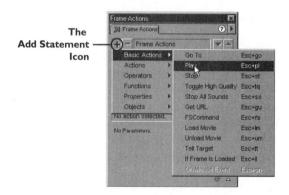

Figure 15-12 The Add Statement Icon and Resulting Menus

6. Double-click on the first Action in the list ... Go To. A line of code appears in the right hand side of the Actions Panel. This Code Window actually displays the ActionScript code (the programming language in Flash) that makes interactivity possible. For those of you who are not skilled in programming, don't worry. The "folders" on the left side of this

window contain lots of Actions that allow you to easily double-click and add preset lines of code to your Movie.

7. The Actions Panel contains two different Editing Modes – Normal and Expert. If you happen to have more advanced programming skills, you can switch to Expert Mode by using the Actions Panel menu, as illustrated in Figure 15-13. Expert Mode allows you to type directly into the Code Window, just like a text editor. This gives you ultimate control over your ActionScript – if you need or want it.

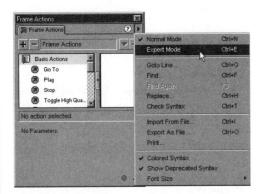

Figure 15-13 Normal and Expert Mode Menu Options

So, that's the basics of the Actions Panel! Now, let's use what we've learned to add interactivity to some Button Instances.

Practice Exercise – Adding Actions to Button Instances

Description

A button – even an animated button – doesn't serve much purpose unless something happens when the user clicks on it. In this exercise you will learn to attach Actions to Button Instances so that something happens when the button is clicked on.

In this exercise you will:

- Create Labels for Frames in your Timeline that will be used by Button Instances.
- Assign Actions to Button Instances to provide navigational control within the Flash Movie.

Take-a-Look

Before beginning the exercise, let's take a look at the exercise in its completed state so that you can clearly see what it is that you are about to build.

CD-ROM

271

- Use the Menu option File / Open and locate the folder named Chapter 15 on the CD-ROM. Find the file named button_actions.swf. Double-click on the file to open it.
- 2. The file **button_actions.swf** should now be playing on your screen.
- 3. Try out the buttons ... and as a side note ... we hope that you will enjoy the "tongue-in-cheek" humor within the exercise.

Please note the following properties of this completed exercise:

- a) Click on the History Button and observe the change.
- b) Click on the Testimonials Button and observe the change.
- c) Click on the Home Button and observe the change.

Storyboard: On-Screen

Figure 15-14 shows you how the Stage will look when you finish this exercise.

Figure 15-14 The Completed Stage

Storyboard: Behind-the-Scene

Figure 15-15 shows you what the Stage and Timeline will look like once you finish assigning Actions to your buttons.

Constant Constant Constant Constant Actions and Lakins Constant Constant

Figure 15-15 The Completed Stage and Timeline

Step-by-Step Instructions

- I. Let's start out using some groundwork that we have already built for you.
 - a) Select the Menu option File / Open.
 - b) Locate and open the midvale_I.fla file in the Chapter I 5 Folder on the CD-ROM.
 - c) Select the Menu option File / Save As to save a copy of this file in the SaveWork Folder on your computer. You can keep the same file name.
 - d) Take a look at the existing Timeline. There are 5 Layers composing a three Frame Movie. The Actions and Labels Layer has a Stop Action in each of the Frames. This prevents the midvale_I.fla Movie from playing Frame-to-Frame. When the Movie loads, the Stop command stops the Movie at Frame I.
 - e) Drag the Playhead through each of the Frames. Each Frame has different information regarding the Midvale School. Since the Movie isn't designed to Play through all Frames, Actions applied to the navigation buttons will be used to take the viewer to each section within the Movie.
 - f) Select the Menu option Control / Test Movie to preview midvale_I.fla. On the first screen we see the introductory information for the school, and if we mouse over the Home, History or Testimonials buttons we get a rollover effect. Clicking the buttons doesn't take us anywhere - yet - that is what you are going to build. We will need to Label the Frames we want to navigate to and then apply Actions to the buttons so they will take us to those Labeled Frames.
 - g) Close the .swf file and return to midvale_1.fla.
- 2. First let's set up the Labels in your Timeline.

Using Button Symbols

Go Solo

- a) Select Frame I in the Actions and Labels Layer.
- b) Select the Menu option Window / Panels / Frame if your Frame Panel is not visible. In the Frame Panel, assign the Label Home to Frame I of the Actions and Labels Layer.
- c) Select Frame 2 in the Actions and Labels Layer.
- d) In the Frame Panel, assign the Label History to Frame 2 of the Actions and Labels Layer.
- e) Select Frame 3 in the Actions and Labels Layer.
- f) In the Frame Panel, assign the Label Testimonials to Frame 3 of the Actions and Labels Layer.
- 3. Next, we need to assign the Action to the Button Instances.
 - a) Select the Instance of the Home Button on the Stage.
 - b) Select the Menu option Window / Actions. The Object Actions Dialog Window appears. See Figure 15-16. Get accustomed to working with this Dialog Window . . . you will use it extensively as you develop further projects with Flash 5!

No action selected,			1
No action selected. No Parameters.			

Figure 15-16 The Object Action Dialog Window

- c) Click the Basic Actions Icon to reveal the list of Basic Actions. Double-click the On Mouse Event Action. Check the box next to Release Outside at the bottom of the Dialog Window. The following code appears in the window to the right: on (release, releaseOutside) {
 - }
- d) Double-click Go To from within the list of Basic Actions. Deselect the box next to Go to and Play at the bottom left corner of the Dialog Window. The code now reads

There are several different kinds of Events that occur in Flash Movies. In this case, we are working with Mouse Events, or events that occur based on a user's mouse interaction with the object on the screen. In general, an event triggers an action – or something that happens in your Flash Movie.

```
on (release, releaseOutside) {
  gotoAndStop (1);
```

```
}
```

}

e) Change Frame Type to Frame Label and change Frame to Home. The code now reads

```
on (release, releaseOutside) {
  gotoAndStop ("Home");
```

f) This code that you have just entered basically states that on the release of the mouse, the Movie will go to and stop at the Frame labeled **Home.**

Select all lines of the code by clicking and dragging the cursor (thus, highlighting) from the first line of code to the third and releasing. In Windows Right-click (Mac – Ctrl & click) on the selected code and choose Copy from the menu.

- g) Move the Object Actions Dialog Window so you have a clear view of the History and Testimonials buttons on the Stage. Select the Instance of the History Button.
- h) In the Object Actions Dialog Window, in Windows Right-click (Mac – Ctrl & click) over the blank window on the right and select Paste from the Menu.
- i) Change the Frame Label from Home to History. The code now reads

```
on (release, releaseOutside) {
  gotoAndStop ("History");
```

```
}
```

j) Select the Instance of the Testimonials Button.

- In the Object Actions Dialog Window, in Windows Right-click (Mac – Ctrl & click) over the blank window on the right and select Paste from the Menu.
- Change the Frame Label from History to Testimonials. The code now reads

```
on (release, releaseOutside){
  gotoAndStop ("Testimonials");
```

```
}
```

- 4. Save the completed file.
- Select the Menu option Control / Test Movie. The buttons now navigate you through the site just as they should. Great job!

Release and Release Outside are both mouse events with similar definitions. In this case, the on (release) event takes place when the user releases the mouse while still over the button's hit area. The on (releaseOutside) takes place when the user releases the mouse after moving the cursor outside the button's hit area.

276

Summary

- Button Symbols are an easy way to add interactivity and navigational control to your Flash Movies.
- Button Symbols have a very unique Timeline with only four Frames. These Frames correspond to the "mouse states" of Up, Over, Down, Hit.
- Enabling a button will allow you to preview the active button states. Use the Menu option Control / Enable Simple Buttons to Enable the buttons and select this option a second time to disable the buttons.
- You can place Movie Clips you've created inside buttons to create animated buttons.
- The first Guided Tour gave you a closer look at the four button states.
- In the first Practice Exercise, you created a button with the different states and learned how to Enable it on Stage.
- In the second Practice Exercise, you placed a Movie Clip within a button.
- In the second Guided Tour, you were introduced to the structure and purpose of the Actions Panel.
- In the third Practice Exercise, you created Actions associated with buttons to create user navigation within a project.

PTER

16

Adding Interactivity with Actions

Chapter Topics:

- Introduction
- ActionScripts and Actions
- Guided Tour Basic Actions
- Frame Actions and Object Actions
- Practice Exercise Using Play, Stop, and Go To
- Summary

Introduction

The drawing and animation capabilities of Flash make it stand apart from other Web development software. But you might ask ... how easily does Flash handle interactivity? In the last chapter, you were given a sneak preview to how easy it is to add interactivity when you were introduced to the Actions Panel. In this chapter, we will more fully focus on interactivity as you learn how to use some basic Actions in Flash to control how the elements of your Movie play, but more importantly, to help the user interact with your application.

By the end of this chapter, you will be able to:

- describe what an ActionScript is and what it does.
- · apply basic Actions from the Actions Panel.
- describe the difference between Frame, Button and Movie Clip Actions.
- · add Labels and Comments to your Timeline.
- · add Frame Actions to your Movie.

ActionScripts and Actions

The Flash Timeline consists of a series of Frames that play like a Cinema film – one Frame after another. At this point, despite all of the interesting effects that you have created with tweening, motion guides and Symbols, all of these previous exercises (with the exception of the Button Symbol exercises) played in a linear fashion and did not allow the user to interact with the elements on the screen.

The element that has been missing ... is making the user part of the experience ... engaging the user ... allowing the user to interact with the program and decide what she/he wants to see/do next. In other words, what has been missing in our Flash programs up to this point is ... interactivity and user control.

In order to provide interactivity, user control and other more advanced functions, most multimedia and Web authoring tools make use of various types of programming or scripting languages. These programming / scripting languages provide the capability to write very detailed and exact instructions about actions that need to performed. An authoring tool that includes a "built-in" programming / scripting language will generally be able to provide a programmer with the ability to write lines of instruction (code) to perform just about any function needed within the multimedia / Web program.

In Flash, this programming / scripting language is called ActionScript. It is Flash's ActionScript that is the foundation upon which interactivity, user control and many other functions and capabilities within Flash are made possible.

For you non-programmers out there, don't panic when you start reading the next few paragraphs. Flash has an easy-to-use solution for you that we will introduce in a page or two.

Adding Interactivity with Actions

ActionScript is an object-oriented programming language with syntax similar to JavaScript. Those who know JavaScript will find it easy to learn ActionScript.

On one hand, a powerful programming / scripting language offers an authoring tool great advantage for those programmers who want to use the authoring tool and push it to its limits to provide increased functionality. On the other hand, a large segment of typical end users of authoring tools don't know and don't want to know very much about programming ... although they do want increased functionality. In response to trying to be the product that appeals to the broadest potential market, many authoring tools (including Authorware, Director, Dreamweaver and Flash) not only include the "raw" scripting capability but also include "pre-built" functions that can often be used as is, or that can be easily modified for use.

In Flash, these "pre-built" functions are called Actions. Actions are "prewritten" chunks of ActionScript that perform specific functions. In previous versions of Flash, Actions could be added to Frames and objects to provide basic functions such as **Stop, Play,** and **Go To** among many others. These basic Actions were easy to add and very useful. These and other Actions provide the ability to add interactive elements and control the display and functioning of elements within a Flash Movie. Actions have been and continue to be the backbone of adding interactivity to your Flash Movies.

Flash 5 introduced the Actions Panel, improving the program's interface, functionality and adding the ability to directly edit the ActionScript. These new editing features in the Actions Panel make it easier for programmers to access the ActionScript code and make changes to the functionality of basic as well as custom-built Actions. With some programming knowledge and a familiarity with the JavaScript syntax, you can create a wide range of custom-built Actions for your applications.

If you are not a programmer...and don't want to be...don't worry, Flash 5's Action Panel contains many different kinds of pre-built Actions, as well as a built-in reference to help you better understand ActionScript. Our intent in this chapter is not to jump right into ActionScript but rather to start you with exercises to help you learn to use Actions. We will concentrate on the builtin Actions but will also show you features in the Actions Panel that can help you develop your own ActionScripts.

As you continue to use Actions, you will become more familiar with the scripting language they are based on and soon will be able to build on your basic knowledge. We will start by working with some of the most frequently used Actions and then in later chapters will continue on to some more advanced Actions that will expand the types of interactivity that can be added to Flash applications.

lavaScript was created by Sun Microsystems as an easy-to-use offshoot of their programming language Java. Adding JavaScript code to regular HTML pages provides the capability to add animation and interactivity to Web pages. These pages can be displayed through Java-enabled browsers. Some of the most frequent uses of JavaScript seen on Web pages include mouseover (rollover) behaviors such as the swapping of images, date and time displays, and simple GoTo behaviors that automatically redirect users to other Web pages. You learned how to accomplish a similar (and easier) rollover effect with Button Symbols in Chapter 15.

We will concentrate on the basics so that you can build on your skills from a strong foundation.

Guided Tour – Basic Actions

Let's start slowly by first taking a quick look at some of the Basic Actions that are included in Flash. We can do this easily by looking at the Action Panel.

- I. Open the Actions Panel by selecting the Menu option Window / Actions.
- 2. The Object Action Panel is now open. See Figure 16-1. As you have seen previously, this panel is like a library, with a list that appears in the left window of this panel. Use the scroll bar to look through the list of "folders"
 - Basic Actions; Actions; Operators; Functions; Properties and Objects.

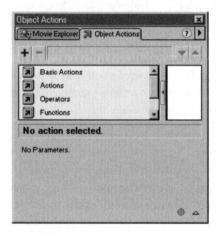

Figure 16-1 The Object Action Panel

3. **Click on** the "folder" called **Basic Actions** to expand this category as shown in Figure 16-2. In the text following the illustration, you will find a brief description of each of these Basic Actions.

280

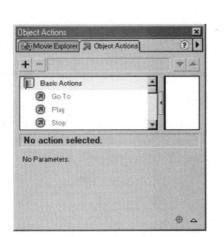

Figure 16-2 Expanded List of Basic Actions

Go To – This Action instructs the Movie to jump to a specific Frame or Scene on the Timeline. You can also specify whether the Timeline will Play or Stop after the Go To action.

Play – Instructs a Movie to begin playing.

Stop – Instructs the Movie to stop playing.

Toggle High Quality – Changes the quality of the image during playback from High to Low or Low to High by turning anti-aliasing on and off.

Stop All Sounds – Halts any sounds that are currently playing.

Get URL – Instructs Flash to jump to a Web page outside of your Flash Movie.

FS Command – This Action provides instructions to the Flash Player or other projector that is playing the Movie.

Load Movie – Opens other .swf files in place of the current Movie or within the current Movie.

Unload Movie - Unloads a Movie in your browser, player or projector.

Tell Target - Allows you to control specific Movies.

If Frame is Loaded – Checks whether a Frame is loaded. This Action is often used to control when your Movie begins to play by specifying how many Frames should download first before the Movie can start. This is often used with pre-loaders on Flash pages.

On MouseEvent – Allows you to assign a specific mouse event to trigger an Action.

CHAPTER 16	C	н	A	P1	ГΕ	R	16
------------	---	---	---	----	----	---	----

4. The Actions Panel is the "mission control" of authoring and programming in Flash. Within it lies everything you need to make your Movies behave the way you want them to.

Frame Actions and Object Actions

Before we continue to work with Actions it is important to distinguish the difference between Frame Actions and Object Actions. Take a look at your Actions Panel and notice that when it first opens, the default for this panel is Object Actions, as illustrated in Figure 16-3.

	Basic Actions		-	
	Actions		1	
	Operators		-1	
	Functions		•	
Mn	antion solor	hat		hinnen
NoF	arameters.			

Figure 16-3 Object Actions Panel

If you select any Frame in your Timeline however, notice that the text at the top of this panel now changes to Frame Actions, as illustrated in Figure 16-4.

+ - Fran	ne Actions		7 4
Basic Ac	tions	-	
Actions			
Derator	s	-1	
Function	6	-	
No action	selected.		
No Parameters			

Figure 16-4 Frame Actions Panel

282

·T/P

Object Actions are Actions that are tied to a specific element such as a Button Symbol or a Movie Clip. In the last chapter, you learned how to add Actions to Button Symbols when creating a user interface. This is an example of an Object Action that responds to user events (Mouse Events).

Frame Actions, on the other hand are tied to particular Frames in your Timeline. Actions within a Frame give instructions that might direct the Playhead to advance to a different Frame or to Stop altogether – often without user input. We will use Frame Actions in the following exercises to control the Playhead on the Timeline.

Frame Labels and Comments

When using Frame and Object Actions, you will probably want to use Frame Labels and refer to these rather than Frame numbers for two important reasons: 1) to provide a brief description of what the Action is doing and 2) as a specific point of reference for use with Actions.

In a previous chapter you added Frame Labels when setting up navigational buttons in a Practice Exercise. Flash recognizes these Labels on the Timeline so that you can use Actions to send the Playhead to a specific Label – based on a button click or when the Timeline reaches the Frame where this Action has been inserted.

Flash will even recognize Labels that are found in other Scenes of the Movie, or in other Movies! This means that your user can click a button to load a new Movie and have that Movie start at the specific Frame Label you specify.

The benefit of using Labels is that if you inadvertently alter the Frame number or move the Label, your Action does not have to be edited. Flash looks for the Label, not the Frame number. To add a Label to a Frame, select the Menu option Window / Panels / Frame to open the Frames Panel. When you select a Frame in your Timeline, the Frames Panel gives you the option of giving this Frame a Label, as shown in Figure 16-5.

Inst Effe	Frame 4 S	our ? >
Label: Add Your	Label Here	
weening: None	-	

Figure 16-5 Adding a Frame Label in the Frame Panel

In creating a Flash application, it is quite likely that you will add and/or delete Frames continually throughout the development process. Using Frame Labels, independent of Frame numbers, will help reduce the amount of recoding you may otherwise have to do because of the adding/deleting of Frames.

Once you add a Frame Label, a red flag will display in that Frame along with the Frame Label on your Timeline. See Figure 16-6.

Figure 16-6 Red Flag and Frame Label

The Frame Label will display as long as there isn't a Keyframe located close by that may concatenate the Label. See Figure 16-7.

Concatenated Frame Label

imeline		
1	a 🗄 🗖	1 5 10 15 20 25
🗗 Layer 1	/••	Add You
•		1 2 0 % [·] 8 12.0 fps 0.6s

Figure 16-7 Frame Label Concatenated

Practice Exercise - Using Play, Stop and Go To

Description

In this exercise you will learn how to use some of the most basic ActionScripts to control and add interactivity to your Movie.

In this exercise you will:

- · Create an animation that begins playing based on a mouse event.
- Insert the Basic Actions for Go, Stop, On MouseEvent, and Go To.

Take-a-Look

Before beginning the exercise, let's take a look at the exercise in its completed state so that you can clearly see what it is that you are about to build.

- Use the Menu option File / Open and locate on the CD-ROM the folder named Chapter 16. Locate the file named actions.fla. Double-click on this file to open it.
- 2. The file actions.fla should now appear in your copy of Flash.
- 3. Select the Menu option **Control / Test Movie** to preview the Movie.
- 4. Move your mouse over the word GO to start the animation loop.
- 5. After 5 seconds or so, click the mouse on GO and watch as the pattern changes.

Please note the following properties of this completed exercise:

- a) The animation begins to play as soon as the mouse enters the target area (GO) and will continue to play as long as the mouse remains in the target area.
- b) The animation stops playing as soon as the mouse leaves the target area.
- c) A second animation begins after a mouse is clicked within the target area and plays only once.

Storyboard: On-Screen

Figure 16-8 shows how the Stage will look once you've completed this exercise.

Storyboard: Behind-the-Scene

Figure 16-9 shows you how the Timeline will look when the exercise is completed.

Actions / •	50	1 5 10 15 20 25 30 35 40 4≢start 0	1111111		11111	
	121	e #start				H
🕼 Go 🔹 •	• 🔤	•				Ц
abstract3 •	년 🐻	0 • • • • • • • • • • • • •				
	5					
🕑 square3 🔹 🔹	9	o o → o → o → o → o				
🖉 square2 •	90	0 8 8 8 8 8 8 8				Π
🛛 square1 🔹 🔹	9	o o o o				
abstract1 •	9	o o → o o				
👽 circle 🔹 🔹	40	o • ≻→ • ≻ •				Π
background abstrac *	9	o a>				Π
				R		
				~		
	1	4 m - 9 - 12 1 50 ms 0.0s +				

Figure 16-9 Completed Timeline

Step-by-Step Instructions:

- I. Let's get started.
 - Open the file named basic_actions.fla in the Chapter 16 Folder on the CD-ROM.
 - b) Save a copy of the file in your SaveWork Folder on your computer
 - c) Take a look at the Timeline. There are 9 Layers. Scroll through the Timeline by dragging the Playhead.
 - d) Before we begin, add a new Layer to the Timeline. Select the Go Layer and then click on the Insert Layer Icon to add a new Layer.
 - e) Rename the new Layer... Actions.
- 2. Now let's add a Stop Action to pause the Movie.
 - a) Select Frame I in the Go Layer.
 - b) Open the Movie Library by pressing the Ctrl & L Keys (Mac Cmd & L).
 - c) Double-click on the Go Button in the Library list to enter Symbol Editing Mode. Take a look the button's Timeline. There are 3 Layers in this Timeline. The audio Layer contains a sound clip in the Down Frame, and the star Layer contains a nested Movie Clip in the Over Layer.
 - d) Select the Scene I Tab to leave Symbol Editing Mode.
 - e) Drag the Go Button from the Library onto the Stage. Open the Info Panel by selecting the Menu option Window / Panels / Info. Set the option to Center Registration and set the coordinates to X=254 and Y=95.
 - f) In the Actions Layer, select Frame I. Open the Frame Panel by selecting Window / Panels / Frame. Label the Frame by typing in ... start. A red flag and the label name should now be inserted in the Timeline.
 - g) **Select Window / Actions** to open the Actions Panel.

In Chapter 18 you will work with sound clips. Here we are just taking a quick look to see a media clip already there.

Go Solo

CD-ROM

- h) Click on the Basic Actions Icon to expand the Actions list.
- Make sure that Frame I is still selected in the Actions layer and double-click the Stop Action in the list. The code added to the right side of the panel should look like this: stop ();
- j) **Save** your file and the Test your Movie to make sure that the Movie stops in the first Frame. Select **Control / Test Movie.**
- 3. Now let's make the Movie play when the user clicks on an object.
 - a) In the **Go Layer, select** the **Go Button Instance** that you placed in **Frame I.**
 - b) **Double-click** the **On MouseEvent Action** in the Basic Actions list.
 - c) Make sure the checkbox on the bottom of the Action Panel has Release and Release Outside checked. The code added to the right hand side of the screen should look like this:

```
on (release, releaseOutside) {
```

```
}
```

d) Now we will specify what happens when the user releases their mouse. Double-click on Play in the Basic Actions list. This will cause the rest of the Timeline to play when the user clicks the Go Button. Your code should now look like this:

```
on (release, releaseOutside) {
   play ();
}
```

- e) Save your file and then Test your Movie to make sure that the Movie plays when the Go Button is pressed and released. Select Control / Test Movie.
- 4. Finally, let's add the Go To Action to send the Movie to a specific Frame.
 - a) When the Movie reaches the end of the Timeline we are going to have it return to the Frame labeled Start. In order to do this, select Frame 24 (the last Frame) in the Actions Layer.
 - b) Insert a Keyframe (press F6) in Frame 24.
 - c) In the Actions Panel, double-click the Go To Action in the Basic Actions list. The code should look like this: gotoAndPlay (1);
 - d) At the bottom of the Actions Panel, change the selection in the Type field to Frame Label. In the Frame field, type in ... start. You are telling the Movie to go to the Frame labeled Start when it reaches Frame 24. Uncheck the box, Go to and Play. This will cause the Movie to go back to the Frame labeled Start and stop playing. Your code should look like:

gotoAndStop ("start")

e) Save your file and Test your Movie to see how it works. Select Control / Test Movie.

Summary

- In order to add interactivity, user control and other more advanced functions, Flash and many other multimedia and Web authoring tools make use of various types of programming or scripting languages.
- In Flash, this programming / scripting language is called ActionScript. ActionScript is an object-oriented scripting language similar in syntax to JavaScript.
- Flash and many other authoring tools not only include the "raw" scripting capability but also include "pre-built" functions that can often be used as is, or that can be easily modified, to facilitate ease of use.
- In Flash, these "pre-built" functions are called Actions. Actions are "pre-written" chunks of ActionScript that perform specific functions.
- In the first Guided Tour we took a closer look at the Basic Actions included in Flash,

Go To; Play; Stop; Toggle High Quality; Stop All Sounds; Get URL; FS Command; Load Movie; Unload Movie; Tell Target; If Frame is Loaded; and On MouseEvent.

- Object Actions are Actions that are tied to a specific element such as a Button Symbol or a Movie Clip.
- Frame Actions, on the other hand are tied to particular Frames in your Timeline.
- When using Frame and Object Actions, you will often want to use Frame Labels to identify Frames by a label rather than a number.
- In the Practice Exercise, you created an animation that begins to play when the user's mouse enters into a target area. A second animation begins after the user's mouse is clicked.

PTER

Application Chapter: Movie Clip and Button Content

17

Chapter Topics:

- Introduction
- Application Exercise Movie Clip and Button Content
- Summary

Introduction

One of the simplest ways of adding interactivity for your user is to create elements that respond to mouse events, such as clicking on a Button. The Button Symbol in Flash makes it easy to create interesting buttons that respond to a user's mouse activity (rollover and click) by changing the visual design of the button. The Movie Clip Symbol can also be added to a Button Symbol to create buttons that respond to mouse events with design changes and animated effects.

Movie Clips with their independent Timelines can also be used to create some interesting effects in the main Movie Timeline. They are the most versatile Symbol and will enhance the appearance and activity that takes place in your site. In this exercise, you will create some fun Movie Clips that will give your site an added boost.

Application Exercise – Movie Clip and Button Content

Description

In this Application Exercise you will now create the buttons for your Movie interface. You will also create some Movie Clips that will be used in some of the roadside attractions you come across.

Take-a-Look

Before beginning the exercise, let's take a look at the exercise in its completed state so that you can clearly see what it is that you are about to build.

- Use the Menu option File / Open and locate on the CD-ROM the folder named Chapter 17. Locate the file named application_17.fla.
 Double-click on application_17.fla to open the file.
- 2. The file **application_17.fla** should now appear in your copy of Flash.
- 3. Preview the Movie. Take a moment to look through the Timeline.

Storyboard: On-Screen

Figure 17-1 shows what will be seen on Stage, when the program file is complete.

CD-ROM

Application Chapter: Movie Clip and Button Content

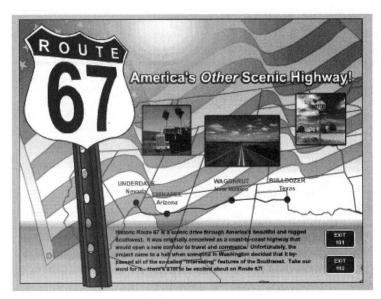

Figure 17-1 The Completed Stage

Storyboard: Behind-the-Scene

Figure 17-2 shows how the Timeline will look when the exercise is completed.

	-	3		1	5	10	15	20	25	30	35	40	45	50	55	60	65	H
Actions and Labels	•	•		a	aaaa													
D Locators	•	3		Π														1.000
D Text	•	2																
Headlines	•	3		•														
🕼 Home Button 🛛 🖌	•	•	11		• 0													
D Buttons	•	8		Ţ	0													
Photos	•	3																
Route Sign	•	3																
Background	•	Ľ		I	0													
•			8	L IN		6	1 12	0 fps 0	105 4		12	1. N.	1.1	1.1	1		1	ſ

Application Project Steps

Complete this exercise on your own, guided by following the general steps provided below. You can always refer back to the completed example that you viewed in the Take-a-Look section of this exercise.

Please Note: The following steps are intended as a guide. This is your project so please feel free to make whatever variations you would like.

L.	Open application_13.fla. You can either use the copy you created and
	saved in the SaveWork Folder on you computer or you can use the copy
	in the Chapter13 Folder on the CD-ROM supplied with this book.

- 2. Add a new Layer and name it Actions and Labels. Position it at the top of the Layer stacking order.
- 3. Select Frame 1 of the of the Actions and Labels Layer and add a Keyframe. Name the Frame . . . Home.
- Add the following ActionScript to the Frame: stop ();
- 5. Select Frame 2 of the Actions and Labels Layer and add a Keyframe. Name the Frame . . . Underdale.
- Add the following ActionScript to the Frame: stop ();
- 7. Select Frame 3 of the Actions and Labels Layer and add a Keyframe. Name the Frame . . . Chikapee.
- Add the following ActionScript to the Frame: stop ();
- 9. Select Frame 4 of the Actions and Labels Layer and add a Keyframe. Name the Frame . . . Wagonrut.
- Add the following ActionScript to the Frame: stop ();
- Select Frame 5 of the Actions and Labels Layer and add a Keyframe. Name the Frame . . . Bulldozer.
- 12. Add the following ActionScript to the Frame: stop ();
- 13. Create a new Button Symbol named Exit 101. In its Symbol Editing Window, rename the existing Layer Graphics.
- Select the Up Frame and drag a copy of Sign Graphic onto the Stage and position it at X=0.0,Y=0.0.
- Using Center-justified, White, 10 point _sans Bold Static Text, enter "EXIT 101" and position it at X=0.0,Y=0.0.
- Select and add a Keyframe to the Over, Down and Hit Frames (you may delete the Text from the Hit Frame if you want to).
- 17. Select the Instance of the Exit Sign Graphic in the Over Frame. Change the Tint Effect of the Instance to 30% #FFFF00 and Change the Text to "Contact Us!" in the Over and Down Frames.
- 18. Return to the main Movie Timeline.

Application Chapter: Movie Clip and Button Content

- 19. Create a Buttons Folder in the Library and drag the Exit 101 Button Symbol into it.
- 20. Create a new Button Symbol named Exit 102 exactly as you created the Exit 101 Button Symbol, except you will enter the text "EXIT 102" in the Up Frame and "E-mail Us" in the Over and Down Frames.
- 21. Return to the main Movie Timeline and drag the Exit 102 Button Symbol into the Buttons Folder.
- 22. Create a new Button Symbol named Home exactly as you created the Exit 101 Button Symbol, except you will enter the text "HOME."
- 23. Return to the main Movie Timeline and drag the Home Button Symbol into the Buttons Folder.
- 24. Create a new Button Symbol named Go exactly as you created the Exit 101 Button Symbol, except you will enter the text "GO!"
- 25. Return to the main Movie Timeline and drag the Go Button Symbol into the Buttons Folder.
- 26. Create a new Button Symbol named Send exactly as you created the Exit 101 Button Symbol, except you will enter the text "SEND!"
- 27. Return to the main Movie Timeline and drag the Send Button Symbol into the Buttons Folder.
- 28. Create a new Button Symbol named Bulldozer, TX. In its Symbol Editing Window, rename the existing Layer Graphics.
- 29. Select the Up Frame and draw a circle with a Red Fill and a Black Stroke with a Stroke Height of 2. Resize the circle to W=9.5, H=9.5 and position it at X=0.0, Y=0.0.
- 30. Using Center-justified, #666666, 10 point _sans Bold Static Text, enter "BULLDOZER Texas" and position it at X=0.0,Y=-27.9.
- Add a Keyframe to the Over Frame and change the color of the Text to Black. Replace the existing stroked circle with an Instance of the Yellow Glow Graphic Symbol.
- 32. Insert a Blank Keyframe to the Down Frame of the Graphics Layer.
- 33. Draw a Rectangle in the Hit Frame of any color (W=69.0, H=44.0) and position it at X=-0.5, Y=-19.0..
- 34. Return to the main Movie Timeline and drag the Bulldozer, TX Button Symbol into the Buttons Folder.
- 35. Create a new Button Symbol named Chikapee, AZ exactly as you created the Bulldozer, TX Button Symbol, except you will enter the text "CHIKAPEE Arizona."

36. Return to the main Movie Timeline and drag the Chikapee, AZ Button Symbol into the Buttons Folder.

- 37. Create a new Button Symbol named Underdale, NV exactly as you created the Bulldozer, TX Button Symbol, except you will enter the text "UNDERDALE Nevada."
- 38. Return to the main Movie Timeline and drag the Underdale, NV Button Symbol into the Buttons Folder.
- 39. Create a new Button Symbol named Wagonrut, NM exactly as you created the Bulldozer, TX Button Symbol, except you will enter the text "WAGONRUT, New Mexico."
- 40. Return to the main Movie Timeline and drag the Wagonrut, NM Button Symbol into the Buttons Folder.
- 41. Create a new Layer in the main Movie Timeline and name it Buttons. Position it above the Photos Layer.
- Select the first Frame of the Buttons Layer and drag an Instance of the Underdale, NV Button Symbol onto the Stage. Position it at X=218.4, Y=333.9.
- 43. Assign the following ActionScript to the Instance of the Underdale, NV Button:

```
on (release) {
  gotoAndStop ("Underdale");
}
```

- 44. Select the first Frame of the Buttons Layer and drag an Instance of the Chikapee, AZ Button Symbol onto the Stage. Position it at X=275.9, Y=353.9.
- 45. Assign the following ActionScript to the Instance of the Chikapee, AZ Button:

```
on (release) {
  gotoAndStop ("Chikapee");
}
```

- 46. Select the first Frame of the Buttons Layer and drag an Instance of the Wagonrut, NM Button Symbol onto the Stage. Position it at X=395.7, Y=329.9.
- 47. Assign the following ActionScript to the Instance of the Wagonrut, NM Button:

```
on (release) {
  gotoAndStop ("Wagonrut");
}
```

- Select the first Frame of the Buttons Layer and drag an Instance of the Bulldozer, TX Button Symbol onto the Stage. Position it at X=499.0, Y=328.9.
- 49. Assign the following ActionScript to the Instance of the Bulldozer, TX Button:

```
on (release) {
  gotoAndStop ("Bulldozer");
}
```

- 50. Select the first Frame of the Buttons Layer and drag an Instance of the Exit 101 Button Symbol onto the Stage. Position it at X=597.2, Y=400.2. We will add the ActionScript to this Button later in the book.
- 51. Select the first Frame of the Buttons Layer and drag an Instance of the Exit 102 Button Symbol onto the Stage. Position it at X=597.2, Y=447.1. We will add the ActionScript to this Button later in the book.
- 52. Create a new Layer in the Main Movie Timeline and name it Home Button. Position it above the Buttons Layer.
- 53. Select Frame 2 of the Home Button Layer and insert a Keyframe. Drag an Instance of the Home Button Symbol onto the Stage and position it at X=46.0, Y=447.1.
- 54. Assign the following ActionScript to the Instance of the Home Button: on (release) {

```
gotoAndStop (1);
}
```

55. Save your file in the SaveWork folder.

Next, let's create a couple of Animated Movie Clips that we will use later in the book.

- Create a new Movie Clip Symbol named Route Movie. In its Symbol Editing Window, drag a copy of the Route 67 Graphic onto the Stage. Resize the Instance of the Route 67 Symbol to W=208.1, H=207.9 and position it at X=0.0, Y=0.0. Add additional Keyframes at Frames 10 and 20 of the Route Movie Timeline.
- 2. Rename the existing Layer Route 67.
- 3. Select the Route 67 Instance in Frame 10 and resize it to W=220.8, H=220.5. Reposition it at X=0.0,Y=0.0.
- 4. Create a Motion Tween between Frames 1-10, and another between Frames 10-20.

5. Create a new Layer above the Route 67 Layer and name it Actions.

- Insert a Keyframe at Frame 20 of the Actions Layer and assign the following ActionScript to it: gotoAndPlay (1);
- 7. Test out the animation and then return to the main Movie.
- 8. Create a new Movie Clip Symbol named Text Movie.
- 9. Rename the existing Layer Text.
- 10. Select Frame 1 of the Text Layer.
- 11. Assign the following Text Properties:

Font_sansFont Height20BoldselectedColorBlackCenter Justified ParagraphStatic TextUse Device Font

Enter the following text with a hard return at the end of the first line:
 Route 67...

America's Other Scenic Highway!

- Insert a Keyframe at Frame 50. Change the text to read as follows: Visit beautiful Underdale, NV for undisturbed natural beauty!
- 14. Insert a Keyframe at Frame 110. Change the text to read as follows: Stop awhile in Chikapee, AZ for "fun" with a capital "F!"
- 15. Insert a Keyframe at Frame 170. Change the text to read as follows: Explore Wagonrut, NM and come face-to-face with exotic wildlife!
- 16. Insert a Keyframe at Frame 230. Change the text to read as follows: Discover Bulldozer, TX and its culinary delights!
- 17. Insert a Keyframe at Frame 290. Do not change the Text.
- 18. Create a new Layer above the Text Layer and name it Actions.
- Insert a Keyframe in Frame 290 of the Actions Layer and assign the following ActionScript to it: gotoAndPlay (1);

Application Chapter: Movie Clip and Button Content

- 20. Test out the animation and then return to the Main Movie.
- 21. Save your file as application_17.fla in the SaveWork Folder on your computer.

Summary

In this chapter you have added some much-needed interactivity by creating buttons that respond to a user's mouse activity. You have also created some fun Movie Clips that will enhance the functioning of your site and will entertain your site visitors. With the addition of the Buttons Symbols, you have now completed the interface design for your site. Remember that by using Symbols you are creating a more efficient Movie, and ultimately a better Web site.

PTER

8

Adding Sound

Chapter Topics:

- Introduction
- Obtaining Sound Files
- Properties of Sound Files
- Sound File Types Supported by Flash
- Practical Considerations When Using Sound
- Guided Tour Adding Sound to the Timeline
 - Sound Sync Options Event, Stream, Start and Stop
 - Guided Tour Sound Effects

•

.

.

- Practice Exercise Adding Sound to a Button
- Work-arounds with Using Sound
 - Summary

Introduction

Unlike traditional HTML editors and the Web sites they create, Flash easily provides true multimedia authoring capability, all within the Flash authoring tool. Up to now we have seen how you can add text, graphics and animation to your Flash project. In this chapter you will learn how easy and fun it is to add sound.

When incorporating sound into your Flash projects, think about your purpose for adding it. Some sounds may be used as a background to set a certain tone for your site. Music and environmental sounds can evoke a particular mood or feeling and can be very effective in this way.

Other uses of sound can include playing a sound effect in response to a user's action, such as a "click" as the user selects a button. This sound lets the user know that the program is responding to their action. You will work with this example in an exercise later in this chapter that shows you how to add sound to a Button Symbol.

Another reason to include sound capability within your project would be to make use of narration to supplement or reinforce information being provided visually through text and/or graphics. Increasing the number of media channels, generally increases the effectiveness of the message being communicated. Narration can be synchronized to the actions taking place on-screen or can be used as an element that plays independently of the Timeline. You may discover other reasons for using narration within you Flash project.

Sound can serve a number of important functions in your Flash project:

- Music and sound tracks can add dynamic support for on-screen graphics or animation, as well as increase the general level of user/viewer interest in your project.
- Narration (audio track) can provide information that either supports or that is in addition to what is presented via text, graphics and/or animation.
- Sound effects can accompany user actions; provide additional feedback concerning a user response or required action; and can be used as a technique to "grab and focus" the user's attention to a particular point of interest.

By the end of this chapter, you will be able to:

- · describe a few advantages to and concerns about using pre-recorded audio.
- describe a few advantages to using professional talent and a recording studio.
- describe what is needed to record your own sound.
- describe the basic properties involved in recording sound (sampling rate, sampling size, channels and file format).

300

- list the sound file formats that are available for use in Flash.
- · describe the differences between Event and Streaming sounds.
- · import sound into your Flash Movie.
- synchronize sounds to particular events in your Movie Timeline.
- · apply effects to imported sounds.
- · control the length of sound files.

Obtaining Sound Files

If you already have all of your sound files prepared for you in the appropriate digital format, then you may not need to read the following section. However, it is more likely that most of you will at some point be faced with the question ... "Where do I get the sound files I need for my Flash applications?"

Pre-recorded Music and Sound Effects

One answer to the question of "where" is to purchase sound effects or music tracks from a number of different vendors that make such products available for multimedia use. There are literally thousands of different sound effects that have been recorded, and almost as many music segments representing a wide variety of different musical styles. Typically these sound files are supplied on CD-ROM or can be downloaded, with at least a couple of different file formats available for each audio selection.

There are also a few software programs available for purchase that allow you to select a pre-existing recording and edit it in a variety of ways, including changing the length (time) of the musical segment to fit your specific time requirement.

Assuming that you can find the selections you need, the next and equally important factor in the use of pre-recorded sound files, is being very careful about examining the license agreement for this music or effects to see what limitations and obligations you may have. Your best bet is to look for music and sound effects products that very clearly state "Royalty Free Use" of their sound files. In other cases, you may need to pay a small licensing fee.

Please be advised that you can NOT use the commercially recorded popular music you listen to on your stereo, without prior written permission (and probably a fee with restrictions of use) from the Producer, Publisher and/or Performer of that music. This still may be an option, especially if the distribution of your application is not for sale and is intended for a small, targeted audience. It's best to check first before spending a lot of time and effort working with something that you may not be able to use.

Using Professional Talent and Studio

There are times when you will not be able to purchase "clip sound files" but must record your own. For example, you may find yourself in need of high quality "professional" narration to accompany the text, graphics or animation that appears on screen. Without question, the most professional results will be achieved by using professional talent and a recording studio. Of course everything comes with a cost. Depending on your needs and budget, this option may be "expensive"... but you may want to check it out.

Most talent agencies will provide you with recorded samples of work from a variety of their clients, so that you can select the voice or two that best meets your project's specific needs. You can then sit in the studio during the recording to ensure proper pronunciation or vocal emphasis by the voice talent.

You will need to provide copies of the script to be recorded to the talent, the studio's technician, and a copy for you. You might want to break the script down, so that each audio file that you will need (per screen or per sequence) is recorded, identified and provided to you as a separate file. This means that you should also provide the file name for each file. Organize and plan ahead. Get everything ready before you go to the studio – once you get there, you are generally "on-the-clock" and paying for time.

The technician at the recording studio will probably ask you a number of questions pertaining to the format and properties of the sound files to be delivered to you (these properties are briefly discussed in the next section). When the recording and editing is finished, the studio will be able to provide you with a CD-ROM with all the digital sound files ready to be imported into Flash.

Recording Your Own Sound

The Equipment You'll Need

What if you have little or no budget, then what are your alternatives? This shouldn't be a problem; recording sound is pretty easy to do. At a minimum, you will need three things, with a fourth component recommended:

- · a sound card in your computer
- · a microphone
- · sound editing software
- recording device (recommended, not required)

Sound Card – you probably have a sound card in your computer already. Even if you don't plan to record sound, any computer that is intended to run your application with sound, will have to have a properly installed sound card

302

·T/P

(most computers these days include a built-in sound port) to play any sound file. Almost all sound cards will include at least two input ports, one for use with a microphone, and a second as a line input for use with another playback device (tape recorder or MP3 player). Most of these input ports require a standard "Sony" plug. The sound card, combined with the use of the sound editing software, will capture and convert sound into a digital format that can recognized by the computer and by Flash.

Microphone – you may have one already or you may need to buy one. The quality of a microphone can vary quite a bit, but you shouldn't have to spend more than about \$50 to get a fairly decent one. You may want to buy a "uni-directional" or limited range microphone to help eliminate recording stray, unintentional sounds. Inexpensive microphones will probably have a "Sony" plug that can be plugged directly into the computer's microphone input. If you are not going to use a recording device, an inexpensive microphone will do fine. Many computers also have built-in microphones that can be used to record short audio clips.

Sound Editing Software – you may have a "lite" version of software already, as some type of sound editing software is generally included with sound cards. There is also a Windows and Mac utility that provides the basics needed for recording and limited editing. If you are going to do more than a little recording, you may want to purchase a more full-featured sound editing software program that will help you do this work more quickly and efficiently.

Recording Device - even though you can connect the microphone directly to the computer and record using the sound editing software, there are a few good reasons for using a recording device. First, sound files can quickly take up a lot of space on your computer's hard drive. How many selections are you going to record? How many times are you going to have to repeat the selection, in order to get a good "take"? Just think of the many times you've observed the scene on TV or in the Movies, where a director says, "take 5," "take 10," etc. Even professional talent will need to repeat lines, in order to achieve the desired result. Each and every "take" will gobble up lots of hard drive space. If you will be doing "more than a little" recording, you may want to get a decent recording device along with a quality microphone and record first into the recorder. You can then identify the "good" takes and transfer these to the computer via the "line output" from the recorder, into the "line input" of the sound card. Use the sound editing software just as you would with direct microphone use. There are many types of recording devices that you can purchase. Some examples are a DAT recorder, mini-disk player, tape recorder, and an MP3 player. When you are searching for a recording device, just make sure that it has ports for line in/out cables that can be connected Try using a headset that is a combination of earphones and a microphone.

to the sound card on your computer. Also make sure you can make clean electronic connections, without any "buzz," "hum," or other noise.

The Recording Environment

You will want to find a nice quiet place to record your narration. This generally means away from windows, high traffic areas (vehicles and people), elevators, stairways, doors that open/close frequently, and loud voices next door. You will be surprised at how many stray (unintentional) sounds you may pick up as you record. You may not even hear them until you listen to the recording later.

If the description of this "nice quiet place" has just eliminated all possibilities at your normal place of work during the day, you may want to consider this same place at night, during the weekend, or find a quieter alternative.

Position your "talent" so that when the microphone is aimed directly at her/his mouth, it will be pointing to the quietest area of the room. Unless you have a microphone stand and other equipment, it will probably be easier to have your "talent" sit common tably at a table, with the microphone mounted in a stable position directly in front of the speaker's mouth.

You will need to experiment, but will probably want to place the microphone no further than 8 - 12 inches from the speaker's mouth. Try to avoid anyone holding the microphone in-hand, as this will undoubtedly produce unwanted noise. Make sure there is room for the speaker to place the script (maybe on a typist's copy stand) so it can be easily read. Holding and turning pages will also, more than likely, produce unwanted noise.

The computer and / or recording device should be placed well out of range of the pickup pattern from the microphone. Figure 18-1 provides a suggestion for how you might arrange your recording space.

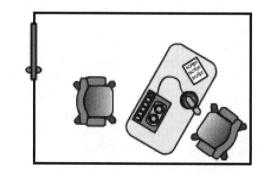

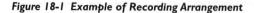

Most robust sound editing software such as Gold Wave will allow you to filter out "noise" that was picked up from the environment, or from the recording device. With such programs, you can isolate this "noise" and delete it. Of course, it is still better to try to avoid "noise" rather than have to deal with it later.

·T/P

Properties of Sound Files

We might describe "real-life" as a continuous stream of changing events. If we listen to a rock band playing, we hear a constantly changing series of different notes, varying loudness, changing beat, changing instruments, etc. In the digital world of computers, if we want to record and playback this sound, we need to capture and represent this continuous stream of events as a long series of individual "moments-frozen-in-time." Each digital "frozen moment" is a sample of that music at a specific point in time. Our ability to digitally represent the live music is significantly influenced by four properties related to how we "sample" or capture these individual "moments-frozen-in-time." These properties include sampling rate, size of sample, mono/stereo capability, and to some extent – file format. To give these properties a concrete reference point, please refer to Figure 18-2 which shows the dialog window used to set up properties for recording sound files in Sound Forge (Sonic Foundry).

Sample rate (2,000 to 96,000 Hz):	44.100 -	OK
Sample size	22,050 32,000 44,100 48,000	Cancel Help
Maximum editing time:	00:22:24	

Figure 18-2 Sampling Rate in New Data Window (Sound Forge)

Sampling Rate – relates to how often a "sample" is taken, how many times per second. The sampling rate is generally expressed as "cycles per second" or in the measuring unit, Hertz (Hz). The pull down menu for Sampling Rate allows you to select a rate ranging from 2,000 to 96,000 Hz. The higher the sampling rate (the higher the number), the better the quality of your digital representation of the music. However, as you increase the sampling rate, you also increase the size of the resulting sound file. For most computer applications you will probably find that a sampling rate somewhere between 12-22 thousand Hz will do the trick. As a comparison, audio CDs are recorded at 44Hz. Many computer speakers are of a fairly poor quality, so high quality recording is frequently a wasted effort – in addition to dramatically increasing file size, which in low bandwidth environments (typical modem Internet access) will significantly degrade performance. You should experiment with different Sampling Rates, depending on your needs. AND the end result is also influenced by the next two sound properties.

Sample Size – relates to how big the "container" is that you use to store the "sample." If we use a large "container," we will have a lot more room to store a lot more information about the "sample." Typically most computer systems provide "containers" that are either 8-bit or 16-bit (See Figure 18-3, lefthand side). Sound cards are described as either 8-bit or 16-bit. As you might imagine, 16-bit sound files offer considerably better quality over 8-bit, but again, they are considerably larger than 8-bit files.

Sample rate (2,000 to 96,00	10 Hz): 22050 -	ОК
Sample size	Channels	Cancel
C 8-bit	© Mono	Help
 16-bit 	C Stereo	
Maximum editing time:	00:49:39	

Figure 18-3 Sample Size (left) and Channels (right)

Channels – relates to whether the file will offer multiple channels (Stereo) that may contain different information or a single channel (Mono), playing the same information on both speakers (See Figure 18-3, right-hand side). For games and other applications where you are trying your best to create a more realistic environment, you may want to try Stereo. For most applications, how-ever, you probably won't add much to the quality by using Stereo, but Stereo will add significantly to the file size...so go with Mono. Channels can also be adjusted in the Publish Settings of your Flash Movies. You can convert Stereo to Mono with some of the compression settings in Flash that will change the audio settings in the exported Movie.

Format – relates to the characteristics of the file type used for the sound file. Flash supports several sound file formats for import as described in the next section. The format you choose will generally be determined by the capabilities of the computers and environment that your application will be delivered into. Flash also allows you to select audio compression settings for your exported Movies in the Publish Settings. Using Publish Settings applies a global compression to all the audio files in your Flash Movie, giving you less control over the final quality of each sound. However, you can also change the compression setting individually by using the Sound Properties window in the Library. The compression choices in Flash are MP3, Raw, ADPCM, or Disable.

Sound File Types Supported by Flash

You can import the following file types for use into Flash:

- MP3 a compressed file format that features high quality sound with small file sizes that are smaller than WAV or AIFF files but that retain much of their quality considering the amount of compression that is applied.
- WAV the standard file format for audio files within Windows. (With Quick-Time 4 installed, WAV files can be used interchangeably on Mac and PC.)
- AIFF this file format was developed by Apple but can be used on a PC as well as a Mac.

The following list of alternate file types can also be imported if QuickTime 4.0 or later is installed on your system:

- Sound Designer II (Mac)
- System 7 sounds (Mac)
- Sun AU (Windows and Mac)
- Sound Only QuickTime Movies (Mac and Windows)
- WAV (Windows and Mac)

Practical Considerations When Using Sound

Now that we have told you that there can be significant benefits to adding sound to your Flash applications, we also need to point out that there are a few practical considerations regarding the use of sound. The first issue is related to performance, especially in the Internet environment with slower modem connections. As you add sound to your Flash program, it can significantly increase the Movie's file size. As is the case with all Flash files, as the file size increases, so does the time required to download and "write-toscreen" – especially with low bandwidth access. There are also some considerations for how Flash keeps pace between audio and Frames during playback. At the end of this chapter, we will discuss some solutions to this issue.

Another important issue is related to whether the use of sound is appropriate in the environment where your typical user / viewer will access your Flash project or Web site. If someone is accessing your Flash site from an office or other public setting and is not using headphones, loud music or sound effects can be an annoyance to others in the area, especially if the sound can not be easily turned down or off.

One way to deal with this last issue is to apply some of what you learned in using ActionScripts as you design your interface. Giving your user control over turning sounds on or off can be a great way to create a user-centered site that appeals to a wide variety of people. Just remember – with the ability to turn

•**T/P**•

We have heard reports that some PC users are having difficulties using the File / Import option for .mp3 files, although once into Flash, they will play correctly. We were unable to confirm any reported bugs by the time of publication.

CD-ROM

308

off sound – you will have to be careful when designing the project so that no important information will be lost if the sound is turned off.

Guided Tour - Adding Sound to the Timeline

In this tour, you will see how easy it is to import sounds into your Flash Movie. Flash will store the Imported sound in the Library with the other Symbols and give it a unique icon that reminds you that this particular item is a sound. See Figure 18-4.

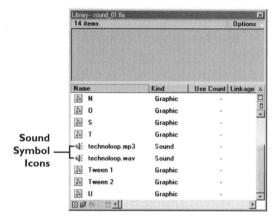

Figure 18-4 Sound Symbols After Importing Both Formats

- I. Let start with an existing file.
 - a) Select the Menu option File / Open.
 - b) Locate and open the **sound_01.fla** file in the **Chapter18 Folder** on the **CD-ROM**.
 - c) Select the Menu option File / Save As to save a copy of the file in the SaveWork Folder on your computer. Name it my_sound _01.fla.
 - d) Take a look at the existing Timeline. There are 14 Layers with a looping 84-Frame animation.
 - e) Select the Menu option Control / Test Movie to preview the Movie. There's a fair bit of action going on . . . but where's the music to accompany it? Let's add some sound to make this file complete.

Tools 😤 Scene 1									2 6.	4
N R		5 10	15 20	25 30	35	40	45 50	55 60	65	1
19 DF	/ • • 10 • >	•>•>>•>								
A DE DE	•••		→ • ≻ <u> </u>	-						ł
	• • 0	•		→•>						
/ 4 50			1 8.2 lps 6	.0s 4			N.		<u>)</u>	ſ
00			Sector Con				States of the	108.03		
20										
Alter								and .		
n Q										
Colors										
/ 🖳										
r 📰										
bØ\$										1
Options										ľ
										l
anala Calder and States and States and										
-5 - (
-5										
-5									<u>,</u>	ŕ
								BA!	2	CONTRACTOR AND ADDRESS OF TAXABLE PARTY.

Figure 18-5 Sound_01 When It Opens

- 2. Now let's prepare the Timeline for sound!
 - a) Select the top Layer (Layer F) in the Timeline.
 - b) Click on the Add Layer Icon to the left of the Timeline.
 - c) Double-click on the name of the new Layer and type in . . . Sound.
 - d) Now let's import a new sound. Select the Menu option File / Import.
 - e) In the Dialog Window that opens, set the Files of Type to either MP3 Sound (.mp3) or WAV Sound (.wav) depending on which you prefer to use.
 - f) Locate and select the technoloop file (either .mp3 or wav) in the Chapter 18 Folder on the CD-ROM. Click on the Open Button.
 - g) Select the Menu option **Window / Library.** Notice that the sound has been imported directly into the Library.
- 3. Now we can add the sound to the Timeline.
 - a) Select Frame I in the Sound Layer. Press F6 to Insert Keyframe.
 - b) With the Frame still selected, drag an Instance of technoloop sound from the Library and drop it anywhere on the Stage. Notice that it does not show up on the Stage. The sound is only visible in the first Frame of the Timeline.
 - c) Select the Menu option Control / Test Movie to preview the Movie again. Much better, but the music ends rather abruptly. How can we improve it?

•**T/P**·

Adding Sound

PC users – you will probably want to use the .wav format. Mac users – you will probably want to use the .mp3 format.

- 4. How about fading it out ... let's take a look.
 - a) Select Frame I in the Sound Layer.
 - b) If the Sound Panel is not already visible, select the Menu option Window / Panels / Sound to make it visible. Select the pull down menu in the Effect Field of the Sound Panel and select Fade Out. This will cause the sound to ... fade out as it nears the end of the sound.
 - c) Select the Menu option **Control / Test Movie** to preview the Movie again. Good, this is a much more polished ending.
- 5. Let's stop for a moment and take a closer look at the options on the Sound Panel and find out what they are all about. Figure 18-6 shows you the Sound Panel. Note that there are four Tabs available in the Dialog Window and the Sound Tab is active. Here is a description of each of the options on this panel.

Sound			X
Inst	Effe : Fr	ar 🛃 Soun	4 (S)
Sound:	technoloop.mp3	1	•
	44 kHz Stereo 16	Bit 7.1 s 124	4.2 kB
Effect:	None	·	Edit
Sync:	Event	•	
Loops:	0		

Sound Field – The first field on this panel is the Sound pull down menu. This function will allow you to choose any sound you want from those that are already in the Library. You can use the Sound Field to assign a sound to a Frame, or to swap one sound for another within a Frame that already has a sound file added to it.

File Properties – Once a sound file has been identified in the Sound Field, the gray area immediately below will show you the current file's properties including sampling rate, sample size, channels and file size. These settings cannot be altered, but are simply presented here as information.

Figure 18-6 The Sound Panel

Effect Field – This pull down menu gives you the opportunity to choose from a number of popular effects that you can apply to your sound. The options are: Left Channel, Right Channel, Fade Left to Right, Fade Right to Left, Fade In, and Fade Out. The Custom option will open up the Edit Envelope Dialog Box, which is discussed in more detail in the next Guided Tour.

Sync Field – This pull down menu allows you to change the nature of the sound's playback. You can choose Event, Start, Stop or Stream. The difference between Event and Stream is discussed in more detail in the next section.

Loops Field – This field allows you to type in the number of times you want the sound to loop around before it stops playing.

Edit Button – pressing this button opens the Edit Envelope Window, as illustrated in Figure 18-7. We will see more details about this Edit Envelope Window in the next Guided Tour.

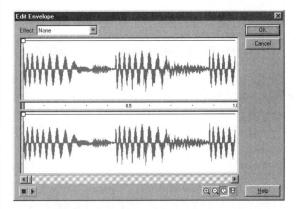

Figure 18-7 The Edit Envelope Window

6. Let's take a look at another place to review Sound properties. Double-click on the technoloop file in the Library. You can see this opened the Sound Properties Window. See Figure 18-8. Within this window, we can rename the sound, import other sounds, and change the compression from default to MP3, ADPCM or Raw formats. If you select one of these compressions, you will also be able to change the bit rate and quality setting.

	Alien Techno.wav	OK
In which the	\\Flash Support\Sounds\Loops\Alien	Cancel
indation	Thursday, August 17, 2000 1:35:12 PM	<u>U</u> pdate
. In the second second	22 kHz Mono 8 Bit 7.0 s 154.6 kB	Import
		<u>I</u> est
		Stop
	Export Settings	Help
	Compression: Default	

Figure 18-8 The Sound Properties Window

Sound Sync Options – Event, Stream, Start and Stop

When you use sound in your Timeline you will need to determine how the sound is synchronized with your Movie Timeline. You can control this with the Sync Field in your Sound Panel. In Flash, synchronization has to do with how the audio plays in relation to the Frames in the Timeline and during the download process. There are four sync settings in Flash that have different properties and applications:

Event – An Event starts in the Keyframe where it is inserted and will continue to play to the end of the sound, regardless of the Movie Timeline. Event sounds are commonly used for background music and effects that do not require the music to correspond to particular Frames in the animation.

Stream – Stream should be used when the audio and animated Frames need to keep pace with one another. With this option selected, the audio is tied to each Frame in the Layer. However, remember the Sound Instance becomes the dominant media element (or the driving force) as the Flash program plays. The Frames try to keep up with the sound, but if they cannot, sometimes Flash will skip Frames in order to keep up with the sound. Stream sounds end when the Movie Timeline ends.

Start – This sync setting allows you to Start a new Instance of a sound while simultaneously stopping an Instance of sound that was previously playing.

Stop – This allows you to Stop Sounds from playing in your Timeline.

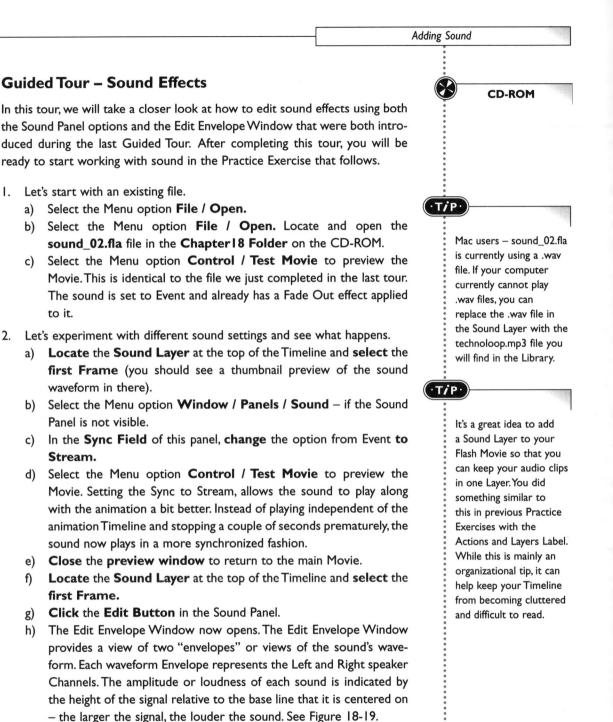

Each envelope includes white square "handles" which allow us to adjust the volume of that particular channel by dragging the handle up or down. You can add more handles by clicking inside the envelope and then moving each handle to the desired volume level. You

2.

a)

f)

g)

h)

313

can have up to eight handles within an envelope, adjusting each independently to create your own audio effects. To remove an Envelope handle, drag it off of the window. You can use these handles and the Effect pull down menu (at the top-left) to apply the same effects that we saw in the Effects pull down menu of the Sound Panel.

Figure 18-9 The Edit Envelope Window

- Adjust the following options according to your own preferences: Change the Starting and Ending points of the sound by dragging the **Time In** and **Time Out controls**. Change the **Left or Right Channel Envelope**, drag the Envelope handles to change the volume level at different points in the sound. Click the **Zoom In / Zoom Out Buttons** to display more or less of the sound in the window. Switch the time increment between seconds and Frames, click the **Seconds** or **Frames Buttons**.
- j) After trying a couple of these controls, **click OK**.
- k) Select the Menu option Control / Test Movie to preview the Movie with your custom sound.
- 3. Experiment! Try a few more variations on the same sound.

Practice Exercise – Adding Sound to a Button

Description

In this exercise we will take an existing button and add sound to it. By adding sound, we can enrich the user's experience by giving them another level of response to the button when a mouse event occurs.

Adding Sound

In this exercise you will:

- Edit a Symbol that already exists in the Library.
- Import the sounds we wish to add.
- Assign the sounds to the proper button states.

Take-a-Look

Before beginning the exercise, let's take a look at the exercise in its completed state so that you can clearly see what it is that you are about to build.

- Use the Menu option File / Open and locate on the CD-ROM the folder named Chapter18 and locate the file named button_complete.fla.
 Double-click on this file to open it.
- 2. The file button_complete.fla should now appear in your copy of Flash.
- 3. Select the Menu option **Control / Test Movie** to see the Movie playback.

Please note the following properties of this completed exercise:

- a) Sounds for particular Mouse Events are nested within the corresponding Button Symbol Frames.
- b) A button can have more than one sound nested within it.

Storyboard: On-Screen

Figure 18-10 shows you what the Button will look like on the Stage when you have completed this exercise.

Figure 18-10 The Completed Stage

CD-ROM

Mac users –

TP

button_complete.fla is currently using a .wav file. If your computer cannot currently play .wav files, you can use the .mp3 format in the following exercise.

Storyboard: Behind the Scenes

Figure 18-11 shows what the Timeline of the **red_glow_button** Symbol will look like when you have completed this exercise.

	-	-		U	Ov	er Do	wn Hit	1			H
🕫 Sounds 👘 🖌	•	•			F		-				
D Layer 1	•	•									
				Π							
			0			al e	र्वा त्यां	1	12.0 fps 0.0	ne al C	

Step-by-Step Instructions:

I. Let's get busy.

- a) Select the Menu option File / Open. Locate and open the button_01.fla file in the Chapter18 Folder on the CD-ROM.
- b) Save a copy of the file in the SaveWork Folder on your computer using the name ... button_complete.na.
- c) Note that there is only one Frame in this Movie Timeline.
- d) **Control / Test Movie** to view the Movie. There appears to be a visible difference in the button when you RollOver or Press the button, but there is no sound. Kind of boring, so let's make it better.
- e) **Close** the test window to return to the main Movie.
- f) Press the Ctrl & L Keys (Mac Cmnd & L) to access the Library if it isn't already visible.
- g) Locate the red_glow_button Symbol and double-click it to edit the Symbol.
- h) The red_glow_button Timeline appears. This Timeline has the four standard Frames that compose a button Symbol: Up, Over, Down and Hit. These Frames all exist within the same layer.
- i) Click the Insert Layer Icon in the Timeline.
- j) Double-click the Layer name and rename it ... Sound.
- k) Select the Frame in the Sound Layer that corresponds to the Over Frame. Press the F7 Key to Insert a Blank Keyframe.
- Select the Frame in the Sound Layer that corresponds to the Down Frame. Press the F7 Key to Insert a Blank Keyframe.
- 2. Now for the sound.
 - a) Select the Menu option File / Import. Locate and then Ctrl & Click (Mac - Cmnd & Click) to select both the downclick and rollover sound files in the Chapter 18 Folder on the CD-ROM.
 - b) **Click Open** to import the sounds.

We have included both the .mp3 and .wav formats – select and use whichever your computer is compatible with. Make sure you select the same format for both the **downclick** and the **rollover**.

CD-ROM

Go Solo

·T/P

- 3. Lets apply sound one way...
 - a) Select the Over Frame in the Sounds Layer.
 - b) Select the Rollover file in the Library. Click the Play Button (it looks like a little arrow) in the Library Preview Window to get an audio preview of the sound.
 - c) **Drag** an Instance of the sound out onto the stage and drop it anywhere. A thumbnail preview of the sound waveform appears in the Over Frame.
- 4. And then another way...
 - a) Select the Down Frame in the Sounds Layer.
 - b) Select the Downclick file in the Library. Click the Play Button in the Library Preview Window to get an audio preview of the sound.
 - c) Select Window / Panels / Sound from the menu if the Sound Panel is not visible. On the Sound Panel, click the pop up window by Sound and choose the downclick file from the list. A thumbnail preview of the sound waveform appears in the Down Frame.
- 5. Let's experience what we have done.
 - a) Select the Menu option **Control / Test Movie** to view the Movie.
 - b) Roll your cursor over the button to trigger the Over sound, and click to hear the Down sound. Pretty sharp! It's easy to see how sound adds so much more to an interactive experience.

Work-arounds With Using Sound

The biggest limitation of using sound in your Flash projects has to do with file size. Sound files can dramatically increase the size of a Flash Movie, and thereby slow down performance. When a Movie is published to the **.swf** format, it is automatically compressed and prepared for the Web environment.

With Flash 5, it is now possible to import MP3 compressed sounds. MP3 audio files are characterized by small file sizes that retain high quality sound despite compression. MP3 is a codec, or compression algorithm, that is used specifically for digital sound files. The use of MP3 allows you to import a much smaller sound file into your Movie, thus decreasing the overall file size. As mentioned earlier in this chapter, you can also choose the MP3 option in the Publish Settings to compress sounds when they are exported from Flash. Using Publish Settings will globally compress all the audio in your Movie using one compression setting on export. You can also individually set compression settings by using the Sound Properties Window in the Library to have more control over each sound's compression.

Another work-around for the amount of space that large sound files take up in your Movie is to loop smaller sound clips. Looping is extremely helpful if

you want a clip to play for an extended period of time, or if your clip isn't long enough when synchronized with the animation in your Movie.

Summary

- Flash easily provides true multimedia capability within the Flash application that you create.
- · Sound can serve a number of important functions in your Flash project:
 - Music and sound tracks can add dynamic support for on-screen graphics or animation, as well as increase the general level of user/viewer interest in your project.
 - Narration (audio track) can provide information that either supports or that is in addition to what is presented via text, graphics and/or animation.
 - Sound effects can accompany user actions; provide additional feedback concerning a user response or required action; and can be used as a technique to "grab and focus" the user's attention to a particular point of interest.
- You can easily purchase literally thousands of different sound effects and music segments representing a wide variety of musical styles.
- Your best bet is to look for music and sound effects products that very clearly state "Royalty Free Use" of their sound files.
- To obtain the most professional results for narration, you may want to use professional talent and a recording studio.
- You can also record your own narration, as it is pretty easy to do. At a minimum, you will need three things, with a fourth component recommended:
 - a sound card in your computer
 - a microphone
 - sound editing software
 - recording device (recommended, not required)
- In the digital world of computers, if we want to record and playback sound, we need to capture and represent a continuous stream of events as a long series of individual "moments-frozen-in-time." Each digital "frozen moment" is a sample of that music at a specific point in time.
- Our ability to digitally represent the live music is significantly influenced by four properties related to how we "sample" or capture these individual "moments-frozen-in-time." These properties include sampling rate, size of sample, mono/stereo capability and to some extent file format.
- You can import the following file types for use into Flash:
 - MP3 a compressed file format that features high quality sound with small file sizes.

- WAV the standard file format for audio files within Windows.
- AIFF this file format was developed by Apple but can be used on a PC as well as a Mac.
- The following list of alternate file types can also be imported if QuickTime 4.0 or later is installed on your system:
 - Sound Designer II (Mac)
 - System 7 sounds (Mac)
 - Sun AU (Windows and Mac)
 - Sound Only QuickTime Movies (Mac and Windows)
 - WAV (Windows and Mac)
- As you add sound to your Flash program, it can significantly increase the file size. As the file size increases, so does the time required to download and "write-to-screen" – especially with low bandwidth access.
- Another important issue related to the use of sound is whether it is appropriate in the environment where your typical user / viewer will access your Flash project or Web site.
- In the first Guided Tour you saw how easy it is to import sound and add it to the Timeline.
- An Event sound must download completely before it begins playing and it continues playing until directed to stop. Event sounds play independently from the Frames in the Timeline.
- Streaming sounds will begin to play as soon as there is enough data available and will continue to play as downloading continues. Streaming sound begins playing where they are inserted and stop when the Movie ends.
- In the second Guided Tour, you worked with the Sound Panel options and Edit Envelope Window to take a quick look at sound effects.
- In the Practice Exercise you learned how to add two different sounds to a button.

PTER

19

Application Chapter: Creating Sound Effects

Chapter Topics:

- Introduction
- Application Exercise Creating Sound Effects
- Summary

Introduction

The Flash Library allows you to store all sorts of media – Symbols, bitmaps, and sounds. Throughout this book, we have talked about the user experience. Sounds can add a great deal of interest in a site by setting the mood and tone.

It's important to choose sounds selectively and to use them in an effective way. This exercise is designed to show you how richly textured a site can become with the addition of sound effects. If you think of your Web site as a separate environment that a user is stepping into, you won't want to leave out the auditory senses.

Application Exercise – Creating Sound Effects

Description

In this Application Exercise you will create sound effects for your site.

Take-a-Luuk

Before beginning the exercise, let's take a look at the exercise in its completed state so that you can clearly see what it is that you are about to build.

- Use the Menu option File / Open and locate on the CD-ROM the folder named Chapter 19. Locate the file named application_19.fla.
 Double-click on application_19.fla to open the file.
- 2. The file **application_19.fla** should now appear in your copy of Flash.
- 3. Test the Movie. Take a moment to look through the Timeline.

Storyboard: On-Screen

Figure 19-1 shows what can be seen on Stage when the exercise is completed.

Application Chapter: Creating Sound Effects

Figure 19-1 The Completed Stage

Storyboard: Behind-the-Scene

Figure 19-2 shows how the Timeline will look when the exercise is completed.

	æ	-		1	5	10	15	20	25	30	35	40	45	50	55	60	65	t
Actions and Labels	×	•		d	aaaa													
Locators	•	•		Π		TH												
🗗 Text 🛛 🖌	•	•	12															
P Headlines	•	3																
Home Button	٠	•		Π	• 0													
D Buttons	•	•																
Photos	•	3																
Route Sign	•	9																
Background	•	8			0													-
• 段			n	II.		B	1 1	2.0 fps	0.0s		R 16	91 90	381			18. 35		ſ

Applications Project Steps

Complete this exercise on your own, guided by following the general steps provided below. You can always refer back to the completed example that you viewed in the Take-a-Look section of this exercise.

Please Note: The following steps are intended as a guide. This is your project so please feel free to make whatever variations you would like.

- 1. Open application_17.fla. You can either use the copy you created and saved in the SaveWork Folder on you computer or you can use the copy in the Chapter17 Folder on the CD-ROM supplied with this book.
- 2. Enter the Symbol-editing Mode for the Bulldozer, TX Button Symbol.

·T/P

- 3. Add a new Layer and name it Sound. Position it below the Graphic Layer.
- 4. Insert a Keyframe in the Down Frame of the Sound Layer.
- 5. Drag an Instance of the car_horn sound file from the Sounds Folder of the Library into the Down Frame.
- 6. Enter the Symbol Editing Mode for the Chikapee, AZ Button Symbol.
- 7. Add a new Layer and name it Sound. Position it below the Graphic Layer.
- 8. Insert a Keyframe in the Down Frame of the Sound Layer.
- Drag an Instance of the car_horn sound file from the Sounds Folder of the Library into the Down Frame.
- 10. Enter the Symbol Editing Mode for the Underdale, NV Button Symbol.
- 11. Add a new Layer and name it Sound. Position it below the Graphic Layer.
- 12. Insert a Keyframe in the Down Frame of the Sound Layer.
- Drag an Instance of the car_horn sound file from the Sounds Folder of the Library into the Down Frame.
- 14. Enter the Symbol Editing Mode for the Wagonrut, NM Button Symbol.
- 15. Add a new Layer and name it Sound. Position it below the Graphic Layer.
- 16. Insert a Keyframe in the Down Frame of the Sound Layer.
- Drag an Instance of the car_horn sound file from the Sounds Folder of the Library into the Down Frame.
- 18. Enter the Symbol Editing Mode for the Exit 101 Button Symbol.
- 19. Add a new Layer and name it Sound. Position it below the Graphic Layer.
- 20 Insert a Keyframe in the Down Frame of the Sound Layer.
- 21. Drag an Instance of the car_engine sound file from the Sounds Folder of the Library into the Down Frame.
- 22. Enter the Symbol Editing Mode for the Exit 102 Button Symbol.
- 23. Add a new Layer and name it Sound. Position it below the Graphic Layer.
- 24. Insert a Keyframe in the Down Frame of the Sound Layer.
- 25. Drag an Instance of the car_engine sound file from the Sounds Folder of the Library into the Down Frame.
- 26. Enter the Symbol Editing Mode for the Go Button Symbol.
- 27. Add a new Layer and name it Sound. Position it below the Graphic Layer.
- 28. Insert a Keyframe in the Down Frame of the Sound Layer.
- 29. Drag an Instance of the car_engine sound file from the Sounds Folder of the Library into the Down Frame.

We have included both .mp3 and .wav formats. Select and use whichever format is compatible with your computer.

- 30. Enter the Symbol Editing Mode for the Home Button Symbol.
- 31. Add a new Layer and name it Sound. Position it below the Graphic Layer.
- 32. Insert a Keyframe in the Down Frame of the Sound Layer.
- 33. Drag an Instance of the car_engine sound file from the Sounds Folder of the Library into the Down Frame.
- 34. Enter the Symbol Editing Mode for the Send Button Symbol.
- 35. Add a new Layer and name it Sound. Position it below the Graphic Layer.
- 36. Insert a Keyframe in the Down Frame of the Sound Layer.
- 37. Drag an Instance of the car_engine sound file from the Sounds Folder of the Library into the Down Frame.
- Return to the main Movie Timeline. Enable Simple Button Actions and try out the buttons.
- 39. Save your file as application_19.fla in the SaveWork Folder on your computer.

Summary

This chapter was all about adding greater interest to your site by adding sound effects. As you have seen, sound can add humor and can set a mood for your site visitors as they peruse all the attractions you have built into your Flash Web site.

PTER

20

Organizing

Movies

Chapter Topics:

- Introduction
- Using Scenes
- Playback of Scenes
- Plan Ahead on Paper (Outline & Storyboards)
- Practice Exercise Creating a Movie with Multiple Scenes
- Practice Exercise Using Actions with Scenes
- Using a Pre-loader
- Practice Exercise Building a Pre-loader
- Practice Exercise Loading and Unloading Movies
- Summary

Introduction

Creating successful Flash projects requires creative energy and dedication, but also depends heavily on project management and organization. Planning how your Flash program is designed and constructed will ultimately affect how efficiently your program will download over the Web. Some important concepts and techniques you will learn about in this chapter are dividing your Flash program into Scenes, linking to other external Movies, and thinking through your project's organization.

By the end of this chapter, you will be able to:

- use the Scene Panel.
- · add a Scene to your Movie
- toggle from one Scene to another.
- use Actions to move from one Scene to another.
- create a pre-loader.
- · load and unload external Movies with Actions

Using Scenes

Early in this book we used the example of a theatrical or movie production to explain the metaphor used for the Flash interface and environment. When you watch a play, the production is generally divided into scenes. These scenes are creative tools and techniques that allow the screenwriter to organize and develop the story line in a logical and meaningful way – by time period, by location, by event, etc.

Your Flash program can also be divided into Scenes. Using Scenes can help you to organize your project content into different categories. How you structure the categories (Scenes) and what you put in each Scene is often heavily influenced by the type of application you are building (Web site; presentation; instruction; game and others); the file size; and personal working habits.

There is certainly no requirement or obligation to use more than one Scene – it's simply an option that may help you keep more organized. Perhaps an example would help. Let's say you want to build a Web site, using Flash to create the whole thing. Take a look at Figure 20-1.

Organizing Movies

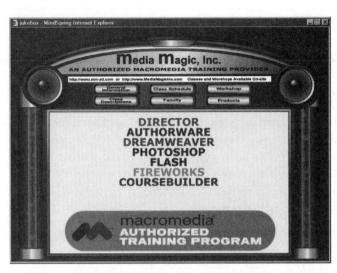

Figure 20-1 Media Magic Web Site Jukebox Interface

You are looking at the Media Magic Home Page and Web site Interface. Here is one organizational scheme for the Flash program.

- **Scene I** The Jukebox Interface includes everything connected with the interface; the animated "bubbles" on each side; an animated banner at the top; and 6 navigational buttons (these are the categories) across the top.
- **Scene 2** The General Info Button everything that will be displayed or heard concerning the General Information . . . within the square content area . . . and does not include the Jukebox interface.
- **Scene 3 –** The Class Descriptions Button everything that will be displayed or heard concerning the Class Descriptions area ... within the square content area ... and does not include the Jukebox interface.
- Scene 4 The Class Schedule Button everything that will be displayed or heard concerning the Class Schedule area ... within the square content area ... and does not include the Jukebox interface.
- **Scene 5** The Faculty Button everything that will be displayed or heard concerning the Faculty Information area ... within the square content area ... and does not include the Jukebox interface.
- Scene 6 The Workshop Button everything that will be displayed or heard concerning the Workshop area ... within the square content area ... and does not include the Jukebox interface.
- Scene 7 The Products Button everything that will be displayed or heard concerning the Products area ... within the square content area ... and does not include the Jukebox interface.

As is the case with any development project, the more thoroughly you plan and organize before you start ... the better the results ... in terms of development efficiency and ease of modification.

Playback of Scenes

Scenes allow you to segment or "chunk" part of a long Movie Timeline into manageable portions. Once you create a Scene in your Movie, this new Scene will appear as a blank Movie until you paste or insert content into the Timeline. By default, every Flash Movie contains one Scene when it is created. The Scene Icon above the Timeline, as illustrated in Figure 20-2, indicates which Scene you are currently working in.

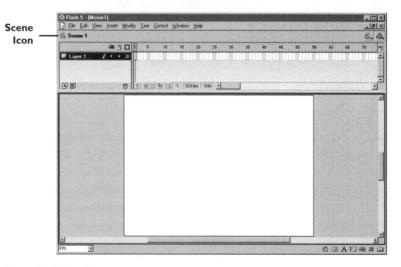

Figure 20-2 The Scene Icon Above the Timeline

You can very easily add a new Scene by selecting the Menu option Insert / Scene. Once you have multiple Scenes to work on, you can select which Scene you would like by clicking on the Edit Scene Icon (see Figure 20-3) and selecting a Scene from the pop up menu that lists all the Scenes you've created. In Figure 20-3, we've created three Scenes and have selected Scene 3 to work on. In the first Practice Exercise, we will show you how to use another way to add and select Scenes, with the use of the Scene Panel.

Organizing Movies

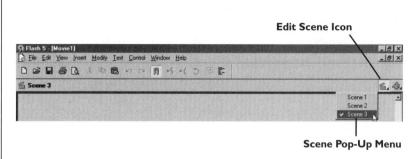

Figure 20-3 The Edit Scene Icon - Scene 3 Selected

Scenes in your Movie are played back linearly – one Scene after another – in the same fashion that Flash plays back Frames in the Timeline. Flash will play back Scenes in order, without pause, unless an Action is inserted within a Frame or an event is triggered that then causes the Movie to play in a non-linear fashion. Essentially, if there are no Actions in place to stop or re-route the Timeline, Flash reads Scenes as if they were all part of the main Movie Timeline and plays them consecutively in the order they appear in the Scene Panel.

Plan Ahead – on Paper (Outline & Storyboard)

When should you create a new Scene? For that matter, what is going to happen in your Movie? And what kind of user interactions will be added? These are common questions for Flash developers that need to be answered before you start to create your project in Flash. While this is not a book on multimedia project development, there are some tools that can help you plan your Flash project, before you even launch the program.

Content Outline

Before you begin creating the project in Flash, we suggest that the use of one or more paper-based tools will help you plan, organize and design your project. The first and simplest tool is the Content Outline, just like most of us had to create before writing term papers in school. The Content Outline requires that you think about and "commit to paper" the content that you want to include, while also forcing you to deal with how to organize and sequence this content. Going back to our example of the Jukebox Web site, a Content Outline of this concept might look like this:

I. Jukebox Interface (Scene I)

A. Foundation Image

- I) Jukebox image (sides / curved top)
- 2) Speakers
- 3) Company Name

B. Navigational Buttons

- General
- 2) Class Descriptions
- 3) Class Schedule
- 4) Faculty
- 5) Workshops
- 6) Products

C. Side Animations

- I) Basic Elements
- 2) Animation Effect I
- 3) Animation Effect 2

D. Banner Animation

- I) Basic Elements
- 2) Animation
- E. Opening Page Animation
 - I) Basic Elements
 - 2) Animation
- II. General (Scene 2)
 - A. Company Background
 - **B.** Location and Directions
 - C. Local Hotels

etc.

Content Outlines can become even more detailed, including a listing of all elements, conceptual descriptions about art / animation, and directions or notes for programming. There is no "right" or "wrong" way to create a Content Outline. It is really the issue of whatever will help you organize and plan the project before you actually start to create it.

Storyboard

Another paper-based design tool is the Storyboard. What a Storyboard "is" and what it looks like varies quite a bit from one multimedia developer to another. However, the common element for all ... is that a Storyboard will help you pre-visualize what the screen will look like before you actually create it. A single sheet of paper is generally used to represent a single Frame – with a large area where you can "quick-sketch" what graphic and text elements will look like and where they will be placed on the Stage. Frequently programming notes are also included, detailing what transition or animation effects will be used; where the current Frame will branch to next; what navigational controls are active / inactive; and other types of information as well.

Storyboards are planning tools that have long been used by film makers, theater directors, set designers, advertisers and animators as they develop the concepts for creative projects. They can be as detailed or as simple as you want, or as time allows, but they are an important part of the development process for most multimedia projects.

Practice Exercise – Creating a Movie with Multiple Scenes

Description

This exercise will give you practice adding multiple Scenes to a Movie.You will learn how to paste content into a new Scene and will see first-hand how Flash automatically plays back a Movie with multiple Scenes when no Actions are inserted in the Timeline.You will also see how changing the order of Scenes in the Scene Panel affects the playback of your Movie.

The Movie we are going to use in this exercise includes animation for a fictitious company with an equally fictitious Web site. For the sake of this exercise, we will break the existing animation into separate Scenes (making it easier to edit parts of the Movie without having to work in a single, large Timeline). In later exercises, we will correct the order of the Movie Playback.

In this exercise you will:

- · Add and label multiple Scenes in a Movie.
- · Move content from one Scene to another.
- Test Playback for a Movie with multiple Scenes.

Take-a-Look

Before beginning the exercise, let's take a look at the exercise in its completed state so that you can clearly see what it is that you are about to build.

- Use the Menu option File / Open and locate on the CD-ROM the folder named Chapter20. Locate the file named dotcomsat_I.fla. Doubleclick on this file to open it.
- 2. The file dotcomsat_l.fla should now appear in your copy of Flash.
- 3. Select the Menu option Control / Test Movie to view the Movie.

Please note the following properties of this completed exercise:

- a) Each Scene represents a logical break in the continuity of the Movie.
- b) Scenes play in the order they are stacked unless directed otherwise.
- c) Different Scenes within the same Movie share a common library.

CD-ROM

Storyboard: On-Screen

Figure 20-4 shows you what the Stage will look like when this exercise is completed.

Figure 20 1 The Completed Stage

Storyboard: Behind-the-Scene

Figure 20-5 shows you what your Timeline will look like after you have completed this exercise.

<mark>≫ Flash 5 - [dotcomsat_1.fla]</mark>	 <u>I</u> ext <u>C</u> ontrol <u>W</u> in	dow <u>H</u> elp		
🔓 Main Body				
5	1 5 10	15 20	25 30	
Guide: Sat Animation • •			0	
Sat Animation • •	•>			
🗾 Button Animation 🥖 🔹 🔹	e >	•	0.	
Logo Animation • •	• >		•	
Background Elements Backgrou	+ 00 8 0	1 12.0 fps 0.0	5 4	

Figure 20-5 The Completed Timeline

Step-by-Step Instructions:

I. Let's divide and conquer!

			ovies
-	· 8 ····	 · · · >	

Go Solo

CD-ROM

- a) Select the Menu option File / Open. Locate and select the file named dotcomsat_start.fla from the Chapter20 Folder on the CD-ROM. Save the file to your own system as dotcomsat.fla.
- b) Select the Menu option **Window / Panels / Scene.** The Scene Panel appears on-screen with Scene I listed.
- c) Click the Add Scene Icon. See Figure 20-6. Name the new Scene ... Intro Animation.
- d) Click the Add Scene Icon and name the new Scene ... Main Body.

Scen		X
	Scene	?
6	Scene 1	
6	Main Body	
6	Intro Animation	
I		

Add Scene

- e) **Select Scene I** in the Scene Panel to return to the main Movie Timeline.
- f) Select Frames 16-55 in the following Layers:

Guide: Animated Sat Animated Sat Logo Mask Logo Blue Spot

- g) Select the Menu Option Edit / Cut Frames.
- h) Click the Edit Scene Icon in the upper-right corner of the Timeline. See Figure 20-7. Select Intro Animation in the Scene Panel to go to the Intro Animation Scene.

Figure 20-6 The Scene Panel

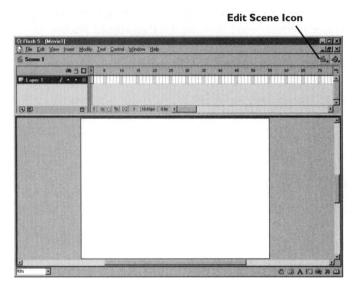

Figure 20-7 The Edit Scene Icon

- i) Select Frame I in the Intro Animation Timeline. Select the Menu Option Edit / Paste Frames.
- j) From the top of the stacking order down, **rename** the Layers in Intro Animation as:

Guide: Animated Sat Animated Sat Logo Mask Logo Blue Spot

- k) Select the Menu Option View / Go To / Scene I to return to the Scene I Timeline.
- I) Select Frames 56-85 in the following Layers:
 - **Guide: Sat Animation**
 - Sat Animation
 - **Button Animation**
 - Logo Animation

Background Elements

- m) Select the Menu Option Edit / Cut Frames.
- n) Select Main Body in the Scene Panel.
- o) Select Frame I in the Main Body Timeline. Select the Menu Option Edit / Paste Frames.
- p) From the top of the stacking order down, rename the Layers in Main Body as:

Guide: Sat Animation

Sat Animation Button Animation Logo Animation Background Elements

- 2. Tidying up.
 - a) **Select Scene I** in the Scene Panel to return to the main Movie Timeline.
 - b) **Delete all Layers except** for the two at the top of the stacking order: **Masthead** and **Background Elements.**
 - c) Select the Menu option Control / Test Movie to preview the Movie. Deselect the Menu Option Control / Loop to prevent the playback from looping. The Movie plays as it did before. As the Playhead gets to the end of one Scene it jumps to the next Scene listed in the stacking order of the Scene Panel. Close the Test Window to return to the Main Movie.
 - d) In the Scene Panel, **drag** the Scene **Intro Animation** above the Main Body Scene.
 - e) Select the Menu option Control / Test Movie to preview the Movie. Deselect the Menu Option Control / Loop to prevent the playback from looping. The order of the playback has now changed, and drastically alters the look and continuity of the Movie. We will use Actions in the next exercise to control the playback of the Scenes (although we could just use the Stacking Order for a simple Movie like this).
 - f) **Close** the preview to return to the main Movie.
 - g) Save your file as dotcomsat_I.fla in the SaveWork Folder.

Practice Exercise – Using Actions With Scenes

Description

In this exercise you will use some basic Actions to control the way your Movie Timeline plays from Scene to Scene. You will see how to stop the Timeline from moving to the next Scene and how to set up an Action to move to the next Scene.

In this exercise you will:

- Add new Layers and insert Keyframes.
- Insert the Go To Action to Change Scenes.
- · Change the Stacking Order of the Scenes.
- · Insert the Stop Action.

CD-ROM

Take-a-Look

Before beginning the exercise, let's take a look at the exercise in its completed state so that you can clearly see what it is that you are about to build.

- Use the Menu option File / Open and locate the folder named Chapter20 on the CD-ROM. Find the file named dotcomsat_2.fla. Double-click on this file to open it.
- 2. The file dotcomsat_2.fla should now appear in your copy of Flash.
- 3. Select the Menu option Control / Test Movie to view the Movie.

Please note the following properties of this completed exercise:

- a) The introductory animation automatically plays upon loading the file.
- b) The main page animation continually plays in a loop.
- c) The menu choices are not yet active.

Storyboard: On-Screen

Figure 20-8 shows you what the Stage will look like when this exercise is completed.

Figure 20-8 The Completed Stage

Storyboard: Behind-the-Scene

Figure 20-9 shows you what the Timeline will look like when this exercise is completed.

Organizing Movies

Go Solo

CD-ROM

Elle Edit View Insert	M	odih	<u>v I</u>	ext	Control	Windo	w <u>Hei</u>	>		
🗟 Main Body							and and a set			
	-	9		1	5	10	15	20	25	6
Actions and Labels	•	•								4
C Guide: Sat Animation	٠	•								6
Sat Animation	•	•		0>						B
E Button Animation /	•	•				• >				0+
Logo Animation	•	•				• >		→ • >		
Background Elements	•	•								6
			n	T	00	6 62	30 12	Olps 2	45 4	

Figure 20-9 The Completed Timeline

Step-by-Step Instructions

- I. Let's get started.
 - a) Select the Menu option File / Open. Locate and select the file named dotcomsat_I.fla from the Chapter20 Folder on the CD-ROM, or use the version that you completed and saved from the last exercise.
 - b) Select Scene I in the Scene Panel. Add a new Layer in the Scene I Timeline and rename it ... Actions and Labels. Make sure the new Layer is at the top of the Stacking Order.
 - c) Insert a Keyframe (F6) in Frame 15 of the Actions and Labels Layer.
 - d) With Frame 15 of the Actions and Labels Layer selected, choose the Menu option Window / Actions.
 - e) Click the Basic Actions Icon in the Actions Panel.
 - f) Double-click the Go To Action. The following ActionScript code is added to your Actions Panel: gotoAndPlay (1);
 - g) In the Parameters of the Action Panel, change Scene from <current Scene> to Intro Animation. The code now reads gotoAndPlay ("Intro Animation", 1);
 - h) **Close** the Actions Panel.
 - Select Intro Animation in the Scene Panel. Add a new Layer in the Intro Animation Timeline and rename it . . . Actions and Labels. Make sure the new Layer is at the top of the Stacking Order.
 - j) Insert a Keyframe in Frame 40 of the Actions and Labels Layer.
 - With Frame 40 of the Actions and Labels Layer selected, choose the Menu Option Window / Actions.
 - I) Click the Basic Actions Icon in the Actions Panel.

m)	Double-click the Go To Action.	The following ActionScript code
	is added to your Actions Panel:	
	gotoAndPlay (1):	

 n) In the Parameters of the Action Panel, change Scene from <current Scene> to Main Body. The code now reads gotoAndPlay ("Main Body", 1);

- 2. Finishing Touches.
 - a) **Select Main Body** in the Scene Panel. **Add a new Layer** in the Main Body Timeline and rename it ... **Actions and Labels.** Make sure the new Layer is at the **top of the Stacking Order.**
 - b) Insert a Keyframe in Frame 30 of the Actions and Labels Layer.
 - c) With Frame 30 of the Actions and Labels Layer selected, choose the Menu Option Window / Actions.
 - d) Click to expand the Basic Actions Icon in the Actions Panel.
 - e) Double-click the Stop Action. The following ActionScript code is added to your Actions Panel: stop ();
 - f) Select the Menu option Control / Test Movie to preview the Movie. Deselect the Menu Option Control / Loop to prevent the playback from looping. The order of the playback is much more fluid and logical! Despite the Stacking Order in the Scene Panel, we are able to control the playback by using Basic Actions!
 - g) **Close** the test window to return to the Main Movie.
 - h) Save your file as dotcomsat_2.fla in the SaveWork Folder.

Using a Pre-loader

A pre-loader is a small animation program that loads quickly and plays while the main Flash program is loading in the background. The pre-loader gives the person waiting at the other end of the pipeline a visual indication that something is being downloaded and that the system is not hung up. Many sites use a very simple "Loading . . ." statement with an animated effect that gives the illusion of activity. Some sites also use a countdown that makes its way down to zero over a certain amount of time.

Since Flash uses streaming media, it is not necessary for the entire program file to download before the Flash file begins playing. However, with the use of a pre-loader, you can ensure that a specified number of Frames in the Movie have downloaded first so that a user can experience seamless animation as the Flash Movie begins to play.

Practice Exercise – Building a Pre-loader

Description

Pre-loaders work by attaching an **If Frame is Loaded** Action to a Keyframe in the pre-loader's Scene. This Action checks to make sure that the specified Frame has loaded before it starts playing the next Scene in the Movie Timeline.

In this exercise you will:

- Set up a conditional loop.
- · Create the ActionScript if all Frames of the Movie have been downloaded.
- Create the ActionScript if all Frames of the Movie have not been downloaded.

Take-a-Look

Before beginning the exercise, let's take a look at the exercise in its completed state so that you can clearly see what it is that you are about to build.

- Use the Menu option File / Open and locate the folder named Chapter20 on the CD-ROM. Find the file named dotcomsat_3.fla. Double-click on this file to open it.
- 2. The file dotcomsat_3.fla should now appear in your copy of Flash.
- 3. Select the Menu option Control / Test Movie to preview the Movie.

Please note the following properties of this completed exercise:

- a) The introductory animation automatically plays upon loading the file.
- b) The main page animation continually plays in a loop.
- c) The menu choices are not yet active.

Storyboard: On-Screen

Figure 20-10 shows you what the Stage will look like when this exercise is completed.

CD-ROM

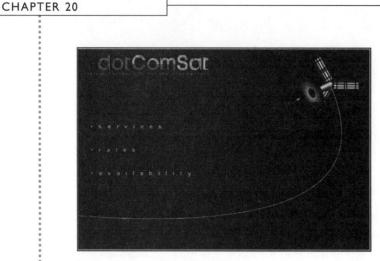

Figure 20-10 The Completed Stage

Storyboard: Behind-the-Scene

Figure 20-11 shows you what the Timeline will look like when this exercise is completed.

🖉 Eile Edit Yiew Inci	at	Mo	dify	Iext	Contro	l Win	town H	eip		
🔓 Main Body										
	-	5		1	5	10	15	20	25	[a]
IV Actions and Labels /	•	•	12							1
C Guide: Sat Animation	•	•								0
Sal Animation			圓	•						6
D Button Animation	•									Die
Logo Animation	•					•				-
Background Elements	•	•		•						6
N2			1	100	0019	51 131	30 12	O fpg 2	45 4	

Figure 20-11 The Completed Timeline

Step-by-Step Instructions

- I. Let's get started.
 - a) Select the Menu option File / Open. Locate and select the file named dotcomsat_2.fla from the Chapter20 Folder on the CD-ROM, or use the version that you completed and saved from the last exercise.
 - b) Select Intro Animation in the Scene Panel.
 - c) Select Frame 40 in the Actions and Labels Layer of the Intro Animation Timeline.
 - d) Select the Menu option Window / Panels / Frame.
 - e) In the Frame Panel give Frame 40 the label name . . . Final Frame. This will be the last Frame to download from the server because it is the last Frame of the last Scene in the Stacking Order.

342

Once it downloads, that is the cue for Flash to continue through the rest of the Movie Timeline.

2. Now we'll set up a Conditional Loop in the Preloader.

- a) **Double-click Scene I** in the Scene Panel. Rename Scene I ... **Preloader.**
- b) Select Frame 10 of the Actions and Labels Layer. Insert a Keyframe (F6). In the Frame Panel assign Frame 10 the name ... Frame Check.
- c) Select the Menu option Window / Actions.
- d) Click the Basic Actions Icon in the Actions Panel.
- e) Double-click the If Frame Is Loaded Action. The following ActionScript code is added to your Actions Panel: ifFrameLoaded (1) {

```
}
```

f) In the Parameters at the bottom of the Actions Panel, change Scene from Current Scene to Intro Animation. Also change Type to ... Frame Label and Label to ... Final Frame. The code now reads:

```
ifFrameLoaded ("Intro Animation", "Final Frame") {
}
```

g) In the Basic Actions category, double-click the Go To Action. In the Parameters at the bottom of the Actions Panel, change Scene from Current Scene to ... Intro Animation. The code now reads:

```
ifFrameLoaded ("Intro Animation", "Final Frame") {
  gotoAndPlay ("Intro Animation", 1);
```

```
}
```

Line I of this code sets up an "If / Then" conditional statement. "If" the Frame labeled "Final Frame" in the Intro Animation Scene is loaded, "Then" something must happen. Line 2 takes care of that something.

- 3. Now we have to define what happens ... if it isn't loaded.
 - a) Select Frame 15 in the Actions and Labels Layer of the Preloader Scene. In the Actions Panel, double-click the Go To Action. The following code is added to the Actions Panel: GotoAndPlay ("Into Animation", "1");
 - b) Select this line of code and change the Scene to <current Scene> and the Frame Label to ... Frame Check. The code now reads as follows:

```
gotoAndPlay ("Frame Check");
```

If the Frame labeled "Final Frame" hasn't downloaded yet, the animation will play to Frame 15, at which point it loops back to the Frame labeled "Frame Check" and the whole "If / Then" issue is checked once again. It will continue to loop this way until the condition has been met.

- c) Select the Menu option Control / Test Movie to view the Movie. Deselect the Menu option Control / Loop to prevent the playback from looping. Since the file is already on your system you may not notice any delay or file buffering from downloading it. You can emulate the download by choosing View / Show Streaming from the menu, and then adjust the download speed by choosing the Menu option Debug, and then selecting any of the modem speed presets.
- d) **Close** the test window to return to the main Movie.
- e) Save your file as dotcomsat_3.fla in the SaveWork Folder.

Practice Exercise – Loading and Unloading Movies

Description

We are continuing to build on the program that we have been developing throughout the Practice Exercises in this chapter. In the final exercise of this series, you will learn how to load and unload external Movies from your main Movie Timeline.

In this exercise you will:

- Set up a Load Movie Action.
- Set up a Unload Movie Action.
- · Set up all Menu selection controls.

Take-a-Look

Before beginning the exercise, let's take a look at the exercise in its completed state so that you can clearly see what it is that you are about to build.

- I. You will need .swf files in order to proceed.
 - a) Select the Menu option File / Open. Locate and select each of the following files from the Chapter20 Folder on the CD-ROM. Save each file, using its original name ... into the SaveWork Folder on your local hard drive.

intro_info.fla availability_info.fla rates_info.fla services_info.fla

CD-ROM

- b) Select the Menu option Control / Test Movie to view each Movie (Testing will produce the .swf file for each Movie and save it in the same folder with its .fla versions). Close all files.
- Use the Menu option File / Open and locate on the CD-ROM the folder named Chapter20, then locate the file named dotcomsat_final.fla.
 Double-click on this file to open it.
- 3. The file dotcomsat_final.fla should now appear in your copy of Flash.
- 4. Select the Menu option Control / Test Movie to test the Movie.

Please note the following properties of this completed exercise:

- a) To preview this exercise, you must have performed Steps Ia and Ib of this Take-a-Look section to Publish the **.swf** files necessary for the Menu selection Load Movie Action.
- b) The main file has multiple animation loops.
- c) Each Menu selection loads a new file with additional information.

Storyboard: On-Screen

Figure 20-14 shows you what the Stage will look like when this exercise is completed.

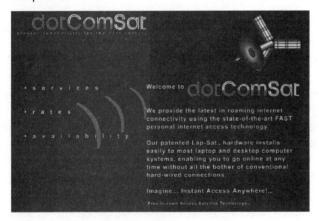

Figure 20-12 The Completed Stage

Storyboard: Behind-the-Scene

Figure 20-13 shows you what the Timeline will look like when this exercise is completed.

🛠 Flash 5 - [dotcomsa	t_final.fla]				
Eile Edit View Int	ert Modify	y <u>I</u> ext <u>C</u> ontrol	Window H	jelp		
Preloader						
a	90	1 5 10	15	20 25	30 3	
🖉 Actions and Lat 🖊 🔸	• •	a	d			1
Masthead •	•		0			
Background Elemer	•	•	<u>o</u>			
	0		15 12.0 fc	125 11		

Step-by-Step Instructions

I) And we begin the last exercise in this series.

- a) Select the Menu option File / Open. Locate and select the file named dotcomsat_3.fla from the Chapter20 Folder on the CD-ROM, or use the version that you completed and saved from the last exercise.
- b) (If you did not perform Steps Ia and Ib during the Take-a-Look Section above, you will need to complete Steps b, c, and d below before proceeding. If you already performed these steps, you can skip to Step 2).

Select the Menu option **File / Open. Locate** and **select** each of the following files from the **Chapter20 Folder** on the CD-ROM. **Save each file,** using its **original name** ... into the **SaveWork Folder** on your computer.

intro_info.fla availability_info.fla rates_info.fla services_info.fla

- c) Select the Menu option Control / Test Movie to view each of the Flash files listed above. As each Flash file is tested, it creates a .swf file in the same directory where the Flash Authoring .fla files are located. These .swf files are the files that will be loaded into a Movie when the Load Movie or Unload Movie Actions are used.
- d) Close all Movie previews and close intro_info.fla, availability_info.fla, rates_info.fla and services_info.fla.
- 2. First, we want to set up the Load Movie Action via a Frame Action.
 - a) In the Main Body Scene of dotcomsat_3.fla, select Frame 30 of the Actions and Labels Layer. There is a Stop Action there from a previous exercise. See Figure 20-14.

Go Solo

CD-ROM

	लि	6	5	10	15	20	25	30	35	40	45	50	55	60	65	H
🧭 Actions and Lat 🔏	•	•						a								1
. Guide: Sat Animatio	٠	•		000	000	CaCaCa		0								
😡 Sat Animation	•	•	,					0								
Button Animation	٠	•			0.00			0.								
Logo Animation	٠	•		• >			1.8.8.1									
Background Element	•	•	1000	0.00	5.5.5	ar an ar		D								-
Background Elemen	•	•														

Figure 20-14 Stop Action in Frame 30

- b) Select the Stop Action in the Actions Panel. Click the Basic Actions Icon in the Actions Panel and double-click on the Load Movie Action.
- c) In the Actions Parameters, change the URL to ... intro_info.swf and the Location to ... Level I. The code now reads:

```
stop ();
loadMovieNum ("intro info.swf", 1);
```

This loads an external Movie into our main Movie.

- d) Select the Menu option Control / Test Movie to view the Movie. Deselect the Menu option Control / Loop to prevent the playback from looping. When the Movie preview gets to the last Frame, intro_info is loaded into main Movie. But suppose we want to replace this information? This calls for the Unload Movie Action!
- 3. We need to now set up the remaining controls.
 - a) Select Frame 30 of the Button Animation Layer in dotcomsat_3.fla.
 - b) Select the Menu option Window / Library to open the dotcomsat_3.fla Library. Drag an instance of the Invisible Button Symbol onto the Stage. Use the Info Panel to position it at X=136 and Y=156.
 - c) With the button instance still selected, open the Actions Panel and expand the Basic Actions category. Double-click the On Mouse Event Action. The code now reads:

```
on (release) {
   }
```

 d) With the first line of code selected, double-click the Unload Movie Action from the Basic Actions category. Change the Location to ... I. The code now reads:

```
on (release) {
unloadMovieNum (1);
```

e) With the second line of code selected, double-click the Load Movie Action within the Basic Actions category of the Actions Panel.With the new line of code selected, change the URL to ... services_info.swf and the Location to ... I. The code now reads:

Organizing Movies

•**T**/P·

Levels represent the hierarchy of Movies that have been loaded into the Flash Player. The main Movie is Level 0, with each subsequent Movie that is loaded occupying a different level in relation to one another. Level 0 is considered the parent layer that also dictates things like Frame Rate of the Movies on other levels.

```
on (release) {
    unloadMovieNum (1);
    loadMovieNum ("services_info.swf", 1);
}
```

- f) Create a duplicate of the Invisible Button Instance that we have just assigned the ActionScript to. Use the Info Panel to position it at X=136 and Y=201.
- g) With the button instance still selected, open the Actions Panel. Select the third line of code. Change the URL to . . . rates_info.swf. The code now reads:

```
on (release) {
    unloadMovieNum (1);
    loadMovieNum ("rates_info.swf", 1);
}
```

- h) Create a duplicate of the Invisible Button Instance that we have just assigned Action Script to. Use the Info Panel to position it at X=136 and Y=248.
- With the button instance still selected, open the Actions Panel and select the third line of code. Change the URL to ... availability_info.swf. The code now reads:

```
on (release) {
    unloadMovieNum (1);
    loadMovieNum ("availability_info.swf", 1);
}
```

So what does this code actually do? For starters, a press and release of any button will unload any Movie that happens to be Loaded in Level I. This includes the one that is Loaded due to the Frame Action we assigned earlier, and will also take care of any Movie we load with the use of the other buttons.

4. Let's try it out.

}

- a) Select the Menu option Control / Test Movie to preview the Movie. Deselect the Menu option Control / Loop to prevent the playback from looping. The intro_info.swf Movie is loaded because of the Frame Action in the last frame. When we press a button we unload whatever Movie is Loaded into Level I and replace it with another.
- b) **Close** the preview to return to the Main Movie.
- c) Save your file as dotcomsat_final.fla in the SaveWork Folder.

Summary

- Carefully planning and designing your Flash program will directly influence the way the program is constructed and will ultimately effect how efficiently your program will download over the Web.
- An important concept and technique that can help you plan and organize your program is to divide your Movie into Scenes.
- How you structure the Scenes and what you put in each Scene is often heavily influenced by the type of application you are building; the file size; and personal working habits.
- Scenes allow you to segment or "chunk" parts of a long Movie Timeline into manageable portions.
- Before you begin creating a project in Flash, we suggest that the use of one or more paper-based tools will help you plan, organize and design your project.
- The first and simplest tool is the Content Outline. The Content Outline requires you to think about and "commit to paper" not only all the content that you want to include, but also the way you plan to organize and sequence this content.
- Another paper-based design tool is the Storyboard. What a Storyboard "is" and what it looks like varies quite a bit. However, the common element is that a Storyboard will help you pre-visualize what the screen (and program) will look like before you actually create it.
- In the first Practice Exercise, you practiced adding multiple Scenes to a Flash Movie and saw how changing the order of Scenes affects the playback of the Movie.
- In the second Practice Exercise, you continued with the same Flash Movie and added Actions to give the user control over the movement from one Scene to another. You also saw how to set an Action to go to specific Frames in multiple Scenes – based on user response.
- A pre-loader is a small animation that loads quickly and plays while the main Flash Movie is loading in the background. This pre-loader provides a visual indication that something is being downloaded – that the system is not hung up.
- In the third Practice Exercise, you continued building on the existing program to include a pre-loader.
- In the last Practice Exercise, you finished the program by adding the capability to load and unload external Movies.

PTER

21

Application Chapter: Setting Up Scenes

Chapter Topics:

- Introduction
- Application Exercise Setting Up Scenes
- Summary

Introduction

A large part of completing a successful and functional Flash site is planning the structure of your site. Early on in this Application Project, you created a scene that represents the main body of your Flash site. Now it's time to create additional structural features to enrich the interface design.

One of the features in Flash that can help you structure your project is the ability to create different Scenes. Scenes allow you to break apart your Movie into categories that act as separate Timelines. With the addition of some simple Actions, you can control how the buttons in your interface navigate between the Scenes and how they play each of these Timelines.

You can also use other Actions to Load external Movies into your main Web site. Learning about how to use these features will help you think about how you want to structure sites in the future.

Application Exercise – Setting Up Scenes

Description

This Application Exercise allows you to connect the Movies that you have been working on by adding Scenes. You will also add commands so that some of these Movies can be loaded or unloaded into you main Movie file. When you finish this exercise, you will have the basis of a connected Web site.

Take-a-Look

Before beginning the exercise, let's take a look at the exercise in its completed state so that you can clearly see what it is that you are about to build.

- Use the Menu option File / Open and locate on the CD-ROM the folder named Chapter21. Locate the file named application_21.fla.
 Double-click on this file to open it.
- 2. The file application_21.fla should now appear in your copy of Flash.
- 3. Select the Menu option Control / Test Movie to view the Movie.

Storyboard: On-Screen

Figure 21-1 shows what can be seen on Stage when the exercise is completed.

CD-ROM

Route 67... America's Other Scenic Highway!

Figure 21-1 The Completed Stage

Storyboard: Behind-the-Scene

Figure 21-2 shows how the Timeline will look when the exercise is completed.

		đ	9		1	5	10	15	i 2	0	25	30	35	41)	45	50	55	60	65	H.
D Button		•	•																		
🥩 Text MC	1	•	•		•																
Route MC		•	•		• 0 •																
🕞 Background		•	•		• □																
 Background Sound 		•	•		-																
•				A	4		6	1	12.0 fps	0.0s		F									•

Figure 21-2 The Completed Timeline

Applications Project Steps

Complete this exercise on your own, guided by following the general steps provided below. You can always refer back to the completed example that you viewed in the Take-a-Look section of this exercise.

Please Note: The following steps are intended as a guide. This is your project so please feel free to make whatever variations you would like.

 Open application_19.fla. You can either use the copy you created and saved in the SaveWork Folder on you computer or you can use the copy in the Chapter19 Folder on the CD-ROM supplied with this book. All the Application Exercises from this chapter forward will make use of the .way format for sounds. However, we have supplied each Library. in each exercise, with the .mp3 format for all sound files. If you would like to change the sound format, please do so. If you are using the .mp3 format, you may find it more convenient to use your version of the last completed exercise for the beginning of the next Application Exercise.

Application Chapter: Setting Up Scenes

T'P

- 2. Create a new Scene and name it Preloader. Move it above the Index Scene in the Scene Stacking Order. We won't do much with this Layer now, but will come back to it in the next Application Exercise.
- 3. Rename the existing Layer in the Preloader Timeline as ... Background.
- Drag an Instance of the Total Background Symbol out of the Graphic Images Folder of the Library and onto the Stage. Position it at X= 320.0, Y=140.0.
- 5. Insert 2 more Frames in the Background Layer.
- 6. Create a new Layer and name it Route MC. Move it above the Background Layer.
- 7. Select Frame I of the Route MC Layer.
- Drag an Instance of the Route Movie Movie Clip Symbol out of the Movie Clips Folder in the Library and onto the Stage. Position it at X= 320.0,Y=198.6.
- 9. Insert a Blank Keyframe in Frame 3 of the Route MC Layer.
- 10. Select Frame 3 of the Route MC Layer.
- Drag an Instance of the Route 67 Graphic Symbol out of the Graphic Images Folder in the Library and onto the Stage. Resize it to W=208.1, H=207.9 and position it at X=320.0,Y=198.6.
- Create a new Layer and name it Text MC. Move it above the Route MC Layer.
- 13. Select Frame 1 of the Text MC Layer.
- Drag an Instance of the Loading Graphic Symbol out of the Graphic Images Folder in the Library and onto the Stage. Position it at X= 326.3, Y=67.3.
- Drag an Instance of the Text Movie Movie Clip Symbol out of the Movie Clips Folder in the Library and onto the Stage. Position it at X= 316.9, Y=356.6.
- 16. Delete Frame 3 of the Text MC Layer.
- 17. Create a new Layer and name it Button. Move it above the Text MC Layer.
- 18. Select Frame 3 of the Button Layer and Insert a Blank Keyframe.
- With Frame 3 of the Button Layer selected, drag an Instance of the Go Button Symbol out of the Buttons Folder in the Library and onto the Stage. Position the it at X=320.0,Y=370.8

·T/P·

20. Assign the following ActionScript to the Instance of the Go Button:

```
on (release) {
  gotoAndStop ("Index", "Home");
}
```

- 21. Create a new Layer and name it Sound. Move it to the bottom of the Layer Stacking Order.
- 22. Select Frame I of the Sound Layer and use the Sound Panel to insert the Loading_beat Sound Symbol.
- 23. Set the Sound Properties to Effects: None, Sync: Start and Loops: 50.
- 24. Select Frame 3 of the Sound Layer and Insert a Keyframe.
- 25. With Frame 3 selected, set the Sound Properties to Sound: Loading_beat, Effects: None, Sync: Stop and Loops: 0 (this will stop Loading_beat from playing).

We'll set the rest of this Scene up in a later exercise.

- 26. Create a new Scene and name it Contact. Move it below the Index Scene in the Scene Stacking Order.
- Drag an Instance of the Total Background Symbol out of the Graphic Images Folder of the Library and onto the Stage. Position it at X= 320.0, Y=140.0.
- 28. Rename the existing Layer in the Contact Timeline Background.
- 29. Select Frame I of the Background Layer and drag an Instance of the Questions Graphic Symbol out of the Graphic Images Folder of the Library and onto the Stage. Position it at X= 361.3,Y=112.9.
- 30. With Frame I of the Background Layer still selected, drag an Instance of the Road Sign Graphic Symbol out of the Graphic Images Folder of the Library and onto the Stage. Resize it to W=208.8, H=483.5 and position it at X= 112.3,Y=221.2.
- 31. Insert I more Frame in the Background Layer.
- 32. Create a new Layer and name it Home Button. Move it above the Background Layer.
- 33. Select Frame I of the Home Button Layer.
- Drag a copy of the Home Button Symbol out of the Buttons Folder in the Library and position it at X=46.0,Y=447.1.

Use whichever sound format you wish. Both .mp3 and .wav have been provided in the Library.

```
CHAPTER 21
```

35. Assign the following ActionScript to the Instance of the Home Button: on (release) {

```
gotoAndStop ("Index", "Home");
```

We'll set the rest of this Scene up in a later exercise.

36. Save your file as application_21.fla.

Summary

}

You now have a working interface that is connected to all the components of your site. At this point, you have formed the basic structure of your site and can now see more clearly how your visitors are going to navigate through the site. You have also used Scenes to consolidate separate Movie files into one manageable Movie file. Finally, you learned how to set up Actions that will load external Movies into your main Movie Timeline.

PTER

22

Publishing Flash Movies

Chapter Topics:

- Introduction
- Publishing Your Movie
- Export Options
- Export Image
- Export Movie
- Publish Settings
- Guided Tour Publish Settings
- Optimizing Movie Files
- Guided Tour Bandwidth Profiler
- Guided Tour Publishing Movies
- Inserting Flash Movies into HTML documents
- The Flash Player Plug-in
- Inserting Flash Movies into Dreamweaver Documents
- Guided Tour Sharing a Library
- Summary

·T/P·

Introduction

Publishing is the final step in creating your Flash Movies. To Publish – a word and concept borrowed from the Print Media – meaning to make available for widespread public distribution. Once you reach the publishing stage, you will be choosing how to package your Movie so that it can be distributed to your audience. There are several ways that a Flash Movie can be packaged. You have had lots of practice in previous chapters building interactive Movies. The standard **.fla** file allows you to edit Movies in Flash, but is not viewable through a browser. In order to use Flash files in an HTML document or even as a standalone presentation, you must publish your Movie in the appropriate format.

By the end of this chapter you will be able to:

- change the Flash Publish Settings for a specified format output.
- publish a Flash Movie.
- use the Bandwidth Profiler to optimize your Movies before export.
- describe the role of the Flash Player.
- describe the general process of inserting a Flash Movie into an HTML file, using Dreamweaver.

Publishing Your Movie

Once you finish creating your Movie, the next step is to Publish it in one or many formats. You have two options when you Publish your file. You can either use the Export feature to specify one file format for your Movie, or you can use Publish Settings to specify multiple file formats and publish them all at once. When you test Movies in Flash using the **Control / Test Movie** option, you may have noticed that instead of creating a temporary file, Flash generates a **.swf** file with the same file name as your **.fla** file and adds this file to the same directory. This **.swf** file is a Shockwave file that is created in order to display all the Actions and Movie Clips in your project accurately – just as they would display when viewed through a browser or a projector.

Export Options

There are two types of Export in Flash – Export Image and Export Movie. When you Export a file in Flash you are actually saving and converting the existing **.fla** file into another file format. Exporting is similar to Publishing because you are generating new file types based on the original Movie. However, when you Export your Flash Movie, you can only choose one format at a time. There are a wide variety of Export Options available in Flash

You can choose to Publish or Export your Flash projects. These terms refer to the same process, but each produces very different results, as you will discover in the details presented in the next couple of sections.

Shortcut

The Publish shortcut is: PC – Shift & F12 Mac – Shift & F12 that allow you to use your Movies, or images from your Movies in a wide variety of formats.

Export Image

Selecting the Menu option **File / Export Image** produces a list of save options that convert selected Frames of your Movie into static graphic images. You can select these file types by choosing from the Format options as illustrated in Figure 22-1.

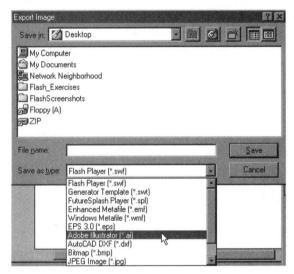

Figure 22-1 Format Options in the Export Image Dialog Window

The following formats are available for exporting **static images** of individual Frames of your Flash Movie files:

Both Windows and Mac Platforms

- **Adobe Illustrator** .ai; Adobe Illustrator format allows you to use Flash files in a drawing program like Illustrator or Freehand.
- AutoCAD DXF .dxf; This file format is used to export files for use with CAD software.
- **EPS 3.0 with preview** .eps; Encapsulated Postscript File; often used for importing graphics into desktop publishing applications.
- **Flash Player** .swf; Shockwave file format used for delivering Flash Movies through the Flash Player, generally through the Flash Player plug-in on a Web site. This file format is not editable in Flash, although files in this format can be imported into Flash and converted back to a .fla file format. You do have the

• T/P ·

When you use the Export Image option for saving out static images from your Flash Movies, Flash exports the graphics placed on the Stage from the Frame you have currently selected.

option of protecting (locking) .swf files during the export process so they **cannot** be imported and edited by other users.

FutureSplash Player – .spl; FutureSplash was the precursor to Macromedia Flash.You can still export Flash files as FutureSplash files, however, they could lose some of their Flash 5 functionality.

- Generator Template .swt; file format for use with Flash Generator files.
- **GIF Image** .gif; a compression format developed by CompuServe that is used for images with 256 colors or less. This file format supports transparency and interlacing. This format is one of the most common image formats on the Web today.
- **JPEG Image** .jpg; a "Lossy" compression format used for 24-bit images. This format is one of the most common image formats on the Web today. Supports progressive download, but does not support transparency.
- **PNG Image** .png; A file compression format developed for use on the Web, although it is not used or supported as frequently as GIF or JPEG. PNG is also the native file format for files created in Macromedia Fireworks. PNG files combine the characteristics of GIF and JPEG files, such as interlacing, smoothing and dithering. PNG also supports multiple levels of transparency.

Mac only Export:

PICT File – .pct or .pic; This bitmap format can be exported from a wide variety of image editing programs and is considered the native file format for bitmaps generated on a Macintosh.

Windows only Export:

- **Bitmap** .bmp; This image format can be exported from a wide variety of image editing programs and is considered the native file format for Windows users.
- **Enhanced Windows Metafile** .emf; Common Windows file format in 32-bit applications created to replace Windows Metafiles (.wmf).

Windows Metafile - .wmf; Common Windows 3.x file format.

Export Movie

Selecting the Menu option **File / Export Movie** produces a list of file formats for saving your Movie into the common **.swf** format as well as other Movie formats. You can select these file types by choosing from the Format options as shown in Figure 22-2. There are several other formats that are not available through the Export Movie or the Export Image Menu options. If you want to save stand-alone projector files, such as a Windows .exe file, you will find this option under Publish Settings that will be covered later in this chapter.

Shortcut

The Keyboard Shortcut for Exporting a Movie is:

PC – Ctrl & Alt & Shift & S

Mac – Option & Shift & Command & S

Publishing Flash Movies

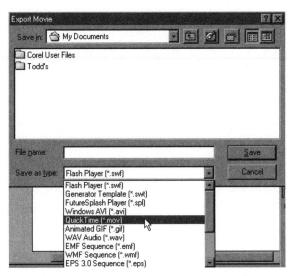

Figure 22-2 Format Options in the Export Movie Dialog Window

The following file formats are available for exporting Flash Movie files:

Both Windows and Mac Platforms

- **Adobe Illustrator Sequence** .ai; Adobe Illustrator format allows you to export a sequence of Frames for use in a vector drawing program like Illustrator or Freehand.
- **Animated GIF** .gif; Popular file format for saving small self-running Frame-by-Frame animations for Web pages that do not require a plug-in.
- **DXF Sequence** .dxf; Converts each Frame in the Movie into individual dxf files.
- **EPS 3.0 Sequence** .eps; Encapsulated Postscript File; Creates a series of EPS files based on each Frame in the Movie Timeline.
- **Flash Player** .swf; file format used for delivering Flash Movies through the Flash Player, generally through the Flash Player plug-in on a Web site. This file format is not editable in Flash, although they can be imported into Flash and converted back to a .fla file format. However, you do have the option of protecting (locking) .swf files during the export process so they **cannot** be imported and edited by other users.
- **FutureSplash Player** .spl; FutureSplash was the precursor to Macromedia Flash. You can still export a Movie in FutureSplash format, although you may lose some of the capabilities of Flash 5 in the conversion.
- **Generator Template** .swt; File Format for use with Generator files created in Flash.

GIF Sequence – .gif; Converts each Frame in the Movie into individual gif files.

- JPEG Sequence .jpeg; Converts each Frame in the Movie into individual jpeg files.
- **PNG Sequence** .png; Converts each Frame in the Movie into individual png files.
- **QuickTime** .mov; Creates movies in QuickTime format by placing the Flash Movie in a QuickTime track. The QuickTime Player displays the exported Flash movie exactly as it does in the Flash Player, but it also retains all of the movie's interactivity.

Windows only

- **Windows AVI** .avi; Converts Movies into Windows video by changing files into a series of bitmaps, but does not preserve any interactivity.
- WAV Audio .wav; Exports only the sound from a Movie into a .wav sound file.

Mac only

- **PICT Sequence** .pic, .pct; Creates a series of PICT files based on each Frame in the Movie Timeline.
- **QuickTime Video** .mov; Converts files into a series of bitmap images that can be played back through the QuickTime Player as QuickTime video.

Publish Settings

Using the Export feature to save your Flash Movie into multiple formats requires that you repeat the Export Image or Export Movie option for each type of file that you want to create. Flash includes another option, Publish Settings, that allows you to choose multiple file settings for export, as well as other publishing options that are not available through Export. For example, Publish Settings allows you to select an option for creating an HTML file with the code already inserted for displaying your Flash Movie. In addition, you can choose to create a stand-alone projector file for both Windows and Macintosh through the Publish Settings Window. Publish Settings also allows you to set global export of sound compression and load options for your Flash Movie in one window without having to export your Movie multiple times. All file formats selected are published at once through the Publish Settings Window and are simultaneously saved in multiple formats.

Selecting the Menu option **File / Publish Settings** opens the Publish Settings Window as illustrated in Figure 22-3. The tabs at the top of this window allow you to toggle between different options. The Guided Tour that follows will give you a closer look at the Publish Settings and the choices on each tab.

Publishing	Flash	Movies
i abiioiiiiig	1 10011	11101100

	Be Edit View Insert Modify New	I ext Control W/s	ndow Help										لم	
	Open Open as Library Open as Shared Library Dose	Ctrl+D Ctrl+Shift+D Ctrl+W	20	25	30	35	40	45	50	55	60	65	70	4 -
3	Save Save As	Ctrl+S Ctrl+Shift+S	12.0 fps	0.0s +		[
•	Import Export <u>M</u> ovie Export Image	Ctrl+R Ctrl+Alt+Shift+S												
	Publish Settings Publish Pjeview Publish	Cid+Shift+F12 Shift+F12												
	Page Setup Print Preview Print	Oxi+P												
	Seng													
	1 form_items.fla 2 C.VFlashBook\\ch22\form.l 3 services_info.fla 4 rates_info.fla	la												
-	Eyst	Ctrl+Q												
														•1
	7										63	Δ #	1.00 5	

Figure 22-3 Publish Settings

Publish Preview

Selecting the Menu option **File / Publish Preview** provides you with an opportunity to view your Movie in the output setting of your choice. Figure 22-4 shows you the options that are available. Notice that some options in the Publish Preview list are grayed out and unavailable for viewing. The Publish Preview options that are available are based on the choices made in the Publish Settings. The default options available are Flash and HTML. Selecting the HTML option creates an HTML file for your *.swf* file. This HTML file contains code that will allow your Movie to be displayed through your browser. Choosing Flash Preview will launch a sample *.swf* file, just like the file that is created when you select **Control / Test Movie**.

Edit View Insert Modify Text	<u>Control</u> Window	<u>H</u> elp
<u>N</u> ew Open	Ctrl+N Ctrl+O	* 5 8 8
Open as Library Open as Shared Library	Ctrl+Shift+O	
<u>Close</u>	Cbl+W	0 15 20 21
Save	Cul+S	
Save As Revert	Ctrl+Shift+S	
Import Export <u>M</u> ovie Export Image	Ctrl+R Ctrl+Alt+Shift+S	1 12.0 ips 0.0s
Publish Settings	Ctrl+Shift+F12	
Publish Preview Publish	Shift+F12	<u>D</u> efault - (HTML) F12 <u>E</u> lash
Page Setup Print Pre <u>v</u> iew <u>Print</u>	Ctrl+P	HTML GIF UPEG PNG
Seng		
1 C.\WINDOWS\\ch22\form fla 2 C.\WINDOWS\\ch22\mytorm.fla 3 C.\WINDOWS\\actions.fla 4 button_actions.fla		<u>Q</u> uickTime
Exit	Chi+Q	

Figure 22-4 Publish Preview Options

Guided Tour – Publish Settings

 Select the Menu option File / Publish Settings. Note that there are three default Tabs on the Publish Settings Dialog Window – Formats; Flash; and HTML as illustrated in Figure 22-5. This is where you select the file formats and specifications for these files that you would like to Publish.

Туре:	Filename:	Publi
Elash (.swf)	Movie1.swf	Cano
Generator Lemplate (swt)	Moviel.swt	
HTML (.html)	Movie1.html	
GIF Image (, gif)	Movie1.git	
JPEG Image (.jpg)	Movie1.jpg	
PNG Image (.png)	Movie1.png	
Mindows Projector (.exe)	Movie1.exe	
Macintosh Projector	Movie1.hox	
DuickTime (.mov)	Moviel.mov	
RealPlayer	Movie1.sml	
	Se default names	

Figure 22-5 The Default Tabs in Publish Settings Dialog Window

Shortcut

The Keyboard Shortcut for Publish Settings is: PC- Ctrl & Shift & F12 Mac – Shift & Command & F12

Publishing Flash Movies

2. Click on the box next to each of the Formats listed here. Note that as you place a check mark in each box, a corresponding Tab is added to the Publish Settings Window. Selecting the box next to any of the formats shown on this Formats Tab will activate and ADD the corresponding Panel with its various options that can then be adjusted. Unless you own and also have Generator installed, this box will remain grayed out. You should be able to add the Tabs for all the other Formats. See Figure 22-6. Let's take a closer look at each available Panel.

Formats Flash HT	ML Generator GIF	JPEG	
			Publi
Туре:	Filename:		Cano
Elash (.swf)	Moviel swi		
Generator Jemplate (.swt)	Movie1.swt		
HTML (.html)	Movie1.html		
GIF Image (.gif)	Moviel.gi		
JPEG Image (.jpg)	Moviel ipg		
I✓ ENG Image (.png)	Movet prg		
Vindows Projector (.exe)	Movie1.exe		
Macintosh Projector	MavieT.hqx		
QuickTime (.mov)	Moviel mov		
RealPlayer	Movie1, smil		
	☑ Use default names		

Figure 22-6 Publish Settings Window – All Formats

3. Select the Flash Tab and look at its options as illustrated in Figure 22-7.

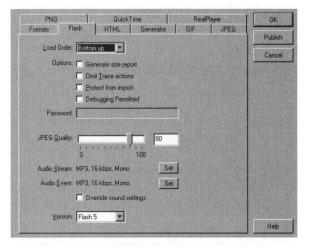

Figure 22-7 The Flash Tab and Options

The great thing about the Publish Settings in a production environment is that once they are set for a particular Movie, they will be saved along with the **.fla** file. So, if you ever need to republish your files, you won't have to reset the Publish Settings. **Load Order:** Sets the order in which Flash will load and draw a Movie's Layers for display in the Flash Player. The Movie will either load from Bottom Up or Top Down.

Generate Size Report: Produces a report that gives you the breakdown of data in the final Flash Player file, showing you which Frames could cause potential slowdowns over an Internet connection. This file is saved in the same folder with your exported Movie and can be opened in Notepad (Windows), SimpleText (Mac) or any other text editor.

	oort		
Frame #	Frame Bytes	Total Bytes	Page
1	9610	9610	Scene 1
2	264	9874	2
3	266	10140	3
4	264	10404	4
5	264	10668	5
6	271	10939	6
7	269	11208	7
8	171	111/70	9
9	264	11743	9
10	269	12012	10
11	271	12283	11
12	269	12552	12
13	271	12823	13
14	269	13092	14
15	269	13361	15
16	271	13632	16
17	269	13901	17
18	276	14177	18

Figure 22-8 Sample Size Report

Omit Trace Actions: Makes Flash ignore any Trace Actions in the Movie. Trace Actions are an ActionScript code that can help you test and debug a Movie by sending comments to the Output Window during playback. Omit Trace Actions prevents the Output Window from opening and displaying your Trace comments.

Protect from Import: Prevents viewers from importing your .swf file and converting it back into a Flash Movie where it could then be edited.

Debugging Permitted: Activates and allows the debugging of a Flash Movie from a remote location. You can choose to password-protect your Movie file if you select this option. Right-clicking (Mac – Ctrl & Clicking) on the Movie as it plays in the browser will activate the Debugger. If someone opens your Movie with the Debugger they can potentially learn how you created certain applications unless Debugging is off or it is Password protected.

Password: Type in a password to restrict unauthorized access and debugging of a Flash Movie that has Debugging permission. To remove

If you don't want others to be able to edit or copy parts of your Flash application, make sure to SELECT the option PROTECT FROM IMPORT. your password, delete the information in the Password field. This field is inactive unless Debugging Permitted has been selected.

JPEG Quality Slider: Used to globally control bitmap compression throughout your Movie. Low quality creates smaller files, while high quality creates larger files. 100 – provides the highest quality and least compression.

Audio Stream: Clicking on the Set button, opens a window where you can set the exported stream rate and compression for all Movie sounds set to Stream in the Sound Panel.

Audio Event: Clicking on the Set button, opens a window where you can set the exported rate and compression for all Movie sounds set to Event in the Sound Panel.

Override Sound Settings: Overrides any settings in the Sound Properties Window found in the Library for your individual sounds. It also creates a larger high-fidelity audio Movie for local use and a smaller lowfidelity version for the Web.

Version: Designates which version of the Flash Player you are publishing for. Not all of Flash 5's features will work in Movies published as earlier Flash versions.

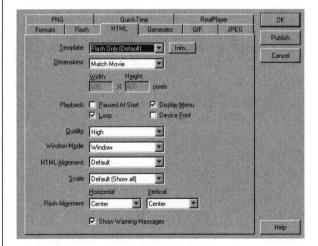

4. Select the HTML Tab and look at its options. See Figure 22-9.

Figure 22-9 The HTML Tab and Options

Template: The pull down menu in this option gives you a variety of options for creating support files that will display the Movie in different players and browsers. Basic templates contain code for displaying the

Movie in a browser. More advanced templates contain the necessary HTML code for enabling browser detection and other such features, as well as calling up plug-ins for things like the QuickTime Player.

Info Button: Select a particular Template option, then select the **Info Button** next to it, to get more information about each Template available in the pull down Template menu.

Dimensions: Sets the values of the Width and Height attributes in the Object and Embed tags. **Match Movie** maintains the current size of the Movie. **Pixels** – allows you to enter the number of pixels in the Width and Height fields. **Percent** uses a percentage relative to the browser window.

Playback: These options control the characteristics of playback as well as other control features for a Movie when it is displayed in a browser. **Paused at Start** pauses the Movie until a user clicks a button in the Movie or chooses Play from the shortcut menu. **Loop** repeats the Movie playback when it gets to the last Frame of the Movie. **Display Menu** displays a shortcut menu when users right-click (Mac – Control & click) over the Movie in their browser. See Figure 22-10 for an example of the Display Menu. Finally, **Device Font** directs your Movie to pull fonts that most closely resemble the Device Fonts specified in your Movie from your user's hard drive.

Figure 22-10 The Display Menu

Quality: Determines the trade-off between processing speed and applying anti-aliasing. **Low** prioritizes playback speed over appearance and does not anti-alias objects or text. **Auto Low** initially prioritizes speed but improves appearance whenever possible. **Auto High** prioritizes

See Chapter 9 for a more complete discussion of device fonts.

·T/P·

speed and appearance equally at first but decreases appearance for speed whenever necessary. **Medium** will anti-alias, but doesn't smooth bitmaps. **High** prioritizes appearance over speed and always uses anti-aliasing. It will smooth bitmaps if the Movie doesn't contain animation but bitmaps are not smoothed if the Movie has animation. **Best** prioritizes the display quality and doesn't consider speed at all. Output is anti-aliased and bitmaps are always smoothed.

Window Mode: (for Windows Internet Explorer 4.0+ with the Flash ActiveX control) – Window plays a Flash Player Movie in its own window on a Web page. **Opaque Windowless** moves elements behind your Flash Movies to restrict them from showing through. **Transparent** Windowless shows the background of the HTML page on which the Movie is embedded through any transparent areas within the Movie.

HTML Alignment: This option positions the Flash Movie window within a browser window. **Default** centers the Movie in the browser window and also crops the edges if the browser window is smaller than the Movie. **Left, Right, Top** or **Bottom** aligns the Movie along that particular edge of the browser window, and then crops the remaining three sides if needed.

Scale: Places the Movie within specified boundaries if you've changed the Movie's original width and height. **Default (Show All)** displays the entire Movie in the specified area while maintaining the original aspect ratio of your Movie. **No Border** scales the Movie to fill a specified area and keeps the Movie's original aspect ratio, although it crops the Movie if necessary. **Exact Fit** will display the whole Movie in a specified area without maintaining its original aspect ratio.

Flash Alignment: Sets how the Movie is placed within the Movie window and how it is cropped, if necessary. **Horizontal** allows you to choose the **Left, Center,** or **Right** options. **Vertical** alignment allows you to choose the **Top, Center,** or **Bottom** options.

Show Warning Messages: This setting displays error messages if tag settings are in conflict.

5. Even though for many of you, the Generator Template Tab is inactive, we have included an illustration of the Publish options available. See Figure 22-11.

CAUTION

Most of you will probably not have Generator installed, so you will not be able to see this Tab in your copy of the Flash software.

CHAPTER 22

PNG	QuickTime RealPlayer	OK
Formats Fi	ish HTML Generator GIF JPE	G Publis
Dimensions:	Width Height 600 X 400 ✓ Match Movie	Canc
Background:		
Erame Rate:	12 fps	
Load <u>O</u> rder:	Bottom up	
Data Encoding:	Default Create External Font Files	
E <u>s</u> ternal Media:	Add	
	Delete	
Parameters:	Name: ⊻alue:	
	Add	
	Delete	

Figure 22-11 The Generator Template Tab and Options

Dimensions: Allows you to either enter a Width and Height in pixels to specify the Movie's width and height, or to Match Movie and make the published Movie the same size as the original.

Background color: Overrides the background color set with the Menu option Modify / Movies.

Frame Rate: Sets how quickly the Frames of the current Movie appear when animation is played back. It overrides the Frame rate set with the Menu option Modify / Movies.

Load Order: Sets the order in which Flash loads a Movie's layers in the Flash Player. It displays the first Frame of your Movie from the **Bottom Up** or from the **Top Down**.

Data Encoding: Sets which encoding method to use when reading all data sources referenced in the template file. **Default** uses the active encoding method of the server that the file resides on. You should use the same encoding system for all data sources.

External Font Files: Enables Generator to create font files.

External Media: Determines the name of the Generator template that contains the symbols and will include its Library in the selected file.

Parameters: Sets variables and their respective values. This allows you to test your templates locally while you develop them, or to test how your variables work while being processed.

6. Select the GIF Tab and look at its options. See Figure 22-12.

CAUTION

You must have GIF selected (a check mark placed next to the option) on the Format Tab in order for the GIF Tab to appear in the Publish Settings Window.

 $/ \Gamma$

Publishing Flash Movies

PNG	QuickT	Contraction of the second second second	RealPl		OK
Formats Fla	ash HTML	Generator	GIF	JPEG	Publish
Dimensions:	Width Height	Match Mc	Vie		Cance
Playback:	 Static Animated 	C Loop Cor C <u>R</u> epeat			
	Optimize Colors Interlace Smooth	Dither So			
<u>T</u> ransparent:	Opaque 💌	128 Three			
Dither:	None				
Palette Type:	Web 216	•			
Max Colors:	255				
Palette:					
					Help

Figure 22-12 The GIF Tab and Options

Dimensions: Allows you to either enter a Width and Height in pixels for the exported bitmap image, or to select Match Movie to make the GIF the same size as the Flash Movie.

Playback: Determines whether Flash will create a still (Static) image or an animated GIF (Animation). If you choose Animation, you then can select Loop Continuously, or enter the number of times that you would like it to loop before going static.

Options: Establishes a number of appearance settings for the exported GIF. **Optimize Colors** removes any unused colors from a GIF's color table. **Interlace** makes the exported GIF display gradually in a browser as it downloads. Do not interlace an animated GIF file as you may get unexpected results! **Smooth** applies anti-aliasing to a bitmap to produce a high quality bitmap image and improve the text display quality. **Dither Solids** applies dithering to solid colors and gradients.

Transparent: Sets the transparency of the background and how alpha settings are converted in GIF format. **Opaque** makes the background a solid color. **Transparent** makes the background transparent. **Alpha** sets partial transparency.

Dither: Determines how the pixels of all available colors will combine to simulate colors that aren't available in the current palette. **None** will turn off dithering. This usually produces smaller files but may provide a few unsatisfactory colors. **Ordered** provides quality dithering with a small increase in file size. **Diffusion** will provide the best quality but will increase both file size and processing time.

7

Palette Type: Establishes the image's color palette. Web 216 uses the standard 216-color browser-safe palette. Adaptive analyzes the colors in the image and fabricates a unique color table. Web Snap Adaptive is the same as the Adaptive palette option except it "snaps" very similar colors to their best match in the Web 216 color palette. Custom specifies a palette that you have optimized for the selected image.

Max Colors: Sets the number of colors used in the PNG image. This option is only available if you select either the Adaptive or Web Snap Adaptive palettes.

Palette: Click on the Ellipsis Button (...) to the right of the empty field to browse for, locate, and select the custom Palette file you want to use. This option is only available if the Palette Type is set to Custom.

7. Select the JPEG Tab and look at its options. See Figure 22-13.

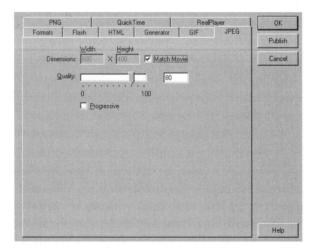

Figure 22-13 The JPEG Tab and Options

Dimensions: Allows you to enter a Width and Height in pixels for the exported bitmap image, or select Match Movie to make the JPEG the same size as the Flash Movie.

Quality: Sets the amount of JPEG file compression to be used.

Progressive: Gradually displays JPEG images in a Web browser.

8. Select the PNG Tab and look at its options. See Figure 22-14.

CAUTION

You must have JPEG selected (a check mark placed next to the option) on the Format Tab in order for the JPEG Tab to appear in the Publish Settings Window.

CAUTION

You must have PNG selected (a check mark placed next to the option) on the Format Tab in order for the PNG Tab to appear in the Publish Settings Window.

Publishing Flash Movies

	Width Height	Publis
Dimensions:		Cance
<u>B</u> it Depth:	24-bit with Alpha	
Options	Dither Solids	
	Interlace Remove <u>G</u> radients If <u>S</u> mooth	
Dither	None	
Palette Type	Web 216	
Max Colors:	255	
Palette:		
Filter Options	None	

Figure 22-14 The PNG Tab and Options

Dimensions: Allows you to enter a Width and I leight in pixels for the exported image, or select Match Movie to make the image the same size as the Flash Movie.

Bit Depth: Sets the number of bits per pixel and colors to use in creating the image. Use **8-bit** for a 256-color image, **24-bit** for thousands of colors and **24-bit with Alpha** for thousands of colors with transparency (32 bits).

Options: These specify the appearance settings of the exported PNG file. **Optimize Colors** will remove the unused colors from the file's color table. **Interlace** makes the exported PNG display in a browser incrementally while it is downloading. Do not interlace an animated PNG as you may get unexpected results! **Smooth** anti-aliases an exported bitmap and improves text display quality. **Dither Solids** will apply dithering to solid colors and gradients. **Remove Gradients** will convert all gradients in the Movie to solid colors.

Dither: Determines how the pixels of all available colors get mixed to simulate colors that aren't available in the current palette. **None** turns dithering off. **Ordered** provides quality dithering with only a small increase in the file size. **Diffusion** provides best-quality dithering but will also increase the file size and processing time. This option is only available if Bit Depth is set to 8-bit.

Palette Type: Establishes the image's color palette. Web 216 uses the standard 216-color browser-safe palette. Adaptive analyzes the colors in the image and uses them to generate a unique color table. Web Snap Adaptive is the same as the Adaptive palette option except it "snaps"

very similar colors to their best match in the Web 216 color palette. **Custom** specifies a palette that you have optimized for the selected image. This option is only available if Bit Depth is set to 8-bit.

Max Colors: Sets the number of colors used in the PNG image. This option is only available if you select either the Adaptive or Web Snap Adaptive palettes.

Palette: Click on the Ellipsis Button (...) to the right of the empty field to browse for, locate, and select the custom Palette file you want to use. This option is only available if the Palette Type is set to Custom.

Filter Options: This option sets a line-by-line filtering method to make the PNG file more compressible. **None** turns filtering off. **Sub** transmits the difference between every byte and the value of the corresponding byte of the prior pixel. **Up** transmits the difference between every byte and the value of the corresponding byte of the pixel immediately above. **Average** uses the average of the two neighboring pixels (left and above) to predict the value of a pixel. **Path** computes a simple linear function of the three neighboring pixels (left, above, upper left), and then chooses as a predictor the neighboring pixel closest to the computed value. **Adaptive** analyzes the colors in the image and creates a unique color table for the selected PNG.

9. The Windows Projector Publish option.

The Windows Projector option creates an executable (.exe) file that anyone can view if they have the Flash ActiveX plug-in or the Flash Player installed on their system. Viewers do not need to have Flash installed to view this type of file. This file has no Publish options.

10. The Macintosh Projector Publish option.

The Macintosh Projector option creates an executable file that anyone can view if they have the standalone Flash Player installed on their system. Viewers do not need to have Flash installed to view this type of file. This file has no Publish options.

11. Select the QuickTime Tab and look at its options. See Figure 22-15.

CAUTION

When this option is checked on the Format Tab, you will **not** get an accompanying tab in the Publish Settings in order to further customize this option.

CAUTION

When this option is checked on the Format Tab, you will **not** get an accompanying tab in the Publish Settings in order to further customize this option.

Formats PNG	Flash HTML Generator GIF JPEG QuickTime RealPlayer	OK
PNG		Publist
Dimens	width <u>Height</u> sions: <u>F00</u> × 400 I Match Movie	Cance
A	Ipha: Auto	
L	ayer: Auto	
Strea	aming 🗖 Use QuickTime Compression 🛛 Settings	incher d'art
<u>C</u> ont	roller. None	
<u>P</u> layt	pack: T Loop T Paused At Start	
	Play gvery frame	
	Eile: 🔽 Flatten (Make self-contained)	
		Help

Figure 22-15 The QuickTime Tab and Options

Dimensions: Allows you to enter a Width and Height in pixels for the exported QuickTime Movie, or select Match Movie to make the QuickTime Movie dimensions match the Stage dimensions.

Alpha: Controls the transparency of the Flash track in the QuickTime Movie. QuickTime separates audio, video, and Flash content into separate tracks in Movies. **Alpha Transparent** makes the Flash track transparent and shows any content in tracks behind the Flash track. **Copy** makes the Flash track opaque and masks any content behind the Flash track. **Auto** makes the Flash track transparent if it's on top of any other tracks, but opaque if it's the bottom track or the only track in the Movie.

Layer: Controls where the Flash track plays in the stacking order of the QuickTime Movie. **Top** places the Flash track on top of all other tracks. **Bottom** places the Flash track behind all other tracks. **Auto** places the Flash track in front of other tracks if Flash objects are in front of video objects within the Flash Movie, and behind all other tracks if Flash objects are not in front.

Streaming Sound: Allows Flash to export all audio within the Flash Movie into a QuickTime sound track. This will recompress all audio using the audio settings selected in the Settings window.

Settings: Only available if the Streaming Sound option is checked. Clicking on this button will open a window where audio settings can be selected.

Controller: Determines the type of QuickTime controller used to play the exported Movie. The options are **None, Standard**, or **QuickTime VR**.

Publishing Flash Movies

QuickTime format allows you to retain any interactivity that you added to your Flash Movie, but delivers the content through the QuickTime 4.0 Player. Since QuickTime creates a new track for the Flash content, you can layer Flash elements - with Actions intact - over video! Think of the possibilities for creating interactive interfaces for your QuickTime video, or adding animation to your video.

Playback: Controls how QuickTime plays a Movie. **Loop** repeats the Movie when it reaches the last Frame. **Paused at Start** pauses the Movie until a user clicks a button in the Movie or chooses Play from the shortcut menu. By default, this option is deselected and the Movie begins to play as soon as it is loaded. **Play Every Frame** displays every Frame of the Movie without skipping and does not play sound.

File Flatten (Make self-contained): Combines the Flash content and any imported video content into a single QuickTime Movie.

12. Select the RealPlayer Tab and look at its options. See Figure 22-16.

Flash Bandwidth Tuning		Publi
Export Tuned Flash		Cano
Bit Rate (Kbps) 12	Adjust bit jate on publish	
Real Audio		
Export Audio		
C Single Rate	Eormat	
SureStream	Voice Only	
28K Modem	Corporate LAN	
56K Modem	256K DSL/Cable Modem	
Single [SDN	384K DSL/Cable Modem	
Dual ISDN	512K DSL/Cable Modem	
SMIL		

Figure 22-16 The Real Player Tab and Options

Flash Bandwidth Tuning includes the following setting options:

Export Tuned Flash: Includes a tuned Flash file with the published Movie.

Bit-Rate (Kbps): Allows you to either type in a number or click on the arrow button and use a slider bar to adjust the bit-rate.

Adjust Bit Rate On Publish: Enables you to manually reset the bit rate when publishing the Movie.

CAUTION

You must have RealPlayer selected (a check mark placed next to the option) on the Format Tab in order for the QuickTime Tab to appear in the Publish Settings Window. Real Audio includes the following setting options:

Export Audio: Exports sounds in the RealAudio format. **Single Rate** will stream the sound for one target audience only while **SureStream** will stream the sound for multiple target audiences.

Format: Compresses the streaming sound. Voice Only applies compression suitable for voices with no background sound. Voice With Background Music applies compression suitable for voices with background sound. Music applies compression suitable for mono music and Music Stereo will apply compression suitable for stereo music.

Target Audience Options includes the following setting options:

These are the potential Internet connections your audience will have when viewing the RealPlayer file. The choices are 28K Modem, 56K Modem, Single ISDN, Dual ISDN, Corporate LAN, 256K DSL/Cable Modem, 384K DSL/Cable Modem, and 512K DSL/Cable Modem.

SMIL Options includes the following setting options:

Export SMIL: Exports a SMIL file along with the published Movie. The SMIL file synchronizes playback of the tuned Flash file and the RealAudio stream in the RealPlayer.

Project Properties: Pressing this button opens a new window that allows you to include information about the project along with the published RealPlayer file.

Optimizing Movie Files

Publish Preview allows you to see how your Movie will look in different file formats. But – for Flash Movies that will stream over the Web, looks are not the only issue – performance is often critical. That is why Flash includes the Bandwidth Profiler, which provides you with information about how your Movie will stream using slow or fast modem connections.

As you tested your Movies during previous Practice Exercises, you may have noticed that a new set of menu items appeared at the top of the screen when your **.swf** test file was displayed. You can access the Bandwidth Profiler from this menu by selecting **View / Bandwidth Profiler.** See Figure 22-17 for a look at the Bandwidth Profiler.

The Menu option View / Bandwidth Profiler is **only** available in a Flash **.swf** file.

CD-ROM

Flash 5 - [sample_file swi] File Edit Vew Control Debug Window Help	
Tee Kok Steve Loves Konse Konse Loep Zoon In Chiee Magnification •	- <u>1918</u> -
Bandwidth Poolfer Cht+B	
Show Stearing Chi-Enter Stearing Stack Chi-Enter Drive Stream (Stack Chi-Stack)	
Quality +	
fee	

Figure 22-17 Menu to Access Bandwidth Profiler

Guided Tour – Bandwidth Profiler

You will want to use the Bandwidth Profiler to view the download performance of your Movie in a graphic format. The Profiler shows you how much data is being sent for every Frame of the Movie, according to a modem speed that you define. You can use the Bandwidth Profiler to simulate each of a variety of different modem speeds. Remember that the Flash **.fla** file format is the editable format and that the **.swf** is the Shockwave format that you will use to distribute your programs over the Web. It is the **.swf** file format that we will use with the Bandwidth Profiler. Let's jump in and give it a try.

Select the Menu option File / Open. Locate and select the file sample_file.swf in the Chapter22 Folder on the CD-ROM. This file automatically loads in the Flash Player since it is a .swf file. The Movie should now be running ... and it does not currently have sound in it ... just animation.

 Select the Menu option View / Bandwidth Profiler to reveal a dynamic bar graph that indicates the Frame-to-Frame download performance of this Movie, based on the default modem setting (we will change this in a minute). See Figure 22-18.

Movie:	Ģ.	
Dim: 550 X 400 pixels	128 KB	
Fr Rate: 12.0 fr/sec	32 KB	
Size: 102 KB (105043 B)	8KB	
Duration: 1 fr (0.1 s)	2 KB	
Preload: 525 fr (43.8 s)	200 B	
Settings:		
Bandwidth: 2400 B/s (200 B/fr)		
State:		
Frame: 1		

378

- a) The Bandwidth Profiler uses real-world estimates of typical online performance (and not theoretical speed) to provide the simulation of a live download. We all know that our actual connection / download speed is generally far less than what is technically possible. For instance, a 28.8K modem can optimally download data at about 3.5 KBPS. Flash, however, will simulate this modem by using a 2.3 KBPS connection that is more typical of real-world connections. Flash can also simulate a 14.4K modem, a 56.6K modem, and other customizable options. We will look at where we can choose these different speeds in the next step . . . but first, let's take a closer look at the Bandwidth Profiler.
- b) The left side of the profiler contains various sections that display different types of information regarding the Movie as a whole. These sections are **Movie, Settings** and **State**. Let's look at these individually.

Movie: This section included the dimensions, Frame rate, size in bytes and Kilobytes, duration, and any pre-loaded Frames represented by number of seconds.

Settings: This section shows the available (simulated) bandwidth and varies according to the setting you chose under the Debug Menu Option.

State: This section shows the current state of the Movie in terms of the currently loaded Frame, percentage of download completed, total Frames and size of any selected Frame within the Frame-by-Frame graph.

- c) The right section of the Bandwidth Profiler resembling the Timeline – shows both the Timeline header and graph. Each bar in the graph represents a particular Frame in the Movie. The height of the bar corresponds to that particular Frame's total size in bytes. The taller the line, the more bytes of information that particular Frame contains. If any Frame block extends above the red line in the graph, this indicates that the Flash Player may be forced to halt playback until the entire Frame downloads.
- d) The red line located below the Timeline header indicates the maximum real-time bandwidth available based on the current (simulated) connection speed (as specified in the Control menu). You can click any bar on the graph and see its settings displayed in the left window. Doing this will also stop the Movie if it is playing.
- Select the Menu option **Debug**. The Debug Menu options are shown in Figure 22-19.

Figure 22-19 The Debug Menu Options

- a) Select the 14.4 Modem Setting. Select Control / Play to watch performance at this speed.
- b) Select the 56.6 Modem Setting. Select Control / Play to watch performance at this speed.
- 4. By selecting the Menu option **View / Show Streaming** you can turn the streaming bar on and off. The streaming bar indicates the number of Frames loaded during the simulated download.
- 5. By selecting the Menu option View / Streaming Graph you can display which Frames will cause pauses in the playback. Its default view will display alternating blocks of light gray and dark gray. These blocks represent individual Frames. Since the first Frame stores a symbol's content, it is often larger than other Frames that hold only Instances (copies) of a Symbol.
- 6. By choosing the Menu option **View / Frame by Frame Graph** you can display the size of each Frame. This view helps you see which Frames are contributing to streaming delays. If any Frame's block extends above the red line in the graph, then the Flash Player halts playback until the entire Frame downloads.

Guided Tour – Publishing Movies

In this Tour you will go through the steps to Publish a Movie using the Publish Settings Menu option. Specifically, you will publish associated HTML and projector files, as well as a Size Report.

·T/P

If you have Sound clips in your Timeline, take extra time to look at the Bandwidth Profiler. Sound files can cause Movies to skip Frames, especially if the Sync option is set to **Stream** in the Sound Panel. Streamed sound can cause the Movie to skip Frames over slow connections in order for the animation to keep up with the audio track.

			······		Publish	hing Flash Movies
	١.	l et	's Export!			
	1.	a)	Select the Menu option Fi	le / Open. Locate and sel		CD-ROM
				Chapter22 Folder on the		
		b)	Save the file to the Save	Work Folder on your of	own system.	
	c)	Select the Menu option F	File / Publish Settings.			
		d)	On the Formats Panel,	choose Flash, HTML a	It is generally a good idea to save the final	
			Macintosh Projector (de	acintosh Projector (depending on your system).		
		e)	Select the Flash Panel.	Assign the following set	tings:	version of a Flash file in
			Load Order:	Top Down		its own Folder so it and
			Generate Size Report:	Selected		the other files that are
			Omit Trace Actions:	Selected		Published are easily
			Protect from Import:	Selected		located and accessed.
			Debugging Permitted:	Not Selected		We aren't doing that here in the Tour, but in
			Password:	Blank		a production environ-
			JPEG Quality:	80		ment this tip may
			Audio Stream:	MP3, 32Kbps, mono		help you stay organized.
			Audio Event:	MP3, 32Kbps, mono		8 6
			Override Sound Settings	Selected		6 6
			Version:	Flash 5		•
		f)	Select the HTML Panel	. Assign the following se	ettings:	
			Template:	Flash Only		
			Dimensions:	Match Movie		6 6
			Paused at Start:	Not Selected		0 0 0
			Loop:	Selected		* *
			Display Menu:	Not Selected		
			Device Font:	Not Selected		8 8 9
			Quality:	Auto High		
			Window Mode:	Window		-
			HTML Alignment:	Default		0 0

Flash Alignment: Center both Horizontal and Vertical Show Warning Messages: Selected

Scale:

Don't Click These Buttons – just read. Clicking the OK Button at this point would allow you to return to the main Movie without losing the settings that you have assigned. Cancel will clear your selections and return you to the main Movie.

Exact Fit

g) Click the Publish Button to Publish the Flash SWF file, a size report, the HTML document and the Projector File. Each of these files will be given the same name as the Flash Authoring (.fla) file that they were published from. After Publishing, click OK to save the settings and return to the main Movie.

·T/P

If you Publish a file without changing the Publish Settings by using the Menu option **File / Publish,** Flash will use the default Publish Setting. This means that a **.swf** and HTML file will be automatically generated. h) Minimize Flash and look inside the SaveWork Folder on your computer. You should find a sample_file report, sample_file.swf, sample_file.html and a sample_file Projector file. Open each of these to investigate the differences!

Inserting Flash Movies into HTML Documents

Most projects created in Flash are exported using the Flash Player (.swf) format and are then inserted into HTML documents that can be uploaded to a server and viewed through a Web browser like Internet Explorer or Netscape. (We will show you an HTML example in a few pages.) HTML, or Hypertext Markup Language, is the basic language for creating most pages on the Web. In order to view things like graphics or multimedia files such as Flash Movies, you must insert a few lines of HTML code that instructs the browser to load and play these files using a particular plug-in. It is helpful to think of HTML as the glue that binds together all the many elements found on a Web page.

The Flash Player Plug-in

Flash Movies also require a Plug-in in order to play through a browser. A Plugin is a very small software application that is installed in your browser and used to play different types of media files such as video and Flash Movie files. The Flash Player Plug-in is used to launch and play the **.swf** files created in Flash. The Flash Player has been included in the later versions of all the major Web browsers (including Internet Explorer and Netscape). However, a user may not have the latest version of the Flash Plug-in installed.

The latest version of the Flash Player can be downloaded from the Macromedia Web site at this address (as of this book's publication date):

http://www.macromedia.com/shockwave

Shockwave Player Plug-in

The Shockwave Player Plug-in is a second Macromedia Web player. The Shockwave Player will play both Flash and Director content. It is a larger file than the Flash Player and will take longer to download and install. The latest version of the Shockwave Player can be downloaded from the Macromedia Web site at this address (as of this book's publication date):

http://www.macromedia.com/shockwave

Sample HTML Code for Flash Files

For many Web designers, the idea of hand coding pages that contain multimedia files such as Flash Player Movies may seem daunting, but the process is actually easier than most people think. Let's take a look at the source code that was published during the last Practice Exercise:

- Double-click on the file named sample_file.html. This file was generated if you completed the last Practice Exercise and is located in the SaveWork Folder on your computer.
- 2. In your browser, view the source HTML source code.
 - a) In Netscape, select View / Source.
 - b) In Internet Explorer select View / Source.
- 3. The source code should look something like this:

Figure 22-20 Source HTML Code

- 4. Wow! If you don't know anything about HTML, aren't you glad that Flash generated this code for you?
- 5. Let's look at another possibility.

Inserting Flash Movies into Dreamweaver Documents

For those of you who are looking for some help generating the HTML documents for your Flash Movies, you may want to download the trial version of Macromedia Dreamweaver. Dreamweaver is a powerful Web development tool that is designed to blend seamlessly with Macromedia's other Web development software like Flash and Fireworks.

The Dreamweaver Environment

The Dreamweaver interface looks very different from the Flash interface. Look at Figure 22-21. The first thing you will notice is that Dreamweaver is

•**T/P**·

Trial versions of all of Macromedia's software are available for download at www.macromedia.com. These trial versions are fully functional and are good for a 30-day review before purchase. not a Timeline-based program. Everything in Dreamweaver centers around the main Document Window – a blank window where you can insert images, text and multimedia files such as Flash Movies.

				Med-11-1 Medita		Commande	Site	Window	Help		
7.00	- Marriel	7.00/1	1.1.1	(Tana)	die .		10,000		10000		22
1											
-											
000	D			436	× 434 -	1K / 1 sec	0001	LIGIO	2 63	2 3	

Figure 23 21 The Dreamweaver Document Window

In its most basic form, Dreamweaver works like a text editor. You can type text directly into the main Document Window, run a spell check, and use alignment and style tools like bold, italic, right align or center align. As you begin to add other elements to your page, you will use the icons found in the Objects Panel as shown in Figure 22-22. The Objects Panel contains a group of icons that are used to insert elements like images and Flash Movies into the Document Window. The Objects Panel can also be used to create forms, insert special characters, set up Frames, to name just a few features. In Dreamweaver, just like in Flash, the floating Panels (or Windows) can be opened from the Window pull down menu. The Objects Panel in Dreamweaver comes with an Insert Flash Movie Icon, as shown in Figure 22-22.

	Objects Z
	1 B
ert	- 5
sh —	赤山
vie	00
	5
	3 0

Figure 22-22 The Objects Panel

384

If you want to insert a Flash Movie into your Dreamweaver document, follow these steps:

- 1. First, make sure to save your Dreamweaver document. Anything you insert into an HTML file must have an associated path to that file on your hard drive. When the file is displayed in a browser, the browser looks for those files wherever the path tells it to look. A published HTML file and all the associated media files reside on a server. When you are creating your file on our hard drive, you can use relative links to establish paths from your HTML file to the media files. You can preserve these links by transferring the directory structure exactly as it appears on your computer ... to the server.
- Next, click on the Insert Flash Icon in the Objects Window. A dialog box will appear that asks you to find your Flash Movie. Find it on your computer and then click OK.
- A gray box with a small Flash Icon will be inserted into your document. That's all there is to it!

If you would like help learning Dreamweaver, please check out another of our books in the **Inside Macromedia Series – Dreamweaver.** This book also includes more details about importing and playing Flash Movies from within Dreamweaver.

Guided Tour – Sharing a Library

Shared Libraries are an efficient way of creating a central storage area for all the elements used in multiple Flash Movies, especially for multiple Movies in one Web site. It's easy to set up a Shared Library and equally easy to link to objects in it. So, what does a Shared Library have to do with Exporting and Publishing files? In order for other Movies to link to shared elements in a Library, the **.swf** file with a Shared Library in it must be exported and posted to a Web server where other Movies can link to it when they are played back.

- 1. Let's take a quick look at how to turn a Library element into a shared object.
 - a) First, find and open the file named **shared.fla** in the **Chapter22 Folder** on the CD-ROM.
 - b) Your Stage and Timeline will be empty when the Movie opens, but that's okay because all we are really interested in is the Library. Open the Library by using the Menu option Window / Library. You should see an assortment of Objects and Symbols in the Library as illustrated in Figure 22-23.

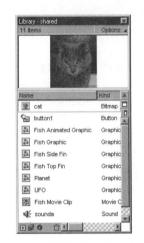

Figure 22-23 The shared.fla Library

c) Select the **cat bitmap** in the Library list. In the Library Options menu, **select Linkage** from the list, as illustrated in Figure 22-24.

Figure 22-24 Linkage from the Library Options Menu

 d) The Symbol Linkage Properties window will appear, as shown in Figure 22-25.

dentifier:	cat	OK
_inkage:	O No linkage	Cancel
	Export this symbol	
	O Import this symbol from URL:	
		Help

Figure 22-25 Symbol Linkage Properties Window

386

- e) To designate the JPEG as a shared element, select the Export This Symbol radio button and type in cat as the identifier. Click OK to close the window.
- f) Save your Movie.
- 2. Linking to a Shared Library
 - a) In order for a Movie to display any shared elements, you must post your Shared Library onto a Web server after the file that contains it has been exported in **.swf** format. Once it is posted on a Web server, any other files that use the Shared Library will be able to link to it and load it into their Movie file.
 - b) First, define the URL where your Shared Library is going to reside. This requires that you know where you are planning on putting the *.swf* file with the Shared Library. To define the URL, choose **Shared** Library Properties from the Options menu in the shared.fla file.
 - c) In the Shared Library Properties window, as pictured in Figure 22-26, type in the URL where the **.swf** file will reside, and click OK.

Shared Library Properties	×
URL:	ОК
	Cancel
	Help

Figure 22-26 URL Field – Shared Library Properties

- 3. Now, you can open a Shared Library and link to the shared elements in it.
 - a) To open a shared Library, select the Menu option File / Open as Shared Library. Find the Movie on your hard drive and doubleclick on it. Notice that only the Library opens.
 - b) Now you can drag any shared elements out of the Library and into a new Movie. When the Movie containing these links is exported, it will look for those Library elements at the designated URL instead of exporting those shared elements in its own Library.

Summary

• Publishing Flash Movies is the final step in creating your Flash Movies. Publishing your Flash file is the means to make it available for widespread public distribution.

CHA	APT	ER	22
-----	-----	----	----

- You can either use the Export feature to specify one file format for your Movie, or you can use Publish Settings to specify multiple file formats and Publish them all at once.
- There are two options for Export: Export Image which turns selected Frames of your Movie into static graphic images; and Export Movie – which allows you to export your Movie into the common .swf format, as well as other Movie formats.
- The first Guided Tour took you for a closer look at the various options available within the following formats: Flash; HTML; Generator; GIF; JPEG; PNG; Windows Projector; Macintosh Projector; QuickTime; and Real Player.
- Flash includes a Bandwidth Profiler that provides information about how your Movie will stream using slow or fast modem connections.
- The second Guided Tour took us for a closer look at the Bandwidth Profiler and its various options.
- The third Guided Tour involved going through the basic steps necessary for Publishing a Flash Movie.
- Most projects created in Flash are exported using the Flash Player (surf) format and are then inserted into HTML documents that can be uploaded to a server and viewed through a Web browser like Internet Explorer or Netscape.
- Flash Movies also require a Plug-in in order to play through a browser. A Plug-in is a very small software application that is installed in your browser and used to play Flash Movie files.
- The Flash Player Plug-in is used to launch the .swf files created in Flash.The latest version of the Flash Player can be downloaded from the Macromedia Web site at this address (as of the publication date of this book): http://www.macromedia.com/shockwave
- The Shockwave Player Plug-in is a second Macromedia Web player. The Shockwave Player will play both Flash and Director content.
- Dreamweaver is a powerful Web development tool that is designed to blend seamlessly with Macromedia's other Web development software like Flash and Fireworks.
- Everything in Dreamweaver centers around the main Document Window a blank window where you can insert images, text and multimedia files such as Flash Movies.
- The Object Window in Dreamweaver comes with an Insert Flash Movie Icon in the Object Panel.
- In the final Guided Tour you learned how to create a Shared Library and why it can be beneficial.

PTER

23

Application Chapter: Building a Pre-Loader

Chapter Topics:

Introduction

Application Exercise – Building a Pre-Loader

Summary

Introduction

Once you have most of your site built, it is time to start thinking about what happens once you publish your site and people start visiting it. As with most graphics rich sites on the Web, you will have users visit your site during times of high traffic or using very slow Internet connections. These conditions will contribute to increased download time and decreased performance on-screen.

Since Flash utilizes streaming technology, your user doesn't have to download the entire Movie file before viewing it. Instead, the Movie is designed to begin playing as it is being downloaded. This is a terrific Flash feature. However, during less than optimal conditions, streaming media will also experience delays and less-than-fluid performance.

A well designed Pre-Loader can make a user's experience much better by letting them know that although the site is still downloading, something is happening in the background. A Pre-Loader can actually serve to keep the user engaged and interested.

In our continuing quest to actively think about our user's experience, in this exercise we are going to build a Pre-Loader to occupy the screen while at least part of the program downloads. By having commonly used elements download in the background, as the Pre-Loader is on-screen, performance for the main program should also be significantly improved.

Application Exercise – Building a Pre-Loader

Description

In this Application Exercise, you will learn to add a Pre-Loader to your main Movie site. This exercise will show you how to use Frame Actions to control how your Movie is initially loaded and displayed.

Take-a-Look

Before beginning the exercise, let's take a look at the exercise in its completed state so that you can clearly see what it is that you are about to build.

- Use the Menu option File / Open and locate on the CD-ROM the folder named Chapter23. Locate the file named application_23.fla.
 Double-click on this file to open it.
- 2. The file application_23.fla should now appear in your copy of Flash.
- 3. Select the Menu option Control / Test Movie to view the Movie.

CD-ROM

Storyboard: On-Screen

Figure 23-2 shows what can be seen on Stage when the exercise is completed.

Figure 23-1 The Completed Stage

Storyboard: Behind-the-Scene

Figure 23-2 shows how the Timeline will look when the exercise is completed.

	8	9		1	i 10	15	20	25	30	35	40	45	50	55	60	65	E.
Actions and Labels	•	٠		aaa													
D Button	•	٠															1
🕼 Text MC 🛛 🖌	•	•		•0													
Route MC	•	•		•0•													
Background	•	•		• 0													
🕞 Sound	•	٠		-													-
•			ñ	1		1 12	.0 fps 0	1.0s 4	F								Ť

Figure 23-2 The Completed Timeline

Applications Project Steps

Complete this exercise on your own, guided by following the general steps provided below. You can always refer back to the completed example that you viewed in the Take-a-Look section of this exercise.

Please Note: The following steps are intended as a guide. This is your project so please feel free to make whatever variations you would like.

١.	Open application_21.fla. You can either use the copy you created previ-
	ously and saved in the SaveWork Folder on your computer or you can
	use the copy in the Chapter21 Folder on the CD-ROM supplied with
	this book.

- 2. Select the Pre-Loader Scene and create a new Layer called Actions and Labels. Move it to the top of the Stacking Order.
- 3. Select Frame 2 and Insert a Blank Keyframe.
- 4. Select Frame 3 and Insert a Blank Keyframe.
- Remember the Frame Labels we assigned to the Index Scene in an earlier chapter? We'll use those to identify when the main body of the Web site has been downloaded and is ready for viewing.
- 6. The last Frame of the Index Scene was Labeled "Bulldozer" and therefore we will target "Bulldozer" as our cue to get out of the Pre-Loader.
- 7. Select Frame I of the Actions and Labels Layer and assign the following Action Script:

```
irrameLoaded ("index", "Bulldozer") {
  gotoAndStop ("Preloader", 3);
}
```

- 8. We want to stop the playback when we get to Frame 3 so the viewer can use the Go button that we have placed there. Let's set that up next.
- 9. Select Frame 3 of the Actions and Labels Layer and assign the following Action Script:

stop ();

These Actions satisfy the "lf" condition. Let's work on creating the rest of the Conditional Loop ... what happens if the "lf" condition is not met?

10. Select Frame 2 of the Actions and Labels Layer and assign the following Action Script:

```
gotoAndPlay (1);
```

This completes the Conditional Loop: If the Frame is loaded, we will go to Frame 3. If the Frame is not loaded, we go to Frame 2 where we Loop back to Frame I and check again. Easy!

11. Save your file as application_23.fla and do a Test Movie to watch your Pre-Loader at work (don't forget to use the Show Streaming option).

Summary

You have added a Pre-Loader to your Movie file in order to enhance the functionality of your site once the site is published. This technique allows you to compensate for slow Internet connections, or perhaps larger Flash files that might not download as efficiently as you would like them to over some connections.

PTER

24

Advanced Actions: Creating Drag-and-Drop Movie Clip Actions

Chapter Topics:

- Introduction
- What is Drag and Drop?
- Guided Tour startDrag and stopDrag Actions
- Practice Exercise Creating a Basic Drag Action
- Practice Exercise Nesting A Button in a Movie Clip for a Drag Action
- Practice Exercise Drop Actions
- Summary

Introduction

This chapter focuses on applying more advanced Actions while creating basic and advanced drag and drop activities in your Flash Movies. The information presented here will build on many concepts learned in earlier chapters, such as nesting Symbols inside of one another, and adding Actions to the Timeline. You will also work with a conditional **if...then statement** to set up the target parameters for the drop component of this activity.

By the end of this chapter you will be able to:

- create a basic drag/drop activity.
- embed a Button inside a Movie Clip.
- use the startDrag Action to drag a Movie Clip.
- use the stopDrag Action to stop the drag Action on a Movie Clip.
- customize the ActionScript code for a drop activity.

What is Drag and Drop?

Drag and Drop is an interactive feature in Flash that lets a user move objects on the screen by clicking on and then dragging an object with their mouse. When the user lets go of the mouse button (and the object), the interaction can be programmed to have the object "snap to the center" of a specified location, return to its original location, or stay exactly where the user released the mouse.

The Drag and Drop technique is a great way to reach out and grab the user by the proverbial collar in order to get him/her to interact with the program that you have created. You can ask the user to drag/drop an object to... match an item to a list; to "fill-in-the-blank"; to place an object in an ordered list; to assemble parts to make a whole ... and any number of other possibilities that you might imagine and create.

You've Got to Have Movie Clips!

The first rule for setting up a Drag Action in your Flash Movie is that you've got to have Movie Clips! The only objects that can be used with the Drag Action in Flash are Movie Clips. In Figure 24-1, the Actions Panel is open and the **Actions Folder** has been expanded to show the list of possible Actions. Note that the **Actions Folder** is different than the **Basic Actions Folder** we looked at in previous chapters.

Advanced Actions: Creating Drag-and-Drop Movie Clip Actions

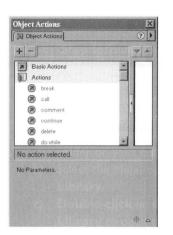

Figure 24-1 Actions in the Actions Panel

Once you have an Instance of a Movie Clip Symbol inserted into your Timeline, you are then able to attach the **startDrag** Action to that Instance so that a user can move (or drag) this Movie Clip around the Stage. Unless otherwise specified, this Movie Clip will remain "drag-able."

Since a Movie Clip has a separate Timeline that is not dependent on the Frames in the main Movie Timeline, a Movie Clip can continue to play through its own Timeline as it is being dragged. The combination of Movie Clips and the startDrag Action has tremendous potential for creative uses in many different types of Flash applications including gaming activities, educational activities and other types of interactive Web applications such as e-commerce sites.

The stopDrag Action contains various components that allow you to control what happens when the user stops dragging (and lets go of) the selected Movie Clip. In the Guided Tour that follows we'll take a quick look at the startDrag and stopDrag Actions.

Guided Tour - startDrag and stopDrag Actions

- 1. Let's open the Flash file that you will be working with in the first Practice Exercise so we can look at these new Actions.
 - a) Select the Menu option File / Open. Locate and select the file named wiggly_start from the Chapter24 Folder on the CD-ROM.
 - b) Select the Menu option Window / Library to open the wiggly_start Library.
 - c) Drag an Instance of the Wiggly Guy Movie Clip onto the Stage.

CD-ROM

·T/P·

- 2. Now let's open the Actions Panel and access the startDrag and stopDrag Actions. Remember, these Actions can only be applied to Movie Clips!
 - a) Select the Instance of the Wiggly Guy on the Stage.
 - b) Select the Menu option Window / Actions to open the Actions Panel.
 - c) Click on the Actions Folder to expand it.
 - d) Scroll down the expanded list to find the ... startDrag Action.
 - e) Double-click on the startDrag Action. The following code is added to the Actions window on the right, as illustrated in Figure 24-2:

```
onClipEvent (load) {
   startDrag ("");
}
```

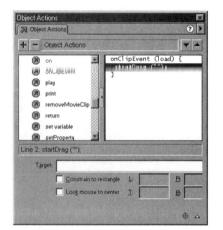

Figure 24-2 The startDrag code in the Action Panel

- 3. This code is the basic architecture of the startDrag Action. As with most Actions, there are parameters (or guidelines for operation) that you have the option of assigning.
- 4. Select Line I of the code. Note that this gives you the following **Event** options in the Parameters Panel at the bottom of the Actions Panel:

Load: The Action occurs when the Movie Clip Instance appears in the Timeline.

Enter Frame: The Action occurs as each Frame is played, similar to Actions attached to a Movie Clip.

Unload: The Action occurs in the first Frame after the Movie Clip is removed from the Timeline.

As you start to add ActionScript code, try to think about what the code is directing your Movie to do. In Step 2e, there is an Event (onClipEvent) that triggers a startDrag action. The term "Event" refers to things that the user does, such as on Mouse Down or Key Press, or things that occur in your timeline, such as Load or Unload. Events and Actions often work in tandem kind of like cause and effect. An Event causes or triggers an associated effect or action.

Mouse Down: The Action occurs when the mouse button is pressed.

Mouse Up: The Action occurs when the mouse button is released.

Mouse Move: The Action occurs every time the mouse is moved.

Key Down: The Action occurs when a key is pressed.

Key Up: The Action occurs when a key is released.

Data: The Action occurs when data is received in a loadVariables or loadMovie Action.

5. Select Line 2 of the code. Note that this gives you the following options in the Parameters Panel at the bottom of the Actions Panel:

Target: This is the target path of the Movie Clip you wish to drag.

Constrain to Rectangle (left, top, right, bottom): These are values that relate to the coordinates of the Movie Clip's parent and specify a constraint rectangle for the Movie Clip. These are optional arguments.

Lock Mouse to Center: This is a Boolean value that states whether the dragged Movie Clip is locked to the center of the Movie Clip (true), or whether it is locked where the user first clicked on the Movie Clip (false). This is an optional argument.

- 6. These are the **startDrag** and **stopDrag** Actions, as well as the respective arguments and parameters used to create a wide variety of Drag and Drop interactions. Many variations are possible within the context of a Drag and Drop interaction because of the large number of options we have to choose from.
- 7. **Close** the **file without saving it –** we want to "start fresh" with this file in the Practice Exercise that follows.

Practice Exercise – Creating a Basic Drag Action

Description

In this exercise you will learn how to attach a Drag Action to the Wiggly Guy ... an animated character that lives within a Movie Clip (we'll activate the animation later in the chapter). You will also experiment with the different settings available when using the **startDrag** Action, and you will ultimately test your Movie to see how it works.

In this exercise you will:

- Resize and reposition a Movie Clip Instance on the Stage.
- Insert the startDrag Action and set various associated parameters.

Figure 24-3 The Completed Stage

Storyboard: Behind-the-Scene

Figure 24-4 shows the Timeline once this exercise is completed.

Figure 24-4 The Completed Timeline

Step-by-Step Instructions:

- I. Let's get started!
 - a) Select the Menu option File / Open. Locate and select the file named wiggly_start.fla from the Chapter24 Folder on the CD-ROM.
 - b) Select the Menu option Window / Library to open the wiggly_start Library.
 - c) Drag an Instance of the Wiggly Guy Movie Clip onto the Stage.
 - d) Use the Info Panel to resize the Wiggly Guy Movie Clip to W=43.8 and H=92. Using a center orientation, set his position at X=400 and Y=325.
 - e) With the Instance of the Wiggly Guy Movie Clip selected, open the **Actions Panel.**
 - f) Click the Actions Folder in the left portion of the Actions Panel to expand the Folder. Scroll down the list of Actions and doubleclick on startDrag. The following code is added to the Actions window:

```
onClipEvent (load) {
   startDrag ("");
}
```

g) Select Line I of the code. Select Mouse down from the list of options. The code now reads:

```
onClipEvent (mouseDown) {
   startDrag ("");
}
```

h) Select Line 2 of the code. Select Lock Mouse to Center. The code now reads:

```
onClipEvent (mouseDown) {
   startDrag ("", true);
}
```

i) Choose the Menu option Control / Test Movie. Click on the Wiggly Guy to begin the Drag operation. But whoa ... we can drag, but the problem is that we can't drop him! This is because we didn't include a Drop Action in the code. Let's close the Preview to return to the Main Movie Timeline.

- mouse will be locked to the center of the
- Movie Clip.

- j) Save your file in your SaveWork Folder on your computer as ... wiggly_1.
- Next, we will learn an alternate way to attach a drag or drop action to a Movie Clip... by nesting a button within the Movie Clip (then we'll figure out the Drop Action once and for all)!

Practice Exercise – Nesting A Button in a Movie Clip for a Drag Action

Description

Although Movie Clips are the only Symbols that can have drag and drop Actions attached to an Instance, you can always nest other Symbols inside of a Movie Clip in order to work around this problem. If you want to use a Button Symbol that responds to mouse events, all you have to do is insert the button inside of the Movie Clip Symbol. Think of the Movie Clip as an invisible container that allows you to capitalize on the strengths of both Symbols.

In this exercise, you will build on what you developed in the last exercise, and will insert a Button Symbol inside a Movie Clip Symbol. You will then drag an Instance of the Movie Clip and see how the Button Symbol and Movie Clip work together.

In this exercise you will:

- Edit the Wiggly Guy and add a new Layer.
- Add an Invisible Button with an On Mouse Event Action.
- Add startDrag and tellTarget Actions, setting appropriate options.

Take-a-Look

Before beginning the exercise, let's take a look at the exercise in its completed state so that you can clearly see what it is that you are about to build.

- Use the Menu option File / Open and locate on the CD-ROM the folder named Chapter24. Locate the file named wiggly_2.fla. Double-click on this file to open it.
- 2. The file wiggly_2.fla should now appear in your copy of Flash.
- 3. Select the Menu option **Control / Test Movie** to preview the Movie.

Please note the following properties of this completed exercise:

- a) You can click and drag the Wiggly Guy anywhere on the Stage.
- b) As you drag the Wiggly Guy around, a sound file plays.

CD-ROM

·T/P

Advanced Actions: Creating Drag-and-Drop Movie Clip Actions

c) You still can't let go ... or get the Wiggly Guy to stop screaming!

Storyboard: On-Screen

Figure 24-5 shows the Stage once this exercise is completed.

Figure 24-5 The Completed Stage

Storyboard: Behind-the-Scene

Figure 24-6 shows the Timeline once this exercise is completed.

	(je	8 🗆	1	5	10	15	20	25	30	35	40	45	50	55	60	65	H
🕏 Layer 1	1.											Libr	ary - wigg	ly_2.fla	×		-
			Ш									4 it	ems	0	ptions 🖌		
																	-
+		Ō	4	00	8 01	1 12.0) fps 0,)s 4	1	80088	8888	0				889	

Figure 24-6 The Completed Timeline

Step-by-Step Instructions:

- I. Let's get started!
 - a) Select the Menu option File / Open. Locate and select the file named wiggly_I from the Chapter 24 Folder on the CD-ROM or use the version that you completed and saved in the SaveWork Folder on your computer from the last exercise.
 - b) Select the Menu option Window / Library to open the wiggly_I Library.
 - c) **Double-click** on the Movie Clip Symbol for the **Wiggly Guy** in the **Library** to open the Movie Clip in the Editing Mode.

d) Create a new Layer in the Timeline. Name it ... Button and make sure it is at the top of the stacking order.

e) Lock the Figures Layer to ensure that we don't accidentally move something in that Layer.

f) Select Frame I of the Button Layer and drag the Invisible Button from the Library out onto the Stage.

 g) Position the Instance of the Invisible Button over the Wiggly Guy Movie Clip that is already on the Stage.

h) With the Instance of the Invisible Button selected, open the Actions Panel.

 Click the Basic Actions Folder in the left portion of the Actions Panel to expand the Folder. Scroll down the list of Basic Actions and double-click On Mouse Event. The following code appears in the Actions window:

```
on (release) {
}
```

 Select Line I of the code. In the Parameters Pane, deselect Release and choose Press. The code now reads:

```
on (press) {
```

```
}
```

k) Select Line I of the code. Click the Actions Folder on the left portion of the Actions Panel to expand the Folder. Scroll down the list of Actions and double-click on startDrag. The code now reads:

```
on (press) {
   startDrag ("");
}
```

 Choose the Menu option Control / Test Movie. Click on the Wiggly Guy to begin the Drag operation. We can drag, but we still can't drop him! These last steps were designed to show you how to create a Drag operation by nesting an Instance of a Button Symbol inside a Movie Clip Symbol.

2. So why should we create a Drag operation by using a nested Button? Because nesting a button allows us to take the simple Drag and Drop operation and combine it with event-triggered animation and interactivity!

 Let's add a couple more lines of code and find out why we call this guy "wiggly" in the first place . . . it'll give us an opportunity to explore our options.

4. Let's close the **Preview** to return to the main Movie Timeline.

5. Now let's add to the fun.

a) You should still be in the Symbol Editing Mode for the Wiggly Guy Movie Clip Symbol. If not, double-click on the Wiggly Guy in the

Advanced Actions: Creating Drag-and-Drop Movie Clip Actions

· T/P·

Library. Select the instance of the Invisible Button on the Stage and then **select Line I of the code** in the Actions pane. Scroll down the list of Actions on the left and **double-click on Tell Target**. The code now reads:

```
on (press) {
   tellTarget ("") {
    }
   startDrag ("");
}
```

b) Select Line 2 of the code in the Action pane. Scroll down the list of Actions and double-click on Go To. The code now reads:

```
on (press) {
   tellTarget ("") {
    gotoAndPlay (1);
   }
   startDrag ("");
}
```

c) Select Line 3 of the code in the Action pane. In the Parameters Pane, change the Frame to ... 2. The code now reads:

```
on (press) {
   tellTarget ("") {
     gotoAndPlay (2);
   }
   startDrag ("");
```

}

Now when the drag operation gets initiated, we will be triggering the animation that we have set up in Frames 2-5 of the Wiggly Guy Movie Clip Timeline.

- d) Choose the Menu option Control / Test Movie. Click on the Wiggly Guy to begin the Tell Target and Drag operations. Ugh! What a noise! This is a quick example of how we can nest a button within a Movie Clip to trigger other Actions along with the Drag and Drop, and it is also more of a reason to examine the Drop Action! Let's do that now.
- Return to the main Timeline and save your file in the SaveWork Folder as ... wiggly_2.

Practice Exercise – Drop Actions

Description

So far we have just learned how to control the drag portion of the drag and drop. When a Movie Clip is dropped, a number of things can happen to it depending on the conditions you set up in your ActionScript. In this exercise The Tell Target Action is used to control Timelines outside of the current Timeline. This means that the Tell Target Action can be used to control Timelines in Movies that are outside of the main Movie Timeline, or in Movie Clip Instances that have their own Timeline.

If you have several Movie Clips nested inside of a Movie Clip, you can use the Insert Target Path button to specify which Movie Clip you want to target. This window shows the hierarchy of Movie Clips and identifies them by their Instance name. Notice that in the code we have been writing the

have been writing, the TellTarget code reads:

tellTarget ("") {

When you select a Movie Clip using the Insert Target Path button, the Instance name will appear in the between the parentheses. you will continue working with the Drag Action created in an earlier exercise and learn to set up specific targets for dropping your drag object. To achieve this, you must use some more advanced components of ActionScripts called conditional statements. The most familiar type of conditional statements, especially to many programmers is the **If...Then statement**. This statement says that **If** a condition is met **Then** an event will occur.

One of the great things about using Movie Clips is that Movie Clips can serve as drop targets for other Movie Clips that are being dragged. This means you can also trigger other Movie Clips to play, depending on how the If...Then statement is constructed in the Actions Panel.

In this exercise you will:

- Edit the Movie Clip and Invisible Button within it to add the stopDrag Action.
- Add another tellTarget Action coupled with a Go To that will stop the screaming.

Take-a-Look

Before beginning the exercise, let's take a look at the exercise in its completed state so that you can clearly see what it is that you are about to build.

- Use the Menu option File / Open and locate the folder named Chapter24 on the CD-ROM. Find the file named wiggly_4.fla. Double-click on this file to open it. (You will end up with a wiggly_3.fla – half way through the current exercise, but the final version of the exercise is wiggly_4.fla.)
- 2. The file wiggly_4.fla should now appear in your copy of Flash.
- 3. Select the Menu option **Control / Test Movie** to view the Movie.

Please note the following properties of this completed exercise:

- a) You can click on and drag the Wiggly Guy anywhere on the Stage.
- b) As you drag the Wiggly Guy around, a sound file plays.
- c) When you let go of the Wiggly Guy outside the target ... the screaming stops and Wiggly Guy goes back to his original position.
- d) When you let go of the Wiggly Guy inside the target ... the screaming stops and the Wiggly Guy snaps to the center of the target.

Storyboard: On-Screen

Figure 24-7 shows the Stage once this exercise is completed.

We have used the .wav format for the file, but have included the .mp3 format in the Library, if you would like to exchange the sound file formats.

CD-ROM

·T/P

Advanced Actions: Creating Drag-and-Drop Movie Clip Actions

Figure 24-7 The Completed Stage

Storyboard: Behind-the-Scene

Figure 24-8 shows the Timeline once this exercise is completed.

		16	8		1	5		10	1	5	20	1	25	30	35	40	45	50	55	60	1.1.4	65	H
📝 Layer 1	1	•	•			111																	
D Target		•	•													- Catri				1000	Libr	ary -	wigg
																					4 it	ems	
•				-	6	Gelle	-	al rai	1	12.0	for	0.0s	•				 						

Figure 24-8 The Completed Timeline

Step-by-Step Instructions:

- I. Here we go.
 - a) Select the Menu option **File / Open. Locate** and **select** the file named **wiggly_2.fla** from the **Chapter24 Folder** on the CD-ROM **or** use the version that you completed and saved from the last exercise.
 - b) Select the Menu option Window / Library to open the wiggly_2 Library.
 - c) **Double-click on** the Movie Clip for the **Wiggly Guy** to open it in the Editing Mode.
 - d) Select Frame I of the Button Layer. Select the Instance of the Invisible Button on the Stage and open the Actions Panel. The following code is already there from the previous exercise:

```
on (press) {
   tellTarget ("") {
     gotoAndPlay (2);
}
```

startDrag ("");

}

e) Select Line 6 of the code. Click the Basic Actions Folder in the left portion of the Actions Panel to expand the Folder. Scroll down the list of Basic Actions and double-click on the On Mouse Event. The following code appears in the Actions window:

```
on (press) {
 tellTarget ("") {
   gotoAndPlay (2);
 }
 startDrag ("");
3
on (release) {
}
```

f) Select Line 7 of the code. Click the Actions Folder in the left portion of the Actions Panel to expand the Folder. Scroll down the list of Actions and double-click on stopDrag. The following code appears in the Actions window:

```
on (press) {
 tellTarget ("") {
   gotoAndPlay (2);
  }
  startDrag ("");
}
on (release) {
  stopDrag ();
```

}

Select the Menu option Control / Test Movie. Click on the g) Wiggly Guy to begin the Tell Target and Drag operations, then release the mouse to drop him in place.

Uh-oh ... we dropped him but we still need to use another Tell Target Action. We told the target to go to and play Frame 2, we now need to tell the target to go back to Frame I to stop the screaming and wiggling when we release the mouse!

Return to the main Timeline. Make sure that you still have the h) Instance of the Invisible Button selected and that the Actions Panel is open. The code from the previous exercise reads:

```
on (press) {
 tellTarget ("") {
   gotoAndPlay (2);
  }
  startDrag ("");
}
on (release) {
```

406

·T/P·

We have again stated that an Event (On

Mouse Release)

will trigger an Action

(stopDrag).

```
stopDrag ();
```

 Select Line 7 of the code. Scroll down the list of Actions and double-click on Tell Target. The following code appears in the Actions window:

```
on (press) {
   tellTarget ("") {
     gotoAndPlay (2);
   }
   startDrag ("");
}
on (release) {
   tellTarget ("") {
   }
   stopDrag ();
```

```
}
```

}

j) Select Line 8 of the code. Scroll down the list of Actions and double-click on goto. The following code appears in the Actions window:

```
on (press) {
   tellTarget ("") {
    gotoAndPlay (2);
   }
   startDrag ("");
}
on (release) {
   tellTarget ("") {
    gotoAndPlay (1);
   }
   stopDrag ();
```

}

beselect gotoAndPlay at the bottom of the Parameters Pane. The code now reads:

```
on (press) {
  tellTarget ("") {
    gotoAndPlay (2);
  }
  startDrag ("");
}
on (release) {
  tellTarget ("") {
    gotoAndStop (1);
  }
  stopDrag ();
}
```

Changing gotoAndPlay to gotoAndStop tells the Wiggly Guy Movie Clip to go to Frame I and Stop playing through the Timeline.

```
CHAPTER 24
```

- Select the Menu option Control / Test Movie. Click on the Wiggly Guy to begin the Tell Target and Drag operations, then release the mouse to drop him in place.
- m) Save the file in the SaveWork Folder as ... wiggly_3.fla.
- n) Finally! We click to drag and wake him up, we release to drop and make him quiet. Now, what do we do if we want him to return back to his original location when we drop him? Let's return to the main Movie Timeline to find out.
- Return to the main Timeline. Make sure that you still have the Instance of the Invisible Button selected and that the Actions Panel is open. The code from the previous exercise reads:

```
on (press) {
   tellTarget ("") {
     gotoAndPlay (2);
   }
   startDrag ("");
}
on (release) {
   tellTarget ("") {
     gotoAndStop (1);
   }
   stopDrag ();
}
```

p) Select Line I of the code. Scroll down the list of Actions and double-click on Set Variable. In the Variable Text Box type in ... initial_x and make sure that the Expression box is not checked. In the Value Text Box type in ... _x and make sure that the Expression box is checked. The following code appears in the Actions window:

```
on (press) {
    initial_x = _x;
    tellTarget ("") {
      gotoAndPlay (2);
    }
    startDrag ("");
}
on (release) {
    tellTarget ("") {
      gotoAndStop (1);
    }
    stopDrag ();
}
```

q) Select Line 2 of the code and right-mouse click (Mac - Ctrl & click) over it. Select Copy from the context menu. Right-

Advanced Actions: Creating Drag-and-Drop Movie Clip Actions

mouse click (Mac – Ctrl & click) again and select Paste from the context menu.

r) Select Line 3 from the code. Change the Variable name initial_x to ... initial_y and the Value _x to _y. The following code appears in the Actions window:

```
on (press) {
    initial_x = _x;
    initial_y = _y;
    tellTarget ("") {
        gotoAndPlay (2);
    }
    startDrag ("");
}
on (release) {
    tellTarget ("") {
        gotoAndStop (1);
    }
    stopDrag ();
}
```

- s) That sequence of code creates two new Variables: initial_x and initial_y. On the press of the mouse, these two Variables take note of the original X and Y coordinates (_x and _y) of the Movie Clip and assign these coordinates numbers to the Variables - as Values.We can now use the Set Property Action to recall the value of the original X and Y positions (remember, they are stored in the initial_x and initial_y Variables ...) and return the dragged Movie Clip to that position.
- t) Select Line 9 of the code. Scroll down the list of Actions and double-click on set Property. In the Property Box, select _x (X Position). In the Value Text Box type in ... initial_x and make sure that the Expression box is checked. The following code appears in the Actions window:

```
on (press) {
    initial_x = _x;
    initial_y = _y;
    tellTarget ("") {
        gotoAndPlay (2);
    }
    startDrag ("");
}
on (release) {
    setProperty ("", _x, initial_x);
    tellTarget ("") {
        gotoAndStop (1);
    }
}
```

Remember that a Variable is a fixed name for a changing value. The Variable initial \mathbf{x} stands for the initial x coordinate of the Wiggly Guy on the Stage. The Variable name allows you to define a value, but we could just as easily have called the Variable by a different name in order to define the x coordinate. The code \mathbf{x} is actually a Property that is predefined in ActionScript as the x coordinate of the Movie Clip in relation to the parent Timeline (main Movie in this case). If you open the Properties book in the Actions Panel, you will see the x Property. Use the Menu option Help / ActionScript Dictionary to look up the meaning of different Properties and other ActionScript code.

(T/P)

The code initial_y stands for the initial y coordinate of the Wiggly Guy on the Stage. } stopDrag ();

- }
- u) Select Line 10 of the code and Right-mouse click (Mac Ctrl & click) over it. Select Copy from the context menu. Right-mouse click (Mac Ctrl & click) again and select Paste from the context menu.
- v) Select Line II from the code. Change the Property _x(X Position) to _y(Y Position) and the Value initial_x to initial_y. The following code appears in the Actions window:

```
on (press) {
    initial_x = _x;
    initial_y = _y;
    tellTarget ("") {
        gotoAndPlay (2);
    }
    startDrag ("");
}
ON (TELEdSE) {
    setProperty ("", _x, initial_x);
    setProperty ("", _y, initial_y);
    tellTarget ("") {
        gotoAndStop (1);
    }
    stopDrag ();
}
```

- w) Select the Menu option Control / Test Movie. Click on the Wiggly Guy to set the _x and _y Values of the two Variables, and begin the Tell Target and Drag operations. When you release the mouse to drop him, he returns back to his initial X and Y position on the Stage!
- 2. Let's add one final twist to the exercise: let's set up a drop target that we can drop him onto. We'll set it up so if we drop the Wiggly Guy over the target area he will snap to its center, but if he falls outside of it he will return back to his original spot. This will take a little deleting, re-writing and re-thinking through the exercise, but we'll make it through!

We will first change the "how" of establishing the initial X and Y positions. Currently the X and Y positions are set on the mouse click, so if the Wiggly Guy is outside of the target area he will return back to the spot established on the mouse click. In this case, if he doesn't land in the target area he will always return back to this same spot.

But what happens to the Wiggly Guy once he lands within the target area and we start to drag him again? If the target is his starting point on the mouse click, he will return back to this starting point if he lands inside (because we coded him to do so). If he lands outside of the target area he will also return back inside of the target area because the initial mouse click established an X and Y position inside of the target area.

What do we do then? Easy... we establish the initial X and Y of the Wiggly Guy Movie Clip when it first loads into the Movie (instead of on the mouse click).

- 3. So let's give it a try ... and set up the Target.
 - a) **Close** the preview window and return to the main Movie.
 - b) Click the Scene I Tab to return to the main Movie Timeline.
 - c) Insert a new Layer in the main Movie Timeline. Rename it . . . Target and make sure that it is at the bottom of the stacking order.
 - d) Select Frame I in the Target Layer.
 - e) Select the Menu option Window / Library to open the Library. Drag an Instance of the Drop Target Movie Clip to the Stage. Make sure the Instance of the Drop Target Movie Clip is selected on the Stage and then select the Menu option Window / Panels / Instance.
 - f) Type in ... target_area in the name text field. This is a unique Instance Name that we assign to this particular Instance of the Drop Target Movie Clip.
- 4. Now to re-establish the initial X and Y positions.
 - a) Select the Menu option Edit / Deselect All. Select the Instance of the Wiggly Guy Movie Clip that is on the Stage.
 - b) With the Instance of the Wiggly Guy Movie Clip selected on the Stage, open the Actions Panel.
 - c) Click the Actions Folder to expand the Folder, then double-click on Set Variable. Name the Variable ... initial_x and assign a Value of ..._x (make sure Expression is checked next to Value).
 - d) Select Line 2 of the code.
 - e) Click the Actions Folder to expand the Folder, then double-click on Set Variable. Name the Variable ... initial_y and assign a Value of ... _y (make sure Expression is checked next to Value). The code now reads:

```
onClipEvent (load) {
    initial_x = _x;
    initial_y = _y;
}
```

This creates two new Variables, initial_x and initial_y, and assigns them Values equal to the X and Y positions of the Movie Clip when it loads into the Movie. This establishes the "return" point for the Movie Clip if we release it outside of the Target Area. We'll just have to adjust the existing code to accommodate these two Variables.

- 5. So we need to now rewrite the Movie Clip Action Script.
 - a) **Double-click** the Movie Clip Symbol for the **Wiggly Guy Movie Clip** in the **Library** to enter the Editing Mode.
 - b) In the Wiggly Guy Timeline, select the instance of the Invisible Button Symbol and open the Actions Panel. Make sure that you still have the Instance of the Invisible Button selected. The code from the previous exercise reads:

```
on (press) {
 initial_x = _x;
 initial_y = _y;
 tellTarget ("") {
   geteAndPlay (2);
 }
 startDrag ("");
}
on (release) {
 setProperty ("", _x, initial_x);
 setProperty ("", _y, initial_y);
 tellTarget ("") {
   gotoAndStop (1);
 }
 stopDrag ();
}
```

For the remainder of the exercise we will work in **Expert Mode** so we can type in our own code. (Come on now, this is getting pretty familiar to you by now!) Click the **Option Arrow** at the top right of the Action Panel and choose **Expert Mode**. This will allow us to write our own code in the Action Panel just as we would write in a text-editing program.

c) Drag the mouse over the Lines 2 and 3 to select them (notice that the Action Panel indicates what line you are on if you first select a line and look under the Toolbar). Press the Delete Key to delete Lines 2 and 3. The code now reads:

```
on (press) {
   tellTarget ("") {
     gotoAndPlay (2);
}
```

412

Advanced Actions: Creating Drag-and-Drop Movie Clip Actions

```
startDrag ("");
}
on (release) {
  setProperty ("", _x, initial_x);
  setProperty ("", _y, initial_y);
  tellTarget ("") {
    gotoAndStop (1);
  }
  stopDrag ();
}
```

d) Next, click the mouse after the line that reads on (release) {

 . . to create an insertion point for new text. Press the Enter/Return Key and type in the following code:

```
if (eval(_droptarget) == _root.target_area) {
  setProperty ("", _x, _root.target_area._x);
  setProperty ("", _y, _root.target_area._y);
  tellTarget ("") {
    gotoAndStop (1);
  }
  stopDrag ();
} else {
```

This code creates the conditional statement for us that says **IF** we drop the dragged Movie Clip on the Instance named target_area (our _droptarget), **THEN** we will assign the dropped Movie Clip the same X and Y coordinates as the _droptarget. It will also Tell Target to go to Frame I and stop playing.

The } else { line we wrote tells the Movie Clip what to do if the condition isn't met. In this case the Movie Clip will snap back to its original X and Y positions (established when the Movie Clip loaded and recorded in the Variables initial_x and initial_y). The complete code now reads:

```
on (press) {
  tellTarget ("") {
    gotoAndPlay (2);
  }
  startDrag ("");
}
on (release) {
  if (eval(_droptarget) == _root.target_area) {
    setProperty ("", _x, _root.target_area._x);
    setProperty ("", _y, _root.target_area._y);
    tellTarget ("") {
        gotoAndStop (1);
    }
```

```
stopDrag ();
} else {
  setProperty ("", _x, initial_x);
  setProperty ("", _y, initial_y);
  tellTarget ("") {
    gotoAndStop (1);
  }
  stopDrag ();
}
```

- e) Select the Menu option **Control / Test Movie**. Drop the Wiggly Guy over the target and he snaps to the center. Drop him outside of the target and he returns back to his original position.
- f) **Save** the file in the SaveWork Folder as **Wiggly_4**. Outstanding job!

Summary

}

- Drag and Drop is an interactive feature in Flash that lets a user move objects on the screen by clicking on and then dragging an object with their mouse.
- The Drag and Drop technique is a great way to reach out and grab the user's collar to actively engage the user within the program that you have created.
- The only object that can be used with the Drag Action in Flash is a Movie Clip.
- Since a Movie Clip has a separate Timeline that is not dependent on the Frames in the main Movie Timeline, a Movie Clip can continue to play through its own Timeline as it is being dragged.
- In the first Guided Tour, you took a closer look at the Action Panel and the various options in the Parameters Pane.
- In the first Practice Exercise, you attached a Drag Action to the Wiggly Guy (an animated character within a Movie Clip) and tried out different settings using the startDrag Action.
- In the next Practice Exercise, you continued with the Wiggly Guy and inserted a Button Symbol inside the Movie Clip.
- In the third Practice Exercise, you continued with the Wiggly Guy and set up specific targets for dropping the object and used an If...Then Statement to evaluate user actions.

The _droptarget code is a Property that can be found inside the Property Actions Book in the Actions Panel. The _droptarget

Property allows you to compare the specified target area with the coordinates of the mouse release. If they are equal to the target area, then the x and y coordinates of the dragged Movie Clip Instance do not revert to the initial x and y positions, but instead go to the x and y coordinates of the target area.

PTER

25

Creating Forms

in Flash

Chapter Topics:

- Introduction
- Editable Text Fields
- Guided Tour The Text Options Panel
- Form Processing
- Practice Exercise Creating a Form
- Summary

Introduction

As you develop Flash Web sites, at some point you may want to gather information from site visitors. In Flash, you can create interesting Forms with editable Text Fields that look as inviting as the rest of your site. Instead of standard HTML-based Forms and surveys that look rather ordinary and institutional, Forms in Flash can be designed using any of Flash's drawing and animation tools. These sections of your Flash Web site can be as creatively designed and crafted as any other aspect your site. They can be fun, interactive and engaging for your site visitors. If they are visually interesting, more people may want to fill out your Forms.

Just as with other functions in Flash, editable Text Fields can also be put to many other uses. Don't limit yourself to thinking only about Forms as you go through this chapter. Think about how you might incorporate editable Text Fields into games, instructional activities, and anything else you may dream up for your site.

By the end of this chapter, you will be able to:

- insert editable Text fields.
- · use the Text Options Panel.
- set variables for Text Fields.
- describe how Forms are processed.
- · create a Form.

Editable Text Fields

You've had plenty of practice in previous chapters using the Text Tool in the Toolbox to insert text elements as part of your project. In this chapter, we are going to create input text boxes so that your users can type in text as they respond to survey questions on your site. We will use the Text Options Panel (Window / Panel / Text Options) to select the type of text object to use. Figure 25-1 shows these options in the pull down menu in the Text Options Panel. We covered some of this information earlier in Chapter 9, but here is a quick review of the text options available to you.

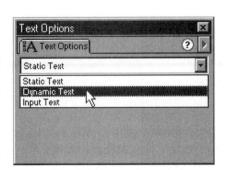

Figure 25-1 Pull Down Menu in Text Options Panel

Static Text – Static Text is the most commonly used text type in Flash applications that do not require dynamically updated information, or input by the user. Unlike text formatted with HTML tags, Static Text in Flash allows you to choose specific fonts to apply to your text that can then be embedded into the final *.swf* file that is exported. This preserves the visual appearance of the font you have applied to your text and insures that the font displays accurately in the user's Flash Player. You can also use Device Fonts with Static Text.

Dynamic Text – Dynamic Text is updated by information provided by a server-side software application (Macromedia's Generator, as an example) that feeds new information to the Text Field. This is useful in applications where frequently updated information is valuable, such as with stock quotes or weather information. Dynamic Text is updated by specifying **Variables**, or fixed names that are associated with a changing value. These changing values may be the numbers for stock quotes that are constantly being updated, and "fed" to the Dynamic Text Field.

Input Text – Input text boxes are invisible text boxes that have a Variable attached to them, just like Dynamic Text. However, Input Text allows you to set up Text Fields that require a visitor to type information into these fields. The visitors to your site have an opportunity to give feedback with Forms, buy stuff (e-commerce), and otherwise interact by providing information in these Text Fields.

Guided Tour – The Text Options Panel

First, let's take a look at the fields in the Text Options Panel and learn how to use them to create Forms. Figure 25-2 shows the Text Options Panel with the default options displayed.

CHA	PTI	ER	25
-----	-----	----	----

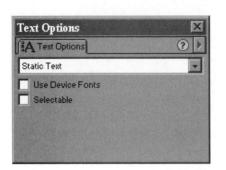

Figure 25-2 The Text Options Panel - Static Text

- I. Select the Menu option Window / Panels / Text Options.
- 2. Click on the pull down menu at the top of the panel. Note that this field has three options for setting the behavior of text in your Flash Movie. The default setting for text boxes to be inserted ... is Static Text, with Dynamic Text and Input Text as the other available options. You have been using Static Text in all the previous exercises.
- 3. Now select Dynamic Text. This option gives you a range of new settings as illustrated in Figure 25-3. With Dynamic Text boxes, you can use these boxes to automatically and dynamically update information like daily temperature, stock prices, and other rapidly changing types of data. The use of Dynamic Text boxes generally requires some type of serverside support, such as a database that supplies the information to be displayed in the Dynamic Text box.

Text Options	X
	? Þ
Dynamic Test	•
Single Line	HTML Border/Bg
Embed fonts: [] Az ^a z ¹ 23 0 !	Selectable

Figure 25-3 The Text Options Panel – Dynamic Text Option

4. Now select the **Input Text** option and look at the available settings as shown in Figure 25-4. We are going to take a little closer look at these options because we will be working with them in the following Practice Exercise.

Creating Forms in Flash

TIP

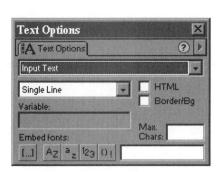

Figure 25-4 The Text Options Panel - Input Text Option

Line Type Menu: Click on pull down menu and take a look at the options: Single Line, Multiline and Password. The option that you choose here will depend on the type of Text Field that you need. If you are asking for information such as a site visitor's last name, a Single Line will be sufficient for inputting that kind of information. In other cases, you might need to provide space for a longer reply, such as for an answer to a survey question. Use the Multiline setting for longer responses. The last setting is Password. This option affects how the text entered by the user is displayed in the Text Field. Usually circles, squares or other symbols "cover-up" whatever you type as your password in a browser.

HTML: This checkbox allows you to retain rich text formatting in your Text Field, including things like font styles using HTML tags.

Border/BG: The Background and Border checkbox allows you to set up an outline and border color for the text box so that the input box is visible.

Variable: Perhaps one of the most important fields in the current panel is the Variable field. A Variable is a name given to a value that changes depending on circumstance. We will use variables in the Practice Exercise later in this chapter.

Max. Chars: Once you have chosen which line type response is appropriate, you will also need to set the upper limit of characters that the user can type in. The Maximum Character field is where you set this limit.

Embed Fonts: The Embed option in the current panel allows you to embed the outlines of an entire character set or only certain characters from a font in your exported *.swf* file. These options are (from left to right as illustrated in Figure 25-5): Include Entire Font Outline; Include Outlines for Uppercase; Include Outlines for Lowercase; Include Outlines for Numbers; Include Outlines for Punctuation. You can turn on any or all of these options simultaneously.

The icons along the bottom of the Text Options Panel deal with embedded Font options. In an earlier chapter, you learned that when Flash exports a **.swf** file, the font sets used in that Movie are embedded as outlines, unless another selection is made.

Flash also uses another type of display for fonts called Device Fonts. Essentially, Flash exchanges the font in your Movie with a similar font found on the computer on which it is running. As you can imagine, using Device Fonts decreases your Movie size, but it also may change the appearance of your Movie somewhat, depending on the font substituted.

There are three Device Fonts that are installed with Flash 5, _san, _serif, and _typewriter. You can select them from your Character Panel and apply them to text. Usually, they are found at the very top of the Font menu in the Character Panel.

~	ш	۸	D	т	Е	D	2 E
-	п	А	г			ĸ	25

·T/P

420

Figure 25-5 Embed Icons in the Text Option Panel

Form Processing

When we set up Forms in Flash, we are essentially setting up a front end – what the user actually sees – with a lot of details behind the scene. It's a little like setting up a display in a store window – there is much more inside the store but you've got to get shoppers to come through the door. Forms in Flash are like window dressing. Once the user fills them out, the processing takes place on the back-end, or behind the scenes on the Web server.

Web Forms on HTML pages are often processed by **CGI** scripts that reside on the Web server. Once the user presses the submit button, the data in the Form is sent to this script, which then processes the information and puts the data into categories based on the variable names set up in the Form. Often this data is e-mailed to someone, or it can also be added to a database – depending on the script used to process it. Flash uses Actions to send or "pass" the variables that you set up in your Text Fields to a Web server for processing.

A **CGI** script is an example of a **server-side application** because it is a program that executes – or runs – on a Web server. **CGI** applications can be written in several programming languages, including C, Perl, Java, and Visual Basic. Examples of **CGI** applications include search features, guestbooks, and other types of functions where data needs to be submitted and processed for collection. When a user submits the data within a Form (usually by pressing a submit button), the associated **CGI** script is triggered and begins to run through its tasks.

The opposite of a server-side application is a **client-side application**. A client-side application runs on the end-user's machine instead of on the Web server. Often, client-side applications run through a user's browser and are written as Java scripts, applets, or ActiveX controls.

Practice Exercise – Creating a Form

Description

We have just gone through looking at the various settings in the Text Options Panel. In this exercise you will now set up a Form for a Web site.

If you don't know how to write your own script to process Form data, don't despair. Since many scripts perform general tasks, such as collecting guestbook data, there are many free scripts available for download on the Web. Most Internet Service Providers also have cgi scripts for certain kinds of tasks that are available for their customers to use as part of their ISP service. Look around on the Web and you will be surprised how many of these free scripts are available for use.

In this exercise you will:

- create a design for a Form.
- insert input text boxes.
- assign variable to those boxes.

Take a Look

Before beginning the exercise, let's take a look at the exercise in its completed state so that you can clearly see what it is that you are about to build.

- Use the Menu option File / Open and locate the folder named Chapter25 on the CD-ROM. Look inside this folder and locate the file named form.fla. Double-click on this file to open it.
- 2. The file form.fla should appear on your screen.
- 3. Take a look at the Form that you will create on the Stage.
- 4. Select the Menu option Control / Test Movie to preview this file.
- 5. Fill out the Form so that you can see how it works. When you are finished, close this file and let's get started!

Please note the following properties of this completed exercise:

- a) The Form allows the user to type in all relevant information.
- b) Behind the scenes, all user information is stored in Variables.

Storyboard: On-Screen

Figure 25-6 shows how the Stage will look once you've completed this exercise.

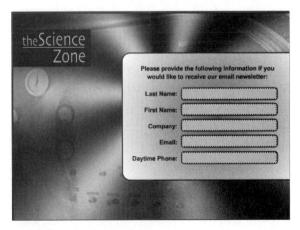

Figure 25-6 Completed Stage

CD-ROM

CHAPTER 25

Storyboard: Behind the Scene

Figure 25-7 shows you what the Timeline will look like when the exercise is completed.

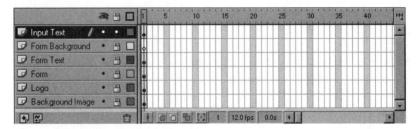

Figure 25-7 Completed Timeline

Step-by-Step Instructions:

- I. Let's start with a blank document.
 - a) Select the Menu option **File / New** to create a new Flash file.
 - b) Select the Menu option **Modify** / **Movie** to open the Movie Properties box.
 - c) Change the **background color** to **black** and **click OK**.
 - d) Now that you have created your base file, select the Menu option File / Save and save the file in the SaveWork Folder ... typing in the file name ... myform.fla.
- 2. Now we need to add elements to your Library so we can start building this Form.
 - a) Select the Menu option File / Open as Library.
 - b) Locate and select the file . . . form_items.fla in the Chapter25 Folder on the CD-ROM.
 - c) When you open a Movie as a Library the only thing that appears on your Stage is the Movie Library, as illustrated in Figure 25-8. These Symbols will be added to the myform.fla Library once they are dragged to the Stage.

Go Solo

·T/P

The Open as Library option allows you to open a Library associated with a Flash Movie that you have previously created. This is a great way to quickly pull together elements that you have created in the past, for use in a current Movie.

CD-ROM

Figure 25-8 New Library

- 3. Now that we have Symbols to work with, let's start building.
 - a) **Double-click** on **Layer I** in the Timeline and rename it . . . **Background Image.**
 - b) Look in the form_items Library and drag the bitmap called machinebkg.jpg to the Stage. Position it so that it covers the background of the Stage.
 - c) Once you get the image in place, **lock** this **Layer**.
 - d) Create a new Layer above the Background image Layer and name it ... Logo.
 - e) **Drag** the **Logo Symbol** from the **form_items Library** and place it on the **Stage.**
 - f) From the Window Menu open the Info Panel and set the x coordinate to 77 and the y coordinate to 67.
 - g) Lock the Logo Layer.
 - h) Create a new Layer above the Logo Layer and name it ... Form Background.
 - i) Drag the box Symbol to the Stage and set the x coordinate to 400 and the y coordinate to 200.
 - j) Lock the Form Background Layer.

4. We've got the background set, now let's create the text for our Form.

- a) **Create** a **new Layer** above the Form Background Layer and name it ... Form Text.
- b) **Select** the **Text Tool** in the Toolbox and **click anywhere** on the Stage to insert a new text box.

CHAPTER	₹2	5
---------	----	---

- c) Open the Character Panel by using the Menu option Window / Panels / Character.
- d) Make the following selections in the Character Panel: set the Font to Arial; the Size to 12, and change the Color to Black and Bold. See Figure 25-9.

Character	X
A Character	?
Font: Arial	-
A1 12 - B I	
₩ Kern	
A‡ Normal 👻	
URL:	

Figure 25-9 Settings in the Character Panel

- e) Open the Paragraph Panel by selecting Window / Panels / Paragraph.
- f) Select Right Align from the Panel options.
- g) **Click in** the **text block** on the **Stage** and type in the following ... (pressing the Enter/Return Key twice after each line).

Last Name: First Name: Company: Email:

Daytime Phone:

- h) **Create** a new **text box** with the **same settings** in the Character Panel. This time **change** the **alignment** to **Center** in the **Paragraph Panel.**
- i) In the new text box, type in the following (you can wrap the text into the second line at whatever break point you would like):

Please provide the following information if you would like to receive our email newsletter:

- j) Move both text blocks until they are arranged as shown in Figure 25-10.
- k) Save your file so you don't lose your work.

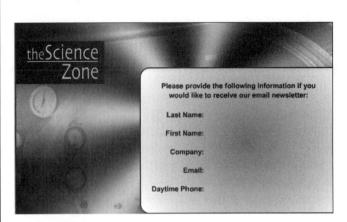

Figure 25-10 Text Form - in Progress

- 5. Almost finished! The final step is to add the input Text Fields and set up the variables.
 - a) Add a new Layer to the Timeline above the other Layers. Name this one ... Text Field Background.
 - b) From the form_items Library, drag the text_entry Symbol to the Stage. Add an Instance of this Symbol next to each Form element as illustrated in Figure 25-11.
 - c) Turn on the Rulers by selecting the Menu option View / Rulers. Drag a Guide line from the left ruler to use a placement guide if necessary.
 - d) Lock the Form Background and the Form Text Layer.

theScience Zone	
Zone	
C. C	Please provide the following information if you would like to receive our email newsletter:
	Last Name:
6	First Name:
	Company:
	Email:
	Daytime Phone:

Figure 25-11 Positioning the text_entry Symbol

e) **Create** a **new Layer** and name it ... **Input Text.** Make sure it is the top Layer.

- f) Select the Text Tool from the Toolbox.
- g) Select **Window / Panels / Text Options** to open the Text Options Panel. **Select Input Text** from the pull down menu.
- h) **Click** and **drag** over the green field next to Last Name to create an input text box. Use the Arrow Tool to reposition as necessary.
- i) Select the Input Text box next to Last Name and take a look at your Options Panel. Set the Text Field type to Single Line, Max Char to 50, name the Variable ... lastname.
- j) Check your **Paragraph Panel** and make sure your **alignment** is set to **Left**.
- k) Check your Character Panel and make sure the text is set to Arial, Black, Bold, 12.
- Repeat steps f-k for the other four Form fields giving each of them the following variable names: firstname, company, email, phone.
- m) Save your file.
- n) Select Control / Test Movie to see how your Form works.
- o) Good job! In the next chapter you will learn to add a Submit button to make your Form functional.

Summary

- As you develop Flash Web sites, at some point you will want to gather information from site visitors. In this chapter, you saw how creating input text boxes will allow your users to fill in information in response to survey or form questions.
- When you create Forms in Flash you can use the Character Panel to specify the font, size, and color that is used to display the text.
- There are three Text Options in Flash, each used in very different ways Static, Dynamic, and Input Text.
- Editable Text Fields, or input boxes are designated in the Text Options Panel.
- In the first Guided Tour, you briefly looked at the Static and Dynamic Text options. The rest of the Tour looked at the details of the Input Text option.
- When we set up Forms in Flash, we are essentially setting up a front end what the user actually sees – with a lot of "production" details behind the scene.
- Flash uses Actions to send or pass the variables that you set up in your Text Fields to a Web server for processing.
- In the Practice Exercise, you created a design for a Form; inserted input text boxes, and assigned a variable to these boxes.

PTER

26

Application Chapter: Information Form

Chapter Topics:

- Introduction
- Application Exercise Information Form
- Summary

Introduction

In many instances, you might want to gather information from the visitors to your site for marketing purposes, or just to find out what kind of things they like or dislike about your site's design. Creating Forms and surveys using editable Text Fields in Flash is an easy way to get feedback about your site.

You can also use ActionScripts to send that information to a script on a server that collects and stores the data in a specified manner.

Application Exercise – Information Form

Description

Now that you have the bulk of your site built, we can add some bells and whistles. First, you will build an "input-form" for the visitors to your site to fill out. Finally, you will make your Form functional so that you can collect the information you've asked for from your site visitors.

Take-a-Look

Before beginning the exercise, let's take a look at the exercise in its completed state so that you can clearly see what it is that you are about to build.

- Use the Menu option File / Open and locate on the CD-ROM the folder named Chapter26. Locate the file named application_26.fla.
 Double-click on this file to open it.
- 2. The file application_26.fla should now appear in your copy of Flash.
- 3. Select the Menu option Control / Test Movie to view the Movie.

Storyboard: On-Screen

Figure 26-1 shows what can be seen on Stage when the exercise is completed.

Application Chapter: Information Form

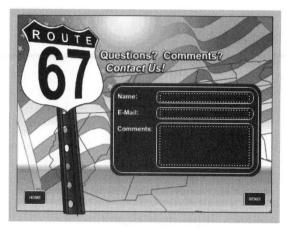

Figure 26-1 The Completed Stage

Storyboard: Behind-the-Scene

Figure 26-2 shows how the Timeline will look when the exercise is completed.

		a	8		1 5	10	15	20	25	30	35	40	45	50	55	60	65	H
Actions		•	•		a a													
🕼 Editable Text	1	•	•	31	0													T
Text Block		•	•															
Send Button		٠	•															
Home Button		•	•		•n													-1
Background		•	•							T								

Figure 26-2 The Completed Timeline

Applications Project Steps

Complete this exercise on your own, guided by following the general steps provided below. You can always refer back to the completed example that you viewed in the Take-a-Look section of this exercise.

Please Note: The following steps are intended as a guide. This is your project so please feel free to make whatever variations you would like.

- Open application_23.fla. You can either use the copy you created and saved in the SaveWork Folder on your computer or you can use the copy in the Chapter23 Folder on the CD-ROM supplied with this book.
- 2. Go to the Contact Scene.

CHAPTER 26

3. Create a new Layer and name it Actions. Position it at the top of the Layer Stacking Order.

- Select Frame I of the Actions Layer and assign the following ActionScript: stop ();
- 5. Select Frame 2 of the Actions Layer and Insert a Keyframe. Assign the following ActionScript to Frame 2 of the Actions Layer:
 stop ();
- 6. Create a new Layer and name it Text Block. Position it above the Home Button Layer.
- With Frame I of the Text Block Layer selected, drag an Instance of the Text Block Graphic Symbol out of the Graphic Images Folder of the Library onto the Stage. Position it at X=423.6,Y=278.6.
- 8. Select Frame 2 of the Text Block Layer and insert a Keyframe.
- With Frame 2 of the Text Block Layer selected, drag an Instance of the Thank You Block Graphic Symbol out of the Graphic Images Folder of the Library onto the Stage. Position it at X=423.6,Y=278.6.
- 10. Lock all Layers of the Contact Scene.
- 11. Create a new Layer and name it Editable Text. Position it above the Text Block Layer.
- 12. Delete Frame 2 of the Editable Text Layer.
- 13. Select Frame 1 of the Editable Text Layer.
- 14. Create a Text Block that corresponds to the "Name" space of the Text Block Symbol. Assign it the following properties:

Font:	_sans
Font Color:	white
Font Height:	14
Align:	Left Justified
Text Type:	Input Text
Line Type:	Single Line
Variable:	visitorName
Max Characters:	35

Make sure that no other properties are checked or selected.

Application Chapter: Information Form

·T/P

15. Create a Text Block that corresponds to the "E-Mail" space of the Text Block Symbol. Assign it the following properties:

Font:	_sans
Font Color:	white
Font Height:	14
Align:	Left Justified
Text Type:	Input Text
Line Type:	Single Line
Variable:	visitorEmail
Max Characters:	35

Make sure that no other properties are checked or selected.

16. Create a Text Block that corresponds to the "Comments" space of the Text Block Symbol. Assign it the following properties:

Font:	_sans
Font Color:	white
Font Height:	14
Align:	Left Justified
Text Type:	Input Text
Line Type:	Multiline
Variable:	visitorComments
Max Characters:	5000
Word Wrap:	Selected

You can add hidden variables to your Form by selecting the first Frame of the first Layer and using a set variable action.

The script you use on your server to process the Form data may require specific names for your variables. For your own projects, check the "Read Me" files associated with your script to make sure.

Make sure that no other properties are checked or selected.

Now that we have the graphics in order, let's set up an ActionScript that will be similar to what you will use to customize Forms on your own Web site. In this exercise, we will use a fictitious Web address, but you can use what we use here as a model.

- 17. Create a new Layer and name it Send Button. Position it above the Home Button Layer.
- 18. Delete Frame 2 of the Send Button Layer.
- 19. Select Frame 1 of the Send Button Layer.
- 20. Drag an Instance of the Send Button Symbol out of the Buttons Folder of the Library and position it at X=597.4, Y=447.1.

PTER

27

Application Chapter: Publishing the Site

Chapter Topics:

- Introduction
- Application Exercise Publishing the Site
- Summary

Introduction

Once you have completed your Flash Web site you've got to publish and deliver it to your audience. Flash's Publish Settings and Export features give you multiple options for saving your Movies into a format for Web delivery, CD-ROM delivery, or for using single Frames of your Movies as static graphics.

Once you have published your site, what happens next? You've got to put your site on a server in order for people to connect to it. Using the Publish Settings window in Flash, you will have an **.HTML** file with an accompanying **.swf** file that are ready to be put on a Web server. Transferring data to a server uses a process known as file transfer protocol or *ftp*. There are many *ftp* software programs that you can download free of charge or use with a nominal fee as shareware.WS_FTP is a popular program for the PC, while Fetch is a program popular with Mac users. If you use Dreamweaver to design your Web pages, you can use the built-in *ftp* program found in the site management tools. Whichever *ftp* program you choose to use, you will need some basic information to connect to your server. In general you will need a host name (server name), a userIL, and a password. I hese details vary depending on the server account you are using.

This application chapter will walk you through publishing your Route 67 site, but you must have access to your own Web server space in order to actually post the files to a server. Server space is *not* provided with this book. If you have an Internet Service Provider for a dial-up account, chances are that you may have a small amount of server space for personal use that comes with your dial-up connection. You may want to contact your provider and find out.

Let's get started with your last application exercise.

Application Exercise – Publishing the Site

Description

In this Application Exercise you will Publish your finished Route 67 project and get it ready for posting on a Web server. While you will *not* actually post it on a server, you will be given general instructions for how you can do this with your own server space. First, let's get your site published and ready to go.

Take-a-Look

Before beginning the exercise, let's take a look at the exercise in its completed state so that you can clearly see what it is that you are about to build.

- Locate the folder named Chapter27 on your CD-ROM. Find the file named application_final.html. Double-click on this file to open it in your default Web browser.
- 2. The file **application_final.html** should now appear in your default Web browser.
- 3. Select the Menu option Control / Test Movie to view the Movie.

Storyboard: On-Screen

Figure 27-1 shows what can be seen in your Web browser when the exercise is completed.

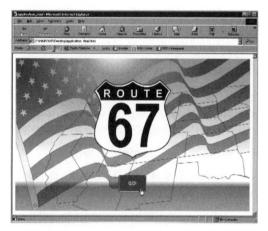

Storyboard: Behind-the-Scene

Figure 27-2 shows you how your new **mysite folder** will look once your files have been published. Your **mysite folder** might have additional files in it depending on the options chosen in the Publish Settings.

CD-ROM

CHAPTER 27

<u>File Edit ⊻iew</u>	Go Favor	rites <u>H</u> elp			10 1 A
↔ Back Forwar	i Up		Copy I	Paste	
Address C: Vmysite					-
Name	Size	Туре	Modifie	ed	
application_final	684KB	Flash Movie	2/8/01	12:12 PM	
application_final	2KB	HTML Document	2/8/01	12:12 PM	
application_final	325KB	Flash Player Movie	2/8/01	12:12 PM	

Figure 27-2 The mysite Folder

Application Project Steps

Complete this exercise on your own, guided by following the general steps provided below. You can always refer back to the completed example that you viewed in the Take-a-Look section of this exercise.

Please Note: The following steps are intended as a guide. This is your project so please feel free to make whatever variations you would like.

- Open application_26.fla. You can either use the copy you created and saved in the SaveWork Folder on your computer or you can use the copy in the Chapter26 Folder on the CD-ROM supplied with this book.
- 2. Create a new Folder on your hard drive and name it ... mysite.
- 3. Save a copy of your file as application_final.fla in the new mysite Folder. This will help keep all the files you are going to publish organized.
- 4. Open the Publish Settings by selecting the Menu option File / Publish Settings.
- 5. You want to create files in the .swf as well as HTML formats since you are going to publish this Movie on the Web.
- 6. On the Flash tab in your Publish Settings, make selections for Load Order, Options, JPEG Quality, Audio Settings, and the appropriate version of Flash.
- On the HTML tab in your Publish Settings, make selections for Template, Dimensions, Playback, Quality, Window Mode, HTML Alignment, Scale, and Flash Alignment.
- 8. Click the Publish button to publish your new files in the mysite Folder.

- 9. Find and open the mysite Folder on your computer. Double-click to open the HTML file in your default browser to check out what you have created.
- 10. Now, you must ftp your file to a Web server. You may want to check with your Internet Service Provider (ISP) to see if you are entitled to server space along with your dial-up account. If you do have server space, you will also need a host name, userID, and password to get into the server space.
- You will need an ftp program. Here are examples of the information required for WSFTP and Fetch. The information entered in these fields is not a valid ftp site.

Session Properties		? >
General Startup Adv	anced Firewall	
Profile Name:	My Website	New
Host <u>N</u> ame/Address:	www.mywebsite.com	D <u>e</u> lete
Host <u>T</u> ype:	Automatic detect]
<u>U</u> ser ID:	username	
Password:	*****	Saye Pwd
Account		
Comment:		
OK	Cancel Apply	Help

Figure 27–3 WSFTP Connection Screen

	New Connection
	ame, userid, and password (or the shortcut menu):
Host:	www.samplesite.com
User ID:	yourusername
Password:	•••••
Directory:	pub
Shortcuts:	▼ Cancel OK

Figure 27–4 Fetch Connection Screen

12. Once you are connected to a server using your ftp program, you can copy files from your hard drive to the server. In Figures 27-5 and 27-6, you can

see how the screens for WSFTP and Fetch will look once you've connected to the server. Notice that you can see the directory structure for the server and can choose which folder to put things into. Most servers have a public_html or www folder where you can publish your files so that they will be available on the Web.

Figure 27-5 WSFTP Interface When Connection is Established to a Server

Summary

Congratulations! You have just created a Flash Web site from start to finish. You now have a working Flash Web site that's ready for posting on a Web server. This is quite an accomplishment. Just think how much easier it will be the second time around, as you work on your own project.

ActionScripts, 278-280

Action(s)

basic Drag, 397-400

using with Scenes, 337-340

startDrag, 395-397

stopDrag, 395-397

Actions Panel, 268-275, 462

Adobe Illustrator, 118

Align Panel, 458

animation, 234-236

AutoCAD DXF, 118

Bandwidth Profiler, 378-380

Basic Actions, 280-282

bitmap, 119

images, 125-128

file formats, 123-125

graphics versus vector graphics, 122-123

Button

adding Actions to, 268-275

adding sound to, 314-317

enabling, 259-260

states, 260-261

symbol(s), 186-188, 258-268

to create animated effects, 290-297

CD-ROM, 11

Character Panel, 459 (CD-ROM)

Clip Parameters Panel, 460 (CD-ROM)

Content Outline, 331-333

Controller, 35-36, 40-43

1-2

		INDEX	
		0 0 0 0	
Debugger Panel, 466 (CD-ROM)		0 0 0	
designing the interface, 107-115		•	
display views, 165-167		0 0 6	
Drag Action, 394-403		4 0 0	
Drag and Drop		•	
definition, 394		0 0 0	
Drop Actions, 403-414		0 0 0	
editable text fields, 416			
Effect Panel, 460		0 0 0	
Enhanced Windows Metafile, 119		6 0 0	
Event, 312		6 6 6	
Export Image, 359-360		6 6 6	
Export Movie, 360-362			
Export Options, 358-359		0 0 0 0	
ile extensions and descriptions, 12		0 0 0	
-lash Player, 118, 382-383		•	
orm processing, 420-426		6 6 6	
rame Actions, 282-284		• • •	
Frame Panel, 213-216, 460 (CD-ROM)		0 0 0	
Freehand, 118		• • •	
importing artwork from, 120-122		6 6 6	
FutureSplash Player, 118		8 8 8	
Generator Panel, 467		* * *	
Go To, 284-288			
graphic formats, 50-52		6 6 6	
Graphics Interactive Format (GIF), 118-119		0 0 0 0	
Grid, 168, 170-173		6 6 6	
grouping objects, 130-136		0 0 0	
Guides, 168-171			

importing artwork, 117-128 files, 118-128 Info Palette, 167 Info Panel, 456 (CD-ROM) Information Form, 428-432 Instance Panel, 460 (CD-ROM) Fill Panel, 456 (CD-ROM) Joint Photographic Experts Group, 119 Keyboard Shortcuts, 446-453 (CD-ROM) Window, 445-453 (CD-ROM) Layers, 81-85, 143-150 Library, 34-35 Library Panel, 466 MacPaint, 119 Macromedia Dreamweaver, 383-385 Macromedia Flash('s) capabilities, 2 computer skills required to use, 3 Controller, 40-43 creating forms in, 415-426 default interface, 22 description (definition), 2 drawing with, 49-86 grouping objects within, 130-132 Help, 37, 444 (CD-ROM) icons used in, 7 importing artwork into, 117-128 interface, 21, 111-116 Keyframe, 27

1-4

	 INDEX	
	•	
metaphor, 20		
opening a new file in, 12-15	•	
panels within, 456-467		
Playhead, 27, 40-43	0 0 0	
sound files supported by, 307	0 0	
Timeline, 26-28		
Toolbars within, 453	0 0 0	
using Windows versus Macintosh with, 9	0 0 0	
Menu(s), 31-33	0 0 0	
Control, 32, 443 (CD-ROM)	0 0 0	
Edit, 32, 441 (CD-ROM)	0 0 0	
File, 31, 440 (CD-ROM)	0 0 0	
Help, 33, 444-445 (CD-ROM)	•	
Insert, 32, 442 (CD-ROM)	0 0 0	
Modify, 32, 442-443 (CD-ROM)	0 0 0	
Text, 32, 442-443 (CD-ROM)	0	
View, 32, 164-165, 441 (CD-ROM)		
Window, 32, 444 (CD-ROM)	0 0 0	
Mixer Panel, 458	0 0 0	
Motion Guides, 212-213, 216-226	0 0 0	
Motion Tweens, 211-212, 216-226	0 0 0	
Movie(s)	6 6 6	
loading, 344-349	0	
organizing, 327-349	0 0 0	
publishing, 358, 380-382	0 0 0	
unloading, 344-349	0 0 0	
using scenes in, 328-330	6 6 5	
Movie Clip(s), 176-180, 238-250	0 0 0	
to create animated effects, 290-297	6 6 6	

Movie Explorer, 36 Movie Explorer Panel, 465 (CD-ROM) Movie files optimizing, 377 Movie Properties, 46-47 nested groups of objects, 137-138 **Object Actions**, 282 objects creating nested groups of, 137-138 grouping, 130-136 ungrouping, 139-143 Onion skinning, 101-105 Panels, 33-34, 456-467 Actions, 268-275 Paragraph Panel, 459 (CD-ROM) Photoshop, 119 PICT, 119 Play, 284-287 Playback Speed, 45-46 Playhead, 40-43 PNG, 119 Pre-Loader, 340-344 building a, 341-344, 390-392 Publishing a Web site, 434 Publish Settings, 362-377 to publish a Web site, 434-436 QuickTime, 118-119 QuickTime Image, 119 QuickTime Movie, 119

1-6

INDEX	
-------	--

Rulers, 168-169 Scene Panel, 462 Scenes, 328-331 creating a Movie with multiple, 333-337 setting up, 352-356 Shape Tweens, 213, 227-230 Shared Libraries, 385-387 Smart Clips, 250-256 sound adding to the Timeline, 308-311 practical considerations when using, 307 work-arounds with using, 317-318 sound effects, 313-314 creating, 322-325 sound files, 301-305 properties of, 305-306 Sound Panel, 462 (CD-ROM) Stage, 23 Start, 312 Stop, 284-288, 312 Storyboard, 332-333 Stream, 312 Stroke Panel, 457 (CD-ROM) Swatches Panel, 458 (CD-ROM) Symbols, 34, 176-182 and Behaviors, 183-184 Button, 186-88, 258-268 creating reusable, 204-207 creating and editing, 189-195

modifying instances of a, 195-201 Test Options Panel, 459 (CD-ROM) text formatting, 157-163 inserting, 157-163 Text Options Panel, 417-419 Text tool, 151-157 Timeline, 26-28, 43-45, 455 Button Symbol, 467 (CD-ROM) Frame(s), 26-27, 88-101 Keyframe(s), 27, 88-101 Layers, 26 Playhead, 27 Toolbar(s) Windows only, 33 within Flash, 453 (CD-ROM) Toolbox, 28-31, 454 (CD-ROM) Tool Section, 29-31 Tool Modifiers, 69-80 Transform Panel, 457 (CD-ROM) tweening definition, 210-211 vector graphics, 52-53 View Menu, 32, 164-165 Windows Metafile, 119 Windows versus Macintosh, 9 Work Area, 24-25